IMPRESSIONS OF FRENCH MODERNITY

UNIVERSITY
ND YO

MANCHESTER
UNIVERSITY PRESS

FOR JONATHAN AND ABIGAIL

IMPRESSIONS OF FRENCH MODERNITY

Art and literature in France 1850–1900

EDITED BY RICHARD HOBBS

Manchester University Press

MANCHESTER & NEW YORK

DISTRIBUTED EXCLUSIVELY IN THE USA BY ST. MARTIN'S PRESS

Published by Manchester University Press
Oxford Road, Manchester M13 9NR, UK
and Room 400, 175 Fifth Avenue, New York, NY 10010, USA

Distributed exclusively in the USA by
St. Martin's Press, Inc., 175 Fifth Avenue, New York,
NY 10010, USA

Distributed exclusively in Canada by
UBC Press, University of British Columbia, 6344 Memorial Road,
Vancouver, BC, Canada V6T 1Z2

British Library Cataloguing-in-Publication Data
A catalogue record for this book is available from the British Library

Library of Congress Cataloging-in-Publication Data applied for

ISBN 0 7190 4895 8 *hardback*
ISBN 0 7190 5287 4 *paperback*

First published 1998

01 00 99 98 10 9 8 7 6 5 4 3 2 1

Typeset by Graphicraft Typesetters Ltd., Hong Kong
Printed in Great Britain
by Redwood Books, Trowbridge

Contents

Illustrations

Contributors

MICHÈLE HANNOOSH is Professor of French at University College London. She has published widely on issues of word and image and on the history and theory of modernity, including *Baudelaire and Caricature: From the Comic to an Art of Modernity* (1992) and *Painting and the Journal of Eugène Delacroix* (1995). She is currently preparing a major new edition of Delacroix's journal, featuring previously unpublished material and full critical notes, to be published in three volumes by Macula in 1998.

RICHARD HOBBS is lecturer in French at the University of Bristol. His early research concerned French Symbolist painting, and he published the first English-language monograph on Odilon Redon (1977). He has since written on various aspects of French Symbolism in art and literature, and on broader topics, notably short fiction. He is currently working on the aesthetics and reception of the writings of French artists from Romanticism to Cubism.

JOHN HOUSE is Professor of History of Art at the Courtauld Institute of Art, University of London. He was co-organiser of the Post-Impressionism exhibition at the Royal Academy of Art, 1979–80, and of the Renoir exhibition (Hayward Gallery, London, Grand Palais, Paris, and Museum of Fine Arts, Boston) in 1985–86, and guest curator of Landscapes of France (Hayward Gallery, London, and Museum of Fine Arts, Boston) in 1995–96. He is author of *Monet: Nature into Art* (1986) and of many essays and articles on French nineteenth-century painting.

JAMES KEARNS is lecturer in French at the University of Exeter. He is author of *Symbolist Landscapes: The Place of Painting in the Poetry and Criticism of Mallarmé and his Circle*, co-author (with Jennifer Birkett) of *The Macmillan Guide to French Literature*, co-editor (with Keith Cameron) of *Le Champ littéraire, 1860–1900*, and has written a number of articles on the relationships between French literature and the visual arts in the nineteenth century. He is currently preparing a critical edition of Gautier's Salons of 1833, 1834 and 1836 and a book on Gautier's art criticism of the July Monarchy.

ALAN KRELL is currently senior lecturer in the School of Art History and Theory at the University of New South Wales College of Fine Arts, Sydney, Australia (after a teaching career that has included South Africa and Britain). He has written on nineteenth-century French art and culture, especially the work of Edouard Manet, the subject of his most recent book, *Manet and the Painters of Contemporary Life* (1996).

JOY NEWTON is reader in French at the University of Glasgow. Most of her publications are about the work of Emile Zola, his connections with the artists of his time and the ways in which his style was influenced by them. Her other publications, which include a book on Robert de Montesquiou and Whistler, also focus in the main upon the work of writers who were deeply involved in the artistic movements of the second half of the nineteenth century.

DEE REYNOLDS is senior lecturer in French at the University of Bristol. She is the author of *Symbolist Aesthetics and Early Abstract Art: Sites of Imaginary Space*

(1995), which deals particularly with the work of Rimbaud, Mallarmé, Kandinsky and Mondrian, and she is co-editor (with Penny Florence) of *Feminist Subjects, Multi-Media: Cultural Methodologies* (1995). Her current research is on dance, and she is preparing a book on modern dance and the aesthetics of abstraction.

DAVID SCOTT holds a personal chair in French (Textual and Visual Studies) at Trinity College, University of Dublin. He has written widely on literature, painting, semiotics and textual and visual studies. He has organised many exhibitions on the visual arts and design, shown in Dublin, London and Paris. Recent books include *Pictorialist Poetics* (1988), *Paul Delvaux: Surrealizing the Nude* (1992) and *European Stamp Design: A Semiotic Approach* (1995). He is currently writing a book on the modern poster. He is an editor of *Word & Image* and the Paris-based bilingual journal *L'Image*.

RICHARD SHIFF is Effie Marie Cain Regents Chair in Art at the University of Texas at Austin, where he directs the Center for the Study of Modernism. He is the author of *Cézanne and the End of Impressionism* as well as numerous studies of nineteenth- and twentieth-century art. With Robert S. Nelson he co-edited *Critical Terms for Art History*, a set of essays on theory and method.

PAUL SMITH is lecturer in History of Art at the University of Bristol. His publications include *Impressionism: Beneath the Surface* (1995), *Interpreting Cézanne* (1996) and *Seurat and the Avant-Garde* (1997). He is co-editor of the forthcoming *Companion to Art Theory* and is currently researching a book on the impact of Baudelaire's aesthetics on Manet and Cézanne.

T HE very existence of the word 'modernité' in France is modern in that it came into current usage as recently as the Second Empire (1852–70). The term 'moderne', from which it was derived, can be traced back continuously through the centuries to its Latin origins, but 'modernité' was still generally considered a neologism in the 1850s. Very rare instances of the word can in fact be found in the Romantic period, but it was not until the early Third Republic that it received the status of appearing in dictionaries.[1] The emergence of a new word obviously points to a new experience that was in need of a signifier. However, definitions, both explicit and implied, of 'modernité' were strikingly diverse, so that we need to speak not of a specific experience but of experiences in the plural, a variety of encounters with a changing world, mainly the urban world of Paris.

Such encounters with modernity are the subject of Chapter 1, 'A painter's impressions of modernity', Michèle Hannoosh's investigation of Delacroix's impressions of modern life as recorded in his diaries, principally those parts of them concerned with the Second Empire. Eugène Delacroix (1799–1863), born in the last year of the preceding century, had known a succession of regimes: the Napoleonic Empire, the Bourbon Restoration, the July Monarchy, and the Second Republic, before the Second Empire. He was truly a citizen of the nineteenth century. His diaries, harking back to the 1820s but in many ways at their peak in the 1850s, were not published until thirty years after his death (beginning in 1893), well into the Third Republic, but immediately achieved fame as an unprecedented and unparalleled document, a reputation that is undiminished today. Delacroix's impressions of modernity introduce us to the themes of this book in a way that has lost none of its topicality. The tripartite structure of *Impressions of French modernity* – 'Second Empire impressions', 'Innovating forms', 'Modernity and identity' – develops themes that are already present in Delacroix's writings, where diary form provides an ideal vehicle to reflect on changes of environment, artistic expression and personal identity in mid-nineteenth-century Paris.

Although the encounters of individuals such as Delacroix with the modernity of Paris in the Second Empire were widely diverse and variously fragmented, Second Empire Paris was itself becoming modern in perfectly coherent ways. The momentous year 1848, which had begun with idealistic revolution on the streets of Paris in February, had continued with the sorry spectacle of slaughter at the

barricades in the June days as the Second Republic became divided, and had ended in December with the future Napoleon III assuming the office of president of the now increasingly bourgeois Republic. The year 1848 had been Janus-like, looking back to the utopian dreams of romantic and revolutionary idealism and ushering in a social and economic agenda in which bourgeois demand for a consumer society would be amply met, at least for a while. Consumerism, property development and speculation, accelerating urbanisation, a nascent leisure industry, new communication and transport facilities and other manifestations of economic growth all proliferated in the 1850s to create a modernising ethos of an uncompromisingly capitalist kind. Central to this, both physically and metaphorically, was the reconstruction of Paris, transformed by Haussmann from the intimacy of *le vieux Paris*,[2] which had evolved little by little from ancient patterns of life, to the swiftly planned and state-co-ordinated spectacle of boulevards and open spaces that is largely Paris as it exists today. It has been claimed with good reason that the debate over the modernity of the city, which has led to postmodern theories and practices of urban space, began with Haussmannisation.[3] Napoleon III and Haussmann succeeded in transforming Second Empire Paris into a new kind of city, despite the recession of the 1860s that forced the Second Empire to adapt in order to survive and the eventual foreign policy blunders by Napoleon III that would bring it to an ignominious end. Such modernisation was aimed in many ways at provoking uniform reactions amongst Parisians, making them ideologically as well as economically comfortable citizens of Napoleon III's capital. The evidence that has come down to us through the arts, through historical documents and through memoirs, and indeed Delacroix's *Journal*, shows a very different pattern in which different social groups and individuals experienced the new world of modernity not as a coherent whole but in terms of various and often fragmentary subjective distortions. It is with such distortions that this book is concerned. By gathering together a number of case-studies taken from the visual arts and literature, beginning with the Second Empire and progressing chronologically to the *fin de siècle*, a network of interconnecting focal points has been assembled that gives a composite view of the complexities of modernity.

'Second Empire impressions' examines encounters with Second Empire Paris in the arts from three specific angles. In Chapter 2, John House reveals the hitherto neglected importance of *curiosité*, a term that at first sight might seem unremarkable but which, on investigation, he finds to have taken on vital new meanings in mid-century that had far-reaching repercussions in a wide range of artistic

theory and practice, from Baudelaire's criticism to Manet's paintings, encompassing social as well as artistic mores. In Chapters 3 and 4, James Kearns and Paul Smith consider two figures who have often been typified as backward-looking and forward-looking respectively in their responses to Second Empire culture: Théophile Gautier and Charles Baudelaire. Seen together, these two chapters show how Gautier's personal and often overlooked version of modernity as well as the ambivalence that permeates Baudelaire's seminal essay 'Le Peintre de la vie moderne' problematise such a polarisation.

Baudelaire and Gautier sought to articulate their responses to modernity not only as theorists and critics responding to personal experiences or public events such as art exhibitions but also as creative writers seeking to initiate appropriate innovations in literary form. Baudelaire tells us that it was chiefly the experience of the modern city that led him to dream of a new poetic language, that of the *poème en prose*.[4]

'Innovating forms' considers new artistic languages during and after the Second Empire, taking the historical context of modernity beyond 1870. Innovating here has a double meaning: both artistic forms judged by critics to be innovative and the innovating efforts of creative artists to invent new forms of artistic language. It is primarily the first of these that David Scott adopts in Chapter 5 in considering responses to sculpture from the legacy of Gericault to the originality of Rodin and Degas. Sculpture was in some ways peculiarly slow to embrace modernity, creating its own telling agenda and debate. My own chapter (Chapter 6) and that of Alan Krell (Chapter 7) examine Realism in the novel and in painting. To represent 'la vie moderne' was a fundamental aspiration of the arts from the 1850s onwards. From Courbet and the Goncourt brothers in the Second Empire to Huysmans and Caillebotte in the Third Republic, Realism was at the cutting edge of innovation. By charting writers' quests to push literary language to new thresholds of inventiveness and of neologistic caricature in the Realist novel, and by plumbing some murky undercurrents in Realist painting, fundamental questions are raised as to what we mean by Realism. Degas is a central figure in both these chapters.

The final section, 'Modernity and identity', moves forward in time predominantly to the Third Republic. Historically, it can be argued that modern France was truly born in the late 1870s. Although 1848 was a watershed in sociopolitical consciousness and cultural awareness, the disappearance of established power hierarchies, the advent of parliamentary republicanism, and social change in the provincial backwaters of *la France profonde* were all long in coming. The political void left by the collapse of the Second Empire early in September

1870, following Napoleon III's crushing defeat by Bismarck's Prussians at the battle of Sedan, was not filled for the best part of a decade. At the 1878 Exposition Universelle, a celebration in part of the reconstruction of France materially and economically after 1870–71, the opening ceremony was officiated by Mac-Mahon, President of the Republic, but also a military leader in the war of 1870 and a former henchman of Napoleon III. When Mac-Mahon resigned as president in January 1879 and was succeeded by a republican lawyer, Jules Grévy, it was a symbolic moment of passage from the dramatis personae of yesterday's men to that of the 1880s and 1890s. Other symbolic events followed swiftly: for example the adoption of 'La Marseillaise' as the French national anthem in February 1879 and the consecration of Bastille Day – 14 July – in 1880 as France's *fête nationale*. The Dreyfus affair and other social earth tremors would disturb this modernising process but the changes instigated by the Second Empire would not truly be threatened in this new and revitalised phase.

'Modernity and identity' explores problems of personal identity – considered through specific case-studies taken from the arts – that were underpinned by such shifts of collective and national identity current in the *fin-de-siècle* world of the 1880s and 1890s. In Chapter 8, Dee Reynolds addresses problems of gender and identity through the challenges posed to contemporaries by Loïe Fuller's highly original dance performances. In particular she considers the far-reaching aesthetic reflections they aroused in the most complex thinker within French Symbolism, Stéphane Mallarmé. Joy Newton traces fictional representations of the modern painter in French fiction (in Chapter 9), showing the mixture of the new and the anachronistic that existed in novelists' conception of the artist. Romantic, Realist and *fin-de-siècle* notions of the artist coalesce in these fictions, still favoured today perhaps to judge by the continuing prestige of novels such as George du Maurier's *Trilby* (1894).[5] Finally, in the closing chapter, Richard Shiff considers artists working *c.* 1891, notably Vincent van Gogh and Claude Monet, whose identity has been mythologised today and was already the subject of speculation and reflection by writers and critics of the time. Richard Shiff analyses essential points about artists' and writers' understanding of the art of painting in the early 1890s, and therefore of our perception of Impressionism and Symbolism today.

Impressions of French modernity is an interdisciplinary book. The genres and media discussed include painting in a variety of guises, sculpture, caricature, criticism, poetry, the novel, diaries, dance. There are of course absences, such as music, or opera, or theatre, which a different kind of book could address. The axis on which this volume

is constructed concerns the visual arts and literature. The contrib-
utors are art historians whose work has led them into the domain of
words, literary scholars whose work has led them into the domain of
visual images, and some who are unwilling or unable to separate the
study of words and the study of visual images. Even the categories
in which the chapters are organised, outlined above, are by no means
watertight. 'Encounters with modern life' is an overall theme of the
book; 'Second Empire impressions', 'Innovating forms' and 'Modernity
and identity' are germane throughout. Issues recur. For example,
gender is addressed primarily by Dee Reynolds' chapter, but is present
in Alan Krell's discussion of the homoerotic in Caillebotte, in James
Kearns's account of Gautier's responses to Manet's *Olympia* and Ingres's
La Source, and elsewhere.

Nonetheless, for all its interactiveness of subject-matter, *Impres-
sions of French Modernity* has an itinerary which takes us from the
impact of Haussmannisation in the Second Empire to the avant-gardist
milieux of the *fin de siècle*. It moves from the 1850s, when the notion
of *modernité* was a neologistic novelty, to the 1890s when it was
common-place. But what of the notion of impressions? Why has this
study been placed under the banner of impressions? 'Impression'
is a complex word in late nineteenth-century France, the more so
because it spawned an untidy progeny in 1874: 'impressionniste'.
Impressionniste and *impressionnisme* are notoriously precarious terms,
even when defined in comparison or opposition to *sensation*, *post-
impressionniste*, *symboliste* or whatever.[6] One general component is,
however, clear: individualism. Whether impressions are understood
as being unique to the individual or formed and shared on a similar
pattern by many individuals, be they conceptualised in terms of a
broadly idealist or a positivist philosophy, they remain individual-
istic. This is the case, whether the term refers to the impression made
by experience upon an individual, to a work of art made by that
individual in response to such an experience or to the reception of
that work of art by a spectator or reader. Monet's *Impression, soleil
levant* (1872), which gave Impressionism its name, has something of
that pluralistic sense. 'Impressions' is certainly intended to have a plural
sense in this book, referring to the effect made upon artists and
writers by modernity, to the works of art they made in response to
that effect and to our reception of those works of art.

Notes

1 For a recent summary of the emergence of the term 'modernité', see R. Kopp, 'Baudelaire: mode et modernité', 48/14, *La Revue du Musée d'Orsay*, no. 4 (spring 1997) 50–5.

2 This expression is used famously by Baudelaire in his poem 'Le Cygne' from the 'Tableaux parisiens' section of *Les Fleurs du mal*.

3 See, for example, David Harvey, 'Modernity and modernism' in his *The Condition of Postmodernity* (Oxford, Blackwell, 1989), pp. 10–38; also Christopher Prendergast, *Paris and the Nineteenth Century* (Oxford, Blackwell, 1992), esp. pp. 1–10 and 207–14.

4 In the letter to Houssaye that forms the preface to Baudelaire's *Le Spleen de Paris*. See, amongst modern editions, Baudelaire, *La Fanfarlo, Le Spleen de Paris*, ed. David Scott and Barbara Wright (Paris, Flammarion, 1987), pp. 73–4 and p. 199 note 1.

5 See figure 28.

6 A recent summary of this much discussed area is provided by a contributor to this book: Paul Smith, *Impressionism* (London, Orion, 1995), pp. 19–24.

ENCOUNTERS WITH MODERN LIFE

1 A painter's impressions of modernity: Delacroix, citizen of the nineteenth century

'TOUTES ces aventures de tous les jours prennent sous cette plume un intérêt incroyable' (All those everyday happenings become, under his pen, incredibly interesting).[1] As most readers have acknowledged since its first publication in 1893, Delacroix's diary is one of the richest writings on art and one of the finest examples of artists' writings in the literature of art history.[2] Yet as his observation, cited here, about the *Mémoires* of Saint-Simon suggests, the *Journal*, inserted into the time of the day to day, into the temporality of the present, also constitutes a work of extraordinary sociohistorical interest, furnishing an ongoing, often indirect, commentary on the culture of nineteenth-century France. Largely ignored in this context, these private meditations of a painter are, in both content and form, *impressions of modernity*, a special testimony – and writing – of history.

Like all diaries, Delacroix's is concerned with time: passing time, preserving time, recovering time, reflecting on time. The day-to-day progression which distinguishes a diary from all other literary forms, its inexorable sequence of dates, is the omnipresent mark of its insertion in time, which the writing attempts to fix or preserve from oblivion.[3] Nineteenth-century France was obsessed with such personal writings – diaries and journals, memoirs, autobiographies, life stories. Most major artists and intellectuals wrote them – Chateaubriand, Berlioz, George Sand, Dumas, Stendhal, Baudelaire, Michelet, the Goncourt brothers, Gide, to name only a few – or they were had second-hand, as in the *Memoirs* of Napoleon, the *Conversations* of Byron, Dickens' autobiographical novel *David Copperfield*, all of which had considerable popularity right through the Second Empire. Clearly they participated in the great interrogation of self and identity, and the great emphasis on individualism, which marked European Romanticism. But they are also a symptom of and response to historical crisis, or at least historical transition: for, like the

writing of history which also flourished at this period, autobiograph-
ical writing might be considered a means of controlling a history
unleashed after the cataclysmic event of the French Revolution, the
history we call modernity.

For the nineteenth-century imagination, the Revolution marked
the beginning of history itself, the moment at which individuals
entered historical processes, acted upon them, engaged with them,
participated in them, changed them; pre-Revolutionary history might
be considered less history than myth – an order outside of time,
stable and unchanging, guaranteed by a figure of absolute authority
whose individual, historical person was subsumed in the role of
monarch. Into the void opened up by the Revolution stepped
historiography at both the national and the private levels: on the one
hand, so many *Histories of France*, of the *Revolution*, of the *Empire*
(Michelet, Guizot, Thierry, Thiers, Quinet, Lamartine, Louis Blanc)
to establish a national identity and history after the collapse of the
old order;[4] on the other, the plethora of personal writings to try to
control, chart or interpret the course of a history which might seem
ever to escape the individual's mental and material grasp. Some have
seen such writing as the individual's protest against that new collec-
tivity called society, the bourgeois individual's consciousness of soli-
tude and isolation *vis-à-vis* an increasingly egalitarian collectivism,
an affirmation of self which fears anonymity and is confused and
overwhelmed by newly won liberties.[5] These anxieties are indeed
present in much nineteenth-century autobiography, as the writer seeks
a unified identity, a temporal security, through writing and memory,
faced with the menace of dispersion which time represents. In this very
resistance, moreover, one can locate the power of the modern, which
induces in the individual a fantasmatic sense of chaos and disorder
that must be mastered and subdued, a nightmare which must be con-
verted into dream.[6]

Yet as I shall argue here, a diary may also be seen less as the
desperate protest of the individual *against* history, than as the
individual's inscription *in* history, the place in which the two meet,
engage, interact and define one another. The formal characteristics
and material circumstances of diary-writing, as opposed to other
autobiographical genres, ensure that traces of the history it interprets
are left within the text. In its discontinuity, its arbitrary, conventional
submission to the order of the calendar, its non-cumulative record of
material, its lack of causality and narrative order, a diary must always,
to some extent, escape the constructed unity of coherent narrative,
however much the writing subject may wish to discover or impose it.
This does not mean that the diarist does not create a persona; rather,

that the conditions of writing permit, and sometimes impose, a sense
of the haphazard, gratuitous, irrelevant, unintelligible. What motivates
a remark, what relation there is among different remarks, is rarely
made clear: a diary has no addressee except the author, and thus may
forgo explanation or contextualisation. Thus it confronts a reader,
including the diarist-reader, not just with recorded history, but with
absent history, what is left out, what falls between the words, in those
gaps which, as the young Delacroix once lamented, seemed to repres-
ent moments that had never existed.[7] More than any other form, a
diary proclaims this idiosyncrasy in the choice of recorded material,
confronts one with eccentricity, makes overt the breaks, disjunctions
and omissions. Indeed Delacroix's takes this to the extreme, making
clear that things have been left out, by design, inadvertence or the
sheer inadequacy of language to capture or translate his impressions.[8]
The *Journal* thus calls attention to what has been lost as much as to
what has survived.

Spanning the period which we have come to associate, through
Walter Benjamin and via Baudelaire, with *modernité* – from the last
years of the July Monarchy through the Second Republic and much
of the Second Empire – Delacroix's later diary, in particular, is a
writing of history which probes the experience of modernity; as such,
it is a testimony to that modernity too. Unlike the early diary, it is
no longer centred on the anguished self-exhortations of a young man at
the beginning of his career. Now nearly fifty, an established yet still
controversial artist, Delacroix has a far wider range of experiences,
and explores them more freely. The rhetoric of self-consolidation,
of timeless wholeness and individuality, of arresting a fleeting time
and controlling a chaotic history, is drastically reduced and nearly
abandoned altogether. Instead the self comes to celebrate, in both
its theoretical reflections and its practice, the mobility and variety,
the fragmentation and discontinuity, the waywardness and even con-
tradiction, of its experience in time, and its experience of history.

On the level of content alone, in no other single text from this
period or, arguably, any other, do we encounter so extensive and
varied a picture of the public and private life of a society. Delacroix's
distinctive position in this society – on the one hand, accepted by
official circles, awarded important state commissions for public build-
ings, elected in 1857 to the French Academy; on the other hand,
a radical painter, a close acquaintance of 'scandalous' artists like
Baudelaire, Courbet and George Sand – brought him into contact
with an extraordinary range of personalities from all walks of life.
Significantly, for ten years he served on the Paris Municipal Council
over which Haussmann presided, in which the daily life of the

capital, including the famous programme of public works, was discussed and debated – a period for which most official records, destroyed in the fire at the Hôtel de Ville during the Commune, are now lost.[9] He was part of numerous special government commissions, from the one in charge of the Universal Exhibition of 1855, to the awards juries of several annual Salons. He moved in 'high' social circles, such as the brilliant group of Polish expatriates to whom he was introduced by his friend Chopin, or, with a certain discomfort, that of the Bonapartes themselves. He frequented artists, critics and intellectuals – visiting Corot's studio and debating the value of an 'improvisational' method, commenting on the poses and movements of a somnambulist being shown about by Gautier, attending a private reading of *Les Troyens* at Berlioz's, ruminating on old age with an ever-effervescent Alexandre Dumas, discussing the vagaries of taste with the philosopher Victor Cousin, walking round the Botanic Gardens with the scientist Jussieu.[10] He was entertained at the soirées of the bourgeoisie, complete with the *séances* and Ouija boards, the 'ridiculously' sumptuous décor, the proliferation of bibelots which were *de rigueur* in the 1850s.[11] He chatted with his colour merchant, settled bills with his suppliers, took a walk in the country with his peasant housekeeper. He regularly read several major newspapers and periodicals, and was an avid reader of contemporary literature, both French and foreign works newly available in *feuilletons* and pocket editions. He quotes Dickens, Emerson, Poe, Turgenev; reading extracts from Thackeray's *Vanity Fair* (4 March 1849) makes him hope that 'everything this author writes will be translated'. He hears about the strange music and radical political ideas of that new composer, Richard Wagner (26 September 1855). The *Journal* carries the traces of all this activity, and in this sense offers a special, personal account – and example – of the history of an entire era, an invaluable source of the practices of everyday life at both the public and private level in the early period of European modernity, viewed through the eyes of an individual who experienced them first-hand and reflected on them at length.

Here I would like to explore how and to what extent the diary permits us to recover the time, and the times, of this early modern era, and what light it may shed on it. The exaggerated essentialism of my subtitle is deliberate, reflecting that optimistic, unbounded extravagance, that confident sense of limitless possibility, that hyperbolic expansivity which Benjamin associated with this period and by which he defined its modernity.[12] The diary provides the kind of detail and minutiae of daily life which sustained Benjamin's approach, seeking the reality of modernity in the shards and fragments of its material past – dolls to dioramas, gaslight to gambling – understanding

that they had historical meaning precisely because of their fragmentary, apparently insignificant character, removed as they were from the continuity of history and resistant to assimilation into its narratives.[13]

The diary is an archive of sorts, but unclassified and unsorted, fragments of Delacroix's life, thought and work, calendrical pages following one after the other like papers in a carton. Interleaved among its pages, moreover, are the paraphernalia of modern existence – clippings from the newspapers (articles, advertisements, notices, reviews), recipes, addresses, train schedules, accounts and investments, pieces of contemporary life with no obvious explanation for their presence or their particular place. (It is telling that most of these items were left out of earlier editions, as being too trivial to matter.) The process of interpreting such a mass of disparate material leads one to a peculiar historical awareness, a consciousness of the resistance of the past, its reticence and uncommunicability, its difference, and distance, from ourselves. We confront, as Delacroix did, the *reality* of the gaps between the entries on a page, between the lines in an entry, between the words or names in a line. From what is said we puzzle over what is not said, what motivated the remark, or what ensued from it. We attempt to reconstruct a monument from the ruins, reweave the textual threads, fill in the picture. Yet perhaps, in those very interstices, lies modernity 'itself'.

Indeed, a diary embraces the same tension between reality and writing that Michel de Certeau saw in the compound term – and concept – of historiography.[14] De Certeau theorised the activity of the historian, who must attempt to draw from the fragmentary remains of the past that essential *otherness* which makes it the past, and which necessarily eludes the effort: 'The other is the fantasm of historiography: the object it seeks, honors and buries.' For de Certeau, the writing of history is an act of separation: of present from past, living from dead, self from other, us from them. In separation there is a sense of loss; for this the historian tries ever to compensate, aiming to know, to understand, to explain – and paradoxically destroying, in that very effort, the otherness on which historical consciousness is based. Historical understanding thus 'silences the dead which haunt our present',[15] just as it seems to give them a voice; it represses those spectres of an ungraspable real, making them instead a projection of our desire and our fictions, an image of ourselves. Confronted with fragments of the past, we become conscious of our alienation from it, and simultaneously seek recovery, through understanding, explanation, interpretation: a 'dialogue' with the dead, which, if de Certeau is right, may paradoxically silence them forever and consign them to the tomb.

Yet de Certeau also described the historian's relationship with the past as an *'uncanny* and *fascinating* proximity' (my emphasis). Indeed, I would argue that within the historical practice of loss and appropriation, a discontinuous, fragmentary work like the *Journal*, holding traces of the past, may be the site of another, more inchoate experience. This proximity, uncanny in its effect, is not only familiar but unsettling and troubling too. For in it we also encounter the unfamiliar and unexpected, exceptions to our rules, things that will not fit our picture, or perhaps any picture we can conceive. In that moment prior to interpretation, prior to the act of writing, history stands independent of us, and thus *withstands* us, resisting our attempts to rationalise it, to make it part of ourselves. Such moments may be profoundly frustrating and worrisome, when our ideas are made invalid and, for a short time, at least, nothing arises to take their place; but they are without doubt moments of discovery. And if the process of interpretation in the end comes to the rescue, to soothe the confusion, the experience nevertheless leaves behind a sense of that real which continues to resist: of what is not, and perhaps never will be, known. Historical consciousness may demand this kind of acknowledgement; such may be an essential part of our dialogue with the past.

In this context, a text like the *Journal* – abbreviated, indirect, laconic, unassimilated – may have a special historical value, preserving openly the traces of the modernity to which it bears witness. The picture which emerges is one of a society highly ambivalent about the experience, a society with collective phobias (I use the term cautiously) and fantasies about the implications of contemporary life, as we shall see. Sometimes the diary's most trivial details signal a historical or social phenomenon of far wider import. For example, the numerous jottings having to do with Delacroix's stocks and shares – in the newly formed private railway companies, in the canals backed by the State, in tontines (an arrangement in which at the death of any shareholder the benefits were spread among the rest) – reflect the radical change in nineteenth-century culture, so brilliantly and wickedly portrayed in fiction by Balzac, in which speculation, and in particular investment in new industries, became a major source of income for the middle class, a replacement for inherited wealth and a supplement to earnings from work.[16] Like so many others who would soon swell the numbers of small shareholders, Delacroix first considers the possibility in 1847, during the economic crisis which would so contribute to the events of 1848. Later, as a brief jotting in 1853 indicates, he will likewise take advantage of what was at the time a highly popular and profitable option, the bonds issued in 1852 by the city of Paris to finance the *grands travaux* – subsequently

dubbed, as one economic scandal succeeded another, 'comptes fantastiques d'Haussmann' and one of the factors in the downfall of the regime.[17] Absent from our available editions, these insignificant notes show the level of participation of a certain class in economic affairs which later became 'disembodied', abstract, defined by their controversy, removed from the context which gave them legitimacy.

Inserted throughout the *Journal* are clippings from the newspapers, that other modern phenomenon whose name it shares, covering a wide variety of topical subjects: for example, that *cause célèbre* of 1856, the trial in London of the surgeon Palmer condemned to hang for a poisoning which the accused consistently denied, and around which crystallised all the debates about capital punishment; the displacement of the native population in California as a consequence of the gold rush, an article which leads Delacroix to a long tirade against the barbarism of the supposedly civilised Europeans; Richard Burton's travels in Africa; the new five-thousand mile telegraph line from Sardinia to Calcutta, which reduced a separation of thirty-six days to a couple of minutes; and many more. Such articles, often reprinted from distant foreign papers in a review of the world press, reveal the effect of truly 'mass' media on a society increasingly in communication with the rest of the globe, avid, like our own, for immediate knowledge and information.

Traces of this communications age appear everywhere in the diary. Trains carry Delacroix through the provinces on visits to his friends and family, to spas, to holidays on the Normandy coast, to Belgium to see the paintings of Rubens, the speed and ease making it 'really tempting to travel' (6 July 1850). In 1853 there would be a high-speed service between Paris and London, a mere thirteen hours via Folkestone and Boulogne. When Delacroix had last gone to London, in 1825, the journey had taken nearly three times as long. He never took the new train between London and Paris, but Queen Victoria did, when she visited the French capital for the Universal Exhibition of 1855, as we shall see later. But trains did allow Delacroix to commute to a country cottage on the outskirts of Paris, in a pattern repeated by so many of his contemporaries, and which would forever change the landscape and initiate the modern suburb. The new chain of railway station bookshops, and the special cheap series initiated by Hachette to stock them, introduced him to recent foreign literature translated into French: in a jotting in 1860 he reminds himself to check at the station for this series, containing *Jane Eyre*, *The Professor*, *Shirley*, 'by Currer Bell, alias Miss Bronte, 2 fr. 50 a volume'.

Modern travel, by train or omnibus, was for Delacroix a time of observation, the space of thought. Riding home from work on his

library murals at the Assemblée Nationale, he says: 'J'ai observé dans l'omnibus à mon retour, l'effet de la demi-teinte dans les chevaux comme les bais, les noirs, enfin à peau luisante' (I noticed in the omnibus as I was coming home the effect of the half-tone in horses with a shining coat). He then goes on to formulate a means of producing this effect, and concludes that 'in a bay-coloured horse it is very striking' (4 February 1847). One is led immediately to wonder about the relationship of this passing observation to the spectacular bay-coloured horse on which he would be working over the following few months, the central horse of the *Attila and his barbarian hordes overrunning Italy and the Arts* at one end of the library. Similarly, on the train from Strasbourg to Baden-Baden (25 September 1855), he writes: 'Jolie route qui me rappelle Anvers et la Belgique. Traversé le Rhin. . . . *Belles montagnes, de loin se confondant presque avec l'horizon*' (Lovely route which reminds me of Antwerp and Belgium. Crossed the Rhine. . . . *Beautiful mountains, from afar almost blending with the horizon*; original emphasis). The sight of the mountains then leads him to a long discussion of the works of Shakespeare, which, like nature, may consist of an accumulation of disparate details, but nevertheless constitute a unified whole for the mind. 'Les montagnes que j'ai parcourues pour venir ici, vues à distance, forment les lignes les plus simples et les plus majestueuses; vues de près, elles ne sont plus même des montagnes: ce sont des parties de rochers, des prairies, des arbres en groupes ou séparés; des ouvrages des hommes, des maisons, des chemins, occupent l'attention tour à tour' (The mountains that I went through coming here, seen from a distance, form the simplest and most majestic lines; seen close to, they are no longer even mountains, but rather parts of rock, meadows, trees in groups or separate, houses, roads, all occupying your attention by turns). These reflections will later become part of a projected article on the sublime, which he associates with a 'modern' aesthetic of unity in fragmentation, disproportion and irregularity.

Travel is also the occasion of *flânerie* which, like that of Baudelaire and Poe, involves both the pleasure of detachment, and self-exploration and discovery. Watching the world go by at the station, he writes:

J'arrive à la gare à huit heures et demie au lieu de neuf heures et demie. . . . Je passe cette heure sans m'ennuyer à voir arriver les partants. Je sais attendre plus qu'autrefois. Je vis très bien avec moi-même. J'ai pris l'habitude de chercher moins qu'autrefois à me distraire par des choses étrangères telles que la lecture, par exemple, qui sert ordinairement à remplir des moments comme ceux-là. Même autrefois, je n'ai jamais compris les gens qui lisent en voyage. Dans quels moments sont-ils donc avec eux-mêmes; que font-ils de leur esprit, qu'ils ne le retrouvent jamais? (7 November 1855)

(I arrive at the station at 8.30 instead of 9.30. . . . I spend the hour without becoming bored, watching the travellers arrive for their trains. I know how to wait more now than I used to. I live very well with myself; I've adopted the habit of trying less to distract myself by other things like reading, for example, which is usually used to fill those sorts of moments. I have never understood people who read while travelling. When can they be with themselves? What do they do with their mind, that they can never be alone with it?)

In the train he has another of the quintessential experiences of the mythology of modern life, the intense, chance meeting with a *passante*:

La jeune dame que je croyais sous la tutelle de l'homme silencieux et désagréable du coin en face d'elle. La langue de la jeune personne se dénoue, à ma grande surprise, dans la salle de la douane, pour s'adresser à moi avec une amabilité extrême. Mon âge et le chemin de fer de Corbeil m'empêchent de donner suite à cette charmante ouverture. (27 July 1860)

(The young woman whom I thought to be under the wing of the silent, disagreeable man in the opposite corner of the compartment. Lo and behold, the young person opens her mouth, to my great surprise, in the waiting-room of the customs office, to speak to me in the most amiable way; my age and the railway prohibit me from following up on this charming adventure.)

But rapid and far-reaching communications had their disadvantages too, reflecting and encouraging further the 'fever for movement' that Delacroix, and so many after him, associated with modern life. Returning to Paris from the fashionable Second Empire resort of Plombières in 1857, he considers the bustling crowd at the station in Epinal, where he picks up the Eastern railway:

Ce chemin n'est qu'ébauché, les cloisons ne sont pas posées, et déjà des myriades d'allants et venants s'y pressent. Il y a vingt ans, il y avait probablement à peine une voiture par jour, pouvant convoyer dix ou douze personnes partant de cette petite ville pour affaires indispensables. Aujourd'hui, plusieurs fois par jour, il y a des convois de cinq cents ou de mille émigrants dans tous les sens. Les premières places sont occupées par des gens en blouse et qui ne semblent pas avoir de quoi dîner. Singulière révolution et singulière égalité! Quel plus singulier avenir pour la civilisation. Au reste ce mot change de signification. Cette fièvre de mouvement dans des classes que des occupations matérielles sembleraient devoir retenir attachées au lieu où elles trouvent à vivre, est un signe de révolte contre des lois éternelles. (31 August 1857)

(The route is only just laid out, the partitions are not yet in place, and already myriads of comers and goers are hastening to it. Twenty years ago, there was probably not even one coach per day, to convey ten or twelve people leaving this little town for important business. Today several times

a day there are convoys of five hundred or a thousand. The first seats are taken by people in workers' smocks and who don't even seem to have the means to pay for their dinner. What a curious revolution, what a curious kind of equality, and what an even more curious future for civilisation. In any case this word is changing in meaning. This fever for movement among classes whose material occupation would seem to keep them tied to the place from which they derive their living, is a sign of revolt against eternal laws.)

This question was extremely topical: the movement of populations from country to city was of course one of the main demographic effects of industrialisation. Delacroix had addressed the issue already in 1853, after reading an article in the newspaper about new mechanical farming instruments: steam picks, diggers and ploughs. The government was considering instituting a policy of pre-emption to create a kind of proto-agribusiness, whereby gigantic private companies would take over the small parcels of land, unsuited to industrial farming, which dominated French agriculture, and would give the farmers shares in the company in return. The model for such a policy was the railways, for a similar procedure had been followed in buying up the land needed for the lines. Delacroix there lashes out against a policy destined to create a disinherited class, driven from their farms and villages into new towns, condemned, as he sees it, to watch helplessly the fluctuations of their investments, without the possibility they had had previously, in times of economic depression, of remedying the situation through hard work. The rhetoric is conservative but the issue crossed political lines, as the newspaper article Delacroix cites suggests: some on the left made similar arguments, adding ironically that the free-market government of Napoleon III was now putting in place the socialist programme of property reforms which had been crushed after the 1848 Revolution. Alienation of labour, *laissez-faire* economics, mechanisation of work, speculation, the substitution of 'false' paper shares for 'real' property, distance from the 'authentic' world of nature: these concerns, treated simultaneously by a very different analyst of modern industrial society, Karl Marx, are documented here throughout, suggesting a profound anxiety about an increasing emptiness, a sense of oppression by the experience – like the rhetoric – of nothingness and lack.

Pauvres peuples abusés, vous ne trouvez pas le bonheur dans l'absence du travail; voyez ces oisifs condamnés à traîner le fardeau de leurs journées et qui ne savent que faire de ce temps que les machines leur abrègent encore. Voyager était autrefois une distraction pour eux: ... voir d'autres climats, d'autres mœurs, donnait le change à cet ennui qui leur pèse et les poursuit. A présent ils sont transportés avec une rapidité qui ne laisse rien voir; ils comptent les étapes par les stations de chemin de fer qui se ressemblent

toutes: quand ils ont parcouru toute l'Europe, il semble qu'ils ne soient pas sortis de ces gares insipides qui semblent les suivre partout comme leur oisiveté et leur incapacité de jouir. Les costumes, les usages variés qu'ils allaient chercher au bout du monde, ils ne tarderont pas à les trouver semblables partout. (6 June 1856)

(Poor, misguided people, you do not find happiness in the absence of work. Look at these idle ones condemned to carry the burden of their days, and who do not know what to do with all that time that machines are saving for them. Travelling used to be a distraction for them: ... seeing other climates, other customs, made up for this ennui which weighs on them and pursues them. At present they are transported with a speed which allows them to see nothing. They count the stages of the journey by the railway stations, which all look alike; when they have crossed the whole of Europe, they seem not to have left those insipid stations, which dog them like their lack of activity and their inability to enjoy anything. The customs and different habits they went to the ends of the earth to look for, it won't be long before they find them the same everywhere.)

Not least of the fears was the danger of modern transport, a material risk exacerbated, as this passage suggests, by suspicions about social and cultural levelling, loss of identity, even (in other sources) trans-mission of disease.[18] A typical mention in the *Revue britannique* in October 1853 – 'The establishment of the railways, in France and abroad, has been marked by such frequent and terrible catastrophes that they have seemed to outweigh, in public opinion, the unques-tionable advantages of the new system of locomotion' – is matched by this simple, unassimilated diary entry in 1855: 'M. de la Ferronnays me dit à propos du danger des chemins de fer, que les administrateurs lui ont dit souvent qu'il valait toujours mieux voyager de jour' (7 November 1855) (M. de la Ferronays tells me, concerning the danger of the railways, that company administrators have often told him that it is always better to travel by day).

Technology was a frequent source of public and private anxiety. An unexplained remark on 16 November 1857 – 'Les poêles de fonte chauffés jusqu'à devenir rouges, quand ils sont neufs, peuvent asphyxier comme le charbon' (Cast-iron stoves heated to red-hot, when they are new, can asphyxiate like coal) – corresponds to recur-rent, gruesome reports in the press over the preceding decade about the dangers of asphyxiation, notably by gas. One needs no better metaphor for the fantasmatic conception of technology's power over the thinking and acting person.

Delacroix was nevertheless fascinated by technology. He experi-ments with the new art of photography, having himself photographed and his own paintings photographed, doing photographs of his own

which he then takes with him on his travels to draw from, and which will inform his own paintings.[19] He had dealings with the major photographers of the day – Nadar, Baldus, Petit, Martens – whose names occur in the *Journal*.[20] In Brussels in 1850 he quotes from an article about American attempts to photograph the sun, moon and stars:

On a obtenu de l'étoile *Alpha*, de la Lyre, une empreinte de la grosseur d'une tête d'épingle. La lettre qui constate ce résultat fait une remarque aussi juste que curieuse: c'est que la lumière de l'étoile daguerréotypée mettant vingt ans à traverser l'espace qui la sépare de la terre, il en résulte que le rayon qui est venu se fixer sur la plaque avait quitté sa sphère céleste longtemps avant que Daguerre eût découvert le procédé au moyen duquel on vient de s'en rendre maître. (13 August 1850)

(They obtained from the star *Alpha*, in the constellation Lyra, an imprint the size of a pinhead. The letter which presents this result makes a remark as correct as it is strange: that is, that in so far as the light from the daguerreotyped star takes twenty years to reach the earth, the ray which ended up being fixed on the photographic plate had left its celestial sphere long before Daguerre had discovered the means to capture it.)

The comment makes the point about the difference between 'universal' and 'modern' time, which changes so quickly, and so rapidly brings new developments, that the light had left its star long before photography was even thought of.

Elsewhere he notes a new kind of heating-stove which might do well in his flat, a new gadget for making Seltzer water, a do-it-yourself technique for molding bas-reliefs; a new type of treated bandage for aches and pains, burns, corns, bunions and chilblains, a new model of English toothbrush; he remarks wryly on the bizarre philosophy behind a new American invention, life insurance; he worries about the effects of smoking and notes down a less noxious type of cigarette, made from green tea; he worries, as we all do, about climate change. Heavy machinery transforms the 'natural' human environment, creating a utopian 'new world', as with the massive system of capstan and pulleys which moved the 24,000-kg Châtelet column so as to align it with the new arrangement of boulevards: 'Je vois au conseil un modèle d'une machine destinée à transporter à une vingtaine de mètres plus loin la colonne de la place du Châtelet. On vient de planter à la place de la Bourse des marronniers énormes. Bientôt on transportera des maisons; qui sait, peut-être des villes' (5 February 1858) (I see at the Council a model for a machine designed to transport the Châtelet column about twenty metres over. Huge chestnut trees have just been brought to the Stock Exchange square. Soon they will transport houses – who knows, perhaps even whole cities).

There was perhaps no event more representative of this era than the Universal Exhibition of 1855, that celebration of industry and agriculture for the new consumer society. After the stunning success – political and financial – of the London Great Exhibition of 1851 held at the Crystal Palace, the France of Napoleon III, not to be outdone, planned to host the subsequent one. What had been the Great Exhibition of Works of Industry of All Nations became, in French hands, the *Universal* Exhibition, extending the industrial emphasis of the earlier British concept to include the fine arts, and implying, in so doing, the internationalism of Paris, the universal reach of French influence and culture.[21] Delacroix participated in this event in more guises than anyone else, thus providing a useful perspective on the issues surrounding it. His role as a municipal councillor involved him in decisions concerning the funding of the event, the buildings erected for it and the festivities surrounding the lavish visit of Queen Victoria to the capital to view it; he served on the Imperial Commission established at the start to direct and oversee the Exhibition as a whole; he was a member of the international committee charged with the Fine Arts section, and also the admissions and awards juries; as one of the leaders of the French school of painting, he was commissioned by the government to paint a special picture, his *Lion Hunt*, now partly destroyed;[22] and he was one of a select few to be invited to hold a special exhibition, gathering together thirty-six paintings spanning the range of his career and the wide variety of genres in which he had produced. Although there is not sufficient space here to deal thoroughly with the issues concerning the Universal Exhibition raised in the *Journal* – its celebration of materialism, its pretentions to progress and enlightenment, the visual and verbal rhetoric of the sacred employed for it, its status as a middle-class dream of self-expansion – two brief examples may be telling.

One of the main concerns surrounding the event was that of privatisation. For the first time in France, the buildings – the Palais de l'Industrie and the Palais des Beaux-Arts – would be built not by the government but by a private holding company; in return the government consented to provide the land and to allow the company to charge admission, another first. These issues turn up in the *Journal* too and take on a particular cast. Having industry finance the building on land given by the government was all well and good, except that the land belonged not to the government, but to the city of Paris; and Delacroix, as a municipal councillor, would have taken part in the discussions. In 1854, walking in the area where they were building the Fine Arts pavillion, he notes:

J'ai trouvé la place de la Concorde toute bouleversée de nouveau. On parle d'enlever l'Obélisque. Périer prétendait ce matin [at the Council meeting] qu'il masquait! On parle de vendre les Champs-Elysées à des spéculateurs! C'est le Palais de l'Industrie qui a mis en goût. Quand nous ressemblerons un peu plus aux Américains, on vendra également le jardin des Tuileries, comme un terrain vague et qui ne sert à rien. (10 May 1854)

(I found the Place de la Concorde all torn up again. They are talking about taking away the Obelisk. Périer claimed this morning [at the Council meeting] that it blocked the view! They're talking about selling the Champs-Elysées to speculators! It's the Palais de l'Industrie that started it. When we come to be a little more like the Americans, they'll sell the Tuileries Gardens, as a vacant lot which serves no purpose.)

The free-market economic policies of the Second Empire and the urban projects to which they were linked were extremely controversial. Walking home one evening with his old friend Pierret via the Champs-Elysées, which were being completely transformed, he recalls the experiences of their youth in precisely the same place:

Etait-ce bien le même Pierret que j'avais sous le bras? Que de feu dans notre amitié! que de glace à présent! Il m'a parlé des magnifiques projets qu'on fait pour les Champs-Elysées. Des pelouses à l'anglaise remplaceront les vieux arbres. Les balustrades de la place ont disparu; l'obélisque va les suivre pour être mis je ne sais où. Il faut absolument que l'homme s'en aille, pour ne pas assister, lui si fragile, à la ruine de tous les objets contemporains de son passage d'un moment. Voilà que je ne reconnais plus mon ami, parce que trente ans ont passé sur mes sentiments ... mais je n'ai pas encore eu le temps de me dégoûter de la vue des arbres et des monuments que j'ai vus toute ma vie. J'aurais voulu les voir jusqu'à la fin. (14 December 1853)

(Was it the same Pierret that I had at my side? What passion there used to be in our friendship! what iciness at present! He told me about the grandiose plans they have for the Champs-Elysées. English-style lawns will replace the ancient trees. The railings in the square have disappeared; the obelisk will soon follow, to be put heaven knows where. Man must absolutely depart this life so as not to witness, fragile as he is, the destruction of all the things contemporaneous with his momentary passage on earth. See how I no longer recognize my good friend, because thirty years have stifled my feelings. ... But I have not yet had the time to grow weary of the sight of the trees and monuments which I've seen all my life. I would have liked to see them right to the end.)

'La forme d'une ville change plus vite, hélas, que le cœur d'un mortel': but perhaps what the changing environment of the city presented most alarmingly was what we most ignore in Baudelaire's famous line, the image of one's own death, the only place of rest for the heart of a 'mortal'. If modernity, in Benjamin's terms, sought to hide this

reminder of death through an emphasis on the new, the ruse was nonetheless understood by some. As in the poem, modernity is here (like its image the city) a space of exile, where the individual is removed from the 'community' of people (his friend Pierret) and things (his familiar surroundings) which defined his existence, his being, his happiness: he has 'not yet had time to grow weary' of them, he 'would have liked to see them right to the end'.

Privatisation was seen to belong specifically to the British who, as Delacroix acknowledged, carried it off well; but as he also saw, it was not for the French. Invited, at a meeting of the committee in charge of the Universal Exhibition, to the reopening of the Crystal Palace – which in one of the technological feats of the century had been dismantled after the 1851 Exhibition and moved from Hyde Park to its new site at Sydenham – he writes:

Ces Anglais ont refait là une de leurs merveilles qu'ils accomplissent avec une facilité qui nous étonne, grâce à l'argent qu'ils trouvent à point nommé et à ce sang-froid commercial, dans lequel nous croyons les imiter. Ils triomphent de notre infériorité, laquelle ne cessera que quand nous changerons de caractère. Notre Exposition, notre local sont pitoyables; mais, encore un coup, nos esprits ne seront jamais portés à ces sortes de choses, où des Américains dépassent déjà des Anglais eux-mêmes, doués qu'ils sont de la même tranquillité et de la même verve dans la pratique. (7 June 1854)

(Those English have rebuilt there one of their marvels, which they accomplish with an ease that astounds us French, thanks to the money that they find whenever they need it, and also that hard-headed business sense which we think we're imitating. They win out over our inferiority, which will never change unless we entirely change our character. Our Exhibition, our locale, are pitiful; but once again, we will never be inclined to these sorts of things, in which the Americans are already overtaking the English themselves, endowed as they are with the same stability, and the same verve in practical matters.)

Britain represented, like the USA today, the values of a modern industrial society: *laissez-faire* economics, technological superiority, substantial private giving, private enterprise. The regime of Napoleon III was following this model; Delacroix's reaction – admiration from afar, refusal at home – suggests the complexity of the issue, the questions of national tradition involved in the new globalisation. Finally, on 30 June 1855, having visited the Exhibition, he remarks on the effects of the new policy of paid admission:

Je déjeune comme un vrai bourgeois, sous une espèce de treille dans un petit café dressé tout fraîchement dans l'attente de ce public qui vient si peu à cette glaciale Exposition, dont tout l'effet est manqué, grâce à ces prix

disproportionnés de cinq francs et même d'un franc, qui ne sont pas dans nos habitudes.

(I have my lunch like a real bourgeois, under a kind of trellis, in a little café newly set up in the expectation of that public which in fact hardly visits this desolate Exhibition; its whole effect has been wrecked, thanks to the exorbitant price of five francs, and even one franc, which we are not used to.)

Despite the official report of the 'success' of this new policy, and the show made of charging an 'equitable' price so as to benefit workers,[23] Delacroix's account of its unpopularity and its effect in depressing attendance is supported by the figures: 1,358 visitors on a five-franc Friday, and 14,463 on a one-franc Saturday, compared to 58,000 on a twenty-centime Sunday. Later, the top fee had to be lowered to two francs.

In another example, the visit of Queen Victoria and Prince Albert in August, Delacroix's testimony puts into perspective, sometimes comically, the versions available elsewhere. On 18 August, the day of their arrival, he leaves his work on the murals at Saint-Sulpice and heads for home:

Point de voiture. Paris est fou ce jour-là. On ne rencontre que corps de métiers, femmes de la halle, filles vêtues de blanc, tout cela bannière en tête et se poussant pour faire bonne réception. Le fait a été que personne n'a rien vu, la reine étant arrivée à la nuit. Je l'ai regretté pour toutes ces bonnes gens qui y allaient de tout leur cœur.

(Not a cab to be found. Paris is crazy that day. All you meet is hordes of corporations of workers, market-women, girls in white dresses, the whole lot holding banners over their heads and jostling to put on a good welcome. The fact is that nobody saw anything, because the Queen arrived at night. I felt badly for all those good people who were putting their whole soul into it.)

The main official newspaper, the *Moniteur universel*, devoted two pages to the event with superb media hype and unabashed nationalistic propaganda, celebrating the alliance of England and France against Russia in the war currently under way in the Crimea. Queen Victoria and Prince Albert arrived at the Gare de l'Est around 7.30 p.m. and crossed the city in an open carriage to get to the imperial residence at Saint-Cloud.

Dès le matin des myriades d'étrangers, venus de tous les points du monde et mêlés, comme des flots mouvants, à la population parisienne, envahissaient les Boulevards et s'installaient dans les meilleures places, qu'ils avaient eu soin de retenir plusieurs jours à l'avance. Bannières, drapeaux, banderoles, emblèmes, colonnes, bustes, trophées et arcs de triomphe accueillirent le

couple royal; de jeunes filles vêtues de blanc se rangeaient tout le long des Champs-Elysées.

(Myriads of foreigners came from all parts of the globe to mingle with the population of Paris, invading the boulevards and taking up the best places, which they had reserved several days in advance. Banners, flags, scrolls, emblems, columns, busts, trophies and triumphal arches greeted the royal couple; young girls in white dresses lined the whole length of the Champs-Elysées.)

If, as Delacroix remarked ironically, the darkness kept people from seeing anything, the country hosting the festival of industry had, at least according to the *Moniteur* of 19 August 1855, a ready answer: 'Une illumination soudaine, éclatante, féerique, dissipait les ténèbres et précédait, comme une traînée de flamme, le passage de Leurs Majestés. Ce nouveau coup d'œil ajouté au programme, a porté au comble l'enthousiasme et le ravissement de la foule' (A sudden illumination, brilliant and magical, dissipated the darkness and led the way of their majesties, like a trail of fire. This surprise, added to the programme, carried the enthusiasm and raptures of the crowd to their height). Yet the *Illustrated London News* (18 August 1855) seems to confirm *his* account: 'Night was rapidly closing in. People exclaimed against the delay which threatened to turn an array so imposing into a failure. As the cortège made its way toward the Madeleine, the light entirely failed. The Royal Lady for whose eyes the various words of welcome were disposed on all sides saw none of them.' In his sympathy for the good folk who were putting their whole soul into the welcome, Delacroix might have been consoled to read the sequel: 'Yet we may be assured that no ouvrière who had withstood the broiling sun, sitting on the gravel of the avenue de l'Impératrice, felt more grieved than did the Queen herself.'

Similarly, on 23 August, Delacroix notes: 'Bal à l'Hôtel de Ville pour la reine d'Angleterre. Chaleur affreuse . . . J'ai fait le tour de l'Hôtel de Ville deux ou trois fois pour conquérir un verre de punch. J'étais glacé, tant j'étais baigné de sueur. Quelles insipides réunions' (Ball at the Town Hall for the queen of England. Dreadful heat . . . I went round the whole building two or three times just to get hold of a glass of punch. I was frozen, I was so bathed in sweat. What insipid gatherings). Small wonder that Delacroix had trouble finding any refreshments, that the air was stifling, the gathering insipid, that he could hardly make his way through the crowd: there were over 8,000 guests, 57,000 people having applied to attend. Once again, the *Moniteur* (24 August 1855) reported things differently:

La fête . . . a dépassé en beauté et en magnificence tout ce qu'on avait vu jusqu'ici de plus brillant et de mieux ordonné. . . . Il y avait à tous les étages,

et dans presque toutes les salles où on ne dansait pas, des buffets servis avec la plus grande profusion.... Les mesures avaient été si bien prises que, malgré l'énormité de la foule, la ventilation a pu être suffisamment entretenue, et la circulation n'a pas été entravée un instant.

(The celebration ... surpassed in beauty and magnificence everything that had been seen thus far for brilliance and orderliness.... On every floor and in nearly every room where dancing wasn't going on, there were buffets in the greatest profusion.... Careful measures had been taken so that, despite the huge crowd, the ventilation could be adequately kept up, and free movement would not be blocked for a single instant.)

Yet the *Illustrated London News* again confirms the *Journal*, noting the numerous fainting fits caused by the heat. In this way, the diary's brief, fragmentary account points more adequately to the 'real'.

The publication of the *Journal* in 1893–95 coincided with a *prise de conscience* of the posthumous 'modernity' of Delacroix's art. The retrospective exhibition of his work held at the Ecole des Beaux-Arts in 1885 provided a context for the self-definition of the avant-garde, and genealogies of modernity taking him as their point of departure proliferated; Signac's influential *De Delacroix au néo-impressionnisme*, however problematic, was the most obvious manifestation of this. The writings of other artists and critics testify equally to the importance of Delacroix for the development of a 'modern' art: Van Gogh, Redon, Matisse, Laforgue, to name only a few.[24] The *Journal*, too, is part of that same modernity. Reading it as such involves, as I have argued, hypothesis and speculation, and thus subjectivity; engaged in making sense of things, one is conscious of removing that historical 'otherness' described above. By the same token, in his diary Delacroix did so too, approaching the material of contemporary history, selecting it, making sense of it for himself, involving his own subjectivity; the *Journal* is at once historiography and autobiography. That modernity is nonetheless there, and in the late twentieth century we are still its descendants, struggling with similar problems, fascinated by similar achievements.

Ultimately for Delacroix this long engagement with time that the *Journal* represents may derive from a seemingly paradoxical, but curiously *modern* fear: not so much the lack of time, but too much time, meaningless time, ennui. His consciousness of the present is intense, as he analyses the temporality proper to modern life – the obsession with speed, 'saving' time, abolishing space – troubling words indeed for a practitioner of that spatial art, painting, and for one who, by his own admission, often found time 'too long' (11 August 1854). Of the modern world's obsession with ever faster communications, he remarks: 'Nous marchons vers cet heureux temps qui aura

supprimé l'espace, mais qui n'aura pas supprimé l'ennui, attendu la nécessité toujours croissante de remplir les heures dont les allées et venues occupaient au moins une partie' (27 August 1854) (We are heading towards that time when space will be abolished but not ennui, considering the increasing need to fill up the hours which used to be occupied with coming and going). For him, the antidote to ennui is work, and work defined specifically as the mind at work: 'The secret of avoiding ennui, for me at least, is to have ideas' (14 July 1850). This, of course, was the function of the *Journal*, and the purpose of painting too. After a lifetime of astounding productivity, of worthwhile time, in which he had, in Baudelaire's words, 'dealt with all genres, covered all areas of the field of painting, made illustrious the walls of our national palaces, filled our museums with vast compositions',[25] a simple, uncontextualised sentence on 19 August 1858 perhaps sums up best what Delacroix – painter, writer and citizen – sought in this activity most of all: 'The purpose of work is not just to produce, it is to give value to time.'

Notes

An early version of this chapter was given as an inaugural lecture at University College London in March 1996, at the kind invitation of the Provost, Derek Roberts.

1 Delacroix, *Journal*, 19 August 1858 (henceforth noted by date only). All references to the diary come from my own reading of the manuscripts. My edition of the *Journal*, including a new text and substantial unpublished material, will appear in 1998 with Macula. Until then, the standard text remains that of André Joubin in three volumes (Paris, Plon, 1932).

2 On the *Journal*'s aesthetic ideas and its status as a form of art-writing, see my *Painting and the Journal of Eugène Delacroix* (Princeton, Princeton University Press, 1995). Also George Mras, *Eugène Delacroix's Theory of Art* (Princeton, Princeton University Press, 1966); Karl Schawelka, *Eugène Delacroix: Sieben Studien zu seiner Kunsttheorie* (Mittenwald, Maander, 1979); Christine Sieber-Meier *Untersuchungen zum 'Œuvre littéraire' von Eugène Delacroix* (Bern, Francke, 1963); Delacroix, *Dictionnaire des Beaux-Arts*, ed. A. Larue (Paris, Hermann, 1996). Artists from Gauguin and Signac to Motherwell have commented on its influence on them. Matisse alone found it too particular to the author, as he said of the writings of *all* painters, including his own (letter to Tériade, 1947, in H. Matisse, *Ecrits et propos sur l'art* [Paris, Hermann, 1972], p. 311); yet he cites it frequently in the context of his own thought and practice.

3 Examples are numerous, e.g. 25 January 1824:

Ma mémoire s'enfuit tellement de jour en jour que je ne suis plus le maître de rien: ni du passé que j'oublie, ni à peine du présent, où je suis presque toujours tellement occupé d'une chose que je perds de vue ou crains de perdre ce que je devrais faire, ni même de l'avenir, puisque je ne suis jamais assuré de n'avoir pas d'avance disposé de mon temps. Je désire prendre sur moi d'apprendre beaucoup par cœur, pour rappeler quelque chose de ma mémoire. Un homme sans mémoire ne sait sur quoi compter. Tout le trahit.

(My memory flees so much as each day passes that I am no longer in control of anything: neither of the past which I am forgetting, nor of the present in which I am so occupied with something that I lose sight, or fear losing sight, of what I should be doing; nor even of the future, since I am never sure that I haven't already booked up my time in advance. I ardently desire to take it upon myself to learn things by heart, to recall something from my memory. A man without memory does not know what to rely on, everything betrays him.)

Such concerns recur repeatedly in the early years in particular (1822–24), as the diary seeks to establish a memory – 'firm', 'solid', 'healthy' – to combat the flight, or worse, the squandering, of time. The effort fails: after a fitful two years, the diary falls silent, not to resume until 1847.

4 See the section on historiography in P. Nora (ed.), *Les Lieux de mémoire II: La Nation*, Pt. I (Paris, Gallimard, 1986), esp. M. Gauchet, 'Les *Lettres sur l'histoire de France* d'Augustin Thierry', pp. 247–316, and P. Nora, 'L'Histoire de France de Lavisse', pp. 317–75. The historical novel participates in this same effort. See Claudie Bernard, *Le Passé recomposé: le roman historique français du dix-neuvième siècle* (Paris, Hachette, 1996), chap. 1.

5 E.g. the full study by Béatrice Didier, *Le Journal intime* (Paris, Presses Universitaires de France, 1976); and her 'Pour une sociologie du journal intime', in V. Del Litto (ed.), *Le Journal intime et ses formes littéraires* (Geneva, Droz, 1978), pp. 245–65; Alain Girard, *Le Journal intime* (Paris, Presses Universitaires de France, 1968).

6 See Walter Benjamin's analysis of modernity in the *Passagen-Werk*, esp. the sections on Louis-Philippe, Baudelaire and Haussmann in the two exposés of the whole (Benjamin, *Das Passagen-Werk*, in Rolf Tiedemann, ed. *Gesammelte Schriften* [Frankfurt-am-Main, Suhrkamp, 1982], V).

7 Delacroix was exceedingly conscious of such gaps: 'Je viens de relire en courant tout ce qui précède. Je déplore les lacunes. Il me semble que je suis encore le maître des jours que j'ai inscrits, quoiqu'ils soient passés. Mais ceux que ce papier ne mentionne point, ils sont comme s'ils n'avaient point été' (7 April 1824) (I have just reread in passing all that precedes. I deplore the gaps. It seems to me that I am still the master of the days which I have recorded here, even though they have passed. But those which these pages do not mention, it is as though they never existed).

8 E.g. 28 February 1849: 'Je n'ai pas écrit depuis le 16 et j'en suis fâché: j'aurais pu noter diverses choses intéressantes' (I haven't written since the 16th and I am upset about it; I could have noted various interesting things). He frequently writes the entries out after the fact, placing them under the date he thinks they took place and acknowledging that he has forgotten some of the experience. For example, having seen a painting of Correggio, he notes on 20 September 1855: 'Je regrette bien vivement de n'écrire ceci que trois semaines après l'impression que j'en ai reçue' (I so regret only writing this three weeks after the impression I had of it). Attempting to describe his impression of the paintings of Decamps he says:

Quand on prend une plume pour décrire des objects aussi expressifs, on sent nettement, à l'impuissance d'en donner une idée de cette manière, les limites qui forment le domaine des arts entre eux. C'est une espèce de mauvaise humeur contre soi-même de ne pouvoir fixer ses souvenirs, lesquels pourtant sont aussi vivaces dans l'esprit après cette imparfaite description que l'on fait à l'aide des mots. Je n'en dirai donc pas davantage . . .

(21 April 1853) (When you take up a pen to describe such expressive objects, you sense clearly, from your inability to give any idea of them through writing, the boundaries of the

two arts. It's like being out of sorts with yourself not to be able to fix your memories, which are yet still as vivid in your mind even after your inadequate description. So I will say no more about the matter . . .)

What more there was to say, or what else there was that would have said it better than the paragraph which remains, we will of course never know.

9 None of this material has been exploited. A frequently cited source, Haussmann's memoirs, are far less reliable, having been written after the fact as a narrative of his career and in view of publication.

10 14 March 1847; 5 March 1849; 22 January 1858; 22 May 1855; 24 December 1853; 6 June 1850.

11 22 May 1853; 26 January 1847 and 3 April 1849; 5 February 1855.

12 See, for example, the Grandville section of 'Paris, capitale du dix-neuvième siècle', in Benjamin, *Passagen-Werk*, pp. 64–6.

13 The point is made repeatedly in dossier N, 'Epistemology, theory of progress', of the *Passagen-Werk*, pp. 570–611.

14 *L'Ecriture de l'histoire* (Paris, Gallimard, 1975), p. 8.

15 *Ibid.*

16 As usual, Delacroix took part but kept a sceptical distance. On 11 March 1847, having received advice about investing, he notes: 'Le dernier actionnaire restant de la première classe sur la tontine Lafarge' – who by rights should receive the whole of the collective investment and return – 'a trente mille francs de rente. Il a cent ans. C'est un peu tard pour en jouir beaucoup' (The last remaining share-holder in the Lafarge tontine gets 30,000 francs a year income. He is a hundred years old. It's a little late to enjoy it).

17 Such was the title of the work of Jules Ferry in 1868.

18 It was noted at the time that the cholera epidemic of 1854 followed the line of the newly opened Strasbourg railway.

19 See Jean Sagne, *Delacroix et la photographie* (Paris, Herscher, 1982); Aaron Scharf, *Art and Photography* (London, Allen Lane, 1968).

20 These have either been omitted from existing editions, as with Nadar, or not glossed, as with Baldus.

21 See Patricia Mainardi, *Art and Politics of the Second Empire: The Universal Expositions of 1855 and 1867* (New Haven, Yale University Press, 1987).

22 Lee Johnson, *The Paintings of Eugène Delacroix: A Critical Catalogue*, 6 vols (Oxford, Clarendon Press, 1981–89), no. 198 (now in the Musée des Beaux-Arts, Bordeaux).

23 Commission Impériale, *Rapport sur l'Exposition Universelle de 1855* (Paris, 1857), pp. 81–3. Attendance figures come from this report also.

24 References in Van Gogh's letters are numerous, e.g. no. 13 to Emile Bernard (*The Complete Letters of Vincent Van Gogh*, ed. J. Van Gogh-Bonger (Boston and New York, Graphic Society, 1978); Odilon Redon, *A soi-même: Journal* (Paris, José Corti, 1961), pp. 170–83; Matisse traces modern colourist usage from 'Delacroix to Van Gogh and Gauguin, by way of the Impressionists and Cézanne' (*Ecrits et propos sur l'art*, p. 199). In 1885, after taking careful notes on Delacroix's correspondence and the notes on art which were then available, Laforgue planned to write an article on his relation to Impressionism. See my article, 'Jules Laforgue, lecteur de Delacroix: Notes inédites', *Studi francesi*, 93 (1987) 407–20.

25 'Exposition Universelle de 1855', *Œuvres complètes*, ed. C. Pichois (Paris, Gallimard, 1975–76), II, pp. 591–2.

SECOND EMPIRE IMPRESSIONS

2

Curiosité

MY starting point is Baudelaire's essay 'Le Peintre de la vie moderne', written around 1859–60, though not published until 1863. In earlier writings, notably the 'Salon of 1846', he had posited *naïveté* as the key to his definition of modern ways of seeing. In 'Le Peintre de la vie moderne', by contrast, the key term for the modern vision of the world is *curiosité*. In contrast to *naïveté*, the notion of *curiosité* has been little studied; the principal account, by Henri Lemaitre in his edition of Baudelaire's *Curiosités esthétiques*,[1] views it in a very different perspective from that proposed here.

In 'Le Peintre de la vic moderne' Baudelaire foregrounds *curiosité* as the defining characteristic of the vision of the graphic artist Constantin Guys, the ostensible subject of his essay. In the section 'L'artiste, homme du monde, homme des foules et enfant' ('The artist, man of the world, man of crowds and child'), Baudelaire posits *curiosité* as the 'starting point' of Guys's genius. Using the narrator in Poe's 'The Man of the Crowd' as his model, he invokes the state of convalescence to convey the freshness and sense of wonder that characterises this vision, and then characterises it as a return to childhood, with the child's capacity to be fascinated by anything, however trivial:

Le Génie n'est que l'*enfance retrouvée* à volonté, l'enfance douée maintenant, pour s'exprimer, d'organes virils et de l'esprit analytique qui lui permet d'ordonner la somme de matériaux involontairement amassée. C'est à cette curiosité profonde et joyeuse qu'il faut attribuer l'œil fixe et animalement extatique des enfants devant le *nouveau*, quel qu'il soit . . .[2]

(Genius is simply *childhood recovered* at will – a childhood now equipped for self-expression with manhood's capacities and a power of analysis which enables it to order the mass of raw material that it has involuntarily accumulated. It is to this deep and joyful *curiosité* that we must attribute the fixed and animally ecstatic gaze of children confronted with something *new*, whatever it may be . . . (original emphasis))

The shift from *naïveté* to *curiosité* is a significant one. *Naïveté*, as characterised in 1846, is primarily about the artist's self-expression, about his capacity to peel off the layers of academic learning and cultural conditioning, in order to realise his own *tempérament* as fully as possible; Baudelaire associates *naïveté* with Romanticism.[3] *Curiosité*, by contrast, is about a mode of engagement with the external world, and its corollary is not Romanticism but *modernité*.

However, it was not Baudelaire's text that suggested how interesting and controversial the term 'curiosité' might be in the study of the 1860s. My interest was sparked, rather, by F. de Lagenevais's review in the *Revue des Deux Mondes* in 1866 of the Goncourt brothers' *Idées et sensations*; this review has the provocative title 'Symptômes du temps: de la curiosité en littérature'. It is a wholesale attack on the loss of values and ideas in contemporary literature and society, in favour of a preoccupation with superficial appearances, novelty, fashions and trivia.[4] I shall analyse strands from this dense and passionate text as we go on.

First I must signal the difference between my account of *curiosité* and Lemaitre's. He consistently refers it back to Baudelaire and his personal pathology, viewing it in existential terms as a metaphor for the poet's constant attempt to stave off boredom (*ennui*). By contrast, I shall look outwards, away from Baudelaire himself, and focus on a wide, public context and a forum of shared social, political and moral debate; it was in this forum that Baudelaire's usages of the term found their original meanings.

For an analysis of the significances of the term in the 1860s, there are two marvellously appropriate sources – two extensive essays on the word in dictionaries published during the decade: in the first volume of Emile Littré's *Dictionnaire de la langue française*, published in 1863 – the same year as Baudelaire's essay – and in Pierre Larousse's *Grand dictionnaire universel du XIXe siècle*, in which a long article on *curiosité* appeared in volume 5, published in 1869.

Littré's account, beneath the dispassionate exterior form of the dictionary, is challenging and provocative.[5] The central meaning to which Littré devotes most of the entry is simply defined as 'Penchant à voir et à savoir' (Inclination to see and to know). At first sight this seems very bland and neutral; but, after this definition, all except one of Littré's examples are outright condemnations of *curiosité* – from La Rochefoucauld, La Fontaine, Pascal, Voltaire and others. La Rochefoucauld associated it with the use of knowledge to gain power over others, Pascal with vanity – with the quest for knowledge merely in order to have something to talk about. The sole exception to these condemnations is a passage from Condillac: 'La curiosité n'est que le

désir de quelque chose de nouveau' (*Curiosité* is simply the desire for something new).

To make sense of these apparent contradictions, we have to look at the politics of dictionary-making in the 1860s. In 1863, in the same year that the first volume of his great work appeared, Littré was turned down as a candidate for a vacant seat on the Académie; a new dictionary was at the time being prepared by the Academy – its first volume came out in 1865. The arguments against Littré's candidacy were put most vividly by Monseigneur Dupanloup, Bishop of Orléans, who launched a savage attack on Littré for his 'fatalism' and 'materialism'. The fear was that Littré, once in the Academy, would take over the Academy's own dictionary project, and would expose the vulnerable youth of France to definitions of terms such as *Ame*, *Pensée*, *Dieu* which would subvert all moral values.[6] (We cannot look to the Academy's own definition of *curiosité*, because this great project to rectify the French language only produced four volumes, between 1865 and 1894, and never got beyond the letter A[7]).

In one sense this was a debate about the function of dictionaries – whether, like Littré's, they should record the range of existing usages, for better or worse, or whether they should be prescriptive, and only record the meanings sanctioned by a particular authority (these issues have a long history in France).

But in the 1860s this particular combat was also an expression of the conflict between two radically different world views and value systems, between the so-called 'eclectic' philosophy endorsed by the Academy and the Catholic Church – a loosely neo-Platonic idealism – and the alternative model, which can be loosely described as materialist or based on sense-experience; positivist is a problematic and ambiguous term in this context, though this view was clearly positivist in Littré's sense of the term.[8] In the context of this debate, the definition of such 'keywords' was a serious matter indeed. The emergence of the materialist model – insisting on the primacy of scientific data and sensory experience – as the dominant ideological position in France was the precondition for France's full emergence into the 'modern' world.

However, this model only gained primacy with the establishment of a truly republican Republic around 1880, and with the final imposition of a secular State education system.[9] The battle between the two positions was at its height in the 1860s. Napoleon III's increasing so-called liberalism in these years was an attempt to placate as many interests as possible and to reconcile them to his regime; this left the Academy feeling very exposed (witness his attack on the Académie des Beaux-Arts in the reforms instituted in 1863). De Lagenevais, in his 1866 homily, explicitly associated the rise of *curiosité* and the loss

of 'passions nobles' with Napoleon's coup d'état of December 1851.[10] But, at the same time, fatalism and materialism were associated with the spectres of atheism, socialism and republicanism, and were viewed from the standpoints of government and moralists such as Dupanloup as a threat to the established order.

The disquiet about curiosité in these years was central to these debates. Littré's bland definition 'Penchant à voir et à savoir' (Inclination to see and to know) allied him with Condillac alone, among all the authorities he cited – allied him, that is, with the key ancestor of the philosophy of sense-experience, as against the great writers of the French tradition of idealist and moralist thought. Although he quotes their condemnations of curiosité, the very neutrality of his own definition seemingly discounts their anxiety.

Pierre Larousse's discussion of the term in 1869 is more open and less loaded – perhaps analogous to the politics of the 'Liberal Empire' of the late 1860s.[11] The examples he gives are far more evenly balanced between positive and negative. In the context of Baudelaire's essay, one pair of citations is particularly relevant. Madame de Puysieux is quoted: 'Punir la curiosité d'un enfant. La curiosité est le défaut des enfants qui ne savent rien et des sots qui s'occupent des sottises d'enfant' (Punish the curiosité of a child. Curiosité is the failing of children who know nothing and of idiots who busy themselves with childish idiocies). But against this we are given a passage from Ernest Renan: 'Les années de la complète maturité n'égalent point en féconde curiosité les premiers mois où s'éveille la conscience de l'enfant' (The years of complete maturity never equal, in fruitful curiosité, the first months when the consciousness of the child is awaking). It would be interesting if Baudelaire knew this comment. Renan was of course on the side of the anti-Christ in this debate of the 1860s, as a result of his controversial Vie de Jésus of 1863.

In Larousse's Grand dictionnaire, a short excursus accompanies the longer articles, defining in a more discursive way the issues that the terms raise. Discussing curiosité, he distinguishes between useless and dangerous curiosité and useful and necessary curiosité; he is clearly more interested in the negative forms: 'dangerous', for him, means involvement with things such as magic and spiritism. But he also adds the more equivocal category of curiosité indiscrète, which, he says, everyone practises but may be cruelly punished.[12] We shall meet this indiscretion again.

We must now explore further de Lagenevais's 1866 homily against the Goncourts and the range and dimensions he attributes to curiosité as a pernicious symptôme du temps. Curiosité, de Lagenevais wrote, has replaced 'enthousiasmes disparus, croyances éteintes, les erreurs

à combattre, les vérités à défendre, la poursuite d'un idéal supérieur à nos sens bornés, le dévouement à quelque noble chimère ou aux intérêts de l'humanité' (lost enthusiasms, extinct beliefs, the struggle against error and the defence of truth, the pursuit of an ideal superior to our blinkered senses, the devotion to some noble aspiration or to the interests of humanity). It is opposed to *idées, causes, conviction, âme, conscience, esprit*. It can be productive but only if applied to worthy materials, and if it appeals to '*intelligence* . . . , *facultés* . . . , *esprit*'. It represents *matérialisme* as opposed to the *idéal*.[13]

So, *curiosité* was associated with the realm of the senses, as against ideas, ideals, values; in the linguistic terms generally used at the time, it represented the world of the *sensation*, not of the *sentiments*. (Wagner's *Tannhäuser*, so controversial on its appearance in Paris in 1861, was re-enacting the same conflict.[14]) In the present context, too, it is interesting that de Lagenevais associated *curiosité* with the art of painting, preoccupied by coloured surfaces alone, in contrast to literature, which could engage with deeper levels of human experience such as the spiritual and the moral.[15]

Beyond this, de Lagenevais saw *curiosité* as pursuing novelty and rarity, as opposed to material that was worth reflecting on, studying, dreaming of.[16] This takes us into the realm of the scholar and the collector, and to the secondary meaning of *curiosité*. This relates to a certain sort of collecting and collectable object, sought for its rarity and exoticism rather than its intrinsic value; it refers to the collected objects as *curiosités* and to the collector's interest as *curiosité*.

In this context, the clearest attack on *curiosité* that I have found is by Gustave Merlet, in *Causeries sur les femmes et les livres*, 1865, in an essay titled 'La Bohême' – a review of Victor Fournel's 1862 book *La Littérature indépendante et les écrivains oubliés; essai de critique et d'érudition sur le XVIIe siècle*:

La curiosité fureteuse est un des goûts, je dirais presque une des manies de notre époque. Nous sommes, nous devenons de plus en plus antiquaires, bouquineurs et gazetiers. La critique tourne sensiblement soit à l'archéologie, soit à la chronique. Elle préfère les ruines aux monuments, les anecdotes aux leçons, les croquis aux tableaux, l'étude des individus à celle des œuvres, l'esquisse des physionomies et des mœurs aux principes et aux doctrines. Elle aime à écouter aux portes des boudoirs ou des salons, à décacheter les correspondances, à causer dans les antichambres, à visiter les coulisses du monde et de la société . . .[17]

(Prying *curiosité* is one of the tastes, I would say one of the crazes, of our epoch. We are, we are becoming more and more antiquarians, old book collectors and compilers of lists. Criticism is visibly turning to archaeology or to the chronicle. It prefers ruins to monuments, anecdotes to lessons,

sketches to finished paintings, the study of individuals to the study of their works, the sketch of physiognomies and customs to principles and doctrines. It likes to listen in at the doors of boudoirs or salons, to unseal letters, to chat in antichambers, to visit the stage wings of the fashionable world and of society . . .)

In the context of collecting, Pierre Larousse in 1869 made a valiant effort to distinguish the *curieux* from the *amateur* and the *collectionneur*; for him, the *curieux* was less obsessively focused than the *collectionneur*, but more informed, less dominated by whim and fashion than the *amateur*.[18] But evidently this was a rearguard action against attacks such as Merlet's, and elsewhere in his account – in discussing the use of the term *curiosités* to describe collectable objects – Larousse produced the most startling analogy that revealed where his convictions lay:

Les curiosités comprennent toutes les choses rares, précieuses ou bizarres qu'un amateur peut se plaire à réunir et à montrer. En général, elles touchent à l'art par quelque point, mais elles ne sont pas l'art lui-même. Elles sont un peu à l'art ce que la lorette est à la femme honnête. On sent que la limite est difficile à tracer.[19]

(*Curiosités* include all sorts of rare, precious or bizarre things which an *amateur* can enjoy accumulating and displaying. Generally, they involve art in some sense, but they are themselves not art. Their relationship to art is something like the relationship of the *lorette* [the courtesan] to the honest woman. One realises that the borderline is hard to trace.)

We shall return to these issues later.

Baudelaire's decision to give the title *Curiosités esthétiques* to his collected art criticism needs to be viewed in this context.[20] Works of fine art were not generally regarded as *curiosités*, nor was the art critic's interest in his objects of study classified as *curiosité*. The title seems to mock and subvert the hierarchy of values that we are looking at, which saw fine art as belonging to the sphere of the intelligence and the ideal, and placed *curiosité* and its objects beyond the pale of the respectable viewer. In 1868, the year after Baudelaire's death, *Curiosités* entered the sphere of fine art by a different path: Vollon exhibited at the Salon a huge still-life painting with this title; commissioned by the French State, it shows a lavish arrangement of elaborate collectibles [1]. Still-life painting itself was viewed as the lowliest of genres in the hierarchy of subject-matter at the Salon; yet Vollon's painting, enormous by the standards of contemporary still life, upgraded the *curiosités* that formed his subject to the status – or at least to the scale – of true history painting.

Within Merlet's attack are several further dimensions of *curiosité* that we must pursue. First is one that de Lagenevais pinpointed: the

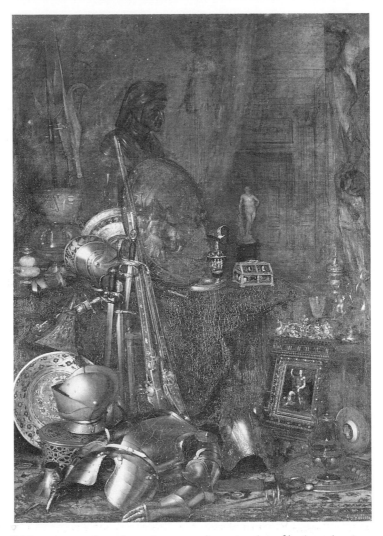

1] Antoine Vollon
Curiosités, 1868

reduction of history to the *chronique* or the anecdote,[21] abandoning
the moral, exemplary dimension that seemed to be the essence of true
history. This parallels the contemporary litanies in the art world,
about the death of history painting, about the decline of Gérôme
from true history painter to painter of historical genre, and about the
dominance of Meissonier.[22]

In this context, Merlet's jibe against archaeology – implicitly a
mere extension of the cult of ruins – is interesting. Heilbuth's paint-
ing *Excavations in Rome* [2] makes a humorous play on the same
issues: the celebrity archaeologist displays his finds with a flourish to
a group of fashionable tourists, watched by the workmen responsible
for the actual digging. In the context of history painting, a preoccu-
pation with archaeology was seen by traditionalists as a loss of true

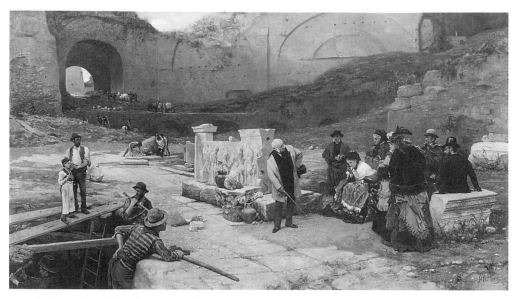

2] Ferdinand Heilbuth *Excavations in Rome (Past and Present, Rome)*, c. 1875

values in favour of superficial accuracy: this involved a focus on the accessory rather than the significant action, and on the finite moment in the past as against timeless values. The same associations of archaeology with *curiosité* recur in art criticism of the works of painters such as Gérôme [3].

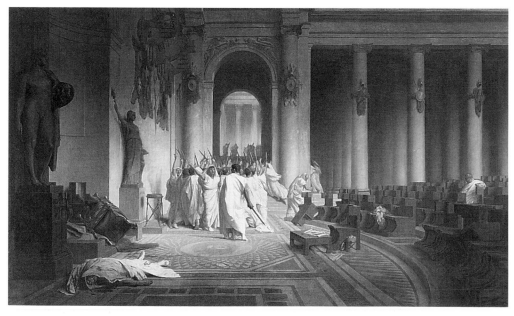

3] Jean-Léon Gérôme *The death of Caesar*, 1867

Merlet's scorn for archaeology also raises an issue that recurs several times in de Lagenevais's text – a deep distrust of any sort of scientific analysis. He compares the indiscriminate concern with details with vision through a microscope, and – perhaps to us more surprisingly – compares its workings with those of pathology and medicine.[23] Medicine is not seen in terms of its capacity to diagnose and cure, but rather it is viewed as an unhealthy and voyeuristic preoccupation with dissection. It is through its association with the medical, it seems, that *curiosité* becomes a *maladie*.[24] In the death-scene in the Goncourts' *Renée Mauperin*, complained de Lagenevais, 'le roman devenait un long procès-verbal pathologique. Rien, à coup sûr, ne se ressemble moins que le *médical* et le *pittoresque* . . . La médécine empiétait sur le roman . . .' (the novel became a long pathological record of symptoms. Nothing, to be sure, can be more dissimilar than the *medical* and the *picturesque* . . . Medicine impinged on the novel . . .).[25]

Two years later, in 1868, Emile Zola staunchly defended the links between science and the novel in his preface to the second edition of *Thérèse Raquin*; this key manifesto of Zola's view of the novel explicitly invoked the *curiosité* of the *savant* – the scholar or scientist – as a positive justification of his vision: 'Le reproche d'immoralité, en matière de science, ne prouve absolument rien . . . Je n'ai pas songé un instant à y mettre les saletés qu'y découvrent les gens moraux, c'est que j'en ai écrit chaque scène, même les plus fiévreuses, avec la seule curiosité du savant' (In matters of science the accusation of immorality proves absolutely nothing . . . I never for an instant dreamed of putting into it the indecencies that moral people are finding in it; I wrote every scene, even the most passionate, with the *curiosité* of the *savant* alone).[26]

The final issue raised by Merlet will lead us, in a roundabout way, to the issue of modernity – the issue of gossip, eavesdropping and voyeurism. The moralists associated two distinct types of looking and viewing with *curiosité* – both inappropriate and indiscriminate; there are significant distinctions to be drawn between the two. Inappropriate looking – looking at the wrong things – is goal-orientated but transgressive in relation to normative manners and etiquettes. It is premissed on a set of values which are repudiated, but it only makes sense to talk of inappropriate *curiosité* in relation to some notion of what it is appropriate to look at – some sense of values. Indiscriminate looking, by contrast, implies no sense of focus, no set of values, no priorities or hierarchies; in principle, anything is as worth looking at as anything else.

I shall look at inappropriate looking first, since the implications of indiscriminate looking are more far-reaching. There were two main,

and interrelated, facets of inappropriate looking. Most obviously, this concerned sexual voyeurism; but it was also involved with the wider world of commerce and urban capitalism. The imagery of commerce and advertising runs throughout de Lagenevais's essay, partly in the direct association between *objets de curiosité* and the art market, but more widely too in images of advertising and posters – of a world that defined value in terms of financial value.[27]

This brings the issue of *curiosité* into direct connection with one of the key *topoi* of nineteenth-century modernity – the imagery of the 'city of spectacle', and especially the world of the boulevard, the department store and the new shop windows, much discussed in recent studies.[28] One point must be signalled about this imagery: the central and indeed almost exclusive place it gives to the sense of sight, detached from either human contact or moral judgement – or, to phrase it in different terms, its focus on *sensation*, not *sentiment*. Here, a distinction made by Alfred Delvau in 1867 is particularly relevant: he describes the feverish behaviour of the crowds on the boulevards as 'pleine d'enseignements pour le moraliste et de renseignements pour le curieux' (full of lessons for the moralist and information for the *curieux*).[29]

The issue of sexual voyeurism is clearly linked with the imagery of the spectacle, both in its exclusive emphasis on sight and in its commodification of human contact. However, there are two types of voyeurism in the discourse of *curiosité* – male and female. Male *curiosité* is the most obvious one: man prying into a world where he does not belong. An example, which draws its force from the visual but goes beyond it, is in the preamble to Madame Romieu's *La Femme au XIXe siècle* of 1858: 'J'offre ce travail consciencieux non à la curiosité des oisifs [the adjective is masculine], mais à la réflexion des esprits sérieux' (I offer this conscientious work not to the *curiosité* of the idle, but to the reflections of serious spirits).[30] Here, again, *curiosité* is associated with idle information, as against reflexion – with the merely sensory, as against the moral. In a similar vein, Baudelaire warned his readers that Guys's drawings would not satisfy 'malsaine curiosité', since they included no prurient detail.[31] Linked to this is the question of gossip – another of the dimensions of *curiosité*.

The visual imagery of male *curiosité* is most explicit in the endless reiteration of Susannas and Bathshebas and Surprised Nymphs in the painting of the period, and alongside these in the ubiquitous Bather theme. Although most Bather subjects do not include a peeping viewer, it was widely understood that they presupposed some such observer.[32]

The language of female *curiosité* is in many ways very similar, as can be seen by comparison of the plots of the only two works of literature that have been traced which use our keyword in their title; one deals with male, one with female *curiosité*.

In comte de Sayve's *Le Curieux*, Viscount Léon de Moreuil is engaged to the widowed Alix d'Ennery. His friend Marquis Pierre de Grandcour (formerly her lover) finds him peeping through her keyhole. Léon is *curieux* because he is peeping, because he wants to marry *par curiosité*, and because he is a fearful gossip; but his *curiosité* comes from a good heart. However, Léon finds a letter that Alix has written to Pierre, and then listens while Alix gives herself again to Pierre, furious that Léon has read the letter: 'Il est insoutenable; la curiosité qui s'abaisse à ce point est un vice odieux qui ne s'excuse point' (He is intolerable. *Curiosité* which lowers itself to this point is an odious vice that is quite inexcusable).[33]

The female equivalents appear in *Les Curieuses* by Henri Meilhac and A. Delavigne (by male authors, of course). Two aristocratic women, Comtesse Ismail and Madame de Lauwereins, are both fascinated by the life of the *cocotte* Nina, and dress up as *cocottes* in order to find out more. Vicomte Alexandre, realising that they are not real *cocottes*, pretends that many clients have come to see them. They think that they are trapped, until Alexandre tells them: 'J'ai tout bonnement voulu vous montrer que la curiosité, poussée trop loin, pouvait parfois exposer les curieuses à de certains désagréments . . .' (I simply wanted to show you that *curiosité*, pushed too far, can sometimes expose the *curieuses* to unpleasant results . . .). They are about to leave when a real client comes for Nina, the real *cocotte*; this client turns out to be Count Ismail, the first woman's husband. She concludes: 'Encore un désagrément de la curiosité . . . on est exposé parfois à voir ce qu'on ne cherchait pas . . .' (Another unpleasant result of *curiosité* . . . sometimes one runs the risk of seeing what one was not looking for . . .).[34]

But of course the prohibitions on female *curiosité* went much further than those on men. Viewed from the point of view of the strict moralist, female *curiosité* could be the starting point of the classic nineteenth-century mythology of the decline and fall of the morally vulnerable woman.

In public spaces, *curiosité* would expose her to moral risk from curious males; manuals of conduct reiterated that women should never look around them, and should be wholly shielded from uncontrolled encounters in public spaces.[35] In private, and potentially just as perilous, was the threat posed by inappropriate reading matter. Here,

Emma Bovary could be invoked as the classic exemplar. In 1866, Monseigneur Dupanloup gave the argument a more topical focus:

On affronte également les livres contre les mœurs et les livres contre la foi, ... à ce point que le plus répugnant ouvrage qui ait paru de nos jours, et le plus fait pour inspirer le dégoût, cette *Vie de Jésus*, par M. Renan, a trouvé, dit-on, chez les femmes chrétiennes, par une vaine et coupable curiosité, plus d'une lectrice.[36]

(One encounters both books against morality and books against the Faith ... the most repugnant book which has appeared recently, and the book most designed to inspire disgust, that *Life of Jesus* by M. Renan, has, they say, found more than one reader among Christian women, through a vain and culpable *curiosité*.)

Here we again meet Renan as anti-Christ, specifically imperilling the *curieuse*, the *woman* reader.

These of course are prescriptive, not descriptive texts. They represent the rhetoric of moral fear, when faced with a world in which values, boundaries and definitions were far less clear-cut. Here two questions were at stake. First, was the world so black and white as the moralists said? Was perdition the only alternative to the strict moral etiquette they preached? And second, and more disturbing, could the modern world be read *at all*, or were the attempts to classify and categorise people in terms of status and morality doomed in the face of a society in which all old certainties had been undermined? These two questions were not, of course, wholly distinct: for the moralists, the very fact that their black and white vision was challenged was itself proof of the collapse of their whole system of values.

In the mid-1860s there was an outspoken controversy about the culture of '*luxe*' in modern Paris. Opinions on this were polarised by the address of Monsieur le Procureur Général Dupin to the French Senate in June 1865, provocatively entitled 'Sur le luxe effréné des femmes' (On the unbridled luxury of women). Dupin argued that fashionable society was slipping into prostitution, because prostitutes had fostered a taste for luxury which inspired emulation and committed weak-willed women to an unsustainable level of expenditure. His homily generated responses from all across the social and political spectrum, most notably from the playwright Ernest Feydeau; Feydeau made a spirited defence of luxury culture, arguing that it was a necessary expression of personal freedom (we would see this in terms of high capitalist consumerism), and that, contrary to Dupin's view, it was the prostitutes who imitated and exaggerated high fashion. He recognised the possibility of excesses within this world, but insisted that the world itself was not at fault.[37]

This debate is relevant to our theme because of a whole genre of painting and literature which deals with amorous intrigue and *curiosité* in the *haute bourgeoisie*. The comte de Sayve's *Le Curieux* and Meilhac and Delavigne's *Les Curieuses* of course belong to this genre. The term was also used in the titles of paintings. Compte-Calix's *Les Curieuses* shows two fashionably dressed women examining a print of Venus and Cupid that they have removed from a portfolio; the setting is evidently old-fashioned – presumably the chamber of a gentleman antiquarian connoisseur. In E. Béranger's *Curiosité* a pretty maid is looking at a statuette of Cupid in an artist's studio.[38] In both, the viewer is a woman in a man's space, and the object of her attention is an emblem of sexuality. In James Bertrand's *Les Curieuses* [4] the viewing crosses boundaries between classes and between public and private spheres, as two young girls on the street, tidily dressed but not in high fashion, and one exposing a plump ankle, peer through half-closed blinds on the ground-floor window of a fine stone-built residence.

Beyond this, other images of various kinds deal with the same issues. There are playful overtones of mild indiscretion in pictures of women admiring exotic *curiosités*, such as in Tissot's paintings of women looking at Far Eastern *objets d'art* – in the poses of the women in one canvas and in the male figure they scrutinise so closely in the other.[39] Female *curiosité* also appears overtly in pictures such as Baugniet's *Les Indiscrètes* [5] and Toulmouche's *Forbidden fruit* [6]; the latter, shown at the Salon in 1866 is a paradigm of the *curiosité* of girls leading them to transgress the etiquette manuals, as they explore the contents of a gentleman's library.

These paintings acknowledge moral ambivalence among the *haute bourgeoisie*; they would have provided material evidence for a moralist such as Dupin. But they do not point any clear moral or invoke an imagery of decline and fall; rather, they seem to appeal lightheartedly to just the luxurious classes whose existence and values Feydeau so staunchly defended. Likewise the threat of male *curiosité* in public places could be treated as a comedy of manners, as in Paulsen's *The promenade of the girls' boarding school* [7], in which a stern chaperon guards the young girls as they walk past two raffish and attentive young men, one of whom smokes a cigarette.

There is no single 'right' reading of these paintings. Like Dupin's and Feydeau's texts, they were interventions into what the artists well knew was disputed territory. Their primary audience was presumably those who saw the issues with similar amusement; the pictures were of course made to sell, and were thus themselves part of the culture of luxury. But at the same time the frisson they offered was premised on the likelihood that they would shock the moralists.

They do suggest a degree of moral ambivalence within the fashionable classes, but, as presented, it was a controlled and comparatively harmless ambivalence – one that Feydeau, too, accepted in his tract and one that he and other dramatists such as Sardou played on in their theatrical works. The scenarios and their ambivalences were readily legible and carefully contained within a bourgeois space – often indoors, or at least under the watchful eye of a chaperon.

Manet's *Déjeuner sur l'herbe* was a blatant repudiation of these values; yet it, too, was sited in a readily legible context. Evidently an immoral, bohemian grouping, this might be seen as shocking and as a threat to moral values, but its viewers, in the public forum of the Salon des Refusés, would readily have been able to locate it socially and define their own positions in relation to the world it presented.

The controlled ambivalence in fashionable genre painting was a way of dealing with a more far-reaching fear, that boundaries within society really were disintegrating. After the breakdown of the hierarchical society of the *ancien régime*, nineteenth-century social theorists developed a battery of analytical methods to determine the individual's place in society, ranging from pseudo-sciences like phrenology or physiognomy to systems of sociological classification which located individuals within society. Though ostensibly descriptive, such systems were in effect regulatory, in ascribing to their objects of study – to the classes they classified – an appropriate place within society at large; the uniqueness of the individual was subsumed into the type.

In itself, social anatomisation such as this could be viewed as an unhealthy *curiosité* by traditional moralists and idealists. Its objects of study were all-inclusive and many of them were considered unworthy of such scrutiny; moreover, its seemingly empirical grounding refused to locate the categories it proposed in terms of any overall moral judgement or idealist model of reality.

However, the deeper fear that lay behind these concerns was that such categorisation was no longer effective – that individuals could no longer be securely located in the flux of modern urban society. The literature of social fear focused on one particular area of ambivalence, the increasing difficulty that was perceived in distinguishing between respectable and immoral women. But this was a displacement on to a symbolic Other of wider fears about the fluidity and disorder of society at large, and specifically of the male-dominated world of capitalist enterprise in the city. The threats to order were obvious: social and geographical mobility, and the extreme insecurities of the evolving and still totally unregulated capitalist system.

Here we must return to *curiosité*, to Baudelaire's 'Le Peintre de la vie moderne', and to its central image, the Crowd. Baudelaire, as we have

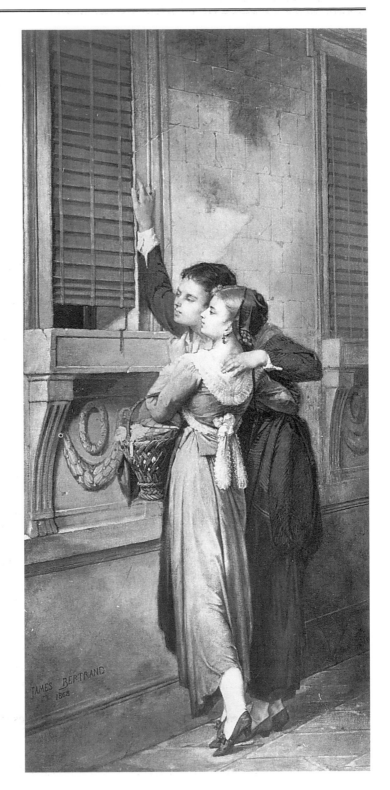

4] James Bertrand
Les Curieuses, 1868

seen, parallels Guys's vision with the child's, with its vivid coloured impressions, seeing everything afresh, whatever it is: 'visage ou paysage, lumière, dorure, couleurs, étoffes chatoyantes, enchantement de la beauté embellie par la toilette' (whether a face or a landscape, gilding, colours, shimmering stuffs, or the magic of physical beauty embellished by cosmetics). In the crowd, the observer/*flâneur* registers absolute trivia about details of clothing; experience of all sorts 'enters him pell-mell'.[40]

5] Charles Baugniet *Les Indiscrètes*, c. 1870

This formulation suggests that Guys's *curiosité* involved an indiscriminate absorption in visual sensations and a loss of self. However, later in the essay, Baudelaire modified this. Writing of Guys's use of memory in producing his drawings, he contrasted the selectivity of his vision with

[l']émeute de détails, qui tous demandent justice avec la furie d'une foule amoureuse d'égalité absolue . . . plus l'artiste se penche avec impartialité vers le détail, plus l'anarchie augmente. Qu'il soit myope ou presbyte, toute hiérarchie et toute subordination disparaissent.[41]

6] Auguste Toulmouche *Forbidden fruit*, 1865

([the] riot of details, all demanding justice with the fury of a mob in love with absolute equality ... the more the artist turns with impartiality to detail, the greater the anarchy. Whether he is long-sighted or short-sighted, all hierarchy and all subordination vanish.)

Here Baudelaire attacked the paintings of Meissonier for their unselective recording of trivia. Later still, he insisted that Guys's practice of selection was inseparable from a process of classification and typecasting; in Guys's images of women, he wrote, 'les différences de caste et de race ... sautent immédiatement à l'œil du spectateur' (differences of caste and race ... leap immediately to the spectator's eye).[42] This implies that the artist's schemes of classification coincided with those of the viewer; they were based on a consensus.

So we have moved in Baudelaire's text from a seemingly indiscriminate model of *curiosité* to one that is goal-oriented, and thus well in line with nineteenth-century social theory; it was only transgressive in the range of objects it studied, and in the potential perils it risked, with the artist's self-immersion in the crowd. In the end, this crowd itself proved classifiable and hence manageable, and the artist/viewer, by dint of being able to classify what he saw, remained conceptually outside the crowd.

7] Fritz Paulsen *The promenade of the girls' boarding school*, 1868

But the issue of indiscriminate, incoherent seeing is crucial to the notion of *curiosité*, and to the emergence of a new notion of modernity in these years. Here the crucial text is not Baudelaire's, but rather the model that he himself cites, Edgar Allan Poe's 'The Man of the Crowd'. Poe's convalescent narrator sits in his café window, first looking at the passers-by 'in masses', but then homing in on details, analysing and classifying every type he sees in the crowd outside. Not surprisingly, in Baudelaire's translation, his interest becomes *curiosité*.[43]

The figure who makes Poe's narrator leap to his feet and pass an extraordinary, restless night pacing haphazardly to and fro through London is the one figure whom he cannot classify, whose demeanour and behaviour conform to no stereotypes. It is this radical unclassifiability, this anonymity, that leads the narrator in the end to label him 'the man of the crowd'. His initial armchair *curiosité* was satisfied by classification, but the extreme of random, disordered looking could only be triggered by the unclassifiable; it was this that forced the convalescent out of his chair, to engage actively with the unknown. And it was this unclassifiability that came to characterise the 'modern' crowd, and this acceptance of unclassifiability that became a defining characteristic of a 'modern' way of seeing.[44]

This distinction throws revealing light on the paintings of Manet. As we have seen, the *Déjeuner sur l'herbe* may be morally and pictorially transgressive, but explicitly so, by its recognition of, and opposition to, normative structures; its ingredients posed no serious problems of classification. By contrast, after about 1865, his figures and compositions lose these clear points of reference. In paintings such as *Le Balcon* [8] and *Le Chemin de fer* [9], both the figures themselves and the settings in which they are placed become ambiguous or puzzling, and Manet's technique, even more than before, refuses to focus in on any element as the key to the image. What is the relationship between the figures in these paintings? What is the context of the balcony and what is the woman on the left looking at? And why are the figures in *Le Chemin de fer* seated there, with a bunch of grapes on the dirty ledge beside them?[45]

In 1868, writing about Manet's *Portrait of Emile Zola*, Théophile Thoré came closest to defining the implications of this pictorial vision:

Quand il a fait sur sa toile 'la tache de couleur' que font sur la nature ambiante un personnage ou un objet, il se tient quitte. Ne lui en demandez pas plus long, – pour le moment. Mais il se débrouillera plus tard, quand il songera à donner leur valeur relative aux parties essentielles des êtres. Son vice actuel est une sorte de panthéisme qui n'estime pas plus une tête qu'une pantoufle; qui parfois accorde même plus d'importance à un bouquet de fleurs

qu'à la physionomie d'une femme . . . qui peint tout presque uniformément, les meubles, les tapis, les livres, les costumes, les chairs, les accents du visage.[46]

(When he has placed on his canvas 'the *tache* of colour' which a figure or an object makes on its natural surroundings, he gives up. Don't ask himself

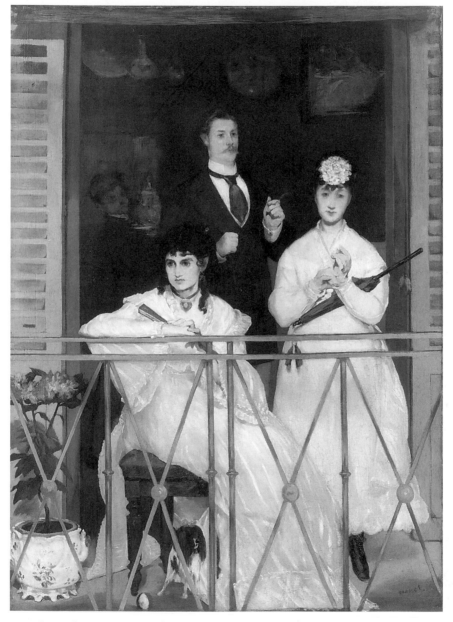

8] Edouard Manet *Le Balcon*, 1869

for anything more, for the moment. But he will sort this out later, when he decides to give their relative value to the essential parts of human beings. His present vice is a sort of pantheism which places no higher value on a head than on a slipper; which sometimes gives even more importance to a bunch of flowers than to a woman's face . . . which paints everything almost uniformly – furniture, carpets, books, costumes, flesh, facial features.)

This 'pantheism' could be seen as a radical attack on the whole structure of humanistic values which underpinned both social order and the history of Western art. This seemingly depersonalised *curiosité* could be viewed as the triumph of materialism in art and as the essence of a new 'modernity'.

However, another strategy for dealing with Manet's art was also proposed by Thoré's text – by stressing his exclusive preoccupation with the *tache de couleur* – the touch or patch of colour. Seen as a figure for a value-free, indiscriminate, non-hierarchical vision of the modern world, the *tache* could be dislocating, subversive. But equally it could be viewed as an aesthetic unit in itself, and the disruptive

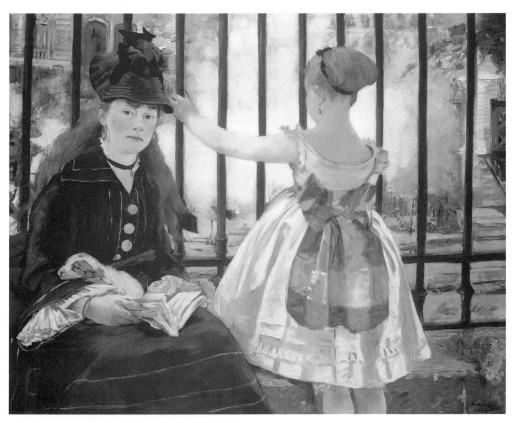

9] Edouard Manet *Le Chemin de fer* (now known as *Gare Saint-Lazare*) 1873

combinations of objects could be explained as merely the result of Manet's taste in colour-combinations; both Jules Castagnary and Paul Mantz used this strategy to explain his 1869 Salon exhibits (including *Le Balcon*),[47] and much the same argument underpinned Zola's 1867 account of his art:

L'artiste, placé en face d'un sujet quelconque, se laisse guider par ses yeux qui aperçoivent ce sujet en larges teintes se commandant les unes les autres. Une tête posée contre un mur, n'est plus qu'une tache plus ou moins blanche sur un fond plus ou moins gris ...

(The artist, placed in front of any subject, lets himself be guided by his eyes which perceive the subject in broad colour areas one against the other. A head placed against a wall is no more than a more or less white *tache* on a more or less grey background ...)

and in *Olympia*, Zola wrote:

Il vous fallait une femme nue, et vous avez choisi Olympia, la première venue; il vous fallait des taches claires et lumineuses, et vous avez mis un bouquet; il vous fallait des taches noires, et vous avez placé dans un coin une négresse et un chat. Qu'est-ce que cela veut dire? vous ne le savez guère, ni moi non plus.[48]

(You needed a naked woman, and you chose Olympia, the first you found; you needed some light and luminous tones, and you included a bouquet; you needed some black accents, and in a corner you placed a negress and a cat. What does that mean? You hardly know, and nor do I.)

Taken at face value, Zola's comments about Manet, taken with those of Castagnary and Mantz, undercut any social reading of Manet's vision. Manet becomes, instead, the stereotypical paradigm of the modernist artist, concerned alone with maximising the inherent properties of his medium. But Zola's 1867 article, in its original context, was an attempt to defuse the criticism that had snowballed around Manet and his imagery; and Manet's art itself was conceived in relation to the social and moral debates that we have been examining. His paintings were presented to a public who he well knew would scrutinise them in terms of these debates.

However, the most revealing literary parallel here is not Zola but Flaubert: in the seemingly dislocating descriptive passages in *Madame Bovary* or the more comprehensive disruptions of narrative and plot in *L'Education sentimentale*. Most of the original responses to the novels saw them as wholesale disruptions of accepted values; however, Flaubert could equally be viewed as an arch protagonist of *l'art pour l'art*.[49] The original reviews of the books seem not to have discussed them in terms of *curiosité*; however, one reviewer of *Salammbo*,

Alcide Dusolier, described Flaubert as '*curieux*, careful and patient', in contrast to creative genius, and spoke of the 'pleasures of a depraved *curiosité*' that he himself had felt on reading the novel.[50]

Framed in similar terms, Manet's art can be viewed in terms of a radically critical and disruptive type of *curiosité*, rejecting the stereotypes of social classification, and presenting its viewers with images that were immediately arresting but ultimately illegible – like modern society itself. At its origins, modernism in painting could function as a radical and critical view of modernity; arguably, the subsequent history of modernism has in a large measure been the story of the successive disempowerment of such readings.

Notes

1 C. Baudelaire, *Curiosités esthétiques: l'art romantique et autres œuvres critiques*, ed. H. Lemaitre (Paris, Garnier, 1962), pp. XVII–XXX; all citations of Baudelaire's criticism in the present essay will be to this edition.

2 Baudelaire, 'Le Peintre de la vie moderne', *ibid.*, pp. 461–2.

3 Baudelaire, 'Salon de 1846', *ibid.*, pp. 101–3.

4 F. de Lagenevais, 'Symptômes du temps: de la curiosité en littérature', *Revue des Deux Mondes* (1 June 1866) 786 ff.

5 E. Littré, *Dictionnaire de la langue française* (Paris, Hachette, 1863), I, p. 937.

6 See F. Dupanloup, *Avertissement à la jeunesse et aux pères de famille sur les attaques dirigées contre la religion par quelques écrivains de nos jours* (Paris, Douniol, 1863); *L'Election de M. Littré à l'Académie Française* (Paris, Douniol, 1872); the latter pamphlet was published on the occasion of Littré's second, and successful, candidature for the Académie.

7 Académie Française, *Dictionnaire historique de la langue française*, 4 vols (Paris, Académie Française, 1865–94).

8 See D. G. Charlton, *Positivist Thought in France during the Second Empire* (Oxford, Oxford University Press, 1959); R. Shiff, *Cézanne and the End of Impressionism* (Chicago, Chicago University Press, 1984), pp. 14–26.

9 On this, see R. Gildea, *Education in Provincial France* (Oxford, Oxford University Press, 1983), pp. 105–17, and S. Elwitt, *The Making of the Third Republic: Class and Politics in France, 1868–1884* (Baton Rouge, Louisiana State University Press, 1975), pp. 170–208.

10 De Lagenevais, 'De la curiosité', p. 790.

11 P. Larousse, *Grand dictionnaire universel du XIXe siècle* (Paris, Larousse et Boyer, 1869), V, pp. 681–4.

12 *Ibid.*, p. 681.

13 De Lagenevais, 'De la curiosité', pp. 787–8, 797.

14 On *Tannhäuser* in this context, see J. House, 'Fantin-Latour in 1864: Wagnerism and Realism', in P. Andraschke and E. Spaude, *Welttheater: Die Kunste im 19. Jahrhundert* (Freiburg, Rombach, 1992).

15 De Lagenevais, 'De la curiosité', pp. 788, 792, 794.

16 *Ibid.*, p. 787.

17 G. Merlet, 'La Bohême', in his *Causeries sur les femmes et les livres* (Paris, Didier, 1865), pp. 263–4.

18 Larousse, Grand *dictionnaire*, V, pp. 679–80.

19 *Ibid.*, p. 683.

20 On the development of the *Curiosités esthétiques* project, see Lemaitre in Baudelaire, *Curiosités*, pp. LXXI–LXXXII.

21 De Lagenevais, 'De la curiosité', pp. 791, 796.

22 On the position of history painting in the 1860s, see J. House, 'Manet's Maximilian: history painting, censorship and ambiguity', in J. Wilson-Bareau and others, *Manet: The Execution of Maximilian* (London, National Gallery, 1992), pp. 87–97, and P. Mainardi, *Art and Politics of the Second Empire* (New Haven and London, Yale University Press, 1987), esp. pp. 155–74.

23 De Lagenevais, 'De la curiosité', pp. 789–90, 792.

24 *Ibid.*, pp. 787, 797.

25 *Ibid.*, p. 792.

26 E. Zola, 'Préface de la deuxième édition', *Thérèse Raquin*, in his *œuvres complètes*, ed. H. Mitterand (Paris, Cercle du livre précieux, 1966), I, p. 521.

27 De Lagenevais, 'De la curiosité', pp. 789, 791.

28 E.g. R. Sennett, *The Fall of Public Man* (New York, Knopf, 1977); R. H. Williams, *Dream Worlds: Mass Consumption in Late Nineteenth-Century France* (Berkeley and Los Angeles, University of California Press, 1982); T. J. Clark, *The Painting of Modern Life: Paris in the Art of Manet and his Followers* (London, Thames & Hudson, 1985); P. G. Nord, *Paris Shopkeepers and the Politics of Resentment* (Princeton, Princeton University Press, 1986); C. Prendergast, *Paris and the Nineteenth Century* (Oxford, Blackwell, 1992); P. P. Ferguson, *Paris as Revolution: Writing the Nineteenth-Century City* (Berkeley and Los Angeles, University of California Press, 1994).

29 A. Delvau, *Les Plaisirs de Paris: guide pratique et illustré* (Paris, A. Faure, 1867), p. 19.

30 Madame Romieu (M. Sincère), *La Femme au XIXe siècle* (Paris, Amyot, 1858), [p. 1].

31 Baudelaire, *Curiosités*, p. 499.

32 This is made explicit in the article on '*baigneuse*' in Larousse, *Grand dictionnaire* (Paris, 1867), II, p. 57.

33 Comte de Sayve, *Le Curieux* (Paris, 1859), p. 57.

34 H. Meilhac and A. Delavigne, *Les Curieuses: Comédie en un acte* (Paris, 1865), p. 58.

35 The classic essay about woman's position in the street is J. Wolff, 'The invisible *flâneuse*: women and the literature of modernity', in A. Benjamin (ed.), *The Problems of Modernity: Adorno and Benjamin* (London, Routledge, 1989), pp. 141–56; for a more positive view of the spaces open to women in the city, and particularly in the department store, see E. Wilson, *The Sphinx in the City: Urban Life, the Control of Disorder, and Women* (Berkeley and Los Angeles, University of California Press, 1991), pp. 55–60.

36 Monseigneur Dupanloup, *La Femme studieuse* (Paris, Douniol, 1869), pp. 44–5 (reprint of an essay of 1866).

37 Dupin's homily, 'Sur le luxe effréné des femmes', is published along with Feydeau's response in E. Feydeau, *Du luxe, des femmes, des mœurs, de la littérature et de la vertu* (Paris, Michel Lévy, 1866).

38 Reproductions of both images were published by Goupil – a lithograph of the Compte-Calix in 1876, and a photograph of the Béranger in the mid-1860s; both reproductions were displayed in the exhibition *L'Amour, Toujours l'Amour*, Musée Goupil, Bordeaux, 1995 (no catalogue published).

39 Reproduced in M. Wentworth, *James Tissot* (Oxford, Oxford University Press, 1984), plates 11 and 59.

40 Baudelaire, 'Le Peintre', pp. 462, 464–5.

41 *Ibid.*, pp. 470–1.

42 *Ibid.*, p. 494.

43 Poe's story is cited in Baudelaire, 'Le Peintre', p. 461); Baudelaire's translation, 'L'Homme des foules', is reprinted in *Œuvres complètes de Charles Baudelaire*, ed. J. Crépet (Paris, Conard, 1933), VII.

44 On changing notions of the crowd, see S. Barrows, *Distorting Mirrors: Visions of the Crowd in Late Nineteenth-Century France* (New Haven and London, Yale University Press, 1981).

45 For further discussion of *The balcony* in this context, see J. House, 'Social critic or enfant terrible? The avant-garde artist in Paris in the 1860s', in K. Herding (ed.), *L'Art et les révolutions, Section 2*, Proceedings of 27th International Congress of CIHA (Strasbourg, Société Alsacienne pour le Développement de l'Histoire de l'Art, 1992), pp. 47–60.

46 T. Thoré, *Salons de W. Burger, 1861–1868* (Paris, J. Renouard, 1870), II, pp. 531–2.

47 J. Castagnary, *Salons (1857–1879)* (Paris, G. Charpentier et A. Fasquelle, 1892), I, pp. 364–5; P. Mantz, 'Salon de 1869', *Gazette des Beaux-Arts* (July 1869) 13.

48 E. Zola, 'Edouard Manet', *Revue du XIXe Siècle* (1 January 1867), reprinted in E. Zola, *Mon Salon, Manet: écrits sur l'art*, ed. A. Ehrard (Paris, Garnier-Flammarion, 1970), pp. 100–1, 109–11.

49 My thinking about Flaubert has been informed by J. Culler, *Flaubert: The Uses of Uncertainty* (London, Paul Elek, 1974), and D. LaCapra, *'Madame Bovary' on Trial* (Ithaca and London, Cornell University Press, 1982).

50 For reviews of Flaubert's novels, see R. Dumesnil's editions: *Madame Bovary* (Paris, Société Les Belles Lettres, 1943), I, pp. CLVII–CLXXXIII; *Salammbo* (Paris, Société Les Belles Lettres, 1944), I, pp. CIV–CXIX (Dusolier's comments, pp. CXV–CXVI); *L'Education sentimentale* (Paris, Société Les Belles Lettres, 1942), I, pp. CX–CXIX.

3 On his knees to the past?
Gautier, Ingres and forms of modern art

'le présent doit, sans superstition puérile, ployer le genou devant le passé
...'

(the present should, without puerile superstition, bend the knee before the
past ...)

(Théophile Gautier)[1]

WHEN, in the *Moniteur Universel* of 24 June 1865, Théophile
Gautier attacked Manet's *Olympia* as the work of an artist
prepared to denigrate the principles and procedures of the French
school of painting for the sake of publicity, he placed himself, for
more than a century as it turned out, firmly on the side of the villains
of modernist art history. With the victory of Manet and the Impres-
sionists over the academic tradition of French painting, Gautier's
attack on *Olympia* was ridiculed as one of the more distinguished
entries in the *bêtisier* of anti-modernism.[2] His failure to recognise a
defining moment in the history of modern art, the tone of his attack
on one of its greatest icons, became case-studies in the blindness with
which even a connoisseur like Gautier might be visited when faced
with 'the art of the future'.

In its form and subject-matter, *Olympia* was a *cas limite* for Gautier,
a point at which his willingness to find compromises between his
neo-classical aesthetic and contemporary trends in French painting
was exhausted. Faced with *Olympia*, he decided to have done with
Manet and all he stood for, for the same reasons and in the same
terms as those he had employed over a decade earlier against Courbet.
For Gautier shared the widely held view in 1865 that Manet was the
heir to Courbet at the head of the Realist movement in painting.
Since he also considered Realism to be the systematic pursuit of what
he called, in the same attack on Manet, the 'laid idéal', *Olympia*
seemed to him to be the reversal of the aesthetic values synonymous

with art itself.[3] He believed that Manet, like Courbet, had deliber-
ately excluded the pictorial means – the system of tonal values,
modelling and balanced relationship of light and shadow – in which
the universal ideal of beauty was embodied in the French tradition.
Gautier's attack on *Olympia* was expressed in these formal terms not
simply because the art-for-art's-sake with which he was so strongly
associated was a theory of beautiful form, but also because from his
viewpoint the subject of the painting defied description. With his
exceptional knowledge of European art history Gautier could hardly
have failed to recognise the classical models which *Olympia* was
reworking in its representation of the conditions of sexuality in
Second Empire Paris, but rather than pursue its implications, he pre-
ferred to dismiss the subject of the painting as gratuitous provocation.[4]
It is significant in this respect that the second work Manet exhibited
in the Salon of 1865, *Le Christ insulté par les soldats*, did not generate
the same force of self-censure. Here, metaphor could make explicit the
results of the painter's refusal to idealise his subject-matter. So Gautier
likened the soldiers to medieval thieves and Christ to an ambushed
vagrant. By 1865 religion was safer ground than sexual politics.

Analysing the critical reaction to *Olympia* in 1865, T. J. Clark
showed that for many of the artists and writers of the 1860s, Ingres's
work provided the exemplary model for the painting of the nude.[5]
This point is more true of Gautier than most, for devotion to Ingres
had by 1865 been the fixed point of his art criticism for over thirty
years.[6] He above all must have sensed that Manet's work was playing
some unspeakable joke on the painter he worshipped. In an article in
1857 on Ingres's *La Source* [10], painted the previous year, Gautier
singled out for praise the very qualities of line, modelling and style
he saw so wilfully negated in *Olympia*.[7]

The damage done to Gautier's posthumous reputation as an art critic
by his failure to embrace modernity as it was retrospectively identi-
fied in histories of modern art was compounded by the ignominious
collapse of the Second Empire with which he was so closely identi-
fied. The position of authority Gautier had enjoyed under the dis-
graced regime ensured that its fall took his reputation with it. As
the work of Manet and his followers eclipsed that of the academic
painters Gautier had supported during the Second Empire, the idea
that he had grasped nothing of Baudelairean modernity and that his
obstinate defence of a classical heritage under siege was inseparable
from his promotion within the Second Empire cultural establishment
became part of the received history of French nineteenth-century art
criticism.[8] Yet Gautier's definition of modernity was in some respects

close to that of Baudelaire, his recognition of the need for painters to represent the modern world was more wide-ranging. The essential difference between the two was the response to Ingres, reserved and qualified in Baudelaire, absolute and non-negotiable in Gautier. As far as trends in contemporary painting were concerned, this commitment to Ingres undoubtedly created for Gautier constraints with which Baudelaire was not concerned. But rather than condemn Gautier in terms of spurious distinctions between heroes and villains of art criticism, it is more important historically to see the forms of accommodation Gautier sought between contemporary painting and his neo-classical aesthetic, the rhetorical means he adopted to convince his readership of the value of these forms and the role his views played in the situation in which French painting found itself in the 1850s.

Already under the July Monarchy Gautier had recognised the need to seek accommodation with the new.[9] By the mid-1830s and whatever he might think of the class which in July 1830 had consolidated its hold on political power, he knew that he could not stand aloof from the cultural and economic conditions it was creating. As an art critic working for some of the most prominent newspapers and journals of the mid-nineteenth century, he chronicled in detail the forms in which, in the course of his professional life, French painters and the system within which they operated were obliged to respond to the demand for the modern subjects (portraiture, landscapes, genre painting) which more faithfully represented the ideological aspirations of a growing and more diverse public. Throughout his career Gautier retained his commitment to the 'beau idéal' and found no contradiction between it and his support for the Romantic cause. The two had come together at a very early stage of his career as an art critic when he defended Ingres's work shown in the Salon of 1833 from the attacks of the supporters of David in the Institute.[10] As he often pointed out, the Romantics of 1830 considered Ingres to be one of their own for they saw his struggle against the Davidians as a counterpart in painting to their own opposition to classicism in literature. According to Gautier, the Davidian faction sought to frustrate Ingres's right to lead the renewal of the neo-classical tradition because they were trying to maintain the French school within the slavish imitation of antique models that Romanticism was determined to overthrow. This antipathy between Ingres and the Davidians resurfaced in 1834 when, in the Salon of that year, the painter's *Saint Symphorien* was subjected to such criticism by his opponents that he left for Rome for seven years and refused to send his work to the Salon again. In his review of the Salon, Gautier responded to this

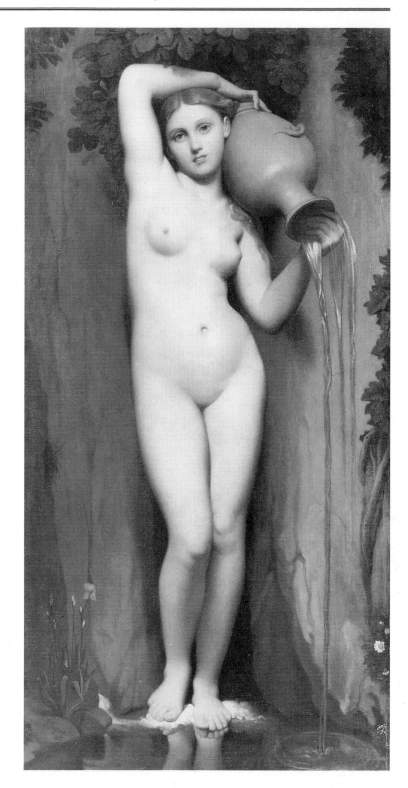

10] Jean-Auguste-
Dominique Ingres
La Source

criticism by calling Ingres a master and comparing him to Dürer.[11] Similarly, however unsympathetic Gautier had been initially to contemporary forms, manners and dress, he recognised the need to integrate modern forms of beauty into his aesthetic years before Baudelaire's famous defence of the heroism of modern life at the close of his Salon of 1845.[12] Since Gautier's commitment to the timeless forms of beauty represented by Ingres's work was unconditional, any accommodation with the modern in painting had to be made within the framework of values which this commitment implied.

The Second Empire made the reconciliation between neo-classical order and modernising adventure an even more relevant issue for Gautier since modernisation was the new regime's big idea. He was well aware that, in the wake of the *coup d'état* of December 1851, the pressures for change and diversification to which the institutions of French painting were subjected were accelerating. To the knowledge of the wider world made available by colonial expeditions, greatly increased opportunities for travel and the development of photography, the Second Empire had added the economic expansion which was in the process of transforming the French art market. As Gautier wrote in his opening article on the Salon of 1857: 'L'horizon de l'art s'est d'ailleurs singulièrement élargi en ces derniers temps' (Art's horizons have singularly broadened these last few years).[13] These changes were reinforcing the lessons of the Universal Exhibition of 1855, which had sealed the triumph of that eclecticism already identified by Gautier in 1839 as the defining feature of modern French painting and now established, in the political and cultural spheres, as quasi-official government policy.[14] Gautier's eclecticism, like that of Cousin, saw the pursuit of ideal beauty as the source of art's spiritual value, and his art criticism was driven by the ambition to achieve and sustain a consensus around this concept.

Gautier was clear about the significance of the Universal Exhibition as a catalyst in this process of change. As he noted in his review of the Salon two years later, the internationalisation of art had produced 'combinations and results difficult to classify in the old categories'.[15] In 1855, a major discovery for the French art public was that of British painting, situated in aesthetic and cultural terms at the opposite extreme to the neo-classical tradition of Ingres.[16] In the sequence of fifty-two articles on the exhibition published in the *Moniteur Universel* between March and December 1855, Gautier began with a lengthy analysis of contemporary British art. He followed this with his most powerful statement to date on the unique status of Ingres in the French school. This juxtaposition of the two traditions highlighted the difficult relationship between modernity

and ideal beauty in Gautier's system. His analysis of British art implied that similar cultural and economic forces to those which underpinned its achievements were also in the process of transforming the French artistic field. His analysis of Ingres made it clear that certain models and procedures retained indispensable authority, irrespective of the forms this transformation took.

French surprise at the British gallery in the Universal Exhibition stemmed primarily from the realisation that there was no emphasis in British painting on the imitation of Antiquity, no hierarchical system of subjects dominated by history painting.[17] British painting, lacking reference to Antiquity, was, said Gautier, modern like a Balzac novel.[18] Genre painting, with its simple narratives of contemporary life and manners, was by far the most dominant type and British formal practices were quite bereft of the idealising virtues with which they were endowed in the French academic tradition, most notably in the taste for what Gautier called their 'impossible associations of colour'.[19] Attentive as ever to the social and cultural contexts in which art was produced, Gautier explained that British life was acted out primarily in an urban environment whose public and private spaces were too small for the dimensions associated with French history painting's 'grandes machines', that England lacked the centralised State-controlled 'direction des beaux-arts' which was embodied in the French institutions of Académie, Ecole des Beaux-Arts and annual Salon, and was able to perpetuate a grand manner through state commissions for the decoration of public architecture, and that in England the official Protestant religion was inherently unsympathetic to elaborate, finely crafted and expensively produced religious art.

It was possible, according to Gautier, to find English examples of a hybrid form of painting which figured prominently in the contemporary French debate on the academic hierarchy of subjects and which combined the prestige of history painting and the accessibility of genre. Thus, the work of Ansdell is described as depicting truthful actions in individualised settings but also as achieving the universality of history painting through its many references to classical iconography. Ansdell's work is, however, judged to be untypical of English art, which was most powerfully and most typically represented by Mulready, notably in his modern version of La Fontaine's fable *The Wolf and the Lamb*, in which humans replace the animals and which, claims Gautier, 'tells you as much about England as a six-months' stay there'.[20] The claim is only partially tongue-in-cheek for Gautier's narration of Mulready's image is a model of the art tourist's guidebook, in which the simple moral drama of the lamb's just revenge on the wolf is recounted for the visitor. The links between

English painting and the melodramas of boulevard theatre, the precision and familiarity of the visual language of gesture and expression, their conformity to established cultural stereotypes of character and manner were, according to Gautier, qualities with their own *titres de noblesse* in Flemish scenes of everyday life. They were part of a wider Northern tradition of the truthful representation of the contemporary and the everyday, whose value for the French public of the 1850s increasingly rivalled that of the 'idéal antique'. To characterise such work, Gautier resorted to a neologism:[21] '[L]e caractère de la peinture anglaise est, comme nous l'avons dit, la modernité. Le substantif existe-t-il? le sentiment qu'il exprime est si récent que le mot pourrait bien ne pas se trouver dans les dictionnaires' (The essential character of English painting is, as we have said, modernity. Does the noun exist? the idea it expresses is so recent that the word may very well not exist in the dictionary).[22]

Gautier had already used the term '*modernité*' three years before the Universal Exhibition, in the context of his analysis of portraiture in the Salon of 1852. It hardly seems a coincidence that the term's first appearance in his art criticism should coincide with the first Salon since the *coup d'état*, nor that it should do so in relation to portraiture. The Second Empire's ruling classes, beginning with the Emperor himself, fuelled a demand for flattering self-images that made portraiture a highly lucrative form of specialisation.[23] For Gautier, portraiture's attraction was obvious: the fusion of the contemporary and the timeless was its *raison d'être*. As he put it in his Salon of 1859, the portrait 'does not tolerate mediocrity' for the challenge it confronted was to summarise an entire epoch or social class in a face painted against an ill-defined background.[24] In particular, his beloved Ingres had throughout his career shown the heights the portrait could reach. Already in 1833, in his first Salon review, Gautier had proclaimed Ingres a master on the basis of his 1807 portrait of Madame Devauçay.[25] As during the Second Empire the tide turned against Ingres and the neo-classical tradition he led, even the most violent of his critics exempted his portraits from attack. Castagnary, for example, dismissed him as a spent force whose reputation was based on bad paintings but conceded that he 'was admirable every time he turned his hand to portraits'.[26]

The *Portrait de Mme P.* (Céline Pastré; [11]) by Ernest Hébert was the most talked-about painting of the 1852 Salon. Gautier described it as 'franchement moderne', for not only had Hébert dispensed with the sculptural values central to the academic representation of the female form, but he had also represented his subject in an authentic modern dress of light-blue *barège* material which had no place in the

academic wardrobe. For Gautier, Hébert had recognised that religion, customs, climate and, above all, corsets had changed the feminine form to such an extent that it was no longer appropriate to seek to represent the beauty of the modern *Parisienne* via the perfection of

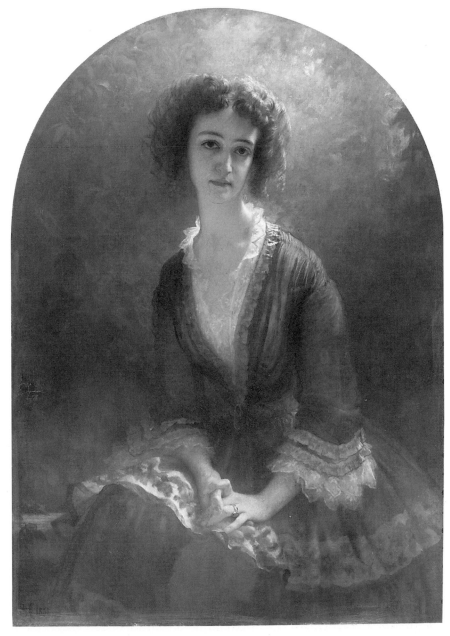

11] Ernest Hébert *Portrait de Mme P.*

sculptural form, which was not designed for her quite different charms. To reinforce his demonstration of the changing forms of Beauty, Hébert had represented his subject sitting out of doors in a low sunlight filtered through trees. The reflections had the effect of desubstantiating the figure, giving it a mysterious, tender and ethereal quality which was another form of its modernity. Gautier acknowledged that in this interplay of figure, dress and light, Hébert was flirting with some quite radical formal developments but their violation of the classical codes of beautiful form was to be seen in the context of the decline of chiaroscuro in the two great 'schools' (those of Ingres and Delacroix) which had dominated recent French painting. This technical reassurance was presumably over the head of the majority of Gautier's readers and no less reassuring for that, but it illustrates the lengths to which he was willing to go to defend the representation of a modern ideal on the part of a painter who had demonstrated his allegiance to, and mastery of, the academic system.

Gautier even preferred the portrait of Céline Pastré to a second Hébert portrait shown in the same Salon, that of Madame M[aria Pucci], more conventional in its references to the Italian painting so prominent in Hébert's usual choice and treatment of subjects and which in the Salon of 1852 served as a sort of guaranty for the formal innovations on display in the portrait of Madame Pastré. It is striking to note, however, that this preference does not appear to have survived beyond the Salon of 1852. In his review of Hébert's work in the Universal Exhibition,[27] no mention is made of the painter's modernity or of the portrait which three years earlier had embodied it to such effect. Similarly, in the Salons of 1857 and 1859, Gautier's comments on Hébert's portraits, though complimentary, are little more than afterthoughts to his study of the artist's Italian subjects.[28] For Gautier, the explicitly modern subject, even when handled by a painter of Hébert's academic credentials, generally took second place to the modern stylisation of classical themes and iconography.

The strengths and limitations of the representation of modern beauty were shown most clearly by Gavarni, Gautier's own 'peintre de la vie moderne', for whom, 'comme Balzac . . . l'antiquité semble ne pas avoir existé' (like Balzac . . . Antiquity does not appear to have existed),[29] and to whom was due 'la gloire non médiocre d'être franchement, exclusivement, absolument moderne' (the by no means mediocre glory of being frankly, exclusively and absolutely modern).[30] Representation of the *lorette* was for Gautier Gavarni's greatest claim to fame and his 1857 article consisted of a long variation on the literary stereotype of the *lorette* popularised in fiction and theatre and of whose world Gavarni had rendered everything, furniture,

costumes, accessories and fashions, 'avec une *modernité* intime'.[31] This modernity (still in 1857 a neologism as Gautier's italics remind us) is that of the material world and its social forms, rendered with a naturalism enhanced by its truthfulness and by the artist's moral sense. Its freedom from inherited themes and forms, its historically contingent beauty, made it a document of exceptional value for future historians of the period 1830–50, but also prevented it attaining what he called the 'more beautiful, more noble, more pure' forms of modern beauty.[32] Though these are not identified, no contemporary reader familiar with Gautier's art criticism could fail to detect the reference to Ingres's nudes as the 'supreme expression of the feminine beauty of our age'.[33] The distinction made here between contingent and absolute forms of modern representation had been the basis of Gautier's homage to Ingres in his review of the Universal Exhibition.

In 1855 Ingres was more than ever the inescapable fact of French painting, its unavoidable point of reference. As Gautier pointed out, virtually every art critic began his review of the French section of the exhibition with Ingres's work.[34] All agreed that it was a model, that Ingres was a law unto himself. The point at issue was whether the model was one to be followed or abandoned, whether the law was effective or irrelevant for an art world in transition. There was support for Gautier's view that '[s]eul, il représente maintenant les hautes traditions de l'histoire, de l'idéal et du style ...' (alone, he now represents the lofty traditions of history, the ideal and style ...), but whether this made Ingres's work essential, dangerous or simply anachronistic depended on commitments wider than the purely aesthetic. For Gautier, Ingres was outside time and proud of it.[35] For Maxime du Camp he was in the wrong time, a Renaissance man marooned in the nineteenth century.[36] Deciding which century, if any, Ingres lived in was inevitably to reflect on the relationship between tradition and modernity. His work, unlike that of other painters, appeared not to be subject to the laws of progress and decline which, within the Universal Exhibition, the retrospective exhibitions of the four most prominent French artists of the first half of the century (Ingres, Delacroix, Decamps and Vernet) invited the visitor to discover.[37] For Gautier, the explanation was obvious. Ingres's art occupied the same 'transparent blue ether' as the Sixtine Sybils, the Vatican Muses and the Parthenon Victories.[38]

For Gautier, Ingres was Painting itself. He dominated every type of subject-matter and every pictorial idiom. His supremacy as a history painter and painter of the nude required no commentary, but his portraits also confirmed his triumph over the Davidians, whose 'pseudo-classical education' had prevented generations of artists and

public from seeing the beauty of modern dress.[39] Alternatively Greek, Roman, medieval, modern, according to choice of subject, Ingres's genius was his 'power of transformation', that is, his Romantic mastery of local colour, 'plus his science of drawing and style, which he never forgets'.[40]

But if the Universal Exhibition set Ingres apart as Europe's most famous living painter, it also galvanised the opposition to his legacy. In this respect it reinforced the polarisation which took place the previous year, when Ingres completed the *Apothéose de Napoléon*, his decoration for the ceiling of the Salon de l'Empéreur in the Hôtel de Ville. Gautier saw the work as the pendant to the painter's *Apothéose d'Homère* of 1827, the most famous poet of Antiquity metaphorically linking hands across Ingres's career with the greatest modern soldier, whose emperor-nephew made the 'pilgrimage' to the artist's studio, 'transformed into a sanctuary of art', to pay appropriate homage to the artist, the 'glorious intermediary' between past and future.[41] In the decoration, the Emperor is for Gautier the perfect synthesis of resemblance and idealisation, at once Napoleon and Mars, while the artist assumes his place in the critic's holy trinity of arch-symbols, Phidias, Raphael and Ingres, Ancient Greece, Renaissance Italy and modern France. This for Gautier is the true dimension of the modern, the transcendent essence's permanent youth.

For those who refused to accept this definition of modernity as the perpetuation of the faith in Antiquity into the modern world, Ingres's decoration of the Salon de l'Empereur marked the end of an era. Maxime du Camp recognised the force of Ingres's talent and conviction but was clear that the painter had brought to a close Raphael's legacy to the French school.[42] As a republican committed to the Revolution of 1789 and to the idea of progress central to the republican ideal, du Camp was scathing about a work which in his view lacked any reference to the age of history which Bonaparte had dominated and whose forward march Ingres's pictorial language reversed. For du Camp Napoleon was a 'genius too profoundly, too radically modern to be represented as Theseus, Pirythous or Achilles might have been'. 'En un mot, où est l'histoire? Je ne la vois pas' (In a word, where's the history? I don't see it).[43] By the mid-1850s Baudelaire did not share du Camp's republicanism but he too disapproved of the representation of Napoleon in costume other than the familiar military greatcoat or official regalia. Had Baudelaire left it at that, he presumably would have kept his column in *Le Pays* for longer than the two articles on the Universal Exhibition that he was able to publish. But the angry response of its editor to his sarcastic comment about Ingres's Napoleonic chariot being doomed like a gas balloon

to crash back down on to the earth's surface is indicative of the polar-isation of opinion taking place on the question of the Ingres legacy.

It was at this important stage in the history of the Ingres literature and of the wider artistic and cultural developments in which this literature played its part that Gautier became editor-in-chief of *L'Artiste*, relaunched under new management with the explicit remit of charting the new expansion and diversity of the artistic field.[44] *L'Artiste* ranged very widely across the visual arts, taking in forms in which respect for the past was not an issue. Since it appeared weekly, it had little choice, with the demand for copy which this implied. This demand was particularly onerous for Gautier himself who contrib-uted a substantial article for most of the issues for a two-year period beginning in December 1856. This weekly obligation to find a new subject for his article together with his own interest in every form of artistic production ensured that respect for tradition was obliged to compete for space with other themes in Gautier's art criticism so that, in the first three months alone, he wrote on Doré, Gavarni and photography as well as on Ingres, Gérôme and Ziegler. Yet despite the fact that past and present exerted their competing claims according to the haphazard contingencies and chronologies of art creation and criticism, support for Ingres was a thread running through *L'Artiste* in 1857 and 1858. Gautier's introductory editorial of 14 December 1846, in which he restated his art-for-art's-sake convictions and his faith in the authority of the past, ensured that this would be so.

Gautier's first and most important homage to Ingres in *L'Artiste* was an article of 1 February 1857 on *La Source* (painted the previous year). He described it as the 'pearl' of Ingres's work, the most com-plete realisation to date of the fusion of idealism and naturalism which had always characterised Ingres's art for Gautier: 'L'idéal, cette fois, s'est fait trompe-l'œil' (the ideal, this time, has become *trompe-l'œil*). The nudity of this fifteen-year-old girl who appears about to step out of the frame to reach for her clothes is of such powerful presence for Gautier that he feels compelled to deny repeatedly that her body is an object of desire and to multiply the references to Greek statuary to substantiate her 'immaculate perfection' of form. But while the descriptions of her body speak only of virginity and modesty, those of line ('une ondulation serpentine d'une suavité extrême' (a ser-pentine undulation of extreme suavity)) and colour (whose 'supreme beauty' rivalled the greatest masterpieces of Flemish and Venetian art) reinstate the intensely sensualised classicism which Gautier found in Ingres's work.[45] *La Source* was, therefore, a definitive modern adaptation of a definitive classical model, eclipsing the Romantics in

its use of colour, eclipsing the Realists in its naturalistic representa-
tion of the nude. From this viewpoint, Gautier's attack on *Olympia*
spoke for itself.

This lesson of the modernity of Ingres's art would be repeated
regularly in *L'Artiste* over the following twelve months. 'Ingres'
(5 April 1857) is hagiography rather than art criticism and has all
the hallmarks of a filler. The review of Meissonier's work on show in
the Salon of 1857 (6 September) has a comparison between these two
'absolute painters', Ingres the master of Italian art, Meissonier that
of the Dutch and Flemish tradition. On 10 January 1858, we find a
piece on *Louis XIV et Molière* painted in 1857 for the foyer of the
Comédie-Française. Three weeks later, in 'Les Soirées du Louvre'
(the Friday evening receptions hosted by the comte de Nieuwerkerke,
Directeur Général des Musées Impériaux de France, in his private
apartments in the Louvre), there is a long paragraph on two Ingres
drawings (one of the Count himself, the other a little-known early
drawing of 'Philémon et Baucis') on display in the Count's bedroom.
In 'De la mode' (14 March 1858), Ingres's portrait of Bertin is cited
as the exemplar of the beauty of modern dress. However conven-
tional and repetitive the terms of praise used by Gautier to refer to
Ingres and his work on these occasions, they served to ensure that
the values which the painter represented for Gautier remained in
the foreground of the critical arguments. That these were becoming
increasingly hostile to Ingres and his supporters is amply demonstrated
by Gautier's article of 14 February 1858, entitled 'La Néo-Critique
(à propos de M. Ingres)'. This new criticism, we learn, had taken on
itself the 'apostolate of invective', rubbishing Ingres's 'gingerbread
Gods' and dismissing his supporters as the 'idiotic worshippers of an
idiotic fetish'. These 'new' critics are not identified but the tone of
Gautier's simplified, polemical presentation of the anti-Ingres trends
in French art and criticism suggests his recognition of the extent to
which his own reputation was tied to that of Ingres. His defence of
the artist quickly turns to that of his own critical positions and method.

The attacks levelled against Ingres together with his continued
absence from the Salon exhibitions served to focus Gautier's efforts
to seek out among the following generation of painters examples of
the synthesis of ideal and modern forms of beauty. Ingres's best-
known pupils, such as Flandrin, Chassériau and Lehmann, were
obvious candidates but Baudelaire's comment in 1846, that Ingres
was still the sole member of his school ('M. Ingres est encore seul de
son école'[46]), remained true ten years on. Hippolyte Flandrin was
widely acknowledged to be the finest contemporary religious painter
but the category appeared condemned to decline in the new secular

age. Chassériau had died in 1856, and though Gautier had in 1853 welcomed him back into the neo-classical fold after what he considered to be a period of dangerous flirtation with the lessons of Delacroix's art, few believed that the future of French painting lay in the sort of synthesis he had sought to achieve between two such powerful but opposing models.[47] Lehmann was a successful portraitist and genre painter but hardly of the stature to bridge the gulf between Ingres and his pupils identified by Baudelaire. The Salon of 1857 merely confirmed to Gautier that though Ingres's former pupils were still in his view distinguished by a shared commitment to his timeless, universal principles, the power of a school of painting to impose itself in the new age of anarchy and individualism was much diminished.[48]

During the 1850s it is in the work of Gérôme that Gautier most firmly locates his aspiration for a synthesis of ancient and modern. In his review of the Salon of 1847, his praise of Gérôme's *Combat de coqs*, a genre scene in an antique Mediterranean setting and painted in dimensions usually reserved for history painting, had established the painter's reputation. In the Universal Exhibition his *Le Siècle d'Auguste* had confirmed for Gautier his status as the leading history painter of the day. The Salon of 1857 had seen the popular triumph of his *Bal masqué*, in which Gautier found the modern subject of genre painting invested with the idealising virtues of serious painting, and the critical acclaim of his *Prière chez un chef arnaute*, in which 'le premier, il a vu l'Orient en peintre d'histoire' (he is the first to see the East as a history painter).[49] On 16 May 1858 Gautier informed readers of *L'Artiste* that on his latest visit to the painter's studio, he had discovered Gérôme engaged on a startling reconciliation of ancient and modern, the decoration of a railway carriage offered by the Roman railways to the Pope, or as Gautier put it, 'the ancient and the modern, unchanging tradition blessing indefinite progress'.[50] In the same article, he gave his readers a preview of the three works which Gérôme was preparing for the Salon of 1859, three different forms of history painting recycled to meet the contemporary taste for ethnographic reconstructions.[51] The three paintings occupy the whole of Gautier's second of twenty-six articles on the Salon, a clear indication of the priority Gérôme enjoyed in Gautier's hierarchy of contemporary artists.

In all of the early articles of his Salon of 1859, Gautier defines different forms of compromise between classical models and the modern spirit in each major figure and subject-type studied. After an opening obituary on the recently deceased academic painter Léon Benouville, Gautier's first article is devoted to Hébert, whose Italian

paysanneries are closest to Gautier's own taste for powerful, sublimated eroticism clothed in the allegedly self-sufficient beauty of classical sculptural forms. Baudry's *La Toilette de Vénus* combines 'la finesse de la Renaissance à la correction de l'antique' but for the nineteenth-century male spectator Gautier adds that the goddesses of mythology 'do not have very complicated bathrooms' and rummages through the modern beauty products that Venus does without.[52] He gazes at the sensual nude of the same painter's *La Madeleine pénitente*, noting that her bosom is not that of a statue but of a modern woman and wondering what Madeleine regrets more, her past sins or her recent repentance of them.[53] Curzon's middle-class Italian domestic interiors combine contemporary genre painting with historical accessories and in this compromise between genre and history there is an implied lesson for the Realists for Curzon 'has brought style to ordinary life'.[54] Bourguereau, in *L'Amour blessé*, showing Venus consoling the infant Cupid stung by a bee or pricked by a rose, has brought ordinary life to the classical theme and Venus herself is as much a woman as a goddess, 'which is no harm'.[55] In the same painter's *Le Jour des morts*, which shows a young widow and her daughter kneeling beside the tomb of husband and father, the classical technique lifts the work beyond vulgar sentimentality and the dark dresses 'have the nobility of antique drapery'.[56]

In Gautier the forms of modern art were varied but the form of art was singular. His definition of modernity has affinities with that of Baudelaire for whom the transitory was one half of art and the eternal the other,[57] but he found wider applications for the heroism of modern life than Baudelaire did and he was much more receptive to the idea of progress.[58] Unlike Baudelaire, however, Gautier maintained a hierarchical relationship between the transitory and eternal, even as he watched the idea of hierarchy being eroded in the academic system of subjects. The terms in which he wrote about contemporary art, the rhetorical practices he evolved to make his vision of the synthesis of the timeless and the modern, the ideal and the natural, accessible to the diverse publics of the Salon are central to the aesthetic, cultural and ideological issues with which painting was engaged in the crucial first decade of the Second Empire, that period of transition which Manet's painting would displace and with it, the forms of compromise which Gautier strove to establish.

Notes

1 T. Gautier, 'Introduction', *L'Artiste* (14 December 1856), 3–5 (p. 4).

2 See J. Lethève, *Impressionnistes et symbolistes devant la presse* (Paris, Editions du Seuil, 1959), p. 32. The text of Gautier's review of *Olympia* may be found in Marie-Hélène Girard's anthology, *Théophile Gautier: critique d'art* (Paris, Séguier, 1994), pp. 294–5.

3 Thus on Courbet's *Enterrement à Ornans*: 'Notre jeune peintre, parodiant à son profit le vers de Nicolas Boileau-Despreaux paraît s'être dit: "Rien n'est plus beau que le laid, le laid seul est aimable . . ."'; on *Olympia*: 'il [Manet] se pose pour le laid idéal et semble avoir adopté comme formule d'art la phrase des sorcières de Macbeth: l'horrible est beau, – le beau horrible' (quoted in Girard, *Théophile Gautier*, pp. 134 and 294 respectively). On Gautier's attacks on the Realists, see J.-P. Leduc-Adine, 'Théophile Gautier et les réalistes', in *Théophile Gautier: l'art et l'artiste*, Proceedings of the Gautier conference held in the Université Paul-Valéry, Montpellier, September 1982 (Montpellier, Société Théophile Gautier, 1982), pp. 21–33.

4 On Manet's use of classical sources and the critical responses to the painting in 1865, see in particular the exhibition catalogue *Manet 1832–1883* (Paris, Editions de la Réunion des Musées Nationaux, 1983), pp. 174–89, and T. J. Clark, *The Painting of Modern Life: Paris in the Art of Manet and his Followers* (London, Thames & Hudson, 1984), pp. 79–146.

5 *Ibid.*, ch. 2, 'Olympia's choice', pp. 79–146 (p. 126).

6 On Gautier's art criticism see M. C. Spencer, *The Art Criticism of Théophile Gautier* (Geneva, Droz, 1968); R. Snell, *Théophile Gautier: A Romantic Critic of the Visual Arts* (Oxford, Clarendon Press, 1982); W. Drost, 'Gautier critique d'art en 1859', in W. Drost and U. Henninges (eds), *Théophile Gautier: Exposition de 1859* (Heidelberg, Carl Winter Universitätsverlag, 1992), pp. 462–99, and Girard's introduction to her anthology of Gautier's art criticism, *Théophile Gautier*. On the strength of the affinity which Gautier felt for Ingres's work see also Snell, 'Théophile Gautier critique d'Ingres', in *Théophile Gautier: L'art et l'artiste*, pp. 11–20.

7 'La Source: Nouveau tableau de M. Ingres', *L'Artiste* (1 February 1857) 113–14 (p. 114).

8 Once established, such ideas have a long life. Philippe Dagen repeats them in his review of Girard's anthology. See 'Gautier l'Antique', *Le Monde des Livres* (30 December 1994) 11.

9 See L. C. Hamrick, 'Gautier et la modernité de son temps', *Bulletin de la Société Théophile Gautier (BSTG)*, 15:2 (1993) pp. 521–42.

10 'Salon de 1833', *La France Littéraire* (March 1833) 139–66 (pp. 152–4).

11 'Salon de 1834', *La France Industrielle*, 1 (April 1834) 17–22.

12 Hamrick, 'Gautier', pp. 524–6, gives examples between 1836 (Gautier on the sculpture of Jean-Auguste Barre) and 1843 (on English engravings).

13 'Salon de 1857: I', *L'Artiste* (14 June 1857) 190.

14 See P. Mainardi, *Art and Politics of the Second Empire: The Universal Expositions of 1855 and 1867* (New Haven and London, Yale University Press, 1987). Gautier had introduced his Salon of 1839 with praise of the new eclecticism of modern French painting. See Girard, *Théophile Gautier*, p. 153. On the relationship between Gautier's aesthetic and the eclecticism of Victor Cousin, see Neil McWilliam, *Dreams of Happiness: Social Art and the French Left* (Princeton,

Princeton University Press, 1993), pp. 26–7. See also A. Boime, *Thomas Couture and the Eclectic Vision* (New Haven and London, Yale University Press, 1980).

15 'Salon de 1857: I', p. 191.

16 See M. B. Howkins, 'French critical response to British genre paintings in Paris, 1850–1870', *Journal of European Studies*, 21 (1991) 111–28.

17 See Maxime du Camp, *Les Beaux-Arts à l'Exposition Universelle de 1855* (Paris, Librairie nouvelle, 1855), p. 298.

18 *Les Beaux-Arts en Europe 1855*, 2 vols (Paris, Michel Lévy, 1855–56), I, p. 7.

19 *Ibid.*, p. 15.

20 *Ibid.*, p. 20.

21 *Ibid.*, p. 19.

22 Hamrick points out that in this respect Gautier was quite right. In 1855, the term was not yet in the dictionaries. See 'Gautier', pp. 536–7, n. 3.

23 See *L'Art en France sous le Second Empire* (Paris, Editions de la Réunion des Musées Nationaux, 1979), p. 300.

24 Drost and Henninges, *Théophile Gautier*, p. 127. On the relationship of this approach to portraiture to the theories of Lavater during the July Monarchy, see M. Tilby, '"Telle main veut tel pied": Balzac, Ingres and the Art of Portraiture', in P. Collier and R. Lethbridge (eds), *Artistic Relations: Literature and the Visual Arts in Nineteenth-Century France* (New Haven and London, Yale University Press, 1994), pp. 111–29.

25 'Salon de 1833', p. 153.

26 J. Castagnary, *Salons*, 2 vols (Paris, Charpentier, 1892), I, p. 43.

27 *Les Beaux-Arts en Europe*, I, pp. 233–6.

28 See 'Salon de 1857: III', *L'Artiste* (28 June 1857) 228; Drost and Henninges, *Théophile Gautier*, pp. 5–9.

29 Salon de 1870', *Journal Officiel* (2 June 1870), quoted in Girard, *Théophile Gautier*, p. 370.

30 'Gavarni', *L'Artiste* (11 January 1857) 65–7 (p. 66). See also Hamrick ('Gautier', pp. 526–7) on Gautier's 1845 articles on Gavarni in *La Presse*.

31 'Gavarni', *L'Artiste*, p. 67.

32 *Ibid.*

33 *Ibid.*

34 *Les Beaux-Arts en Europe*, I, p. 142.

35 *Ibid.*, p. 143.

36 'Il vivait absolument dans le siècle de la renaissance, dont il s'était fait l'homme' (du Camp, *Les Beaux-Arts*, p. 45).

37 The same point was made, but from very different critical perspectives, by du Camp (*Les Beaux-Arts*, p. 45) and Baudelaire (*Œuvres complètes*, ed. Claude Pichois, 2 vols (Paris, Gallimard, Bibliothèque de la Pléiade, 1975–76), II, p. 589).

38 *Les Beaux-Arts en Europe*, I, p. 145.

39 'De la mode', *L'Artiste* (14 March 1858) 169–71 (p. 170).

40 *Les Beaux-Arts en Europe*, I, p. 163.

41 Gautier's article 'L'Apothéose de Napoléon, plafond par M. Ingres' was published in *Le Moniteur Universel* of 4 February 1854 and in *L'Artiste* eleven days later. It was republished in *L'Art moderne* (Paris, Michel Lévy, 1856), pp. 297–303.

42 Du Camp, *Les Beaux-Arts*, p. 86.

43 *Ibid.*, p. 65.

44 See P. J. Edwards, 'Théophile Gautier, rédacteur en chef de *L'Artiste*', in *Théophile Gautier: L'art et l'artiste*, pp. 257–68.

45 See Carol Ockman, *Ingres's Eroticized Bodies: Retracing the Serpentine Line* (New Haven and London, Yale University Press, 1995), chap. 4, 'The Flatulent Hand: Nineteenth-Century Criticism', pp. 85–110.

46 Baudelaire, *Œuvres complètes*, II, p. 460. See also Daniel Ternois, 'Baudelaire et l'ingrisme', in U. Finke (ed.), *French 19th Century Painting and Literature* (Manchester, Manchester University Press, 1972), pp. 17–39.

47 For the text of Gautier's review of Chassériau's *Tepidarium* in the Salon of 1853, see Girard, *Théophile Gautier*, pp. 104–8.

48 'Salon de 1857: II', *L'Artiste* (21 June 1857) 209.

49 'Salon de 1857: IV', *L'Artiste* (5 July 1857) 247.

50 'A travers les ateliers: MM. Gérôme, Gleyre, Delacroix, Appert, Paul Huet', *L'Artiste* (16 May 1858) 17–20 (p. 17).

51 I have analysed different aspects of Gautier's interpretation of Gérôme's paintings in the Salon of 1859 in two articles, 'The official line? Academic painting in Gautier's Salon of 1859', *Journal of European Studies*, 24 (1994) 283–98, and 'Quelle histoire? Gautier devant l'œuvre de Gérôme au Salon de 1859', in Keith Cameron and James Kearns (eds), *Le Champ littéraire 1860–1900: études offertes à Michael Pakenham* (Amsterdam and Atlanta, Rodopi, 1996), pp. 71–80.

52 Drost and Henninges, *Théophile Gautier*, p. 16.

53 *Ibid.*, p. 18.

54 *Ibid.*, p. 26.

55 *Ibid.*, p. 28.

56 *Ibid.*, p. 29.

57 Baudelaire, *Œuvres complètes*, II, p. 695.

58 See C.-M. Book, 'Théophile Gautier et la notion de progrès', *Revue des Sciences Humaines*, 128 (1967) 545–57. The author does not deal with Gautier's art criticism during the Second Empire, in which science and technology is frequently credited with opening up new possibilities for the renewal of French painting. See, for example, in Drost and Henninges, *Théophile Gautier*, his comments on the importance of modern forms of transport in the context of Fromentin's painting (pp. 38–9).

4 'Le Peintre de la vie moderne' and 'La Peinture de la vie ancienne'

To the form of the new means of production which in the beginning is still dominated by the old one (Marx), there correspond in the collective consciousness images in which the new is intermingled with the old. These images are wish images, and in them the collective attempts to transcend as well as illumine the incompletedness of the social order of production. There also emerges in these wish images a positive striving to set themselves off from the outdated – that means, however, the most recent past. These tendencies turn the image fantasy, that maintains its impulse from the new, back to the ur-past.
(Walter Benjamin)[1]

BAUDELAIRE'S 'Le Peintre de la vie moderne' is still widely regarded by art historians as a eulogy of the *flâneur*'s central role in what his 'Salon de 1846' described as 'l'héroïsme de la vie moderne' (the heroism of modern life).[2] However, this idea sits ill beside the repugnance in much of Baudelaire's poetry towards modern life: with the 'Horrible ville! Horrible vie!' (Horrible city! Horrible life!) of 'A une heure du matin' (I, 287), for instance. And other cotextual references of this kind, along with many intertextual references, suggest that while Baudelaire's essay is a paean to modernity, it is also a trenchant parody of the *flâneur* and his efforts to control his experience. Any attempt to characterise 'Le Peintre de la vie moderne' is further complicated by the fact that Baudelaire stipulates that a work of art must contain 'un élément éternel, invariable' (an eternal, invariable element) as a necessary supplement to the 'élément rélatif, circonstantiel' (relative, contingent element) deriving from its 'époque' (period), if it is to have beauty (II, 685). Since Baudelaire repeatedly advances eternity as the mirror-image of modernity in the poems, it may be assumed that he is suggesting that beauty is only complete when it (somehow) combines 'la beauté passagère, fugace, de ... la modernité' (the transient, fugitive beauty of ... modernity)

and the 'timeless' qualities of 'l'éternel et l'immuable' (the eternal and immutable) (II, 724), which here as elsewhere are to be conjured by memory and the imagination. However, it is difficult to envisage what Baudelaire means by the duality of beauty, and the idea therefore gives 'Le Peintre de la vie moderne' only the semblance of plausibility or coherence. This becomes even more apparent when it is realised that the essay uses the same fatalistic irony to describe the eternal that Baudelaire uses in the poetry to make any hankering after eternity seem nostalgic or deluded.

In his *Charles Baudelaire: A Lyric Poet in the Age of High Capitalism,* Walter Benjamin reworked the distinction between the experiences of modernity and eternity in terms of the difference between *Erlebnis,* or the endured experience of modern life, and *Erfahrung,* or experience experienced as such through being recuperated mnemonically in poetry or art.[3] However, Benjamin has little to say about how these notions are deployed in 'Le Peintre de la vie moderne'. As Hans Robert Jauss has argued, Benjamin is unfair in treating the essay as a marginal text, and in dismissing its theory that beauty is composed of an unchangeable and a contingent element for not being a 'profound analysis' (82).[4] However, others, and notably Christopher Prendergast,[5] have developed Benjamin's argument in ways that suggest it can illuminate how Baudelaire's essay is the mature *summa,* or at least the *terminus,* of his aesthetic.

The present attempt to demonstrate that this is the case will rest on the assumptions that reading Baudelaire must involve understanding his intentions (as they are expressed in his writing), and that this must involve understanding them historically. On these points, Prendergast has shown that Baudelaire's work often makes little sense, or seems incoherent, unless it is read as ironic and deliberately inconsistent and thus adequate to the fragmentary experience of modernity.[6] This general thesis certainly applies to 'Le Peintre de la vie moderne' as it is full of veiled sarcasm, odd contradictions, and shifts of tone and register whose sense and relative coherence only emerge when the essay is seen against the recurrent thinking of the poet's larger œuvre. It then becomes clear that Baudelaire's cannibalisation of his other work in 'Le Peintre de la vie moderne' is a function of the way that his intentions are satisfied by recurrent lines of thought that he develops more fully elsewhere. This is not to say that the odd disjunctions in the essay resolve within some greater unity when it is seen as part of a mega-text. Instead, the essay remains recalcitrant in its ambiguity over the virtues and shortcomings of *Erlebnis* and *Erfahrung* alike, and suggests a critic unsuccessfully struggling for a position on modernity, and art's critical relation to it, and not an

author who has found his voice. Put succinctly therefore: I want to advance a reading of 'Le Peintre de la vie moderne' that shows how its refusal to perform closure suited an author both fascinated with, and repelled by, what Benjamin has called the 'Ur-phenomena' of our own social and political reality.[7]

In places, Baudelaire enthusiastically proclaims that the painter of modern life is a 'flâneur' (II, 687, 691, 694) and thus celebrates in him the characteristics of a literary construct and a real social type that came into being in the Paris of the second quarter of the last century. This type is distinguished by a speed of perception which allows him to cope with the real and phenomenal speed of city life, and by an analytical vision which allows him to deal with the bewildering or hostile social situations he encounters in the 'sea' of an urban crowd composed of anonymous 'competitors' in Benjamin's analysis (60–1 and 39). These skills seem almost to make him both an artist and an amateur 'detective' (40–1). Baudelaire certainly emphasises his hero's ability to register impressions of a 'modernité' that he defines as 'le transitoire, le fugitif, le contingent' (the transitory, the fleeting, the contingent) (II, 695). His work is also a model of how 'il y a dans la vie triviale . . . un mouvement rapide qui commande à l'artiste une égale vélocité d'excécution' (there is in mundane life . . . a rapidity of movement which demands an equal speed of execution from the artist) (II, 686). In addition, the painter of modern life is an 'observateur passionné' (rapt observer) and 'L'Homme des foules', like Poe's 'The Man of the Crowd', ostensibly a skilful taxonomist of social types (II, 687–91). Like the detective, or police-spy, he also cherishes the ambition to 'voir le monde, être au centre du monde et rester caché au monde' (see society, be at the centre of society and remain hidden from society) (II, 692). It even seems that Baudelaire's 'parfait flâneur' (perfect *flâneur*) is so well equipped for city life that, for him, 'c'est une immense jouissance que d'élire domicile dans le nombre, dans l'ondoyant, dans le mouvement, dans le fugitif et l'infini' (it is an immense joy simply to set up home among the throng, the bustle, the ebb and flow, the fleeting and the infinite) (II, 691).[8]

In these respects, Baudelaire's *flâneur* is intertextually related to the type as he appears in three of the canonical texts of *flânerie*: Auguste de Lacroix's 'Le Flâneur' of 1841 (republished in 1859), Louis Huart's 'Le Flâneur' of *c.* 1842 and (one of Benjamin's sources) Victor Fournel's *Ce qu'on voit dans les rues de Paris* of 1858.[9] According to Huart, 'le flâneur voit et regarde' (the *flâneur* sees and looks) (16) with his 'bons yeux' (keen eyes) (7) – visual gifts that culminate in the 'flâneur-artiste' (artist-*flâneur*) (14). For Lacroix, he

possesses 'une organisation d'artiste' (artistic constitution) (67) and
'la faculté de tout saisir d'un coup d'œil et d'analyser en passant' (the
ability to take everything in at a glance and analyse it in passing) (65).
And by Fournel's account, he is an 'artiste par instinct' (instinctive
artist) (263) and even 'un daguerréotype mobile et passionné ... en
qui se reproduisent ... le mouvement de la cité, la physionomie
multiple de l'esprit publique ... des antipathies et des admirations
de la foule' (a moving and inspired daguerreotype ... in whom are
reproduced ... the bustle of the city, the multifarious physiognomy of
the public mind ... the loves and hates of the crowd) (261). As regards
his capacities as detective, Lacroix asserts that the *flâneur* has '[des]
yeux de lynx' (the eyes of a lynx) (67) and 'sait mieux que ... le
préfet de police, où, et de quelle manière a commencé le drame sanglant
... qui a épouvanté la société' (knows better ... than the prefect of
police, where, and in what fashion began the bloody drama ... that
has terrified society) (68). For Huart, he is the *alter ego* of 'cet autre
flâneur de profession nommé sergent de ville, et qui a pour mission
spéciale de voir des figures suspectes dans tous les visages qu'il
rencontre' (this other professional *flâneur*, known as the policeman,
who has the special mission of seeing suspect characters in all the
faces he meets) (4). And notoriously, for Fournel, the *flâneur* com-
pares with '*l'Homme dans la foule* de Poë' (Poe's 'The Man of the
Crowd') (269) in that he tackles the crowd with techniques of char-
acter analysis and detection devised by the phrenologist Gall, the
physiognomist Lavater and the scientist Cuvier.[10] Such are the *flâneur*'s
powers in combination that, according to Huart, he is able to make
the boulevard 'son domicile' (his home) (13).

The *flâneur* is not so straightforward, however. As Benjamin sug-
gests, his efforts to play the detective are part of an attempt to render
the crowd innocuous, and often amount only to fantasy (121–2).
Even the brash confidence which Lacroix, Huart and Fournel declare
in the *flâneur*'s powers is undercut by their anxiety that his experi-
ence threatens at every turn to overwhelm him. Fournel even openly
ironises his own fantasies of control, for while he claims that 'Rien
n'échappe à mon regard qui perce les ténèbres les plus impénétrables'
(Nothing escapes my glance which pierces the most impenetrable
shadows), he admits nevertheless: 'il me le semble du moins, et cela
suffit' (at least, so it seems to me, and that will do) (270). Again,
while he asserts 'Chaque individu me fournit ... la matière d'un
roman compliqué' (Each individual provides me with ... the material
for a complex novel)[11] and 'comme Cuvier reconstituait un animal
avec une dent, et un monde entier avec un animal, je reconstitue
toutes ces vies éparses; je fais mouvoir, penser, agir à mon gré ce

théâtre d'automates dont je tient les fils' (like Cuvier reconstructing an animal from a tooth, and an entire world from an animal, I reconstruct these scattered lives; I make move, think and act as I please this theatre of automatons whose strings I hold), he nonetheless concludes: 'Malheurewsement je ne suis pas Cuvier.... Qu'il vaudrait bien mieux être badaud pur et simple, et se contenter de jouir, sans chercher à trop approfondir!' (Unfortunately, I am not Cuvier.... One would be much better off being a gawper pure and simple, and to be happy to enjoy oneself, without looking to go too deeply into things!) (270–1).

Like Baudelaire, Lacroix insists that the *flâneur* is at home in the crowd, claiming that: 'Sans doute le flâneur aime aussi le mouvement, la variété et la foule; mais il n'est pas travaillé par un irrésistible besoin de locomotion; il circonscrit volontiers son domaine ... il sait moissonner encore d'incroyables richesses dans ce vaste champ de l'observation où le vulgaire ne fauche qu'à la surface' (Without doubt the *flâneur* likes bustle, variety and the crowd; but he is not tormented by an irresistible need to keep moving; he willingly circumscribes his territory ... he knows how to harvest fabulous riches from this vast field of observation where the common man only skims the surface) (65). In this respect he seems superior to his counterpart, the *badaud* or the *musard*,[12] who Huart argues: 'apporte dans ces discours la même déplorable infirmité que dans ses flâneries: il reste toujours en chemin' (brings to his conversation the same pitiable disability that he brings to his strolls: he remains for ever on the move) (5). However, the distinction between the two types is so insistent that it is arguably motivated by an anxiety that *flâneur* and *badaud* are equally victims of a senseless attachment to the novelty and show of a modernity that promises, but never delivers, repose.

This conclusion is roughly consistent with Benjamin's trenchant diagnosis of the *flâneur*'s predicament, and whose central plank is the contention that the population of the capitalist city is no longer a community in the sense that its members have shared values and histories. In such a situation, people no longer have the necessary social basis for communication, and hence are estranged from one another, and from any tradition which could bind them together. As Benjamin remarks (110–13), and as Fournel and Lacroix betray, a major symptom of this *aporia* is that the city dweller no longer hears nor tells the repeatable stories that once bound the community together, and instead, the novel – the one-off story of one segment of time unconnected to any other – is now its story, and his.[13] For Benjamin, modernity also erases the operations of history (class struggle) by appearing as spectacle, or a show that displays no intelligible signs of its own

history, and thus declares itself as the natural order of things by pro-hibiting interrogation. All in all, therefore, for Benjamin, the lived experience, or *Erlebnis*, of modernity is no longer experience in the qualitative sense of experience (fully) experienced, or *Erfahrung*. Instead, it is marked by a powerful sense of the absence of social, and existential, belonging. In Benjamin's words, it is a 'dream',[14] or as Huart puts it in a moment of lucidity: 'le flâneur . . . rêve . . . qu'il flâne' (the *flâneur* dreams that he is being a *flâneur*) (8).

If popular descriptions of the *flâneur* intermittently offer a critique of his predicament, Baudelaire is more explicitly critical. As Benjamin points out, many of the poems treat with lugubrious irony the way that capitalism has altered the speed of modern life for the city dweller – through technology, and through the way that the evolution of labour-time into a commodity has led to the tyranny of the clock (54 and 129).[15] Other poems deal with different aspects of 'shock', the way that, for instance, tradition, community, ritual, and the sense of belonging that these normally generate, have been replaced by offi-cial spectacles and the fetishism of wealth and the commodity (39, 111–19 and 131–8).[16] Yet other poems deal with the illegibility of modern life that ensues from these conditions, and with the futile attempts of the *flâneur* to play the detective in response. For exam-ple, 'La Corde' (I, 328–32), a poem Baudelaire dedicated to Manet, details the bizarre experience of its painter-narrator who finds the boy he has taken in as a *rapin* hanging in his studio after threaten-ing to send him back to his parents for stealing sweets and liquors. The painter's shock at this seemingly inexplicable suicide is explained, but also redoubled, when he uncovers its cause in learning of how the child's mother took away the fatal rope, not as a keepsake (as she had given him to believe), but in order to sell it off in lengths to ghoulish souvenir-hunters.[17]

These intertexts and cotexts strongly argue that Baudelaire is as if split in two by admiration and contempt for the *flâneur*. Seen this way, his enthusiasm for the *frisson* to be had from perceptual shock is an undecidable.[18] Hence while Huart claims that 'le plus grand charme de la flânerie c'est d'être imprévue' (the greatest attraction of *flânerie* is its unpredictability) (15), Baudelaire's claim is more manic-defensive: that his *flâneur* can enjoy a mastery of shock or have 'le plaisir d'étonner et la satisfaction orgueilleuse de ne jamais être étonné' (the pleasure of being astonishing and the haughty satisfaction of never being astonished) (II, 710). Moreover, Baudelaire is explicitly negative in his related, but rather different claim that the *flâneur* 'aspire à l'insensibilité' (longs for numbness) (II, 691), which shows how the *flâneur*'s best solution to the bombardment of modernity on

his senses is, as Benjamin suggests, to try to block it out or to parry it (68 and 118–20). Many of Baudelaire's other references to the *flâneur*'s experience simultaneously affirm and undercut the idea that he has the power to make his lived experience cohere. For instance, his efforts to do so involve him in 'un duel entre la volonté de tout voir, de ne rien oublier, et la faculté de la mémoire qui a pris l'habitude d'absorber vivement la couleur générale et la silhouette' (a duel be-tween the will towards seeing everything and forgetting nothing, and the inclination of a memory whose habit is to take in brusquely the general colour and outline) (II, 698). As Benjamin points out (70–4), the painter of modern life continues this duel in his nocturnal work, which finds him 's'escrimant avec son crayon, sa plume, son pinceau . . . comme s'il craignait que les images ne lui échappent' (duelling with his pencil, pen or brush . . . as if he feared that his pictures would escape him) (II, 693). He thus becomes 'querelleur quoique seul, et se bousculant lui-même' (quarrelsome although alone, and jostling himself) (II, 693). In doing this, he mimics the narrator of 'Perte d'auréole' who, as Benjamin points out (153–4), loses his halo as he crosses the road because of the jostling he gets in the crowd – only the artist turns his anger and frustration towards the crowd inward, against himself.

Benjamin does hint at Baudelaire's scepticism over the value of detective-work when he mentions the poet's analogy between the painter of modern life and the 'convalescent' narrator of Poe's 'The Man of the Crowd' (48 and 126–35). Like this character, the painter of modern life is distinguished by his 'curiosité' (inquisitiveness), but a *curiosité* 'devenue une passion fatale, irrésistible!' (that has become a fatal, irresistible passion!) (II, 690). Baudelaire's allusion is to the way that, although Poe's narrator begins his tale by analysing the passing crowd into its constituent types, he quickly descends into confusion and spends a fruitless night and day in pursuit of a mysterious old man who is maniacally drawn to the urban crowds. As Rignall suggests, one point of Poe's senseless yarn is that physiognomy and the allied tools of the amateur-detective trade have no real epistemological purchase.[19] (Rather, they are only props of fantasy, which explains why, once the narrator leaves the café window that frames the crowd as spectacle, his techniques are revealed as useless.) What is more, the senseless attachment of the eponymous anti-hero to the crowd parod-ies the narrator's equally pointless and maniacal attachment to him. In effect, *both* characters are 'The Man of the Crowd' – the old man is to all intents and purposes the narrator's (necessarily elusive) *doppel-gänger*.[20] To add insult to injury, Poe ends the tale (in Baudelaire's translation) with the in/conclusion: 'il ne se laisse pas lire' (it does

not permit itself to be read): the world, and its story, have become illegible.[21]

Baudelaire further undermines the *flâneur*'s capacities as a detective by designating him 'un *prince* qui jouit partout de son incognito' (a *prince* who rejoices everywhere in being incognito; original emphasis) (II, 692), and by ascribing him the 'modestie nuancée d'aristocratie' (the subtle modesty of aristocracy) (II, 691).[22] While these terms bear on the character of the painter of modern life as dandy, they also suggest that he is intertextually related to Prince Rodolph of Gerolstein, the incognito prince-cum-detective of Eugène Sue's *Les Mystères de Paris* of 1845. Baudelaire's *flâneur* is also anonymous in the urban crowd in his *habit noir*, just as the protean Rodolph is inconspicuous among the *bas-fonds* of the Cité in his workers' *bleus*,[23] and his acute powers of observation mimic Rodolph's as well. One point made by this odd rapprochement is that the *flâneur*'s activities, *qua* detective, have meaning only within a virtuous/vicious circle where he is the criminal's *alter ego* (cf. Benjamin, 41). So, for instance, Rodolph's il/licit nature is revealed by the way that he resorts to disguise and argot just as criminals do, and by his skills in pugilism which allow him to take on fearsome adversaries like the Schoolmaster and the Skeleton. Rodolph even employs his physiognomic powers and keen sight to detect and outsmart enemies equipped with similar, but lesser powers, and when he eventually captures the Schoolmaster, Rodolph blinds him, ostensibly to turn his thoughts inwards towards repentance, but effectively to deprive him of his most vital criminal power. The character of the *flâneur* in popular literature is also il/licit, culminating in Huart's absurd suggestion that he might act as a 'défenseur' (protector) to women pursued by other, more 'ignobles' (base) *flâneurs* (10).

Baudelaire's comparison between his *flâneur* and the detective is also a way of suggesting that both figures exist as fantasies of control born of insecurity. Sue's *feuilleton* super-hero is absurdly powerful, but he is also extraordinarily lucky, several times escaping the cliff-hanger that ends an episode by some chance or bizarre coincidence. In performing this way, Rodolph provides the reader with the re-assurance that the world is not beyond control, but also offers the consolation that when it is, a benign Providence is none the less at work.[24] Sue reinforces this consoling effect by allowing the reader to see ahead of Rodolph and the narrator and correctly anticipate the progress of the story. Both hero and reader thus inhabit a dream, and Baudelaire's allusions to such phantasmagoria (cf. II, 693) effectively pierce their comforting veneer, and lay bare the fact that the crowd is sometimes so alienating a domain, it can only be fantasised about.

The cotexts of Baudelaire's essay also do this. For instance, while in 'Les Foules' Baudelaire advocates taking 'un bain de multitude' (a crowd-bath) because 'Celui-là ... qui épouse facilement la foule connaît des jouissances fiévreuses' (He who ... readily espouses the crowd enjoys ecstatic pleasure) (I, 291),[25] he undercuts this enthusiasm in 'La Solitude', where he speaks of the 'honte' (shame) of those 'qui courent s'oublier dans la foule' (who are in a hurry to lose themselves in the crowd) (I, 314). Baudelaire does this again in 'Les Tentations', where the poet rejects Satan's gift of being able to enter the souls of others, with: ' "je n'ai que faire de cette pacottille d'êtres qui ... ne valent pas mieux que pauvre moi" ' ('I will have nothing to do with that rag-bag of beings ... who are as worthless as myself') (I, 308–9).[26] By analogy, Baudelaire is both sincere and ironic about the achievement of the painter of modern life when he asserts: 'la foule est son domaine, comme l'air est celui de l'oiseau, comme l'eau celui du poisson' (the crowd is his territory, as the air is the bird's, as water is the fish's) (II, 691). That is, while Baudelaire may contend that being in the crowd allows the painter of modern life to be 'hors de chez soi, et pourtant se sentir partout chez soi' (outside the home, but to feel everywhere at home) (II, 692), he also accepts that this sense of belonging is partly the wilful fantasy of a deracinated dandy – which he acknowledges explicitly when he describes his hero as 'un solitaire ... traversant *le grand désert d'hommes*' (a solitary individual ... crossing *the great desert of humanity*; original emphasis) (II, 694).

It helps with understanding Baudelaire's strategy in *Le Peintre de la vie moderne* to see that he describes two distinct, and even opposite kinds of *flâneur* in his essay: the 'pur flâneur' (pure *flâneur*), and another with 'un but plus élevé' (a more elevated aim) – that of extracting the 'poétique' (poetic) from the 'historique' (historical) (II, 694) – or the *flâneur* in his role as 'philosophe' (philosopher) (II, 687). In this respect, Baudelaire's is not unlike Lacroix's text, which attributes the *flâneur* a philosophical dimension because of his abilities as a detective (65 and 68), or Huart's, in which the *flâneur* is seen as a philosopher because he rises above the culture of the commodity (6). However, it is nearer the mark to suggest that Baudelaire takes an already existing distinction and develops it in his own way by characterising the *flâneur*'s philosophical dimension as something deeper than mere perspicacity. In 'La Corde', for instance, Baudelaire operates the distinction in assigning the role of the pure *flâneur* to the narrator, and unmasks this character as bankrupt at the end of the poem when he reveals himself as the more sagacious and 'philosophical' poet.[27] Baudelaire also operates the distinction in many of

the prose poems where he disidentifies the poet from the *flâneur-*
narrator, and/or identifies the poet with the philosopher, often in the
guise of a dispossessed marginal observing the futility of the society
of spectacle from outside.[28] Therefore, while modernity undoubtedly
had its 'héroïsme' for Baudelaire, Benjamin is right to suggest that
the real 'heroes' of modernity for Baudelaire emerge as those 'who
have traversed the city absently ... lost in thought or worry' (69;
cf. 66 and 97). And so, while Baudelaire allows the painter of modern
life to enjoy the superficial pleasures of the 'pompes et solennités'
(pomp and ceremony) of modernity (II, 704–6), he has more compel-
ling reasons for declaring: 'Je le décorerais bien du nom de philosophe'
(I would decorate him with the name of philosopher) (II, 691).

 Baudelaire thus seems almost to relish the lack of resolution in his
essay, just as he plays with the reader's ability to detect the failing
detectives in his text. By using such strategies, he maintains an aristo-
cratic aloofness which serves as a carapace behind which he is able to
deflect the 'shocks' of modernity whilst preserving his 'real' feelings, and
he produces a text that serves to express, and also to mask, its author.

The motif of the philosopher-*flâneur* finds perhaps its most poignant
expression in 'Le Vin des chiffonniers' from *Les Fleurs du mal*, where
the drunken ragpicker, the philosopher or modern-day Diogenes of
contemporary discourse,[29] waxes lyrical in the belief he is invisible to
'ses sujets' (his thralls), the 'mouchards' (police spies), and exalts in
the 'splendeurs de sa propre vertu' (splendour of his own virtue)
(I, 106–7). For Benjamin, the poem not only shows how 'wine opened
to the disinherited dreams of future revenge and glory' (18), but, in
the respect that the ragpicker's radical separateness from modernity
allows him to salvage beautiful things from its detritus, its also per-
sonifies the isolated, philosophically detached poet who culls 'fleurs'
(flowers) from 'mal' (evil) while drunk on his creative imagination
(79–80). This character is therefore the pastoral *alter ego* of the
sophisticated, urbane poet, or the philosopher-*flâneur* in his poetic
(as opposed to artistic) guise.

 The same poem explores the philosopher-*flâneur*'s character in
rehearsing his desire to escape from the phenomenal world of the
pure *flâneur* to an intoxicating realm divorced from the flow of Time.
This theme is rehearsed again in the prose poem 'Enivrez-vous', where
the poet exhorts his readers: ' "Pour n'être pas les esclaves martyrisés
du Temps, enivrez-vous ... ! De vin, de poésie ou de vertu, à votre
guise" ' ('So as not to be the martyred slaves of Time, intoxicate
yourself ... ! With wine, poetry or virtue, as you will') (I, 337).
Much the same ideas are rehearsed once more in 'La Chambre double',

where the experience of modern life is (temporarily) replaced by a 'rêverie' from which 'le temps a disparu' (time has disappeared) and where instead, 'l'Eternité ... règne, une éternité de délices!' (Eternity ... reigns, an eternity of delights!) (I, 280–2). The experience described in these poems is closely akin to the phenomenon of *correspondance*, or the experience of being transported to a 'timeless' past resonant with synaesthetic sensations. And in 'La Chambre double', the poet is 'entouré de mystère, de silence, de paix et de parfums' (swathed in mystery, silence, peace and fragrance),[30] rather as he is in 'Correspondances' (I, 11–12). Similar ideas inform the 'Salon de 1846' and 'Salon de 1859', where Baudelaire argues that the artist is endowed with the God-like power of creating his own world, if only he uses the imagination to intuit *correspondances*, and memory to simplify and crystallise these intuitions (II, 454–5 and 619–28). Although 'Le Peintre de la vie moderne' may seem remote from this aesthetic, it nonetheless lies behind Baudelaire's dualistic definition of beauty, or his statement that 'Le beau est fait ... d'un élément relatif, circon-stantiel' (Beauty is made up of ... a relative, contingent element) *and* 'd'un élément éternel, invariable' (an eternal, invariable element) (II, 685). That is, Baudelaire inscribes the painter of modern life (*qua* philosopher-*flâneur*) firmly within an aesthetic of timelessness and *correspondance*. It therefore makes sense that he describes him as the 'peintre des choses éternelles' (painter of things eternal), a 'poète' (poet) and 'le peintre de la circonstance et de tout ce qu'elle suggère d'éternel' (the painter of circumstances and everything of the eternal that they suggest) (II, 686), and that he remarks upon his ability to 'tirer l'éternel du transitoire' (extract the eternal from the fleeting) (II, 694).

It also makes sense that Baudelaire describes how his ideal artist 'dessine de mémoire, et non d'après le modèle' (draws from memory, and not after the model) (II, 698), and how as a result of this, 'les choses renaissent sur le papier ... singulières et douées d'une vie enthousiaste' (things are reborn on paper ... remarkable and endowed with an exhilarating liveliness) (II, 693–4). Here, evidently, Baudelaire suggests that the painter's memory arranges his sensations in a resonant form, as does *correspondance*. And, if *correspondance* is taken as a metaphor for an ontogenetically early condition, it also ex-plains why Baudelaire insists that the painter of modern life can access a primitive, yet resonant kind of experience through a mnemonic activity in which 'Tous les matériaux dont la mémoire s'est encombrée se classent, se rangent, s'harmonisent et subissent cette idéalisation forcée qui est le résulat d'une perception *enfantine*' (All the materials encumbering the memory become classified, arranged, harmonised

and undergo the forcible idealisation that is the effect of *childlike* perception; original emphasis) (II, 694).[31] The same aesthetic of *correspondance* also explains why the painter of modern life works in a summary fashion, 'avec une exagération utile pour la mémoire humaine' (with an exaggeration useful to the human imagination), because then, 'l'imagination . . . du spectateur' (the spectator's imagination) is able to transform these 'dessins informes' (amorphous drawings) into 'choses parfaites' (perfect articles) (II, 697). As Baudelaire explains, 'Le spectateur est ici le traducteur d'une traduction toujours claire et enivrante' (The spectator here is the translator of an always clear and intoxicating translation) of mundane modernity (II, 698).

In Benjamin's analysis, the allusion of *correspondance* to the (synaesthetic) experience of infancy is also a way of expressing how memory can recover sensuous experience in its plenitude, or recuperate the sensations accompanying sight that become unconscious when (predominantly) sight is used to deflect the shocks of city experience (18 and 151). More importantly for Benjamin, the idea that *correspondance* recuperates a lost, or timeless, experience is a metaphorical way of expressing the hope that memory might give access to *Erfahrung*.[32] 'Correspondances' certainly confirms this reading, in that the world the poet seeks to reach beyond is a babel of 'confuses paroles' (muddled utterances), and the world he seeks to reach is a sensuous, pre-linguistic paradise which figures a pre-lapsarian human existence in which all things did have resonance.[33] However, Benjamin insists upon the point that the timeless experience evoked by *correspondances* is beyond the experience possible in modern life, or is 'irrevocably lost' (139). Hence, while Benjamin suggests that in 'La Vie antérieure', 'The murmur of the past may be heard in the *correspondances*' (141), its opening phrase – 'J'ai longtemps habité . . .' (My home was for a long time . . .) – makes it clear that this past is already irrecoverable (I, 17). *Correspondance* thus only seems to revive *Erfahrung*, as this can only exist under modernity in memory, or as nostalgia. Baudelaire seems to figure this idea in 'La Vie antérieure', where the only task of the poet's slaves was to 'approfondir / Le secret douloureux qui [le] faisait languir' (fathom / the saddening secret that made him pine). Just as poignantly, in 'La Chambre double', *Erfahrung* is anything but eternal, since the poet's *rêverie* is shattered by the realisation: 'Le Temps est reparu; le temps règne en souverain maintenant' (Time has reappeared and now reigns tyrannical). More importantly perhaps, *correspondances* are ineluctably personal because the collective experience that might have made them public no longer exists. The poet's own, idiosyncratic couplings of colours, sounds and smells are therefore an index of his isolation, or

of the fact that the private and the public domains are irrevocably sundered.[34]

In the same vein, Baudelaire claims that the painter of modern life can render modernity 'en images plus vivantes que la vie elle-même, toujours instable et fugitive' (in images more alive than life itself – always labile and fleeting) (II, 692); but he is finally fatalistic about the painter's powers to recover *Erfahrung*, since the artist's feverish execution is driven by two contradictory urges: 'une ... mémoire résurrectionniste, évocatrice ... qui dit à chaque chose: "Lazare, lève-toi!"' (a ... resurrectionist, evocative memory ... that says to everything: 'Lazarus, arise!'), and 'un feu, une ivresse de crayon, de pinceau, ressemblant presque à une fureur' (a passion, an intoxication of the pencil or brush, amounting almost to a frenzy) (II, 699). This second force issues from 'la peur de n'aller pas assez vite, de laisser échapper le fantôme avant que la synthèse n'en soit extraite et saisie' (the fear of not acting quickly enough, of letting the phantom escape before its synthesis can be extracted and seized), and Baudelaire's implication can only be that the painter of modern life is fighting a losing battle when trying to rescue *Erfahrung*.

Put crudely, what the poet and artist seek, but fail to attain, is a kind of belonging – both an existential and social sense of having a place and a meaning in the world. It is therefore appropriate that Baudelaire uses erotic imagery to express this yearning for fulfilment, but always despairingly. For instance, in the second version of 'Le Chat' (I, 50–1), the poet caresses the animal's fur from which there arises 'un parfum si doux' (such a sweet fragrance) that he becomes 'embaumé' (steeped in its balm). And in 'La Chevelure' (I, 26–8), the poet, exhilarated by the 'parfum' of his mistress, declares his desire to plunge his head, 'amoureuse d'ivresse / Dans ce noir océan où l'autre est enfermé' (in love with intoxication / Into this black ocean that conceals the other), in the hope of finding 'Infinis bercements du loisir embaumé!' (the infinite lullaby of balmy leisure). However, the rub is that the loved object and the intoxicating experience it promises are absent in so far as they are present only metaphorically or metonymically, just as their presence in memory places them firmly in the past. In 'La Chevelure', Baudelaire thus describes the delight he evokes as merely 'Tout un monde lointain, absent, presque défunt' (A whole world, far away, absent, almost passed away). He evokes the elusiveness of the past just as tellingly in the prose poem 'Le Crépuscule du soir' (I, 311–12), which assimilates the glow of the streetlights and the stars through the dark sky both to the way that, 'sous le noir présent transperce le délicieux passé' (from beneath the darkness of the present, the delicious past shows through), and also

to the way that, in the dancer's costume, 'une gaze transparente et sombre laisse entrevoir les splendeurs amorties d'une jupe éclatante' (a dark, transparent gauze discloses the deadened splendour of a dazzling skirt). Unravelled, this metaphorical thread suggests that the erotic delight that the gauze and skirt hint at (metonymically) is just as elusive as the promise of belonging that the past holds out in showing through into the present: the one, like the other, is only the 'feux de la fantaisie qui ne s'allument bien que sous le deuil profond de la nuit' (the will-o'-the-wisp of fantasy, which only kindles in the deep mourning of the night) (I, 311–12).

In corollary, Baudelaire makes extensive use of the imagery of mourning, and erotic frustration, to characterise *Erlebnis*, and its lack of fulfilment. As Benjamin points out, he couples the image of modernity, mourning and frustrated erotic wishes in 'A une passante', in which the poet catches sight of a beautiful woman 'en grand deuil' (in heavy mourning) only to see her disappear into the darkness of the street (I, 92–3)[35] – an experience which causes the poet to muse his love might be consummated in 'éternité'.[36] By analogy, as Prendergast points out, the ambition of the *flâneur* in 'Le Peintre de la vie moderne' to *'épouser la foule'* (espouse the crowd; original emphasis) (II, 691) and thereby discover 'jouissances' (ecstasy) is exciting, but doomed.[37] By the same reasoning, the 'habit noir' (black dress) of the bourgeoisie described in 'L'Héroïsme de la vie moderne' has the same 'beauté poétique' (poetical beauty) as the widow's mourning: it symbolises the loss, under modernity, of vitality, or, as Baudelaire stated in the 'Salon de 1846', it signifies how 'Nous célébrons tous quelque enterrement' (We are all celebrating some funeral or other) (II, 494). Rather as Benjamin suggests (77), the image of mourning thus allegorises how the *Erfahrung* of eternity and the *Erlebnis* of modernity are both experienced only in 'désolation' (grief) (II, 494).

Benjamin assumes that the 'M.G.' whom Baudelaire mentions in 'Le Peintre de la vie moderne' is Constantin Guys, the 'anonyme' (anonymous person) (II, 688) who works 'toujours sans signature' (always without a signature) (II, 689); but the identity of the painter of modern life is far from straightforward. Plainly there are several artists more competent than Guys who satisfy Baudelaire's criteria for the painter of modern life better. However, one reason Baudelaire selected Guys as his paradigm artist was that the very lack of definition in the sort of 'ébauche' (preliminary sketch) he produced provided the poet with the pretext for imaginatively recreating it into an 'ébauche parfaite'

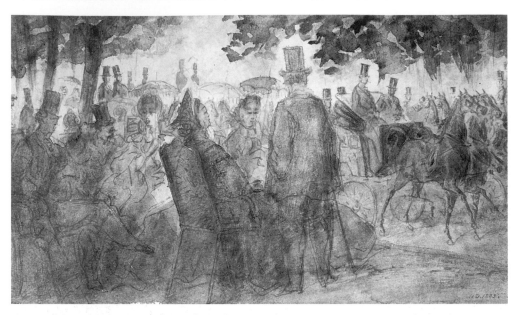

12] Constantin Guys *Avenue des Champs-Elysées*

(II, 698) [12]. Elsewhere Baudelaire picks out the unfinished quality of Jongkind's etchings – which he calls 'gribouillages' (scribblings) II, 736 and 740) – and their consequent ability to support projection, as criteria of their quality. Once it is realised that Baudelaire's evaluations of artists involve considerable projection, or appropriation, it is difficult to resist the temptation to see the painter of modern life as an amalgam of his own preoccupations. And by way of confirmation, it is significant that Baudelaire attributes the 'aristocratie' (aristocracy) he admires in his hero to Méryon as well (II, 667 and 735).

Baudelaire also compares Méryon to Guys (whom the Realist critics Champfleury and Duranty despised) in a letter of 8 January 1860 to Poulet-Malassis, where he argues: 'les *réalistes* ne sont pas des *observateurs* . . . Il [*sic*] n'ont pas la patience philosophique nécessaire' (the *Realists* are not observant . . . They do not have the necessary philosophical resignation; original emphasis). Pursuing the same line of thought, he follows this remark by describing the prospect of writing verses to accompany Méryon's etchings as 'une occasion d'écrire des . . . rêveries philosophiques d'un flâneur parisien' (an opportunity to write some philosophical reveries of a Parisian *flâneur*). Perhaps Baudelaire thought this because of Méryon's ability to make the absent past show through the present in his etchings of *le vieux Paris* under reconstruction: the buildings in these, he writes, exhibit 'la pensée de tous les drames qui y sont contenus' (the feeling of all the dramatic events contained within them), and are such that 'aucun

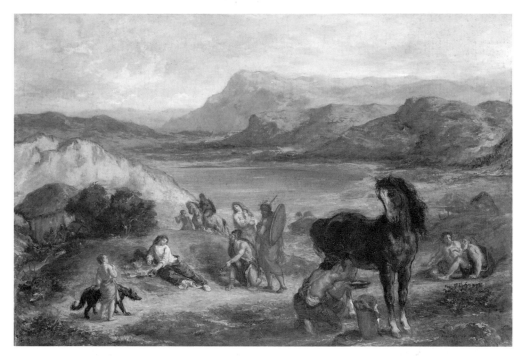

13] Eugène Delacroix *Ovide en exil chez les Scythes*

des éléments complexes dont se compose le douloureux et glorieux décor de la civilisation n'était oublié' (none of the complex element composing the painful and glorious scenery of civilisation is forgotten). In effect, therefore, Méryon qualifies as a philosopher-*flâneur*, because his insistent commemoration of the lost past behind modernity constitutes a critique of spectacular, a-historical, *Erlebnis* equivalent to the poet's own.

By contrast, it seems, Baudelaire often cites Delacroix as an artist who successfully recuperates *Erfahrung*, claiming he is a painter of 'philosophique' tendencies (II, 611), whose work exemplifies how 'imagination' and 'mémoire' (II, 433–4 and 631–2) produce resonant and synaesthetic paintings (II, 596) that conjure 'souvenirs' (memories) of a lost Elysian past (II, 438), or a glimpse of 'l'âme dans ses heures belles' (the soul in its happiest hour) (II, 637). However, Baudelaire also holds to a more sceptical view. For instance, when in the 'Salon de 1859' he reiterates his contention from the 'Salon de 1846' that Delacroix is the 'moderne' artist *par excellence* (II, 427 and 634), he singles out Delacroix's 'mélancolie' (melancholy) as the feature that merits this epithet. Baudelaire's meaning is made clearer in the ensuing discussion of *Ovide en exil chez les Scythes* [13], where he speaks of 'la volupté si triste qui s'exhale de ce verdoyant *exil*' (the

crushingly sad sensuality given out by this blooming *exile*; original emphasis) – suggesting that what attracts him to Delacroix's painting is its poignant sense of the overwhelming isolation of the sophistic-ated, urban poet among the barbarians, for all that they offer him the primitive pleasures of a golden age (mare's milk and wild fruit). Read allegorically, Baudelaire's reaction to this work spells out his own sense of the impossibility of recuperating experience as *Erfahrung*; it thus marks his mature acceptance of the disingenuousness of any aspiration to return to a state of (phylogenetic) childishness.

Arguably, Manet is the artist who most fully exemplifies Baudelaire's belief that the painter of modern life should maintain a critical attitude towards both modernity and eternity. Many of Manet's works (the *Déjeuner sur l'herbe* and *Olympia*, for example) imitate the alienating strategy of the *Petits poèmes en prose* through inviting the spectator to assume the physical and psychological stand-point of the *flâneur* implicitly present in and surveying the scene represented in the picture, only to make any identification with this viewpoint morally unbearable, and impossible to proceed with.[38] In contrast, dispossessed, ragpicker-philosophers in other works (such as *Le Philosophe*) express how intoxication and inwardness provide an alternative experience to the detective-work of modern life.[39] But other paintings (notably the *café-concert* pictures and the *Bar aux Folies-Bergères*) characterise this state as ineluctably private, and finally only a temporary retreat from the unbearably empty public life of spectacle.[40] In much the same vein, Manet represents Lola de Valence as the 'bijou rose et noir' (rose and black jewel) of Baudelaire's quatrain, who thus promises *Erfahrung* in the fashion of the dancer in 'Le Crépuscule du soir' (I, 168); but, as with the poem, Lola's promise is not redeemable; it is only a *show* – which is perhaps why Manet reworked the painting to include the backstage sets and the audience awaiting the spectacle of Lola's performance [14].[41] Manet also ex-presses fatalism in his representations of Berthe Morisot in mourn-ing, where any possibility that she may fulfil desire is ruled out, or at least deferred until eternity, by the fact that her state of loss makes her unattainable.[42]

Baudelaire himself is evidently a contender for the title of 'Peintre de la vie moderne'. That he thought of literature as capable of *depicting* modernity (and its *Erlebnis*) is evidenced by his addition of the section entitled 'Tableaux parisiens' to *Les Fleurs du mal* (I, 82–104), and by his description in 'Le Peintre de la vie moderne' of Poe's 'The man of the Crowd' as a 'tableau' (picture) (II, 689). Baudelaire also mentioned, in the preface to the *Petits poèmes en prose*, that it was his

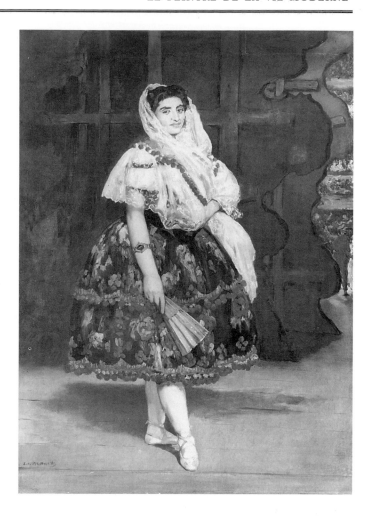

14] Edouard Manet
Lola de Valence

ambition to imitate the *passéiste* style of Aloysius Bertrand in *Gaspard de la nuit* (subtitled *Fantaisies à la manière de Rembrandt et Callot*) and apply 'à la description de la vie moderne . . . le procédé qu'il avait appliqué à la peinture de la vie ancienne, si étrangement pittoresque' (to the description of modern life . . . the procedure he had applied to depiction of ancient times, so strangely picturesque) (II, 275). It would seem that the poet's aim was to use a style that evoked a past for modernity only in the fantasy of an ur-past, and thus depicted the radical sundering of modernity from its real, historical past. In a similar fashion, in 'Le Peintre de la vie moderne', the ur-past of eternity (or *correspondance*) and modernity are treated alike with enthusiasm and despair – a strategy that serves in its recalcitrant refusal of closure to expose the impossibility of fantasy enriching life with historicity.

Notes

I am indebted to Michael Podro and Richard Shiff for kindly looking over an earlier draft of this chapter, and to the Humanities Research Board of the British Academy and Bristol University for generously funding the research time during which it was completed.

1 Cited in S. Buck-Morss, *The Dialectics of Seeing: Walter Benjamin and the Arcades Project* (Cambridge, Mass., and London, MIT Press, 1989), p. 114.

2 C. Baudelaire, *Œuvres complètes*, 2 vols (Paris, Gallimard, 1975–76), II, p. 493; cf. *ibid.*, 'Salon de 1845', II, p. 407. All further references are given in parentheses.

3 On *Erlebnis* and *Erfahrung*, see W. Benjamin, *Charles Baudelaire: A Lyric Poet in the Age of High Capitalism* (London, Verso, 1983 (1969)). All further references are given in parentheses. See also A. Benjamin, 'Tradition and experience: Benjamin's "On some motifs in Baudelaire"', in A. Benjamin (ed.), *The Problems of Modernity: Adorno and Benjamin* (London and New York, Routledge, 1989), pp. 122–40, and R. Shiff, 'Handling shocks: on the representation of experience in Walter Benjamin's analogies', *Oxford Art Journal*, XV: 2 (1992) 88–103, esp. note 30.

4 See H. R. Jauss, 'Reflections on the chapter "Modernity" in Benjamin's Baudelaire fragments (1979)', in G. Smith (ed.), *On Walter Benjamin: Critical Essays and Recollections* (Cambridge, Mass., and London, MIT Press, 1988), pp. 180–1.

5 See C. Prendergast, *Paris and the Nineteenth Century* (Cambridge, Mass., and Oxford, Blackwell, 1992), esp. pp. 139, 144–52 and 163.

6 Cf. *ibid.*, pp. 26–27, 128–32 and 198–200.

7 See Buck-Morss, *The Dialectics of Seeing*, p. 71.

8 On 'jouissance(s)' and the crowd, see pp. 84 and 89.

9 Auguste de Lacroix, 'Le Flâneur', *Les Français peints par eux-mêmes* (Paris, Curmer, 1841), III, pp. 65–72; Louis Huart, 'Le Flâneur', *Les Physiologies parisiennes*, 1st series (Paris, Bibliothèque pour rire, n.d. (1842?)), pp. 1–16; Victor Fournel, *Ce qu'on voit dans les rues de Paris* (Paris, Dentu, 1858). All further references to these works are given in parentheses. On Huart's and Fournel's *flâneur*, see Prendergast, *Paris*, pp. 133–6.

10 Cf. R. L. Herbert, *Impressionism: Art, Leisure and Parisian Society* (New Haven and London, Yale University Press, 1988), pp. 33–7.

11 The *flâneur* is also treated as a 'novelist' in Huart, 'Le Flâneur', p. 8, and Lacroix, 'Le Flâneur', p. 68.

12 Cf. W. Benjamin, *Charles Baudelaire*, p. 69, which makes the distinction between the *flâneur* and the *badaud*, following Fournel, *Ce qu'on voit*, p. 263. See Prendergast, *Paris*, pp. 5, 9–10, 134–5 and 189–97.

13 Benjamin approved of Lukac's description of the novel as 'the form of transcendental homelessness'. See A. Benjamin, 'Tradition and experience', p. 125.

14 See Buck-Morss, *The Dialectics of Seeing*, pp. 32–4.

15 Cf. Prendergast, *Paris*, pp. 189–93. Baudelaire treats 'mechanical time' in e.g. 'Les Dons des fées' (I, 305–7), 'Portraits de matresses' (I, 345–9), 'Le Galant Tireur' (I, 349–50) and 'L'Horloge' in *Les Fleurs du mal* (I, 81).

16 Cf. Prendergast, *Paris*, pp. 38 and 143–9. For Baudelaire's treatment of wealth as spectacle, see 'La Fausse Monnaie' (I, 323–4). On the official spectacle, see 'Un plaisant' (I, 279).

17 Cf. Prendergast, *Paris*, pp. 152–4.

18 Cf. W. Benjamin, *Charles Baudelaire*, p. 132; Prendergast, *Paris*, pp. 18–19 and 144–52 and Shiff, 'Handling Shocks', esp. pp. 92–6 which contains a discussion of Baudelaire's effort to render shock 'auratic'.

19 See J. Rignall, 'Benjamin's *Flâneur* and the problem of Realism', in A. Benjamin, 'Tradition and experience', pp. 112–21, esp. 116–17.

20 Benjamin identifies the 'man of the crowd' with the old man; Adorno with the narrator. For their dispute over this, see Rignall, *ibid.*, pp. 118–19; cf. W. Benjamin, *Charles Baudelaire*, p. 48.

21 See *Nouvelles histoires extraordinaires par Edgar Poë* (Paris, Calman-Lévy, 1933), p. 67, and Rignall, 'Benjamin's *Flâneur*', p. 119.

22 Cf. W. Benjamin, *Charles Baudelaire*, p. 40, on how the first of these comments qualifies Baudelaire's *flâneur* as a detective.

23 On the anonymity of the *flâneur*, cf. Lacroix, 'Le Flâneur', pp. 66–7: 'Il s'habille, du reste, comme tout le monde et marche comme vous et moi'. In effect, he is kind of 'purloined letter' in that his resemblance to everyone around him makes him invisible. See also R. Burton, 'The unseen seer, or Proteus in the city: aspects of a nineteenth-century Parisian myth', *French Studies*, XLII (1988) 50–68.

24 See U. Eco, 'Rhetoric and ideology in Sue's *Les Mystères de Paris*', in his *The Role of the Reader: Explorations in the Semiotics of Texts* (London, Hutchinson, 1981), pp. 125–43 (esp. 139–40).

25 On 'Les Foules', see W. Benjamin, *Charles Baudelaire*, pp. 55 and 57, and Prendergast, *Paris*, pp. 139–41.

26 This also parodies the assertion in 'Les Foules', that 'Le poète jouit de cet incomparable privilège, qu'il peut à sa guise être lui-même et autrui. Comme ces âmes errantes qui cherchent un corps, il entre, quand il veut, dans le personnage de chacun' (The poet enjoys this incomparable privilege: that he can be himself or someone else as he pleases). Cf. Lacroix, 'Le Flâneur', p. 67: 'C'est un homme que l'amour de la science peut pousser jusqu'à la cruauté, et qui prendra quelquefois, pour sujet de ses expériences, le cœur même de son ami intime' (He is a man whom the love of knowledge can drive almost to cruelty, and who will sometimes take for the subject of his experience the very soul of his closest friend). See also Rignall, 'Benjamin's *Flâneur*', pp. 114–16, on the device in Balzac's 'Facino Cane'.

27 Cf. 'Chacun sa chimère', where the narrator can see the chimeras that, unknown to their victims, inflict upon them 'un invincible besoin de marcher', but who, nonetheless, cannot see the cause of his own 'irrésistible Indifférence' to their condition, or its meaning (I, 282–3).

28 See 'Les Veuves' (I, 292–4), 'Le Thyrse' (I, 335–6), 'Les Bons Chiens' (I, 360–3) and 'Assommons les pauvres' (I, 357–9).

29 On the ragpicker-philosopher figure, see L.-A. Berthaud, 'Les Chiffonniers', *Les Français peints par eux-mêmes* (Paris, Curmer, 1841), III, pp. 333–44, esp. 344–8; A. Delvau, *Histoire anecdotique des cafés et cabarets de Paris* (Paris, Dentu, 1862), pp. 63 and 174–7; A. Delvau, *Les Heures parisiennes* (Paris, Librairie centrale, 1866), pp. 7–8; Fournel, *Ce qu'on voit*, p. 327; A. C. Hanson, 'Popular imagery and the work of Edouard Manet', in U. Finke (ed.), *French Nineteenth-Century Painting and Literature* (Manchester, Manchester University Press, 1972); A. C. Hanson, *Manet and the Modern Tradition* (New Haven and Loudon, Yale University Press, 1977), pp. 64–5 and K. Adler, *Manet* (London, Phaidon, 1986), pp. 81–3.

30 See F. W. Leakey, *Baudelaire and Nature* (Manchester, Manchester University Press, 1969), pp. 173–9 and 195–217.

31 Cf. Lacroix, 'Le Flâneur', p. 68: 'Laissez venir pour lui l'âge des souvenirs et de la méditation … où tout se classe et s'ordonne dans le cerveau de l'homme à la faveur du calme profond de l'imagination et des sens' (Let him reach the age of memories and meditation … when everything is categorised and ordered in the mind of man by virtue of the profound calm of the imagination and senses). Baudelaire also likens the painter of modern life to an 'enfant' (II, 688) and declares that genius is 'l'*enfance retrouvée* à volonté' (*childhood recuperated* at will) (II, 690). On Benjamin's ideas about childhood, see Shiff, 'Handling shocks', pp. 88–9.

32 See W. Benjamin, *Charles Baudelaire*, pp. 112–13 and 139–40, and A. Benjamin, 'Tradition and experience', pp. 124–6 and 133–4.

33 Cf. the prose poem 'Déjà!' (I, 337–8).

34 Cf. Prendergast, *Paris*, pp. 130 and 61–6.

35 W. Benjamin, *Charles Baudelaire*, pp. 124–5 and 44–6. Cf. 'L'Horloge' in the *Petits poèmes en prose*, where the poet says, when he looks in the eyes of his beloved cat, 'Oui, je vois l'heure; il est l'éternité!' (I, 209).

36 Cf. Prendergast, *Paris*, pp. 36–8 on 'Les Yeux des pauvres' (I, 317–19) and 138–42.

37 See Prendergast, *Paris*, pp. 139–42.

38 D. Rouart and D. Wildenstein, *Edouard Manet: catalogue raisonné* (Geneva, Bibliothèque des Arts, 1975), nos. 67 and 69, and J. C. Harris, *Edouard Manet: Graphic Works, a Definitive Catalogue Raisonné* (New York, Collectors Editions, 1970), no. 53. Cf. also Rouart and Wildenstein, *Edouard Manet*, nos. 50, 51 and 207.

39 *Ibid.*, nos. 19, 99, 100 and 137; Harris, *Edouard Manet*, nos. 16 and 47. On how Manet saw all four works 'philosophes', see Rouart and Wildenstein, *Edouard Manet*, no. 17.

40 *Ibid.*, nos. 280, 311, 313 and 388. Cf. *ibid.*, no. 134.

41 *Ibid.*, no. 53; cf. Harris, *Edouard Manet*, no. 33. On *Lola*'s reworking, see A. Tabarant, *Manet et ses œuvres* (Paris, Gallimard, 1947), p. 81.

42 Rouart and Wildenstein, *Edouard Manet*, nos. 228 and 181 (?); Harris, *Edouard Manet*, no. 74 (?). On the complexity of Manet's relationship with Morisot, see H. Perruchot, *La Vie de Manet* (Paris, Hachette, 1959), p. 200.

INNOVATING FORMS

5 Matter for reflexion: nineteenth-century French art critics' quest for modernity in sculpture

THE tension between academicism and modernity in nineteenth-century French painting, especially as it was viewed by contemporary art criticism, has been widely discussed. Much less has been said about critics' reaction to sculpture in the same period. This may be because writers on the arts were more reticent and ambivalent about sculpture and because sculptors themselves found it more difficult to free themselves – and those who viewed or commissioned sculpture – from the weight of the classical and neo-classical tradition. The writers' ambivalence is partly a function of a tension they felt between two mutually exclusive attitudes to sculpture, especially in the first half of the century. On the one hand, a rejection of what was perceived to be a primitive art; on the other, a celebration of it as a form that represented the apotheosis of the ideal as it had been best achieved in the Western artistic tradition.[1] A sense, however, that sculpture should have a contemporary vocation becomes clear in critical writing around the mid-century. Its expression is complicated by the fact that it is mostly formulated by literary writers whose personal or creative agendas, as much as their aesthetic or technical judgement, tended to colour their response.[2] Nevertheless, steering a course between primitivism and academicism, a rudimentary aesthetic of the modern in nineteenth-century French sculpture emerges. The aim of this chapter will be to explore its development through the writings of mid-century critics such as Gautier and Baudelaire (in the context of Géricault, Clésinger and Pradier) and in those of later writers such as the Goncourts, Zola and Huysmans (in the context of Solari, Degas and Rodin). Focusing first on the myths and prejudices that coloured contemporary views of sculpture, I will then trace the growing awareness later in the century of the 'modern' potential of contemporary (and even some classical) sculpture, as the false dichotomies of earlier views gradually became resolved.

Despite the long and distinguished French tradition in the visual arts, early nineteenth-century critics in France, essentially literary in their culture, tended to view sculpture with distrust, especially if it were not mediated by some form of text. It may be that the Old Testament of the Bible, with its horror of idolatry, played a role in this. In any case, from the beginning of the century, a certain disdain of the plastic image is visible in writing on the arts, as is shown in J. F. Sobry's comment in 1810 that 'les hommes grossiers seront partout, et dans tous les temps, naturellement adorateurs d'images, et des images extraordinaires ...' (coarse men everywhere will always and as a matter of course adore images, especially extraordinary ones).[3] The most iconic of the arts, sculpture is the most able to produce the image-objects or fetishes which respond best to man's latent idolatry. This may be why Baudelaire, at the beginning of his career as an art critic, rejected sculpture as boring. 'Brutale et positive comme la nature', and 'vague et insaisissable',[4] sculpture, he declares in the *Salon de 1846*, was 'un art de Caraïbes', one mastered by primitive peoples who were able to carve fetishes long before they discovered painting.

This attitude is the opposite of that expressed by Baudelaire's immediate predecessors, aesthetic theoreticians such as Quatremère de Quincy and Victor Cousin, and poets and art critics like Théophile Gautier who admired sculpture as the summit of European art, an ideal to which artists should aspire. Their reaction to sculpture reflects the neo-classical tradition in Europe and in particular the impact of eighteenth-century German aesthetic thinking, especially as it was influenced by Johan Joachim Winckelmann (1717–1768) and by Gotthold Lessing (1729–1781). For the latter, one of the remarkable features of Greek sculpture was its ability, even when representing scenes of extreme violence or passion, to maintain a certain serenity: effort, terror, pain and even death could all be represented without ugliness. This ability to idealise the expression of the real passions of men had been much admired also by Winckelmann, and is expressed in the way he describes the statue of Apollo in the Vatican collection:

On dirait que l'artiste a composé une figure purement idéale, et qu'il n'a employé de matière que ce qu'il fallait pour exécuter et représenter son idée. ... Pour sentir tout le mérite de ce chef-d'œuvre de l'art, il faut se pénétrer des beautés intellectuelles et devenir, s'il se peut, créateur d'une nature céleste; car il n'y a rien qui soit mortel, rien qui soit sujet aux besoins de l'humanité. Ce corps, dont aucune veine n'interrompt les formes, et qui n'est agité par aucun nerf, semble animé d'un esprit céleste ...[5]

(It could be said that the artist has composed a figure that is purely ideal, that he has used matter only in so far as it was necessary for the execution

and representation of his idea. . . . To feel the full merit of this masterpiece, one must allow the mind to be invaded by intellectual beauty and become, as far as possible, creator of a celestial nature; for there is nothing mortal here, nothing subject to human needs. This body, whose surface forms are interrupted by no veins and which is infused by no nervous energy, seems animated by a celestial spirit . . .)

Winckelmann here reads the Greek statue as the expression of a spiritual idea: its form evokes not the palpitating life of human flesh but the serenity of divine power, although when he tells us that sculpture makes sense only when envisaged from an intellectual stand-point, nothing he proposes justifies this view. When, however, in his book *Du Vrai, du Beau et du Bien*, published in 1836, Victor Cousin describes the same statue, the idealising tendency of Winckelmann is nuanced by an element of human interest, necessary, Cousin argues, for the viewer to identify with the work:

Ce front est bien celui d'un dieu: une paix inaltérable y habite. Plus bas, l'humanité reparaît un peu, et il faut bien, pour intéresser l'homme aux œuvres d'art. Dans ce regard satisfait, dans le gonflement des narines, dans l'élévation de la lèvre inférieure, on sent à la fois une colère mêlée de dédain, l'orgueil de la victoire et le peu de fatigue qu'elle a coûté.[6]

(This forehead is indeed that of a god: an inalterable peace resides there. Lower down, human feeling reappears a little, and necessarily so, if man's inter-est is to be engaged in works of art. In this satisfied look, in the swelling of the nostrils, in the curling of the lower lip, are felt at the same time anger mixed with disdain, pride in victory and the slight fatigue that victory cost.)

For Théophile Gautier (1811–1872), poet and art critic, sculpture (that is, antique, neo-classical or academic sculpture) was both the ideal to which each art aspired and, at the same time, the most per-fect expression of the physical and sensual qualities of the human body; it was both spiritual or intellectual and physical or material. In particular Gautier envied the sculptor's freedom in relation to the representation of the human body – especially that of the woman, as he shows in his story *Le Roi Candaule*:

– Si nous étions un grec du temps de Périclès, nous pourrions vanter tout à notre aise ces belles lignes serpentines, ces courbures élégantes, ces flancs polis, ces seins à servir de moule à la coupe d'Hébé; mais la pruderie moderne ne nous permet pas de pareilles descriptions, car on ne pardonnerait pas à la plume ce qu'on permet au ciseau, et d'ailleurs il est des choses qui ne peuvent s'écrire qu'en marbre.[7]

(– If I were a Greek of Pericles's time, I could extol at leisure these beautiful sinuous lines, these elegant curves, these polished thighs, these breasts formed to serve as moulds for Hebe's cup; but modern prudery does not permit

such descriptions, since what is allowed to the chisel is forbidden to the pen, and, moreover, there are things which can only be written in marble.)

He was therefore delighted when, in 1848, four years after his story, the sculptor James Pradier (1792–1852) created a marble statue of Nyssia [15].[8] Gautier's attitudes are so rooted in idealism that he will in his writings always judge the beauty of women according to the criteria of antique or neo-classical art. Gautier's evocation of the woman in terms of sculpture is, however, not only an academic convention but also the expression of a deep fantasy. For although to the poet of *Emaux et camées*, the ideal of physical beauty was established once and for all in Antiquity, it nonetheless presented a creative challenge – as much to the imaginative writer as to the artist.

For sculpture constituted *matter for reflexion* in which was to be found the source of a number of the myths and desires, conscious or unconscious, that pervaded mid-century aesthetic writing, especially that by the poets. The use of the word marble as a synecdoche for sculpture or for a statue is symptomatic in this respect. Sculpture in wood was scarcely perceived as existing at this time, or was dismissed as a primitive art, an 'art de Caraïbes'. (Its reappearance, or a serious critical reconsideration of it would, as I shall show later, have profound bearing on the emergence of a 'modern' approach to sculpture.) When in *Emaux et camées*, Gautier uses the phrase 'marbre de Paros' as a subtitle to his 'Poëme de la femme', it is as a synecdoche for *Statue en marbre de Paros*. For Gautier and other poets of his time, marble is white – or sometimes pink – so that it can signify human flesh, especially female flesh. The fact that even Greek sculpture was often polychrome was ignored or repressed by poets and critics who wanted to maintain the suggestiveness of the marble/flesh metaphor.

Synecdoche, as a part of metaphor, proposes a quality of an object rather than the object itself, enabling the poet to bring out the particular suggestive quality of the object, often in a way that lends itself to further metaphorical development. This is why the synecdoche *marbre* appears so often in Parnassian poetry, especially Gautier's. In his 'Symphonie en blanc majeur', for example, the combination *marbre/blanc/chair* lends itself to a rich network of metaphorical connections, in which the adjective white is used both literally and figuratively:

> Le marbre blanc, chair froide et pâle,
> Où vivent des divinités ...
> Sphinx ... qui, sous sa poitrine blanche,
> Cache de *blancs* secrets gelés?
>
> (my italics)

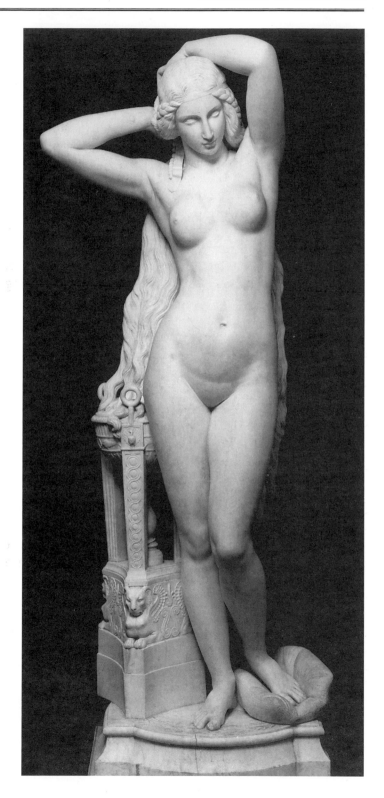

15] James Pradier
Nyssia, 1848

(White marble, cold and pallid flesh
Where divinities reside . . .
Sphinx . . . who, 'neath its white torso,
Hides *white* secrets frozen?)

In the same way, a phenomenon of the natural world is transformed into aesthetic dynamism:

Un sphinx blanc que *l'hiver sculpta.*
(my italics)

(A white Sphinx *carved by Winter.*)

The metaphorical elaboration, highly developed in 'Symphonie en blanc majeur', of the woman/sculpture link, is symptomatic of a more general phenomenon associated with the marble/flesh combination: the Pygmalion myth. The meaning of this myth to eighteenth-century neo-classical and nineteenth-century academic art is clear: the sculptor tries, consciously or unconsciously, to reproduce in the *matière dure* of marble the vitality and the life of the human body; his aim in sculpting is to produce not only a fine work but also to realise the object of his desires. For contemporary writers on the arts, the Pygmalion myth had a similar meaning: it was their vocation to breathe life through their poetry into the perfect but mute images created by the sculptor.

This myth or this ambition – to make the statue speak – also became a leitmotiv of Parnassian literature. Gautier pursues it through his short stories (*Le Roi Candaule*) and art criticism (*Salon de 1847*) as well as his poetry (*Emaux et camées*); and Baudelaire in both his verse and his prose poetry. In her study *Rêve de pierre: la quête de la femme chez Gautier*,[9] which borrows its title from a Baudelairian sonnet, Natalie David-Weill deconstructs the male fantasy of seduction by the women of stone by indicating the profound Freudian reverberations associated with it. Desire, according to David-Weill, is 'ontologiquement castrateur' and the male preoccupation with statues of women expresses an anxiety in relation to male desire. The contemplation of a stone or marble statue of a woman allows the poet to satisfy his physical desires by transforming or sublimating them into aesthetic pleasure. He can therefore experience pleasure without risking the castration threatened by the forbidden sex of his mother or the beauty of the live woman. The marble woman, being an object, can be possessed by the poet, enjoyed at leisure: she/it threatens him with neither a physical presence nor an individual personality. The poet is thus free to follow his desire which, like the love evoked in Baudelaire's sonnet, is 'Eternel et muet ainsi que la matière' (Like matter, eternal and mute).

The Pygmalion myth is of course only one of many among the male fantasies provoked by sculpture. The rich potential the marble image offers for fantasy projection and erotic reverie has been analysed in depth in the context of nineteenth-century French academic art by Michel Thévoz in *L'Académisme et ses fantasmes*,[10] and is illustrated by a sculpture [**16**] which caused a sensation in 1847 – *Femme piquée par un serpent* by Auguste Clésinger (1814–1883). The model for this woman reclining in a pose of flagrant abandon was Madame Sabatier whose famous salon welcomed some of the most talented Parnassian poets and academic artists of the time, including Baudelaire, with whom she had a brief affair. The serpent which bites the woman's wrist had been added by the sculptor only after the completion of the work – to disarm critics who would otherwise have been outraged by the provocative pose. Poets, nevertheless, continued to reflect on the meaning of this sculpture before the serpent was added, as Gautier shows in the following remark: 'Qu'exprimait-elle avant l'addition du serpent? Eh bien, elle avait reçu en pleine poitrine une des flèches d'or du carquois d'Eros, le jeune dieu que craignent les immortels eux-mêmes, et elle se tordait sous l'invisible blessure' (What did she express before the snake was added? Well, her breast was struck by a golden arrow from the quiver of Cupid, the young god feared even by the Immortals, and she was writhing under the invisible wound).[11] Gautier, who had said that there were 'des choses qui ne peuvent s'écrire qu'en marbre', swathes his explanation of the woman's flagrant pose in paraphrase, euphemism or circumlocution, so as not to have to confront too frankly the sculpture's sexual implications, and later supressed the stanza devoted to the *Femme piquée par un serpent* which was to have been part of 'Le Poëme de la femme':

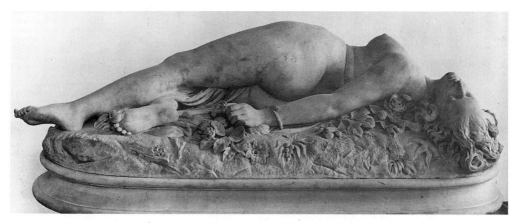

16] Auguste Clésinger *Femme piquée par un serpent*, 1847

Elle rend, par l'aspic mordue
Le spasme qu'on ne peut singer
Voluptueusement tordue
Comme un marbre de Clésinger.

(Bitten by the snake, she effects
The spasm impossible to fake
Twisting voluptuously
Like a Clésinger marble.)

The mystique of marble becomes so intense for Gautier that he uses it not only as a metaphor for female flesh and a symbol of beauty but also as a synonym for poetic language. So, in his famous poem 'L'Art', verse shares with marble, onyx and enamel, the essential qualities of beauty and hardness. This analogy invites us to read all further references to sculpture in the poem as being also applicable to poetry. So, like the sculptor evoked in stanza four, the poet must struggle with carrara and paros, marbles celebrated for their hardness and purity (terms whose synonymity is confirmed by the rhymes *pur/dur*). Robust art endures, the poet declares, but even a metal as hard as bronze will not survive poetry:

Mais les vers souverains
　　Demeurent
Plus forts que les airains.

(Sovereign verses
　　Remain
Stronger than bronzes.)

This final hyperbole that Gautier's rhetoric persuades us to accept, at least during the reading of the poem, is in fact based on a misconception. For, if (fragile) verse will survive ultra-hard marble or bronze, what is the point of establishing the analogy between these different terms, an analogy that is the very stuff of the poem? If verse will survive, it will do so because it is memorisable: it will depend not on matter but on spirit. It is through the ear or through the eye that it will survive eternally. This *aporia* encourages us to re-examine the marble/verse analogy and leads us to perceive that it also is false. Marble is a raw material, brute matter; verse is an instrument, a phenomenon already refined and created, furthermore susceptible itself to create further objects: beautiful ideas, poetry. Nor is language in the least like marble, being itself also an instrument, already created and refined by centuries of toil.

This misconception does not spoil our pleasure in Gautier's poem, which is after all a poem, not a treaty on aesthetics or poetics. But it

does underline the fact that the marble/verse analogy was only meta-
phorical: the problem with the metaphor was that it was so persuas-
ively presented by poets such as Gautier, and to a lesser extent
Baudelaire, who were also hugely influential as art critics. It was
this persuasive presentation of the marble/verse analogy that led to
the occultation of other possible areas of analogy between poetry
and sculpture. Sculpture tended therefore, if it were not rejected as
a primitive fetish, to be associated with a literary and classical tradi-
tion, sharing common myths and conventions of representation. If
sculpture were to reinvent itself as a modern medium of artistic
expression, it would have to abandon marble and classical subject-
matter, and to distance itself from poetry.

No real 'theory' of modern sculpture emerged in the nineteenth
century. In what follows, I try to piece together, retrospectively, a
broad concept that gradually developed through the responses, direct
or indirect, to sculpture of nineteenth-century writers and artists. As
we shall see, many of the elements that progressively constitute a new
conception of sculpture developed as a reaction to the criteria against
which sculpture had hitherto been measured. Thus the potential of
the fragmentary (Géricault, Rodin, perceived even in the antique by
the Goncourt brothers) was set against the seemless unity of clas-
sical sculpture; the expressive against the serenely impassive (as, for
example, in Christophe, Degas and Rodin as appreciated respectively
by Baudelaire, Huysmans and the Goncourts); the individual and par-
ticular (as seen by the Goncourts in Carpaux and Rodin and by Zola
in Degas, Solari and other sculptors of the time) against the general
or universal; the contemporary against the timeless or eternal (as
generally noted); the (relatively) 'ugly' as opposed to the 'beautiful'
(especially in relation to woman – compare the reactions of Gautier
in relation to Pradier with Zola on Solari or Huysmans on Degas);
a flexible and tentative response to materials, including a commit-
ment to those such as wax or clay previously thought worthy only
of sketches or maquettes (Géricault, Degas, Rodin), as opposed to an
automatic choice of marble or bronze. In some cases, discoveries made
by artists who were primarily painters were translated into sculpture,
sometimes in the work of others than themselves. So Géricault's paint-
ings of severed limbs are complemented three-quarters of a century
later in Rodin's arrangements of sculpted fragments of the human
body, while Degas's mastery of pigment and sense of texture are
transferred to his polychrome and multi-media statuettes of dancers.
There was also – was this a return to the fetishism so dreaded by
neo-classical critics and theorists? – a growing acceptance from the
mid-century of the fact that sculpture need no longer, to be important,

be vast in scale: hence the return of the figurine and the statuette. Sculpture need no longer then be primarily a public art; it could be possessable and private.

 The first modern sculptor in nineteenth-century France was a painter scarcely recognised for his work in clay or stone: Théodore Géricault (1791–1824). He was the first to manifest a flexible response to conventional materials and to classical subject-matter. Although, like classical and neo-classical sculptors, he was committed to the representation of the human figure, in particular the male body in action, he submitted it to more expressive treatment. Often compared to Michelangelo, Géricault's work in fact reflects many of the qualities Baudelaire attributes to Michelangelo's seventeenth-century French successor Puget (1620–1694) whose work is evoked in 'Les Phares' in terms of 'Colères de boxeur', 'impudences de faune', and 'la beauté des goujats'. But, unlike Michelangelo and Puget, Géricault, as painter and sculptor, sought out modern subjects (often based on current political or historical events) in which he could represent the male nude. Hercules is reborn as a Negro boxer (as in the famous print *Combat de boxe*), while the Vulcan-seducing-Venus theme is reinvented as *Noir qui brutalise une femme* (a clay figurine dating from around 1818) or *Satyre attaquant une nymphe* [17], a bronze of the same period. Anticipating the move

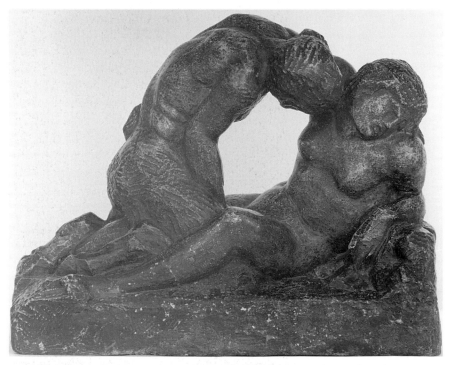

17] Théodore Géricault *Satyre attaquant une nymphe*, c. 1818

towards modern, even contemporary, subject-matter advocated by
Baudelaire, the titles of Géricault's prints and sculptures foreshadow
uncannily the images the poet evokes in the context of Puget. They
also anticipate the more expressive handling both of the subject – the
terror of the abducted woman, the fatigue of the boxer – and of mater-
ials: the rough finish of the clay in the *Noir qui brutalise une femme*.
We see here none of the Olympian calm of the Greek Apollo, nor the
smooth marble of the decorously contorted flesh of the Vatican *Laocoön*.
Géricault's use of the *black* male body is astute: it enables him to
explore heroic or strenuous masculine poses while avoiding the stereo-
types associated with those of the Greek athlete sculpted in white
marble. Blackness also renders plausible a depiction of contemporary
male nudity in public. It is then no coincidence that exactly half a
century later Zola will discover modern sculpture in the Salon of 1868
in the form of Philippe Solari's *Nègre endormi* (now lost; [18] shows
a clay figurine of another work by Solari, *Chez le barbier*).[12]

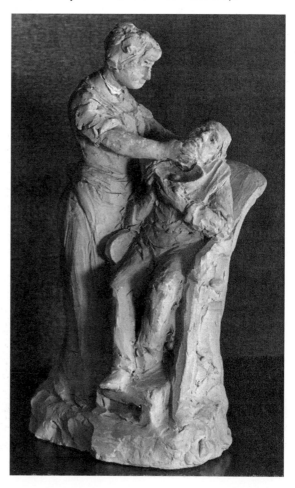

18] Philippe Solari *Chez le barbier*

Zola begins his essay on sculpture in *Mon Salon* by recapitulating some of the myths and prejudices of his century in relation to sculpture: 'Chez tous les peuples, à la même heure, des fétiches ont été taillés dans le bois ou dans la pierre. L'art est fils des rêveries religieuses et a grandi au fond des temples' (Every race, at a certain epoch, carved fetishes in wood or stone. Art is the son of religious reverie and grew up in temples).[13] He is paraphrasing Baudelaire, and, like the latter, seemingly unaware of the contradiction implicit in mixing two different primitive sculptural traditions. He then describes the Greek tradition as it was understood in the eighteenth century, and evoked so persuasively in the nineteenth by writers like Cousin and Gautier:

Le sculpteur grec est un poète, un rêveur fils de Platon, qui vit dans les gymnases, ayant toujours sous les yeux les membres parfaits des athlètes. S'il connaît la nature, il ne la copie pas, il l'idéalise, n'oubliant jamais qu'il crée des dieux et non des hommes. Une statue est pour lui un poème, un acte de foi, une tendance vers la beauté divine en passant par la beauté humaine.[14]

(The Greek sculptor is a poet, Plato's dreamy son, living in gymnasiums, with athletes' perfect limbs always before his eyes. If he knows nature, he does not copy it, remembering that he is creating gods not men. A statue is for him a poem, an act of faith, a striving towards divine beauty through human form.)

But, Zola admits that by his time, sculpture, as the Greeks understood it, is now 'une langue morte' (one notes the unconscious use of the language metaphor that had, until now, vitiated the possibility of an independent vocation for sculpture). It can be revived only if it recontextualises itself in contemporary civilisation, a culture not of Gods and heroes, but of individuals going about their business in the modern world or suffering from the stresses and tensions it imposes on them. Philippe Solari's *Nègre endormi* perfectly encapsulates modern sculpture in these terms.

First of all, we are confronted with the object as matter. Lacking the finish of academic sculpture – 'un dédain du fini qui doit scandaliser bien des gens' (a disdain of finish which must scandalise many) – the work makes no attempt to reproduce 'la beauté plastique, telle que l'entendent nos derniers classiques' (plastic beauty as understood by classicists until now).[15] The black man is portrayed asleep, unconscious, expressing therefore no literary idea, no spirituality, no subject: 'Ce nègre est vautré à terre, sur le ventre, la tête renversée, les membres étalés, dormant d'un sommeil de plomb' (This negro sprawls on the ground, on his stomach, head thrown back, limbs

askew, fast asleep).[16] Zola describes the head as superb, not because beautiful, but because 'une tête de bête humaine, idiote et méchante'. Admittedly, he does go on to interpret the work as the 'personification de cette race nègre, paresseuse et sournoise, obtuse et cruelle, dont nous avons fait une race de bêtes de somme' (personification of the negro race, lazy and sly, obtuse and cruel, whom we have exploited as beasts of burden), but this reading is soon curtailed as Zola's gaze focuses again on the sheer physical, material presence of the object: the body almost seems to be breathing, 'on croit voir les muscles soulever lentement, à chaque souffle du dormeur'.[17]

Zola's description of Solari's sleeping Negro is strangely anticipated by the Goncourt brothers' evocation of a classical sculpture, the Barberini Faun in Munich (also a fragment whose correct position has never been decisively determined), as recorded in their *Journal* in 1860:

Cette belle tête renversée par le sommeil sur l'oreiller du bras, avec l'ombre calme de ses yeux clos, le sourire de cette bouche entr'ouverte, d'où semble s'exhaler un souffle, la mollesse et la tendresse de ces joues détendues par le repos, ce marbre qui vit et qui dort. . . .[18]

(This head thrown back in sleep, with an arm for pillow, with the calm shadow of closed eyes, the smile of this half-opened mouth which seems to breathe, the soft tenderness of cheeks relaxed in repose, this marble form which lives, sleeping. . . .)

The Goncourts were indeed the first French art critics to rediscover in classical sculpture the sensuous presence of matter, irrespective of the literary or mythological status of the work. Their delight in fragmentary works confirms the originality of their perspective, for the fragment of antique marble, cut off from its context, is free to express the suggestive potential of its material presence. In the following description of the *Belvedere Torso* in the Vatican, they adopt a reading of the sculpture that is diametrically opposed to that of eighteenth-century idealist aestheticians such as Winckelmann:

Le Torse, le seul morceau d'art au monde qui nous ait donné la sensation complète et absolue du chef-d'œuvre. . . . Il nous confirme dans cette idée, déjà instinctive en nous, que le suprême beau est la représentation exacte et pure de la nature, que l'idéal, qu'ont cherché à introduire dans l'art des talents inférieurs, est toujours au-dessous du beau et du vrai. Oui, voilà le sublime divin de l'art que ce *Torse* admirablement humain, qui tire sa beauté de la représentation de la vie, ce morceau de poitrine qui respire, ces muscles en travail, ces entrailles palpitantes dans ce ventre qui digère. Car c'est sa beauté de digérer, contrairement à cet imbécile éloge de Winckelmann, qui croit faire honneur au chef-d'œuvre en disant qu'il ne digère pas.[19]

(italics in original)

(*The Torso*, the only work of art in the world which gave us the complete and absolute sensation of a masterpiece It confirms the idea, already instinctive in us, that supreme beauty is a pure and exact representation of nature, that the ideal that inferior artists sought to introduce into art, is always beneath beauty and truth. Yeah, this admirably human *Torso* represents art in all its sublime divinity, drawing its beauty from the representation of life, this fragment of breathing breast, these swelling muscles, these palpitating entrails in this stomach busy digesting. For its beauty lies in its digesting, contrary to what Winkelmann says in his silly panegyric, thinking he was honouring this masterpiece by denying the digestive function.)

Despite their grasp of the essential, material qualities of sculpture as an art, the Goncourts were able to discover such qualities in the work of few contemporary artists. One of the few was Jean-Baptiste Carpeaux (1827–1875),[20] the great sculptor of *La Danse*, whose busts in particular they admired – 'Oui, des bustes, où aucun sculpteur n'a mis comme lui, dans le marbre, le bronze, la terre cuite, la vie grasse de la chair' (Yes, busts in which no other sculptor has been able to infuse as he did marble, bronze or clay with the fleshy life of the body).[21] The brothers especially admired Carpeaux's treatment of women in his sculpture, his ability to capture their sensuous presence, 'la spiritualité matérielle de la créature féminine', and their contemporary vitality.[22] It is noteworthy that Carpeaux was one of the few French sculptors able to carve figures in marble in natural poses in contemporary dress, as in *Le Prince impérial et son chien Néron*, of 1866 (now in the Musée d'Orsay, Paris, along with the plaster model of 1865), and the *Jeune garçon* of 1868 (now held in the Château de Compiègne). The other contemporary sculptor they admired for the modernity and originality of his approach was Rodin (1840–1917). In Edmond de Goncourt's account of a visit to Rodin's studio in the boulevard de Vaugirard in 1886, he focuses on Rodin's treatment of women (see [19]) and of the faun/woman theme:

Ce sont d'admirables torses de petites femmes, dont il excelle à modeler la fuite du dos et pour ainsi dire les battements d'aile des épaules. Il a du plus haut degré l'imagination des attaches et des enlacements de deux corps amoureux noués l'un à l'autre, ainsi que ces sangsues qu'on voit roulées l'une sur l'autre dans un bocal. Un groupe de la plus grande originalité représente dans sa pensée l'amour physique, mais sans que la traduction de sa pensée soit obscène. C'est un mâle qui tient contre le haut de sa poitrine une faunesse contractée et les jambes ramassées dans un étonnant resserrement de grenouille qui s'apprête à sauter.[23]

(These are admirable busts of small women, whose tapered backs and shoulderblades' wingbeats he excels in modelling. He possesses to the highest degree an imaginative grasp of the limbs and couplings of lovers

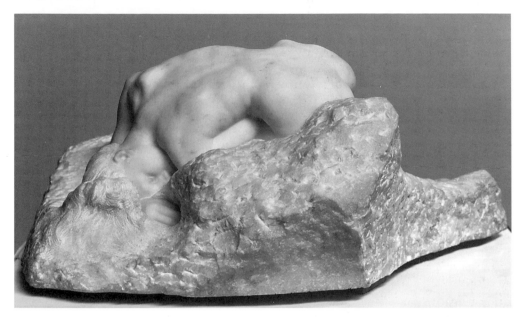

19] Auguste Rodin *Danaïde*, 1885

amorously entwined with each other, like leeches in a jar. A particularly original group represents his idea of physical love, without his thought's translation into matter being obscene. It is a male who clasps to his breast a female faun whose body is contracted, her legs drawn up in the astonishing movement of a frog about to jump.)

The Goncourts were also among the first to discover an authentic representation of modern woman in the paintings of Degas.[24] But it was Joris-Karl Huysmans (1848–1907) who extended this appreciation to Degas sculpture where, just as the classical athlete had been reinvented earlier in the century as the black boxer, so Venus is reborn as a ballet dancer. Huysmans evokes the public's response and then his own to Degas's *Petite danseuse de quatorze ans* [20] at the Indépendants of 1881 in the following terms:

La terrible réalité de cette statuette lui produit un évident malaise; toutes ses idées sur la sculpture, sur ces froides blancheurs inanimées, sur ces mémorables poncifs recopiés depuis des siècles, se bouleversent. Le fait est que, du premier coup, M. Degas a culbuté les traditions de la sculpture comme il a depuis longtemps secoué les conventions de la peinture ...
 La tête peinte, un peu renversée, le menton en l'air, entrouvrant la bouche dans la face maladive et bise, tirée et vieille avant l'âge, les mains ramenées derrière le dos et jointes, la gorge plate moulée par un blanc corsage dont l'étoffe est pétrie de cire, les jambes en place pour la lutte, d'admirables jambes rompues aux exercices, nerveuses et tordues, surmontées comme un pavillon par la mousseline des jupes, le cou raide, cerclé d'un ruban porreau,

les cheveux retombant sur l'épaule et arborant, dans le chignon orné d'un ruban pareil à celui du cou, de réels crins, telle est cette danseuse qui s'anime sous le regard et semble prête à quitter son socle.

Tout à la fois raffinée et barbare avec son industrieux costume, et ses chairs colorées qui palpitent, sillonnées par le travail des muscles, cette statuette est la seule tentative vraiment moderne que je connaisse, dans la sculpture.[25]

(The terrible realism of this statuette evidently causes unease; all popular ideas about sculpture, about those cold white inanimate forms, about those memorable clichés recopied century after century, are overthrown. The fact is that, in one stroke, Mr Degas has overturned the traditions of sculpture, just as he has long since shaken those of painting ...

The painted head, slightly thrown back, chin up, the mouth half open in the sickly face, drawn and old before its time, hands joined behind her back, the flat breast sheathed in a costume whose material is heavily waxed, the legs positioned in readiness for struggle, admirable limbs disciplined through exercise, twisted and nervous, surmounted as by a tent by the muslin of the ballet skirt, the neck stiff, encircled by a ribbon, the hair falling to the shoulder, the bun with matching ribbon, real hair, such is this dancer who comes alive beneath one's gaze and seems ready to spring from her plinth.

At the same time refined and barbarous with her ingenious costume, her coloured and palpitating flesh, furrowed by swelling muscles, this statuette is the only real attempt at modernity in sculpture that I know.)

Huysmans also incorporates in his commentary on Degas's dancer serious consideration of the scope of wood as a medium for sculpture. If, as he recommends, sculptors resolutely reject 'l'étude de l'antique et l'emploi du marbre',[26] they can turn to wood, one of the original sculptural media and one adapted with great success in the Middle Ages. Wood, because it is more organic, is closer to the human form than stone: 'malléable et souple, docile et presque onctueux' (malleable and supple, docile, almost creamy), it is more susceptible to capturing the 'vie de corps' Huysmans admired in medieval wood sculpture. It lends itself much better than marble to re-creating the special beauty of contemporary woman, that 'mélange pondéré de nature et d'artifice' (that measured blend of nature and artifice), the 'charmes de son corps' and the 'grâces de sa toilette'.[27]

In the paradox 'barbarous and refined', Huysmans perhaps best sums up the qualities of sculpture that would enable it once again to give authentic expression to contemporary experience. Combining the 'brutal positivity' noted by Baudelaire with distaste and Zola with approval, Huysmans' formula also stresses the refinement of Degas's sculpture, despite the artist's use of unconventional and heterogeneous materials (real hair, paint, tulle, ribbon, etc.). In confronting the

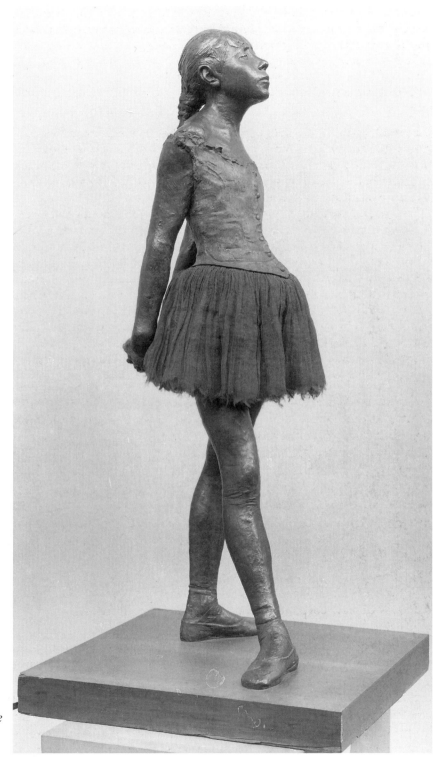

20] Edgar
Degas
*Petite
danseuse de
quatorze
ans*, 1880

viewer once again with the mystery of matter and the miraculous way it comes to life (first in biological, second in creative terms), the sculpture of Degas or of Rodin continues to provide the potential for reverie of classical sculpture but offers different patterns of reading: the Pygmalion myth and other fantasies relating (in particular) to male desire are supplemented or replaced by other, more general, but nonetheless profound reveries – the animation of matter not through divine intervention or spiritual agency but through natural or evolutionary processes; the human ability further to shape and give significance to matter through aesthetic transformation.

Notes

1 For the nineteenth century, only beginning to discover the creative originality of Near and Far Eastern art, the Western tradition had been considered as the only viable one. European sculpture became truly modern only when it had absorbed the sculpture of other so-called primitive cultural traditions, such as those of Africa and the South Pacific, as it did in the early twentieth century. For an account of classical sculpture's impact on European aesthetic thinking until 1900, see Frances Haskell and Nicholas Penny, *Taste and the Antique: The Lure of Classical Sculpture, 1500–1900* (New Haven and London, Yale University Press, 1981).

2 Gautier's appreciation of sculpture is closely linked with his theory and practice of poetry, and when Zola comments favourably on sculpture – that of Philippe Solari for example – it is to argue the case of Naturalism. What sculptors themselves thought of their work or of contemporary critical reaction to it, is less well known. The publication of James Pradier's letters rectifies this situation only to a certain extent, see his *Correspondance*, ed. Douglas Siler, 3 vols (Geneva, Droz, 1984–88).

3 J. F. Sobry *Poétique des arts ou cours de peinture et littérature comparées* (Paris, Delaunay, 1810), p. 36.

4 Charles Baudelaire, *Œuvres complètes*, ed. Cl. Pichois (Paris, Gallimard, 1976), II, p. 487.

5 Cited in Victor Cousin, *Du Vrai, du Beau et du Bien* (Paris, Perrin, 1917), p. 162.

6 *Ibid.*, pp. 162–3.

7 Cited in Gautier, *Le Roman de la Momie* (Paris, Garnier, 1963), p. 86.

8 See *La Presse* (23 April 1848).

9 Natalie David-Weill, *Rêve de pierre: La Quête de la femme chez Gautier* (Geneva, Droz, 1989), p. 120.

10 *L'Académisme et ses fantasmes* (Paris, Minuit, 1980), p. 140.

11 *La Presse* (10 April 1847).

12 Philippe Solari (1840–1906), of Italian origin, was a minor sculptor specialising in medallions and busts, one of the latter of which decorates Zola's tombstone in the Montmartre cemetery. Zola knew Solari from his childhood days in Aix-en-Provence and championed his work on a number of occasions – as, for example, in his *Lettre parisienne* on Jongkind of 1872.

13 'La Sculpture', in Antoinette Ehrard (ed.), *Mon Salon, Manet: écrits sur l'art* (Paris, Garnier-Flammarion, 1970), p. 169.

14 *Ibid.*, pp. 169–70.

15 *Ibid.*, pp. 172–3.
16 *Ibid.*, p. 173. It appears that Solari's black man had originally been conceived as a standing figure but fell and broke and thus took on its subsequent form.
17 *Ibid.*, p. 173.
18 Cited in Goncourts, *L'Art du 18e siècle et autres textes sur l'art*, ed. J.-P. Bouillon (Paris, Hermann, 1967), p. 37.
19 *Ibid.*, p. 41.
20 On Carpeaux, see Anne-Middleton Wagner, *Jean-Baptiste Carpeaux: Sculptor of the Second Empire* (New Haven and London, Yale University Press, 1986), and Laure de Margerie, *La 'Danse' de Carpeaux* (Paris, Editions de la Réunion des Musées Nationaux, 1989).
21 Goncourts, *L'Art du 18e siècle*, p. 247.
22 *Ibid.*, p. 247.
23 *Ibid.*, p. 249.
24 *Ibid.*, pp. 251–2.
25 Joris-Karl Huysmans, 'L'Exposition des Indépendants', in H. Juin (ed.), *L'Art moderne, certains* (Paris, 10/18, 1975), pp. 228–9.
26 *Ibid.*, p. 230.
27 *Ibid.*, p. 231.

6 Visual display in the Realist novel:
'l'aventure du style'

FRENCH Realist novelists of the latter part of the nineteenth
century became of necessity virtuosi of literary description. Their
ambition to be historians of the present, representing modern life
within a more or less positivist paradigm of documentation and sin-
cere observation, obliged them to experiment with literary stratagems
whereby texts seemed to present to the reader the actual spectacle of
modernity. The notion of the novel as 'une tranche de vie', as a slice
of life, became a familiar convention, a common-place. Romantic plots
and peripeteia became the enemy of the essential task of showing life
'à l'état normal'.[1] Description, and especially visual description, as-
sumed unprecedented status in narratives. The aesthetic of the Realist
novel became increasingly visual.

In devising stylistic stratagems that would be equal to the task of
making novels increasingly into vehicles of visual spectacle and dis-
play, novelists were faced with an age-old paradox of mimetic litera-
ture: that the creation of an impression of naturalness depends on
skilful and illusive manipulation of the artificial conventions of liter-
ary form, an impression of truthfulness that relies for its effect on a
lie. It is a paradox that is particularly striking when the verbal and
the pictorial become consubstantial, as in visual description where
pictures are suggested by words. Some much earlier practitioners of
Realist fiction had highlighted the paradox in order to dwell upon its
significance. Diderot, for example, had made in the course of his art
criticism (*Le Salon de 1767*) the following theoretical remark that
relates directly to his own practice as novelist:

Mais la nature étant une, comment concevez-vous, mon ami, qu'il y ait tant
de manières de l'imiter, et qu'on les admire toutes? Cela viendrait-il de ce
que, dans l'impossibilité reconnue de la rendre avec une précision absolue,
il y a une lisière de convention sur laquelle on permet à l'art de se promener;
de ce que, dans toute production poétique, il y a toujours une part de
mensonge dont la limite ne sera jamais déterminée?[2]

(But since there is only one nature, how do you explain, my friend, that there are so many ways of imitating it, and that we admire them all? Could this stem from the fact that, given the acknowledged impossibility of representing nature with absolute accuracy, there is a periphery of convention in which we allow art to move around; from the fact that, in all poetic production, there is always an element of lying whose limits will never be determined?)

This passage takes as its starting point the work of a painter, Casanova, and develops its frame of reference in terms of a general poetics. Art, whether painting or literature, is merely representation, and cannot be considered true to its model in any literal sense, however *vraisemblable* it may seem. The dividing line between conveying a truth and telling a lie is never clear. For an eighteenth-century writer such as Diderot, an investigation of such an aesthetic problem intensifies the pleasure of the text, leading in his own novels to the playful fictional excentricities of *La Religieuse* or *Jacques le fataliste*. For many nineteenth-century Realists, however, to give an impression of naturalness was all-important. To conceal the need to deceive by lying, rather than highlighting it in a self-referential mode, was a condition for the reader's readiness to suspend disbelief in the manner famously proclaimed at the beginning of Balzac's *Le Père Goriot* (1834–35):

Après avoir lu les secrètes infortunes du père Goriot, vous dînerez avec appétit en mettant votre insensibilité sur le compte de l'auteur, en le taxant d'exagération, en l'accusant de poésie. Ah! sachez-le : ce drame n'est ni une fiction, ni un roman. *All is true*, il est si véritable, que chacun peut en reconnaître les éléments chez soi, dans son cœur peut-être.[3]

(After reading of the secret misfortunes of old Goriot, you will dine with a hearty appetite making the author answerable for your insensitivity, accusing him of exaggeration and poetic licence. Ah! take heed. This drama is neither a fiction, nor a novel. 'All is true'. It is so truthful that everyone can recognise its elements in oneself, in one's heart perhaps.)

Balzac invites readers to believe that the novel they are reading is not a novel at all because it is so true. Of Realist novelists of the latter part of the nineteenth century, none perhaps sought to maintain this claim to truthfulness more vigorously than Emile Zola. In his critical writings, whether it be his art criticism and passionate defence of Manet of the late 1860s or his literary manifestos such as *Le Roman expérimental* (1880), Zola repeatedly uses truth to nature as an aesthetic criterion in a manner that bears the mantle of moral integrity. His Realist theory needs to disown any criterion corresponding to what Diderot had called 'mensonge', and the display of visual spectacle in

his novels needs to embrace an aesthetic of 'vérité', no matter how open such a term may be to objections on ideological or epistemological grounds.

Two lines of specific investigation follow inevitably from these general considerations about description in the Realist novel, the second of which will be the subject of this chapter. The first topic, and the one with which I am not concerned here, is to analyse Zola's theory and practice. This involves revealing in what problematic ways his claims to naive 'vérité' relate to his undoubtedly complex and sophisticated literary practices in his descriptions of modern life. Zola specialists have already done much to unravel this problem, notably William J. Berg in his authoritative *The Visual Novel, Emile Zola and the Art of his Times* (1992).[4] The second line of investigation is to ask whether it was in fact general for Realist novelists of the time of Zola to tend to conceal the kind of duality or contradiction that must exist between the apparent naturalness of modern-life subject-matter and the unnaturalness of its means of representation. Within the context of what William J. Berg calls the visual novel, were there novelists who, in their own way, cultivated or celebrated 'le mensonge' as Diderot, in his way, had done earlier? It is this question and its implications that this chapter will address.

Despite the advances of modern narratology,[5] perhaps the most eloquent response to this specific question was provided as long ago as 1926 by – surprisingly – a poet: Paul Valéry. Writing about the language of the Realist novel, Valéry acknowledges that the Realist novelist seeks to use ordinary language to describe the observed world with minimal distortion. If the novel tends to simplify the world, this in itself corresponds to the way that human perception and consciousness simplify experience. However, Valéry continues:

Mais si le lecteur devient difficile, le langage ordinaire ne suffit plus à l'émouvoir. Le réaliste cherche alors à obtenir le trompe-l'œil par l'excessif du 'style'. Goncourt, Huysmans paraissent . . . Un langage extraordinaire est appelé à suggérer des objets ordinaires. Il les métamorphose. Un chapeau devient un monstre, que le Héros réaliste armé d'épithètes invincibles chevauche, et fait bondir du réel dans l'épopée de l'aventure stylistique.[6]

(But if the reader becomes demanding, ordinary language is no longer enough to move him. The Realist seeks then to achieve *trompe-l'œil* through extremes of 'style'. The Goncourts and Huysmans make their appearance. Extraordinary language is called upon to suggest ordinary objects. Which metamorphoses them. A hat becomes a monster which the realist Hero, armed with invincible epithets, sits astride and rides beyond the real into the epic of stylistic adventure.)

Valéry claims that the reader of Realist fiction, swiftly aided and abetted by certain novelists, felt the need to go beyond the rendering of observed reality through ordinary language to a different kind of literary enterprise: one characterised by the representation of ordinary objects through linguistic excess and hyperbole, implying a discrepancy between the ordinariness of the objects represented and the surprising adventurousness of their means of representation. He presents this as a quest of epic proportions: style as an adventure, 'l'aventure du style'.

Valéry names the Goncourt brothers and Huysmans as practitioners of this art of linguistic excess, and implies the identity of another. The mention of a hat that becomes monstrous is clearly an allusion to one of the most baffling passages of visual description in the nineteenth-century French novel. At the beginning of Flaubert's *Madame Bovary* the hat that the young Charles Bovary wears to school is described in these words:

C'était une de ces coiffures d'ordre composite, où l'on retrouve les éléments du bonnet à poil, du chapska, du chapeau rond, de la casquette de loutre et du bonnet de coton, une de ces pauvres choses, enfin, dont la laideur muette a des profondeurs d'expression comme le visage d'un imbécile. Ovoïde et renflée de baleines, elle commençait par trois boudins circulaires; puis, s'alternaient, séparés par une bande rouge, des losanges de velours et de poil de lapin; venait ensuite une façon de sac qui se terminait par un polygone cartonné, couvert d'une broderie en soutache compliquée, et d'où pendait, au bout d'un long cordon trop mince, un petit croisillon de fils d'or, en manière de gland. Elle était neuve; la visière brillait.[7]

(It was one of those head-pieces belonging to the composite order, in which elements can be recognised of the bearskin, the chapska, the bowler hat, the otter cap and the cotton bonnet, one of those wretched objects, in fact, whose dumb ugliness has the depths of expressiveness of an idiot's face. Egg-shaped and puffed out with whale-bone, it began with three circular sausage forms; then there alternated, separated by a red band, diamond shapes in velvet and rabbit-skin; next came a kind of bag whose end was a polygon bound in cardboard, covered with complicated braid embroidery, and from which there hung, on the end of a long and excessively thin cord, a small transom of gold threads, a kind of tassel. It was new; the peak shone.)

How is the reader to make sense of this passage, in which the signifying words describe a hat that could never exist literally as a signified object? Do we attribute the distortion to the intentional exaggeration of an implied narrator? Do we see it as pastiche and parody, a puzzle that initiates the reader to an experimental type of novel that is a critique of other forms of novel, notably the Balzacian?

Or do we see it as an example of what Barthes called 'la Littérature impossible',[8] an early glimpse of the self-conscious literariness that would permeate modernist innovations? Flaubert criticism of today of course emphatically embraces the second and third of these possibilities, removing *Madame Bovary* from the Realist context altogether. Charles's hat defeats our visual imaginations by its linguistic excess, so that we are denied the experience of a visual description in the Realist sense. Valéry's allusion to *Madame Bovary* is therefore both helpful and unhelpful. It indicates and illustrates forcefully what he means by 'l'excessif du "style"', but it does not answer the question of whether the Realist novel itself can incorporate linguistic excess and hyperbole without allowing such obvious artifice simply to break the mould of the Realist genre. It is therefore to the Goncourts and to Huysmans that we must turn to clarify Valéry's claims.

It is in their earlier texts that the Goncourts and Huysmans most centrally confronted problems of realist and visual description. In the 1860s, before the death of Jules in 1870, Edmond and Jules de Goncourt were forging new aesthetic aims for the novel at the forefront of Second Empire Realism. In the 1870s, Huysmans was both a loyal disciple of Zola and an independent creator of a kind of Impressionist novel, before spurning Realism in the name of decadence and subsequently religion. Notably, it is in their early works that the Goncourts and Huysmans began their long-term experiments with transferring into narrative the fruits of their experience as acutely perceptive connoisseurs and commentators of the visual arts, past and present.

In 1860 the Goncourts published their first mature novel, *Charles Demailly*.[9] Originally it was to be called *Les Hommes de Lettres*, referring to a whole community of contemporary men of letters and journalists of the Second Empire, but the title was later restricted to the name of the principal character. The plot concerns the tensions and obstacles encountered by Charles Demailly, an aspiring writer, in relation to a literary community corrupted by journalism and social ambition. It is in many ways an updated version of Balzac's *Illusions perdues* (1843), although Charles – neurotic and hypersensitive and finally driven to insanity – is closer to a *fin-de-siècle* neurasthenic than to Balzac's equivalent central figure, Lucien de Rubempré. Both *Illusions perdues* and *Charles Demailly* depend for their effect on an impression of authenticity, the conviction formed by the reader that these fictional accounts correspond to social realities, notably the commodification and corruption of culture in a developing capitalist society. *Charles Demailly* reinforces its claim to be a documentary novel by being in part a *roman à clefs*.[10] A character called Masson,

for example, is described as an admired writer given to indolence who is nonetheless very actively concerned with 'la forme artiste' as opposed to utility in literature, making notably the following statement: 'Critiques et louanges me louent et m'abîment sans comprendre un mot de ce que je suis. Toute ma valeur, ils n'ont jamais parlé de cela, c'est que je suis *un homme pour qui le monde visible existe*' (Criticisms and eulogies praise me and damn me without understanding a word of what I am. My whole worth, and they have never spoken of this, is that I am *a man for whom the visible world exists*; original emphasis).[11] The reader has little difficulty in deciphering that Masson is a very thinly disguised portrait of Théophile Gautier.

Other characters in *Charles Demailly* similarly correspond to Second Empire figures or are closely related to them, including a certain Laligant. Laligant – a minor character in the novel but a very striking one – is, we learn, a traveller and a talker. He has travelled a great deal – throughout Europe and in the Near East – and can conjure up the exotic colours of the East and South as well as the more reserved tones of England on which he is an authority. He is small, with a moustache, and with eyes that express great energy. He is a charismatic conversationalist, whose torrent of words form a visual spectacle:

C'est une parole peinte, éclatante, coupée de changements à vue, une éloquence bavarde, fortunée, où tout à coup une métaphore de voyou, une image d'argot ou bien un grand mot de la langue des penseurs allemands, ramasse votre attention et l'emporte. Tantôt une façon de dire, empruntée à la technique de l'art, détache l'idée comme un médaillon grec.[12]

(It is painted, brilliant speech, broken up by shifts of perspective, a talkative and rich eloquence, in which a loutish metaphor, a slang image, or a fine expression from the language of German thinkers, grabs your attention and carries it away. At times an expression taken from the technique of art gives relief to an idea like a Greek medallion.)

Laligant is modelled, as regards the *roman à clefs* aspect of *Charles Demailly*, on the artist Constantin Guys whom the Goncourts met in 1858.[13] Their verbal portrait of Guys perhaps surprises us initially because we are so used to Baudelaire's depiction of him in 'Le Peintre de la vie moderne' where he is a more taciturn *flâneur* in the Parisian crowd. Perhaps our perception of Guys as an artistic personality has been overdetermined by Baudelaire. However, there is more to Laligant than an authentic and documentary snap-shot taken from Parisian artistic life of the late 1850s. He has a dual function. He represents Constantin Guys, but also transforms him – metamorphoses him to use Valéry's term – into a hyperbolic figure, the wit and talker whose words correspond to a visual palette and much

more besides. He is a figure of excess, linked intertextually with Diderot's *Neveu de Rameau* when his speech is compared to 'un fleuve, comme la parole de Diderot!' (a torrent like the speech of Diderot!).[14] Laligant's double function in *Charles Demailly* is to be both a mimetic figure in a *roman à clefs* and also a mirific spectacle of linguistic invention, a bewilderingly rich verbal display that uses an array of visual palettes.[15]

Laligant is a minor character, but he is typical – almost like a *mise en abyme* – of the novel as a whole regarding its narrative strategies. Descriptions of tableaux, for example elaborate evocations of water, provide set-piece pictorial spectacles. A profusion of listings of motifs and objects disrupt 'vraisemblance' by their rapidity and variety. Fragmentation of what is not a long novel into nearly a hundred chapters of varying length and register – the shortest contains twenty-four words of which eight are proper names[16] – adds impressionistic discontinuity to the general effect. *Charles Demailly* clearly displays that adventure in style that Valéry was to evoke.

The discrepancy already evident in *Charles Demailly* between a Realist agenda of presenting a documentary account of modern life and a tendency towards the extraordinary and exceptional in its presentation would become more accentuated in later novels by the Goncourts. The individuality of their language would sometimes be taken by the public and critics as a symptom of aesthetic error or self-indulgent preciosity.[17] More charitably, Zola was to refer to it as linguistic play, a ludic engagement with difficulty: 'Ils [les frères de Goncourt] se laissent aller au plaisir de décrire, en artistes qui jouent avec la langue et qui sont heureux de la plier aux mille difficultés du rendu' (They [the Goncourt brothers] abandon themselves to the pleasure of describing, as artists who play with language and who enjoy bending it to the thousand difficulties of expression).[18] In later years Edmond, after the death of Jules, would defend their position, writing for example in his preface (1884) to *Chérie*:

le romancier, qui a le désir de se survivre, continuera à s'efforcer de mettre dans sa prose de la poésie, continuera à vouloir un rythme et une cadence pour ses périodes, continuera à rechercher l'image peinte, continuera à courir après l'épithète rare, ... continuera à ne pas rejeter un vocable comblant un trou parmi les rares mots admis à monter dans les carosses de l'Académie, commettra enfin, mon Dieu, oui! un néoligisme ...[19]

(the novelist, who has the desire to come down to posterity, will continue to put poetry into his prose, will continue to wish for rhythm and cadence in his sentences, will continue to seek out the painted image, will continue to pursue the rare epithet, ... will continue not to reject a term filling a gap

amongst the few words allowed to ride in the carriages of the Academy, will in fact commit, good heavens, yes! a neologism . . .)

The term 'écriture artiste' became associated with such writing, used and promoted by Edmond de Goncourt himself.[20] Artistic both in the sense of departing from the banality of everyday discourse and in its use of effects from the visual arts, such writing introduces into Realism precisely the type of 'aventure du style' evoked by Valéry. Its tendency is not simply to employ an enriched register of language; it even invents new language.

Before considering equivalent aesthetic tendencies in Huysmans, a consequence of this use of language must be taken into account. If, to use Valéry's expression, extraordinary language is being used to depict ordinary objects, do these objects themselves become extraordinary through the process of their representation? A suitable test-case is the novel by the Goncourts in which they went furthest in focusing on ordinary life. This is *Germinie Lacerteux* (1864), their Realist depiction of 'les basses classes',[21] of working-class Paris through the double-life of a maid who hides depravity and suffering behind a veneer of respectability. The Goncourts' means of representing Germinie's life does indeed distort the banality of the subject, and in two ways that have to do directly with visual display. The first is that descriptions of Germinie's environment are presented in her own terms as she notices it and also as visual pictures of a very bourgeois sensibility. In chapter 12 she goes on a outing to the 'fortifications', the very edge of Paris. She encounters a panoramic landscape: 'sur la ligne toute plate de l'horizon, traversée de temps en temps par la fumée blanche d'un chemin de fer, les groupes de promeneurs faisaient des taches noires, presque immobiles, au loin' (against the totally flat line of the horizon, crossed occasionally by white smoke from a railway, groups of walkers formed black almost immobile marks in the distance.).[22] When she returns home, sunset and coming night transform the scene: 'Le ciel était gris en bas, rose au milieu, bleuâtre en haut. Les horizons s'assombrissaient; les verdures se fonçaient, s'assourdissaient, les toits de zinc des cabarets prenaient des lumières de lune, des feux commençaient à piquer l'ombre, la foule devenait grisâtre, les blancs de linge devenaient bleus' (The sky was grey below, pink in the middle, bluish above. The horizons were darkening; green patches became darker and quieter, the zinc roofs of taverns took on the hues of moonlight, lights began to pierce the gloom, the crowd becoming greyish, white clothing turning blue).[23] There is a double perspective here: that of Germinie's point of view and that of an artistic narrative voice that transforms the scene with impressionistic

skill into 'une image peinte'.[24] Other examples of this artistry abound in the impressions of modernity to be found in *Germinie Lacerteux*.

The second mode of distortion in this novel resulting from representing the ordinary by extraordinary means concerns chiefly Germinie herself. The unrelenting stream of disasters that befall her is on a scale that makes her seem untypical, despite the Goncourts' claims to social and physiological authenticity. She becomes an exaggerated figure through the concentration of effects that accumulate in her and through the social criticism of the Paris of the Second Empire that she so clearly embodies. This effect is related indirectly to an important tendency within Realism of which the Goncourt were well aware, caricature. The kind of caricature concerned is neither comic nor simply entertaining; it is an exaggeration of features that become charged with social and moral criticism.

The Goncourts' most treasured companion amongst contemporary artists in the years preceding *Germinie Lacerteux* had been a practitioner of just such socially targeted and often serious caricature: Gavarni (1804–1866), about whom they were to write a critical biography.[25] Whilst specific borrowings from Gavarni are not to be found in the pages of *Germinie Lacerteux*, broader common ground between his work and the Goncourts' novel is not hard to find. The Goncourt brothers first met Gavarni early in 1852. In 1852–53 Gavarni was at work on what was arguably his finest achievement, *Masques et visages*, republished in 1862 in a pocket-sized volume.[26] *Masques et visages* has twenty-one sections devoted to various aspects of modern life such as 'Les Lorettes vieillies', 'Les Maris me font toujours rire', 'Comédie bourgeoise' and 'Balivernes parisiennes' (*Prostitutes grown old*, *Husbands always make me laugh*, *Bourgeois comedy* and *Parisian nonsenses*). In each section a series of caricatural images are accompanied by penetrating captions in the manner of Daumier or Grandville. The whole forms a satirical critique of contemporary Paris with the emphasis very much on the private lives of individuals. Within Paris, Gavarni showed a marked preference for the Bréda district where a new bourgeoisie found itself in uncomfortable proximity to a well-established working class, and where, paradoxically, a local church – Notre-Dame de Lorette – had given its name to a prominent feature of the district: prostitutes, known as 'lorettes'.[27] The bizarre social mix of this 'quartier' typifies Gavarni's subject-matter. The Goncourts' *Germinie Lacerteux* is set largely in and around the Bréda, showing, as Gavarni had done, the moral consequences of the mixture of social communities to be found there. Furthermore, as we have seen, Germinie herself acquires caricatural exaggeration and this is to be found also in minor characters of the novel such as Madame

21] Paul Gavarni Title page of
Masques et visages, 1862

Jupillon at the local 'crémerie' and her good-for-nothing son. *Masques et visages* and *Germinie Lacerteux* therefore share preconceptions and assumptions about the representation of modern life. Gavarni also, like the Goncourts, experiments with modes of representation, as in the Magritte-like frontispiece to *Masques et visages*, in which an artist's means of expression (his easel and palette), his plump bourgeois subject (portrayed on the canvas) and parts of the artist himself coexist and interact before us [21].

The caricatural tendencies of the Goncourts' novels are of course situated within a style affected by the more refined tone of 'écriture artiste', and are easily overlooked. To find literary caricature of a more robust kind, we need to turn to a passage such as this:

C'était madame Teston, une femme mariée, une vieille bique de cinquante ans, une longue efflanquée qui bêlait à la lune, campée sur de maigre tibias, la face taillée à grands pans, les oreilles en anses de pot; c'était madame

Voblat, un gabion de suif, une bombance de chair mal retenue par les douves
d'un corset, un tendron abêti et béat qui riait et tâchait de se tenir la paille
à propos de tout, pour un miaulement de chat, pour un vol de mouche . . .[28]

(There was Mme Teston, a married woman, an old goat of fifty, long and
emaciated and bleating at the moon, perched on thin tibias, her face sculpted
in tall sections and with ears like pot handles; there was Mme Voblat, a
basket of suet, a feast of flesh barely contained by her corset staves, a
blissfully happy but stupified dish of meat who laughed and blathered on
endlessly about nothing at all, when a cat miaowed, when a fly passed . . .)

This passage is from *Les Sœurs Vatard* (1879) by Huysmans, his
second novel and the peak of his experiments with Realist fiction.[29]
Like *Germinie Lacerteux*, it has a working-class subject, in this case
the life of women employed in a Parisian workshop. The passage just
quoted is from chapter 2, in which the different types of worker
are presented to the reader. Objectionable though it may be for its
apparent misogyny, it is a very fine example of caricature in literature.
Extremes of visual distortion are rendered in language so inventive that
it becomes obscure to modern readers and defies adequate translation.
Again, and in a more extreme way than the Goncourts, we have a
discrepancy between ordinary subject-matter and an extraordinary
language of representation.

Les Sœurs Vatard* in general takes further the trails blazed earlier
by the Goncourts. For example, the documentary value of *Germinie
Lacerteux* had been underscored in a curious way by the fact that the
plot is based on the bizarre and sad life of the Goncourts' own maid,
Rose Malingre. The book-binding workshop that is the principal
setting of *Les Sœurs Vatard* describes one that actually belonged to
Huysmans himself, inherited by a quirk of family finances.[30] Also,
the shift of emphasis from plot to static description already initiated
by the Goncourts is taken to extreme lengths by Huysmans; *Les
Sœurs Vatard* has virtually no plot beyond the inconsequential and
meandering life-styles of the sisters of the title. It is pre-eminently a
visual novel in which we see Paris in the 1870s through the perspect-
ive of the Vatard sisters' daily lives. They live in Montparnasse, close
to its railway station. They work on the left bank, but need to walk
along the city streets to and from the workshop. They gaze covet-
ously at the goods displayed in the windows of department stores. For
leisure they go to a *café-concert* or to a fair. The reader witnesses a
visual display of modern Parisian life and a composite portrait of
'l'ouvrière'.[31] It is an account of modern life that is contemporary with
Impressionism and uses Impressionist subjects, and yet Huysmans's
trains at Montparnasse are unlike Monet's contemporary pictures of

the Gare Saint-Lazare, and Huysmans's street scenes differ from the whole range of Impressionist street scenes from Renoir to Caillebotte. Like the Goncourts before him, Huysmans has adapted and cultivated extraordinary and idiosyncratic language to represent these banal subjects. Although colour and movement are constantly present in an Impressionist way, Huysmans shows them through extremes of language, notably slang (as in the caricature quoted above), and also a kind of *écriture artiste* as in this description of dawn in the workshop:

Le soleil se décidait à mûrir. Il allait, fonçant à mesure la rougeur de son orbe. – La danse de la poussière dans un rayon de jour commença, tournoyant en spirales, du plancher aux vitres. – La lumière sauta, jaillit, éclaboussa de larges gouttes le plancher et les tables, alluma d'un point tremblant le col d'une carafe et la panse d'un seau, incendia de sa braise rouge le cœur d'une pivoine qui s'épanouit, frémissante, dans son pot d'eau trouble, creva enfin en une large ondée d'or sur les piles des papiers qui éclatèrent avec leur blancheur crue sur la suie des murs![32]

(The sun was beginning to ripen. It came, darkening as it did the redness of its sphere. – Dust began to dance in a ray of sunshine, spiralling from the floor to the window panes. – Light jumped, spurted, splashed the floor and tables with large drops, lit up in a trembling spot the neck of a jug and the belly of a bucket, burning with its red coal the heart of a peony blossoming delicately in its pot of cloudy water, and finally burst in a broad wave of gold on to the piles of paper whose raw whiteness clashed with the soot of the walls!)

Huysmans, whether it be in caricature or in colourful description, was seeking to push literary language to new thresholds, taking 'l'aventure du style' further than the Goncourts had done.[33]

As if to emphasise the unconventionality of his representation of modern life, Huysmans includes in *Les Sœurs Vatard* a minor character who is a bourgeois painter of modern life whose own life is governed by depraved proclivities, Cyprien Tibaille. Cyprien Tibaille is a committed, if unconventional, painter of modern life, who has thrown off the out-dated teaching of Cabanel and Gérôme to paint the contemporary world he knows:

Il ne comprenait, en fait d'art, que le moderne. Se souciant peu de la défroque des époques vieillies, il affirmait qu'un peintre ne devait rendre que ce qu'il pouvait fréquenter et voir; or, comme il ne fréquentait et ne voyait guère que des filles, il ne tentait de peindre que des filles.[34]

(He could only conceive, concerning art, of the modern. Caring little for the strange clothes of aged times, he maintained that a painter should represent only what he could frequent and see; now as he scarcely frequented and saw anything but prostitutes, he only attempted to paint prostitutes.)

In addition to his obsession with prostitutes, he is a neurotic decad-
ent, surrounding himself with the textures and colours of silk fabrics,
and dreaming of a life of self-indulgent perversity: 'Frêle et nerveux
à l'excès, hanté par ces sourdes ardeurs qui montent des organes lassés,
il était arrivé à ne plus rêver qu'à des voluptés assaisonnées de mines
perverses et d'accoutrements bizarres' (Excessively frail and nervous,
haunted by those hidden passions which rise from tired organs, he
had reached a stage where he could dream only of pleasures spiced
with perverse appearances and bizarre clothes).[35] Cyprien Tibaille has
no exact equivalent in the world of the Impressionists or indeed amongst
contemporary artists at all. Like the Goncourts' Laligant, he is a
literary fantasy, a stylistic spectacle.

However, Huysmans did find within the broad context of Im-
pressionism a painter who combined modern subject-matter with a
personal style in a way that seemed to him the equivalent of his own
practice and that of the Goncourts: Edgar Degas. Huysmans was
highly active as an art critic at the time of *Les Sœurs Vatard*. In his
'L'Exposition des Indépendants' (1880), later included in his collec-
tion of articles entitled *L'Art moderne*,[36] Huysmans sets out to put
into words his admiration for Degas:

Il est difficile avec une plume de donner même une très vague idée de la
peinture de M. Degas; elle ne peut avoir son équivalent qu'en littérature; si
une comparaison entre ces deux arts était possible, je dirais que l'exécution
de M. Degas me rappelle, à bien des points de vue, l'exécution littéraire des
frères de Goncourt.[37]

(It is difficult with a pen to give even a very vague idea of the painting of
Mr Degas; it can have its equivalent only in literature; if a comparison
between these two arts were possible, I would say that the execution of
Mr Degas reminds me, from many points of view, of the literary execution
of the Goncourt brothers.)

He goes on to explain his comparison between Degas and the
Goncourts:

De même que pour rendre visible, presque palpable, l'extérieur de la bête
humaine, . . . pour exprimer la plus fugitive de ses sensations, Jules et Edmond
de Goncourt ont dû forger un incisif et puissant outil, créer une palette
neuve des tons, un vocabulaire original, une nouvelle langue; de même, pour
exprimer la vision des êtres et des choses dans l'atmosphère qui leur est
propre, . . . pour traduire des effets incompris ou jugés impossibles à peindre
jusqu'alors, M. Degas a dû se fabriquer un instrument tout à la fois ténu et
large, flexible et ferme.
 Lui aussi a dû emprunter à tous les vocabulaires de la peinture, combiner
les divers éléments de l'essence et de l'huile, de l'aquarelle et du pastel, de

la détrempe et de la gouache, forger des néologismes de couleurs, briser l'ordonnance des sujets.[38]

(Just as in order to make visible, almost palpable, the exterior of the human animal, . . . to express the most fleeting of his sensations, Jules and Edmond de Goncourt have had to forge an incisive and powerful instrument, to create a new palette of colours, an original vocabulary, a new language; in the same way, in order to express the spectacle of beings and objects in the atmosphere that belongs to them, . . . in order to translate effects hitherto beyond comprehension or judged impossible to paint, Mr Degas has had to manufacture an instrument at the same time faint and broad, supple and firm.

He also has had to borrow from every vocabulary of painting, to combine spirit and oil, watercolour and pastel, tempera and gouache, to forge colour neologisms, to break the ordering of subjects.)

Huysmans notes particularly the unexpected angles of vision, the play of artificial gas light ('la lumière factice du gaz') in interiors, the bizarre poses and the technical innovations to be found in the pictures of ballet dancers that Degas exhibited in 1880. Despite the presence of a fine portrait of Duranty, it is Degas's study of women that occupies centre stage in Huysmans's account, a theme that Degas would himself pursue further later in the 1880s (figures 24 and 25). Although he does not refer to his own fiction in 'L'Exposition des Indépendants', Huysmans is clearly associating his own quest for a new literary language with that of the Goncourts amongst the preceding generation of novelists and with Degas's original visual language in painting. Description and visual display, whether in his own works or in those of the Goncourts and Degas, present the reader and viewer with surprising new vocabularies and compositions verbally and visually, in brief 'une nouvelle langue'.

The proposition I have been developing stemmed initially from Paul Valéry. His formulation has proved to be convincing in relation to developments in the Realist novel and to correspond to a strong current more generally within Realism. But there are two other contextual points concerning Valéry that must not be forgotten. The first is that as a poet he had been the companion and follower of Stéphane Mallarmé. The search for a new literary language is an obvious basic feature of Mallarmé's poetry and of Symbolist poetry in general. Huysmans's invocation of 'une nouvelle langue' concerning Degas echoes Mallarmé's 'j'invente une langue'[39] of 1864 or Rimbaud's 'Trouver une langue'[40] of 1871. Generically, the Realist novel is a porous vessel. Huysmans's first book *Le Drageoir aux épices* was, after all, a collection of *poèmes en prose*.[41] The second contextual point is that just as my itinerary through visual display

and stylistic adventure has led me to Degas, so did Valéry's own thoughts about the visual arts lead him to Degas. His classic book *Degas, danse, dessin* (1938) combines personal memories of his early contacts with the ageing Degas and his circle with acute reflexions on aesthetic matters. Amongst the anecdotes included by Valéry in *Degas, danse, dessin* is the following remark by Degas that was noted by Berthe Morisot after dining with him: 'Degas a dit que l'étude de la nature était insignifiante, la peinture étant un art de convention, et qu'il valait mieux apprendre à dessiner d'après Holbein ...' (Degas said that the study of nature was of no importance, painting being an art of convention, and that it was of more value to learn to draw by copying Holbein ...).[42] There could be no better epigram with which to end this chapter, in which truth to nature within Realism has been overtaken by 'l'aventure du style'.

Notes

1 Various prefaces by Realist novelists set out these principles, notably Maupassant's 'Le Roman' (1887) where he uses the expression 'à l'état normal'. See H. S. Gershman and K. B. Whitworth, *Anthologie des préfaces de romans français du XIXe siècle* (Paris, 10/18, 1972).
2 *Salon de 1767*, article on Casanova. Quoted by J. Seznec in Diderot, *Sur l'art et les artistes* (Paris, Hermann, 1967), p. 43.
3 The final words of the first paragraph of *Le Père Goriot*. 'All is true' appeared as an epigraph ascribed to Shakespeare under the novel's title in early editions.
4 Published by the Pennsylvania State University Press.
5 For example, James H. Reid, *Narration and Description in the French Realist Novel: The Temporality of Lying and Forgetting* (Cambridge, Cambridge University Press, 1993).
6 Quoted from Valéry's *Analecta* (1926) by Philippe Hamon in *La Description littéraire. De l'Antiquité à Roland Barthes: une anthologie* (Paris, Macula, 1991), p. 168.
7 The passage occurs on the second page of the novel in the first chapter.
8 'La modernité commence avec la recherche d'une Littérature impossible' (Modernity begins with the quest for an impossible Literature). Roland Barthes in *Le Degré zéro de l'écriture* (Paris, Gonthier, 1971), p. 36. Originally published in 1953.
9 It was their third venture into fiction but the first of quality. It was preceded by *En 18..* (1851) and *Une voiture de masques* (1856). *Manette Salomon* (1866–67), although concerned specifically with painting, is excluded from discussion here, as it raises distinctly different problems regarding the language of description.
10 See Robert Ricatte, *La Création romanesque chez les Goncourt 1851–1870* (Paris, Colin, 1953), chap. 3, esp. pp. 115–36. Useful also is Nadine Satiat's preface to the 10/18 edition of *Charles Demailly* (Paris, 1990).
11 *Ibid.*, p. 117.

12 *Ibid.*, p. 184.

13 See Ricatte, *La Création romanesque*, and Satiat, *Charles Demailly*, esp. p. 23 of her preface.

14 *Ibid.*, p. 184. Diderot and his fictional creation from *Le Neveu de Rameau* (1762) are no doubt conflated here. Satiat, *ibid.*, p. 23, confirms the allusion to Rameau's nephew.

15 As in 'il change de langue et de palette . . .' (he changes language and palette . . .), *ibid.*, p. 185.

16 *Ibid.*, chap. 40, p. 245.

17 An example is Maupassant in his essay 'Le Roman', referred to in note 1 above. Maupassant's essay is regularly republished as it normally serves as a preface to his novel *Pierre et Jean*.

18 From Zola's *De la description* (1880). Hamon in *La Description littéraire* quotes this passage in context (p. 158).

19 Gershman and Whitworth, *Anthologie*, pp. 276–7.

20 For example in his preface to *Les Frères Zemganno*, *ibid.*, p. 270.

21 The expression 'les basses classes' is used by the Goncourts themselves in their preface (1864) to *Germinie Lacerteux*, a Realist manifesto to be found in any edition of the novel and in Gershman and Whitworth, *Anthologie*, pp. 264–6.

22 Satiat, *Charles Demailly*, pp. 115–16.

23 *Ibid.*, p. 117.

24 'Une image peinte', a painted image or picture, is the expression used in the quotation from Edmond de Goncourt's preface to *Chérie*. See note 19 above.

25 *Gavarni, l'homme et l'œuvre*, first published in 1873 but written before the death of Jules in 1870.

26 Published by Dentu, 213 pages.

27 The *quartier Bréda* is on the right bank, close to the Gare du Nord. Notre-Dame was a recent church, completed in 1836, and the word 'lorettes' was modern, dating from the end of the July Monarchy.

28 *Les Sœurs Vatard* (Paris, 10/18, 1985), p. 154.

29 His first novel, *Marthe* (1876), was also Realist, being considered suspiciously close in subject and treatment to Edmond de Goncourt's *La Fille Elisa* (1877), written 1875–76.

30 The fullest source for such information remains Robert Baldick's biography *The Life of J.-K. Huysmans* (Oxford, Clarendon Press, 1955).

31 Concerning this and other documentary aspects of Huysmans's Realism, see F. Zayed, *Huysmans: peintre de son époque* (Paris, Nizet, 1973).

32 The end of chap. 1, pp. 153–4 of the 10/18 edition (Paris, 1985), in which *Les Sœurs Vatard* is preceded by *Marthe*.

33 The topic of Huysmans and language was studied in detail by Marcel Cressot in 1938 in his linguistic study *La Phrase et le vocabulaire de J-K Huysmans*. Concerning language in Huysmans's *A rebours*, see Pierre Jourde, *Huysmans: 'A Rebours, l'identité impossible'* (Paris, Champion, 1991).

34 *Les Sœurs Vatard*, 10/18 edn, p. 287.

35 *Ibid.*, p. 287.

36 First published by Charpentier in 1883; 10/18 published an edition in 1976 (Paris) that also contains Huysmans's *Certains* (1889).

37 *L'Art Moderne* (Paris, 10/18, 1976), p. 129.

38 *Ibid.*, pp. 129–30.

39 In a celebrated letter to Henri Cazalis written in October 1864. For the complete text of the letter, see Mallarmé 'Correspondance', ed. H. Mondor (Paris, Gallimard, 1959), I, pp. 137–8.

40 In the so-called *Lettre du voyant* written to Paul Demeny, 15 May 1871; published in various editions of Rimbaud, for example Suzanne Bernard's edition, *Œuvres* (Paris, Classiques Garnier, 1962), p. 347.

41 Huysmans's *Le Drageoir aux épices* (1873) and *Croquis parisiens* (1880 and 1886) both contain prose poetry that is highly visual and related directly to visual works of art.

42 Valéry, *Degas, danse, dessin* (Paris, Gallimard, 1938), p. 146.

7

Dirt and desire:
troubled waters in Realist practice

WHAT are we to make of a cartoon dating in all likelihood from 1867 that shows a rather obsequious-looking Courbet greeting a dapper Manet accompanied by the black cat from his scandalous *Olympia* [22]?[1] Entitled 'Tableau de M. Manet pour l'année prochaine (*peinture de l'avenir*)', it is a pastiche of Courbet's own *La Rencontre* of 1854. That picture memoralised an intrepid young Courbet's arrival at Montpellier as the guest of his friend and patron Alfred Bruyas.[2] The cartoon juggles with this theme by showing a now older Courbet, dressed in a costume resembling the one worn by Bruyas and striking a similar pose, welcoming Manet on 'les

Tableau de M. Manet pour l'année prochaine (*peinture de l'avenir*). — M. Courbet accueille M. Manet dans les champs élyséens du réalisme.

Ils vont visiter ensemble l'intérieur du puits de Grenelle, dernier asile de la vérité moderne. *1865*

22] Puits de Grenelle cartoon (of Courbet/ Manet), 1867?

champs élyséens du réalisme'. The two artists, so the caption tells us, would like to visit 'l'intérieur du puits de Grenelle, dernier asile de la vérité moderne' (the interior of the well at Grenelle, the last refuge of modern truth). If this coupling of Realism and Elysian fields alerts us at once to a teasing subtext, then the well at Grenelle, shown behind Courbet on the left, raises other tantalising questions. It was in fact an old artesian well in the 15th *arrondissement*, sunk in the 1830s but not operative until 1841, which supplied Paris with a small amount of very pure but lukewarm water at a temperature of 26 degrees.[3] But why single it out as a metaphor for 'modern truth'? Its 'last refuge'?

That the subject of water supply and distribution should feature in a discourse on the 'modern' is not surprising. It was integral to the wider concern for sanitary reform which, as the nineteenth century drew on, increasingly occupied the attention of governments and municipal authorities. In Paris, the policy found an enthusiastic advocate in Napoleon III's Prefect of the Seine, Baron Eugène Georges Haussmann, who 'saw modernization of the water and sewage system as fundamental to the transformation of Paris into the "imperial Rome of our time"'.[4] Assisted by Eugène Belgrand, his head of Water and Sewer Services, the baron set about building new reservoirs in places such as Passy, Belleville and Buttes-Chaumont, and constructing a vast network of distribution pipes: by the end of his prefecture in 1870, over 840,000 metres of new piping had been layed down. To handle this increase in water, the city's sewer system was thoroughly reorganised and extended, growing some fourfold during the life of the Second Empire.[5]

So pleased was Haussmann with his achievement that, commencing in 1867, the year Paris played host to an Exposition Universelle, he opened his sewers to the public. Ensconced in modified cleaning trucks, dignitaries visiting the city and other curious sightseers were able to experience firsthand a subterranean world which, contrary to its dark and threatening evocation in Victor Hugo's popular novel *Les Misérables*, was well ordered and brightly lit. Yet even Hugo had to recognise that the sewers of the new Paris, the Paris of the early 1860s, were 'clean, cold, straight, and correct ... orthodox and sober',[6] the very antithesis to that which his character Jean Valjean in *Les Misérables* had experienced some thirty years earlier. And it was to this new underground that the photographer Nadar turned his lens in a series of remarkable photographs from 1861. 'His pictures of the channels, crossroads, arcades and machinery are clean-lined, geometric ... Just as there were (to his amazement and suspicion) no signs of rats or poisons here, there were also no hints of the mystery

or foulness that had inspired such horror of the "Stinkhole"'.[7] Yet as Donald Reid has pointed out, 'The long-standing metonymic use of sewer for filth persisted in the final decades of the nineteenth century, at precisely the time when open and overflowing sewers became things of the past. The sewer's improved capability to concentrate urban waste ironically enhanced its attraction as a signifier for all that was rotten and fetid in modern society'.[8]

Which returns us to the scenario of our cartoon – a visit to the interior of an artesian well – an oblique reference, surely, to the recently introduced tours of Haussmann's sewers.[9] If that much is now self-evident, then the other more elaborate issues under negotiation are certainly less so. As I have already said, the *puits de Grenelle* was sunk in the 1830s. Thus by describing it as the 'last refuge of modern truth', the cartoon not only embeds modernity in the recent past, but in a past which, like the pure but tepid waters issuing from Grenelle itself, is unsullied although not especially inviting – lukewarm, so to speak. That Courbet and Manet should be seeking 'vérité moderne' there and not in the new sewers may be read as an ironic comment on a basic Realist tenet – 'to be of one's own time'. The irony is further compounded, however, by the fact that Grenelle, as we have seen, signified the pure and the uncontaminated, concepts alien to the popular formulation of Realism. One neatly summed up by Louis Leroy in his satirical little book *Artistes et rapins*, where he noted, 'Tel réaliste qui se tire proprement d'un tas de fumier, échoue dans l'imitation d'un manteau de cour' (Such a realist who can quite happily cope with a dung-heap, fails when it comes to copying an ermine coat).[10]

Needless to say, my reading of the cartoon – an image that combines irreverence, irony and seriousness in varying degrees – is partial. But it does point to a time in which Realism was caught up in debates about past and present, about the 'health' of modern society, and about an aesthetic deemed to be vulgar and foul. It is this latter perception which is the agenda of another cartoon, one by Gill, that appeared on the cover of *L'Eclipse* on 29 March 1868 [23]. A caricature of the Realist writer and spokesperson Champfleury (Jules Husson), it shows him bathing his feet in a bowl of water (or is it a chamber pot?) on which is inscribed the word 'Réalisme'.[11] One foot is exposed and is being licked by a black cat with arched back and taunt tail, a reminder of the cat at the feet of the naked woman in *Olympia*. If the suggestion here is that Realism ought to clean itself up, it is no wonder that Manet's infamous painting of a prostitute be referenced. A view common among critics in 1865, as T. J. Clark has shown, was that Olympia was unwashed. 'Ce corps est sale',

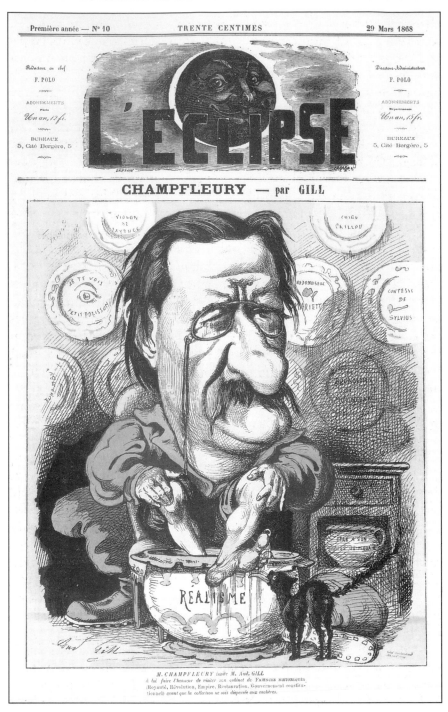

23] Gill Cartoon of Champfleury, cover of *L'Eclipse*, 29 March 1868

observed Aubert. 'The colour of the flesh is dirty', wrote Gautier, *père*. For Bertall, in a cartoon published in *L'Illustration*, Olympia was 'cette belle charbonnière' (this beautiful coal lady) 'whose modest outlines had never been outraged by water, that banal liquid'.[12] Manet's picture, it should be said, was not the only one that year to come in for such vitriol. Similar accusations were also levelled at the naked woman in Fantin-Latour's *Le Toast (Hommage à la Vérité)*. That work (now destroyed) depicted a gathering of artists, including Manet, Whistler and the engraver Félix Braquemond, presenting a bouquet of flowers to 'Truth', personified in the figure of a nude around whose head appeared the word '*vérité*'. Considered by critics to be a gathering of Realists (a judgement also passed on Fantin's *Hommage à Delacroix* of the previous year) the painting won few admirers.[13] Louis de Laincel mockingly called it *Amis de la Vérité*; related the bouquet in the picture to the one carried by the black woman in *Olympia* (an audacious comparison, since the latter was clearly a gift from a male client to a prostitute); and asked 'pourquoi, en fait de modèles, vont-ils [Realists], par exemple, choisir des femmes malpropres, et, après cela, reproduire jusqu'à la crasse qui enduit leurs contours?' (why do they [Realists] choose dirty women as their models and, having done so, reproduce even the grime which coats their contours?)[14]

'What is this Odalisque with a yellow stomach,' wrote Jules Claretie in *L'Artiste*, 'a base model picked up I know not where, who represents Olympia? Olympia? What Olympia? A courtesan no doubt.'[15] Although the term 'courtesan' was one of those ambiguous descriptions which could embrace a range of meanings, it by and large denoted a powerful and wealthy *femme fatale*.[16] At the opposite end of the scale to the courtesan was the low-class streetwalker, and for many commentators Olympia was exactly that. Thus Geronte saw fit to refer to her as 'cette Olympia de la rue Mouffetard'.[17] And the rue Mouffetard was certainly not a salubrious locale: 'cette rue sordide, puante l'été, boueuse l'hiver et sale de tout temps ...' (this squalid street, stinking in summer, muddy in winter and filthy throughout the year ...) was how the writer Charles Virmaître described it in 1868.[18]

Stench and filth were precisely the terms of reference for Bertall's outrageous cartoon of *Olympia* in the *Journal Amusant* (27 May 1865).[19] Entitled 'Manette, ou La Femme de l'ébéniste' (The cabinet-maker's wife), it removes Olympia from her sumptuous bed and places her in a grubby interior: the bed linen is unkempt; the mattress is shabby; and there is a chamber pot under the bed. Clearly this is not the boudoir of a prosperous courtesan, but rather the run-down

dwelling of a poor prostitute. Olympia's body is grotesque: she appears to be wearing a body stocking and a clown's mask; her right arm is ungainly and her feet ridiculously large. Here the working-class prostitute is turned into a figure of ridicule, while at the same time her female attributes are rendered ambiguous. The extended caption to the cartoon reads:

Ce tableau de M. Manet est le bouquet de l'Exposition. – M. Courbet est distancé de toute la longueur du célèbre chat noir. – Le moment choisi par le grand coloriste est celui où cette dame va prendre un bain qui nous semble impérieusement réclamé.

(This painting is the bouquet of the exhibition. – M. Courbet has been overshadowed by the celebrated black cat. – The moment chosen by the great colourist is that one where this lady is going to take a bath which she seems to need urgently.)

So this explains the steam clouds to the one side of the maid. Or perhaps these represent the foul smell rising from Olympia's absurdly large feet. Bertall's exaggeration of this part of her anatomy, incidentally, invites comparison with the similarly distorted feet of Christ in his caricature of Manet's other submission to the Salon, *Jesus insulté par les soldats.* That painting shows an all too real Christ, forlorn almost to the point of exaggeration, with His hands hanging limply to one side. He is surrounded by contemporary personages, including a powerfully built, barefooted soldier, eyes wide open and mouth ajar, who stares vacantly out at the spectator. Flesh and muscularity seem as much Manet's concern as the religious dimension of the work, a feature which may have prompted Bertall to dub the painting 'The Foot Baths', and portray Jesus as a rag-and-bone man (*chiffonier*) surrounded by 'four employees of the grand sewer collector'.[20]

Ragpickers, in fact, were part of that pantheon of undesirables which included prostitutes, sewermen, knackers and drain cleaners, 'comrades in stench . . . who worked with slime, rubbish, excrement, and sex . . .'.[21] Understandably, then, Bertall's caricature of Olympia associates her with this milieu. But it goes further, and turns the black maid's expression into a wide-eyed grimace, mimicking that of the agitated cat at Olympia's feet. Cartoon after cartoon pursued this theme, incriminating both Negress and *chat noir* in some frenzied erotic subtext. A theme consistent with the widespread belief in the voracious sexuality of the cat, especially the female of the species, as well as the rampant sexuality of black women.[22] Equally spurious was the view that Negroes exuded a distinct body odour, one unique

to their race. Carl Vogt put forward such a view in his *Leçons sur l'homme*, published in the very same year that *Olympia* was exhibited. He wrote: 'The exhalations from the skin also have their specific characteristics, which in certain races do not disappear in any circumstances, even the most scrupulous cleanliness ... the specific odour of the Negro remains the same whatever attention he pays to cleanliness or whatever food he takes.'[23] This 'specific odour', never pleasant, translates comfortably into Bertall's cartoon, where the odious smell from Olympia's feet swirls around the maid. She meanwhile looks goggle-eyed at whatever is hidden behind the oversize bouquet, an item which conceals Olympia's genitals, to be sure, but has little to do with 'feminine' modesty. The 'bouquet of the exhibition', indeed!

The underlying narrative of Bertall's obnoxious image was consistent with a dominant theme in the (male) discourse on prostitution, one which linked female sexuality, human excreta and disease.[24] An equation unambiguously articulated by Alexandre-Jean-Baptiste Parent-Duchâtelet, the public hygienist obsessed with the need to clean up the sewers of Paris (and, in fact, spent many hours doing research in them), who then turned his talents to a study of prostitution. In his influential *De la prostitution dans la ville de Paris* of 1837, Parent-Duchâtelet observed: 'Prostitutes are as inevitable in an agglomeration of men as sewers, cesspits, and garbage dumps; civil authority should conduct itself in the same manner in regard to the one as the other ...'.[25] In other words, both the prostitute – in her capacity as 'receiver' of male ejaculation – and other sites/receptacles of human waste required close monitoring and control.

Bertall's suggestion that Olympia was in dire need of a bath was echoed by the critic Ernest Filloneau in the *Moniteur des Arts*, who asked, 'Is Olympia waiting for her bath or the laundress?'[26] This reference to a laundress reappears, reformatted, in Jules Claretie's remarks published in *Le Figaro* on 20 June. He noted that during the last few days of the Salon Manet's *Venus with a cat* (*sic*) had been rehung (chased from 'her place of honour' by public censure), and now appeared 'above the huge door of the last room, where you scarcely knew whether you were looking at a parcel of flesh or a bundle of laundry'.[27] Notwithstanding the obvious association of laundry and dirt and hence the body of Olympia, it should be remembered that French middle-class culture had turned the laundress into a figure of loose morals and flirtatious behaviour. Eunice Lipton has examined the reasons behind this in her study of Degas where she suggests, among other things, that the sexualising of working-class women may have reflected bourgeois contempt and fear of the poor.[28] This turning

of the object of disdain into one of desire may help account, in part, for the extraordinary invectives hurled at Olympia.

Degas often depicted commercial ironers and washerwomen, but these representations, contrary to convention, are invested with little or no sexual content. There is physical exertion, drudgery, a hint of the picturesque poor and, just occasionally, a suggestion of lasciviousness. Which may shed light on why Maurice Chaumelin, reviewing Degas's work in the second Impressionist Exhibition of 1876, complemented him on his 'accurate and firm draughtsmanship', but said that his laundresses 'will never get my business: the laundry that they are ironing is repulsively dirty'.[29] One wonders what 'business' Chaumelin had in mind? And as for the 'repulsively dirty': echoes of the criticism levelled at Olympia. Nor should we forget that that particular woman was described as a 'coal lady', a sentiment expressed by Emile Pocheron in front of Degas's *A woman ironing* [24]: 'Degas offers us, among other delights, a laundress whose head and arms are almost black. The first thought the picture inspires is to make you ask yourself whether the coal seller is a laundress, or whether the laundress is a coal seller.'[30]

Black has no place in Emile Zola's paean to whiteness in the final chapter of his *Au bonheur des dames* (1883), where the modern emporium is presented as a shrine to Woman and to purity. A 'grande exposition de blanc' (great exhibition of household linen), Zola writes, was to mark the official opening of the refurbished *grand magasin*, Bonheur des Dames:

Rien que du blanc, tous les articles blancs de chaque rayon, une débauche de blanc ... Bientôt les yeux s'accoutumaient ... Autour des colonnettes de fer, s'élevaient des bouillonnés de mousseline blanche, noués de place en place par des foulards blancs. Les escaliers étaient garnis de draperies blanches ... Puis, le blanc retombait des voûtes, une tombée de duvet, une nappe neigeuse de larges flocons ... Et la merveille, l'autel de cette religion du blanc, était, au-dessus du comptoir des soieries, dans le grand hall, une tente faite de rideaux blancs, qui descendaient du vitrage ... cette décoration géante, qui tenait du tabernacle et de l'alcôve. On aurait dit un grand lit blanc, dont l'enormité virginale attendait ... Oh! extraordinaire! répétaient ces dames. Inouï![31]

(There was nothing but white, all the white goods from every department, an orgy of white ... Soon the eyes gew accustomed to it ... Around the iron pillars froths of white muslin were twining up, knotted from place to place with white scarves. The staircases were decked with white draperies ... From the domes the whiteness was falling back again in a rain of eider-down, a sheet of huge flakes of snow ... And over the silk counter in the main hall there was a tent made of white curtains hanging down from the glass roof, which was the miracle, the altar of this cult of white ... this

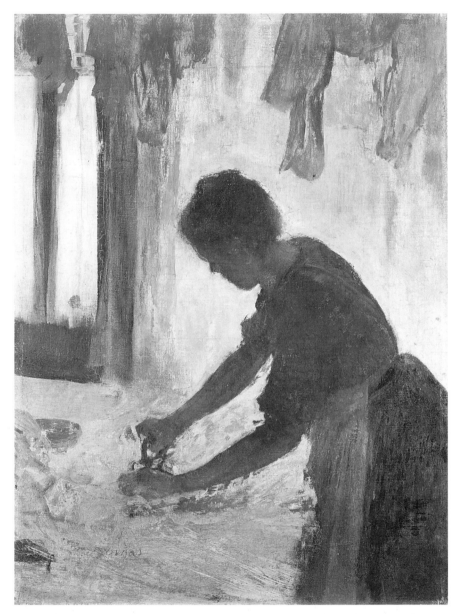

24] Edgar Degas *A woman ironing, c.* 1874

gigantic decoration, which smacked both of the tabernacle and the bed-room. It looked like a great white bed, its virginal whiteness waiting ...
'Oh! It's fantastic!' the ladies were repeating. 'Extraordinary!')[32]

And later in this same chapter, Zola describes the visit to the trous-seau department by the virtuous Denise Baudu, one of the central characters in the novel:

C'était, aux trousseaux, le déballage indiscret, la femme retournée et vue par
le bas, depuis la petite bourgeoise aux toiles unies, jusqu'à la dame riche
blottie dans les dentelles, une alcôve publiquement ouverte ... La femme se
rehabillait, le flot blanc de cette tombée de linge rentrait dans le mystère
frissonnant des jupes ... Puis, il y avait encore une salle, les layettes, où le
blanc voluptueux de la femme aboutissait au blanc candide de l'enfant: une
innocence, une joie, l'amante qui se réveille mère ... et des robes de baptême,
et des pelisses de cachemire, le duvet blanc de la naissance, pareil à une pluie
fine de plumes blanches.[33]

(The display in the trousseau department was lavish and indiscreet, it was
Woman – from the lower middle class woman in plain linen to the rich lady
smothered in lace – turned inside out and seen from below, a bed-chamber
exposed to the public eye ... And as Woman dressed herself again, the
white billows of this flood of linen once more were hidden beneath the
quivering mystery of skirts ... Beyond that there was still one more room,
the baby linen, where the voluptuous white of Woman lead to the guileless
white of a child: innocence, joy, the sweetheart who wakes up a mother ...
and christening robes, and cashmir shawls, white down like a rain of fine
white feathers.)[34]

We have travelled a considerable distance from the soiled sheets
and filthy body of Olympia, to another fiction where the uncontam-
inated, the clean, the sexually chaste is the order of the day. A world
Gustave Caillebotte alludes to in his seductive yet troubling *Rue de
Paris; temps de pluie*, included in the third Impressionist Exhibition
of 1877. An artist considered by some to be 'an Impressionist only
in name',[35] and by others a 'Realist as crude as but far more witty
than Courbet, as violent as but far more precise than Manet',[36]
Caillebotte's near life-size figures take their place in an environment
that is Haussmann through and through. The district he depicts was
once a sparsely populated area outside the city limits, but under the
Second Empire it was developed into a residential district for the
upper middle classes,[37] two of whom are foregrounded in the smartly
dressed Parisian couple who appear to be walking out of his picture.
With the exception of a working-class woman in a white apron and
a house-painter carrying his ladder (placed, respectively, in the neg-
ative shapes to the immediate right of the woman's and her escort's
head, and literally dismissed to the background), this painting is very
much about the identity of a particular class and its relationship to
the new Paris. It goes further, however, and offers an image of mod-
ernity which, as one critic in 1877 recognised, speaks of consumer-
ism, fashion and cleanliness in the same breath:

Continuons l'examen de la toile de M. Caillebotte: sur le pavé méticulie-
usement (*sic*) nettoyé et où j'ai peine à reconnaître mon vieux et toujours

gras pavé parisien, plusieurs groupes circulent . . . un monsieur et une dame, costume moderne, physionomies contemporaines, abrités sous un parapluie qui semble décroché fraîchement des rayons du Louvre et du Bon Marché.

(Let us continue the examination of Monsieur Caillebotte's canvas: on the meticulously clean paving stones, where I have difficulty in recognizing my old and always dirty Parisian pavement, several groups move about . . . a gentleman and a lady, modern dress, contemporary physiognomies, shelter under an umbrella that seems freshly taken from the racks of the Louvre and the Bon Marché.)[38]

It was at the Bon Marché and to a lesser extent its chief competitor, the Louvre, that Zola had in fact begun research for *Au bonheur des dames*. Dating from the 1830s but rebuilt along lavish lines in 1869, the Bon Marché was your quintessential *grand magasin*, 'selling consumption' on a grand scale, as Michael B. Miller has observed, but never loosing sight of respectability: 'Especially sensitive to charges of immorality because of its large Catholic and provincial clientele, the Bon Marché did its best to appear as chaste as a convent'.[39] An apt description, in many ways, of the 'monsieur et une dame' in Caillebotte's painting, who are forced into an intimacy imposed by their umbrella, but yet remain emotionally worlds apart. A genteel, orderly, controlled sexuality.

This sanitising, as it were, of desire, manifests itself literally in Zola's fiction where water, bathing and immersion often constitute the prelude or the context for sexual activity. In *La Curée*, a novel that scrutinises the speculator/café society of the Second Empire, Zola sets the tone for Madame Saccard's first lovemaking session with Maxime (a case of incest; he was her stepson) by describing in detail her daily ritual in the bath: 'Every morning Renée took a bath that lasted some minutes. This bath filled the dressing-room for the whole day with moisture, with a fragrance of fresh, wet flesh . . . When Renée left her bath, her fair-complexioned body added but a little more pink to all the pink flesh of the room.'[40] The young sweethearts, Miette and Silvere, in *La Fortune des Rougon* indulge in playful but provocative bathing *en plein air*: 'The river was but a source of enervating intoxication, voluptuous languor, which disturbed them strangely.'[41] While in *Germinal*, the miner Maheu, having been sexually excited by his wife in the course of her washing him, proceeds to make love to her: 'The bath always ended up like this . . .'.[42]

Degas often depicted women bathing: sponging their legs, stepping out of baths, attended by maids. In 1886, he exhibited his largest group of bather and toilette subjects in the eighth and last Impressionist Exhibition, held at 1 rue Laffitte from 15 May to 15 June.[43]

Listed as ten pastels in the catalogue, although apparently fewer were displayed, they were immediately singled out for sustained commentary [25]. That Degas had turned his back on the 'porcelain nymphs' of academic art was evident to all. 'As Realism, [the series] is complete. No artist will go further in the art of frightening the philistines.' For some, the pictures brought into question the very genre of the Nude: 'One could not categorise these violent photographs (sic) as nudes', wrote Jules Desclozeaux. 'It is nakedness not enlivened by any touch of obscenity, a sombre and gloomy nakedness ... a sad bestiality.'[44] Many reviewers opted for the label *malitournes* (slatterns), 'and thus characterised the figures as decidedly ugly and repulsive, probably poor, and indecent'.[45] The jump from this categorisation to prostitution was not great, a case made explicitly by Henry Fèvre: 'With fine and powerful artistic impudence Degas lays bare for us the streetwalker's modern, swollen, pasty flesh. In the ambiguous bedrooms of registered houses, where certain ladies fill the social and utilitarian role of great collectors of love, fat women wash themselves, soak themselves and wipe themselves off in basins as big as troughs.'[46]

The phrase 'great collectors of love' is surely not gratuitous; but a reference, one suspects, to the terminology of the underground, to the great collector sewers constructed by Haussmann and Belgrand to carry waste water to the Seine below Paris. The sewer analogy, which we have encountered before in Parent-Duchâtelet's writings on prostitution, is further reinforced by Fèvre's observation that the streetwalker fulfils a 'social and utilitarian role', in much the same way, one could extrapolate, as the sewers of the city.

Whether Degas set out to represent prostitutes, or, indeed, depicted them in actuality, is not at issue here. What does concern me is that for some reviewers in 1886 this identification was clear-cut.[47] One encouraged, perhaps, by the fact that he had shown women in the intimate act of washing their bodies; an activity associated more with 'regulated' brothels (*maisons de tolérance*) where registered prostitutes were required to bathe frequently, than the milieu of the *femme honnête*.[48] For her, the practice was irregular, entangled, as it was, in a matrix of societal conventions and beliefs which problematised personal ablutions.[49] These observations, incidentally, may have a bearing on the critics' reaction to Olympia. Their insistence that she was dirty and in need of a bath suggests that they took her for an unregistered prostitute (*insoumise*), one operating outside of the system of 'regulated' prostitution.

But 1886, of course, was not 1865. Public debate on prostitution had acquired a far greater visibility, with feminists taking a particularly vocal stance against regulationist policies.[50] At the same time, the

flames of regulationism were being fanned by a perceived threat of
large-scale venereal disease. Nonetheless, the commentary surround-
ing Degas's *Bathers* and Manet's *Olympia* shares much in common.
Emphatically male, it weaves its way through constructions of female
sexuality, of moral and physical well-being, of public and private beha-
viour, and of class. Concerns that underpinned J. K. Huysmans's
review of the *Bathers* published in 1889. His elaborate critique, as
Martha Ward has shown, moved from a consideration of the women's
public identities which he supposed to involve manual labour, to what
they did in their most intimate moments, provide 'pleasures', and then
wash the muck from their bodies. 'By the end of his essay filth had
become the aftermath of sex'.[51]

One wonders, then, what Huysmans and others would have made
of Caillebotte's *Man at his bath* [**26**], sent to Brussels in 1888 for the
exhibition of Les XX, but not in the show. If what an anonymous
writer implied in *La Chronique* is correct, the painting was removed
from public view and placed in a closet-like chamber.[52] Unlike
Olympia which, as we have seen, was taken from its 'place of honour'
in the Salon and rehung in a less conspicuous spot, Caillebotte's
picture was simply concealed – out of sight, out of mind. But per-
haps this act of concealment speaks volumes. The naked figure, seen
from the rear, vigorously dries himself; his clothing lies neatly on a
wooden chair with his boots nearby. Revealed beneath parted thighs
is the man's scrotal sac, shadowed; the vulnerability suggested here
is reinforced by his left leg which, in a movement barely detected at
first, bends inwards slightly at the knee.[53] The heavily impastoed,
rather grotesque shape at the bottom right (another towel or smock?),
adds to the aura of insecurity. Wet footprints conspicuous on the
floor emphasise the singularity of the person; it is *his* mark, on *this*
surface. Not the so-called dirty paw prints of Olympia's black cat;
nor the 'vérité' signalled by Fantin-Latour's female nude in *Le Toast*.
And not, for that matter, the 'vérité moderne' of the *puits de Grenelle*,
'pure' and 'unsullied'. But rather a hitherto unimagined 'vérité': one
inscribed in the body of an individualised male; one emphatically
'modern'; and one throwing into question the traditional 'gaze' of
men looking at naked women.[54]

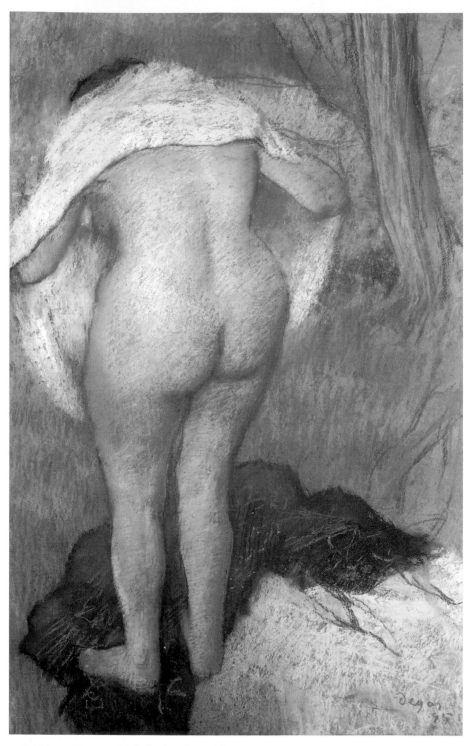

25] Edgar Degas *Girl drying herself*, 1885

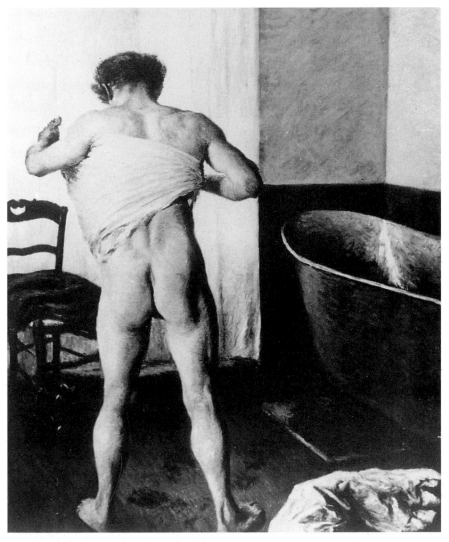

26] Gustave Caillebotte *Man at his bath (L'Homme au bain)*, 1884

Notes

This chapter is a revised and expanded version of a paper I first delivered at the Toulouse-Lautrec Symposia held in conjunction with the exhibition 'Toulouse-Lautrec: Prints and Posters from the Bibliothèque Nationale', Paris, which was shown at the Queensland Art Gallery, Brisbane, from 21 August to 6 October 1991, and then at the National Gallery of Victoria, Melbourne, and at the Bibliothèque Nationale, Paris. See Suzanne Grano (ed.), *Collected Papers: Toulouse-Lautrec Symposia* (Brisbane, Queensland Art Gallery, 1993), pp. 50–8. Thanks are owed to my research assistant, Eric Riddler.

1 The cartoon is in the Bibliothèque d'Art et d'Archéologie, Paris, Carton 59, Dossier 5, *Caricatures sur Manet et son œuvre*, where it is assigned to 1865. As will become clear from my discussion, this dating would seem incorrect.

2 See the exhibition catalogue *Gustave Courbet 1819–1877* (London, Arts Council of Great Britain, 1978), pp. 110–13.

3 See section entitled 'Service des Eaux' in Guy Durier (ed.), *Mémoires du Baron Haussmann*, 2 vols (Paris, n.d. [1890–93]), II, pp. 26 and 35.

4 D. Reid, *Paris Sewers and Sewermen: Realities and Representations* (Cambridge, Mass., and London, Harvard University Press, 1991), p. 29.

5 On Haussmann's transformation of Paris, see D. H. Pinkey, *Napoleon III and the Rebuilding of Paris* (Princeton, New Jersey, Princeton University Press, 1958). Also J. M. and B. Chapman, *The Life and Times of Baron Haussmann: Paris in the Second Empire* (London, Weidenfeld & Nicolson, 1957).

6 Victor Hugo, *Les Misérables* (London, Penguin Books, [1862] 1982), translation by Norman Denny, p. 1071.

7 S. Rice, 'Souvenirs', *Art in America*, 76:9 (1988), p. 166.

8 Reid, *Paris Sewers and Sewermen*, p. 49.

9 In 1867, the year that saw the commencement of tours of the sewers, both Manet and Courbet held private exhibitions: the former on the place de l'Alma, on the corner of the avenue Montaigne, and just across from Courbet's own pavilion. This additional information supports my proposition that the cartoon dates from 1867.

10 L. Leroy, *Artistes et rapins* (Paris, 1868), p. 60.

11 See A. Krell, *Manet and the Painters of Contemporary Life* (London, Thames & Hudson, 1996), p. 66. On the wall behind Champfleury are plates inscribed with the titles of some of his publications, for example *Chien-Caillou: fantaisies d'hiver* (1847), *Confessions de Sylvius* (1849) and *Le Violon de faïence* (1862).

12 F. Aubert, *Le Pays* (15 May 1865), quoted in T. J. Clark, *The Painting of Modern Life: Paris in the Art of Manet and his Followers* (London, Thames & Hudson, 1984), p. 96; T. Gautier, père, *Le Moniteur Universel* (24 June 1865), quoted in G. H. Hamilton, *Manet and his Critics* (New York, The Norton Library, [1954] 1969), p. 73; Bertall, *La Queue du chat, ou La Charbonnière des Batignolles*, in *L'Illustration* (3 June 1865), illustrated and quoted in Clark, *The Painting of Modern Life*, pp. 96, 145.

13 See the exhibition catalogue *Fantin-Latour* (Ottawa, National Gallery of Canada/ National Museums of Canada, 1983), pp. 177–92.

14 L. de Laincel, *Promenade aux Champs-Elysées; L'Art et la démocratie, Causes de décadence – Le Salon de 1865. L'Art envisagé à un autre point de vue que celui de M. Proudhon et M. Taine* (Roanne, 1865), pp. 13–14.

15 Hamilton, *Manet and his Critics*, p. 73.

16 See A. Krell, 'The fantasy of Olympia', *The Connoisseur*, 195:786 (1977) 297–302.

17 Geronte (pseud. of Victor Fournel), *La Gazette de France* (30 June 1865); quoted in Krell, 'The fantasy of Olympia', p. 300; Clark, *The Painting of Modern Life*, p. 97.

18 C. Virmaître, *Les Curiosités de Paris* (Paris, 1868), p. 17.

19 See Krell, 'The fantasy of Olympia', p. 301, and Clark, *The Painting of Modern Life*, pp. 96–7.

20 Bertall, *Le Journal Amusant* (27 May 1865); reproduced in Krell, *Manet*, p. 65.

21 A. Corbin, *The Foul and the Fragrant: Odour and the French Social Imagination* (London and Basingstoke, Picador, [1982] 1994), translated by Berg Publishers Limited and the President and Fellows of Harvard College, p. 145.

22 On cats and sexuality, see K. Kete, *The Beast in the Boudoir: Petkeeping in Nineteenth-Century Paris* (Berkeley and Los Angeles, University of California Press, 1994), pp. 115–35. Gustave Flaubert, among others, referred to the lasciviousness of black women in his *Dictionnaire des idées reçues*; see T. Reff, *Manet: Olympia* (London, Penguin, 1976), pp. 92–3.

23 Carl Vogt, *Leçons sur l'homme* (1865), quoted in Corbin, *The Foul and the Fragrant*, n. 90, p. 274.

24 See C. Bernheimer, *Figures of Ill Repute: Representing Prostitution in Nineteenth-Century France* (Cambridge, Mass., Harvard University Press, 1989).

25 A. J.-B. Parent-Duchâtelet, *De la prostitution dans la ville de Paris*, 2 vols (Paris, Baillière, 1836), II, pp. 513–14, quoted and translated in Bernheimer, *Figures of Ill Repute*, p. 16. See also A. Corbin, *Women for Hire: Prostitution and Sexuality in France after 1850* (Cambridge, Mass., and London, Harvard University Press, [1978] 1990), translated by A. Sheridan.

26 E. Filloneau, *Le Moniteur des Arts* (5 May 1865), quoted in Hamilton, *Manet and his Critics*, p. 72.

27 J. Claretie (pseud. of Jules Arsène Arnaud), *Le Figaro* (20 June 1865), quoted in Hamilton, *Manet and his Critics*, p. 73.

28 E. Lipton, *Looking into Degas: Uneasy Images of Women and Modern Life* (Berkeley, University of California Press, 1987), pp. 132–3.

29 M. Chaumelin, *La Gazette* (8 April 1876), quoted in C. S. Moffett *et al.*, *The New Painting: Impressionism 1874–1886* (Geneva, Burton and the Fine Arts Museums of San Francisco, 1986), p. 175.

30 E. Pocheron, *Le Soleil* (4 April 1876), quoted in Moffett, *The New Painting*, p. 175.

31 E. Zola, *Au bonheur des dames* (Paris, G. Flammarion, [1883] 1971), pp. 409–10.

32 Translation by A. Fitzlyon, E. Zola, *Ladies Delight* (London, John Calder, 1957), pp. 374–5.

33 Zola, *Au bonheur des dames*, p. 422.

34 A. Fitzlyon, *Ladies Delight*, pp. 386–7.

35 Anon., *La Petite République Française* (10 April 1877), quoted in Moffett, *The New Painting*, p. 209.

36 Maurius Chaumelin, *La Gazette [des Etrangers]* (8 April 1876), quoted in Moffett, *The New Painting*, p. 167.

37 See K. Varnedoe, *Gustave Caillebotte* (New Haven and London, Yale University Press, 1987), pp. 88–95.

38 E. Lepelletier, *Le Radical* (8 April 1877), quoted and translated in Varnedoe, *Gustave Caillebotte*, pp. 187–8.

39 M. B. Miller, *The Bon Marché: Bourgeois Culture and the Department Store, 1869–1920* (New Jersey, Princeton University Press, 1981), p. 220.

40 E. Zola, *The Kill (La Curée)* (London, Elek Books, [1872] 1969), translated by A. T. De Mattos, p. 162.

41 E. Zola, *The Fortune of the Rougons* (London, Chatto & Windus, [1871] 1898), translated by E. A. Vizetelly, p. 220.

42 E. Zola, *Germinal* (Harmondsworth, Penguin, [1885] 1956), translated by L. W. Tancock, p. 118.

43 See the analysis of the 1886 exhibition by M. Ward, 'The rhetoric of independence and innovation', in Moffett, *The New Painting*, pp. 421–42. A facsimile of the catalogue is reprinted on pp. 443–7. Also R. Thomson, *Degas: The Nudes* (London, Thames & Hudson, 1988), p. 131.

44 Maurice Hermel, *La France Libre* (27 May 1886); Firmin Javel, *L'Evénement* (16 May 1886); Jules Desclozeaux, *L'Opinion* (27 May 1866): all quoted in Moffett, *The New Painting*, pp. 452–3.

45 M. Ward, in Moffett, *The New Painting*, p. 431.

46 H. Fèvre, *Le Revue de Demain* (May–June 1886), quoted in Moffett, *The New Painting*, p. 453.

47 Eunice Lipton, *Looking into Degas*, has argued that the *Bathers* are in fact depictions of prostitutes. This view is countered by Norma Broude in 'Edgar Degas and French feminism, ca. 1880: "The young Spartans", the brothel monotypes, and the Bathers revisited', *The Art Bulletin*, LXX:4 (1988), p. 654. For Broude, Degas's images of ' "real" women', conforming 'to no ideal standard of feminine beauty', are 'women who are naked for no one but themselves'. Accusations of prostitution levelled at the *Bathers*, she suggests, were 'not only understandable but even necessary ones in a society that seems to have been virtually obsessed with the need to regulate "vice" in order to draw clear and recognizable distinctions between "good" and "bad" women'.

48 See Lipton, *Looking into Degas*, p. 169.

49 See Corbin, *The Foul and the Fragrant*, esp. chap. 11, pp. 176–99. Also the illuminating essay by A. Callen, 'Degas *Bathers*: hygiene and dirt – gaze and touch', in R. Kendall and G. Pollock (eds), *Dealing with Degas* (London, Pandora Press, 1992), pp. 159–85; and A. Callen, *The Spectacular Body: Science, Method and Meaning in the work of Degas* (New Haven, Yale University Press, 1995).

50 See Broude, 'Edgar Degas', p. 644.

51 Ward, in Moffett, *The New Painting*, p. 431.

52 See the entry on this painting by Gloria Groom in the catalogue *Gustave Caillebotte: Urban Impressionist*, ed. Adam Jolles (The Art Institute of Chicago, Abbeville Press, 1995), p. 216, published in conjunction with the exhibition of the same name held in Paris, Chicago and Los Angeles, 1995. G. Vigarello, *Concepts of Cleanliness: Changing Attitudes in France since the Middle Ages* (Cambridge, New York, Sydney, etc., Cambridge University Press, [1985] 1988), translated by Jean Birrell, p. 218, notes that 'The bathroom finally won space for itself, and appeared in some apartment houses after 1880'. Attitudes towards personal cleanliness changed during this period, encouraged by Louis Pasteur's discoveries of microbes and bacteria in the 1870s.

53 I am grateful to Malcolm Park for bringing this action to my attention.

54 The question of the 'gaze' in this and other works by Caillebotte is considered by Groom in *Gustave Caillebotte*, pp. 178–91.

MODERNITY AND IDENTITY

8 The dancer as woman: Loïe Fuller and Stéphane Mallarmé

IN comparison with Mallarmé, Loïe Fuller is an obscure figure. In her day, however – she made her debut at the Folies-Bergère in 1892 – Fuller dazzled her audiences, including numerous writers and artists (among them Mallarmé, Yeats, Rodenbach, Rodin, Toulouse-Lautrec and Whistler), and came to epitomise for many the spirit of Art Nouveau. Her friends and admirers also included scientists, notably Pierre and Marie Curie, and the astronomer Camille Flammarion. Anatole France credited her with formulating 'a considerable theory of human knowledge and philosophy of art', while Rodin described her as 'a woman of genius'.[1] When she presented a dance to the music of Debussy's *Nuages* at the inaugural concert of the Théâtre des Champs-Elysées in 1913, Debussy commented that it was the first time he had heard his music really played.[2] Recently, partly as a result of the famous few pages which Mallarmé wrote about her, Fuller has once again entered the critical limelight.[3]

Mallarmé in fact wrote very little on dance and had no special credentials in this field, and if he is nonetheless still revered – and widely published[4] – as a critic and theoretician of dance, this is largely because he brought to dance theory a level of sophistication directly related to his thoughts on language and writing. Moreover, the 'danseuse' was a prominent figure in the cultural life of nineteenth-century France, and is a focal point for contradictions and paradoxes in myths of femininity which come into play in Mallarmé's writings on dance.

Dancing was frequently associated with a seductiveness natural to women, as in Baudelaire's poem 'Le Serpent qui danse' (The Dancing Serpent): 'et quand elle marche, on croirait qu'elle danse' (and when she walks, it's as if she were dancing).[5] The art of the ballet dancer, who was typically female, could itself be judged in terms of its 'femininity', rather than as the product of cerebral creativity or artistic skill and techniques. Berthe Bernay, a ballerina, wrote in 1890 that

'aux yeux inexpérimentés des spectateurs, la *femme* prime souvent l'artiste. C'est celle-là que le public applaudit souvent plus que celleci' (original emphasis) (To the inexperienced eye of the spectator, the *woman* often takes precedence over the artist. It is the former rather than the latter whom the public applauds).[6] She cited Balzac's belief that 'la danse est une manière d'être' (dance is a way of being).[7] In fact, training was rigorous, and the reality of life as a professional ballerina was harsh. The majority came from lower-class backgrounds, had to work extremely hard, were very poorly paid and were easy prey for rich gentlemen admirers. At the Opéra, privileged male visitors were allowed to watch the performance from backstage, where they could also mingle freely with the dancers.

It is instructive to read Gautier's discussions of ballet dancers, where he declares that 'the first quality that a dancer should possess is that of beauty; she has no excuse for not being beautiful and she can be reprimanded for her plainness'.[8] Since the dancer's body is itself the material of her art, to comment on its shape is no different from commenting on, say, the structure of a line of verse. It is therefore acceptable for Gautier to discuss, often in scathing terms, intimate anatomical details of dancer's bodies. The dancer's persona commanded scant respect, and the 'sorte de discrédit' (kind of disrepute) which surrounded her also facilitated her association with the image of the 'femme fatale'.[9] Indeed, the figure of the dancer was frequently linked with that of the courtesan, thereby personifying both a social and a mythical evil. The dancer, like the prostitute, held power over men by making them slaves to their own desire. Lorrain writes of prostitutes: 'ce sont elles, les vraies, les éternelles ... *danseuses* ...' (It is they, the true, the eternal ... *dancers*).[10]

The kinds of fears aroused by prostitution, which were at their height in France in the 1860s and 1870s, fed into a myth of woman as embodying evil powers of seduction which were both more and less than human. It is well known that the late nineteenth century saw a 'huge investment of the masculine imagination and symbolism in the representation of women'.[11] Symbolic projections, unlike real women who made concrete political and economic demands, could be controlled by the (male) imagination. The art of ballet contributed to the investment in symbolic representations of women. Outwardly, it seemed as if women occupied a superior position in ballet. 'The conventions of the modern "classical" ballet, with the performance organized around the leading female soloists and a female *corps de ballet*, were to a large extent established in Paris during the 1820s and 1830s ... this so-called Romantic ballet took traditional fairy tale-like narratives, and adapted them so that a woman would come at the

centre of the action. The female prima ballerina is the hero, the prince or lover usually no more than her foil'.[12] However, ballet's dominant institutions were in the hands of men, who controlled both financial management and choreography, and this is reflected in women's roles as living symbols of male ideals. Heavily influenced by Romanticism, classical ballet in the nineteenth century presented a highly idealised image of woman, as 'the symbol of moral and physical beauty',[13] in stark contrast to the realities of women's back-stage and off-stage lives.

Like Isadora Duncan and Ruth St Denis, Loïe Fuller was both dancer and choreographer and founded and managed her own company. This combination of dancer and choreographer in one person (usually a woman), which was a feature of early modern dance, was in striking contrast to the ballet tradition. In 1908–09, Fuller formed into a school the all-female troupe of dancers who had toured with her after the 1900 Paris Exhibition. Giles Dusein comments of Fuller that 'elle ne vit qu'entourée de femmes, reine d'une cour qu'Isadora Duncan décrira dans ses mémoires … les danses de Loïe Fuller imposent le culte de la femme. L'homme y est complètement absent' (she lives surrounded only by women, the queen of a court which Isadora Duncan will describe in her memoirs … Loïe Fuller's dances impose the worship of woman).[14] He also comments on Fuller's lesbianism: it has been suggested that had it not been for this, she would have achieved wider recognition as a founder of modern American dance.[15]

By all accounts, Fuller was a most feisty character. Arsène Alexandre described her behaviour during the construction of the special theatre dedicated to her at the 1900 Paris Exhibition:

On ne connaissait pas l'énergie et l'entrain de la Loïe. C'est ce qu'on appelle 'a very pushing (sic) woman'. La construction qui devait durer six mois, au dire des gens experts, a duré six semaines. Pendant ce temps, Miss Fuller a été architecte, peintre, décorateur, machiniste, électricien, *manager* et le reste.[16]

(People didn't realize the strength of Loïe's energy and spirit. She was what is called 'a very pushing (sic) woman'. The construction which according to the experts should have taken six months lasted six weeks. During this time, Miss Fuller was architect, painter, decorator, stagehand, electrician, *manager* and the rest.)

Enormous energy, endurance and technical skill were qualities essential to Fuller's performances, which involved far more than dancing in the conventional sense. Fuller had discovered, while playing with the movement of silk and light in front of a mirror, that she could create abstract patterns based on correlations between particular movements in the silk and harmonised lighting effects. The dance

technique which resulted from this discovery required the manipulation of huge volumes of gossamer-like silk, achieved by means of wands which acted as an extension of the dancer's arms, in combination with complex lighting. The actual manipulation of the material using the wands required great physical strength. Fuller claimed that she was twice threatened with paralysis of the arms.[17] Her dance 'The Lily of the Nile' (1895) used 500 yards of gossamer-thin silk and could radiate 10 feet from her body in every direction and be thrown up to 20 feet. The wands used in this dance were very long, and at the very end of the dance she formed the figure of a colossal white lily.

In the early 1880s, theatres began converting from gas to electric light (Edison invented the incandescent lamp in 1879), and Fuller's performances would have been impossible without electricity, which at this time had an almost magical aura. Although in the early part of her career Fuller's dances were solos, she had to manage a large team of electricians, sometimes as many as forty. Fuller herself described her art in terms of 'light, colour, motion and music',[18] and it was the prominence of complex lighting effects in her work which necessitated the presence of so many electricians. In her performances, lighting itself replaced conventional stage décor. The stage was draped with black silk, and the auditorium was plunged into complete darkness. Her 'Fire Dance' (1895) required fourteen electricians, to whom she gave instructions during the performance by 'gestures, taps of the heel, and other signals worked out between them'.[19] She created further stunning effects by projecting lights through slides decorated with coloured gels, or glasses, which could be used singly or together. She discovered the effect of blended lights, arranging colours as if they fell on her through a prism. A *New York Times* review of 1896 referred to 'the refraction of different coloured lights crossing and recrossing each other in bewildering and exquisite combinations'.[20]

Fuller also pioneered unusual staging techniques, whose effects astounded her audiences. In her 'Mirror Dance' of 1893, she created a complex structure of mirrors on stage (patented in 1895 as 'Theatrical Stage Mechanism'), whereby four obliquely positioned, mutually reflecting mirrors placed in a semicircle at the back of the stage reflected the lights, the dancer, the stage floor and the ceiling. In 1894, she patented an extremely complex system of double-stage flooring, where spotlights were shone upwards through glass openings in the upper layer, and where the dancer was positioned on a circular platform raised above the stage, itself comprising a glass inset which could also function as a mirror. Another patented device (1900) was a glass wall erected between the audience and the stage, combined with mirrors placed diagonally to meet at the back of the stage,

forming a triangle, with further glass walls fitted into the corners of the triangle, thereby creating a prismatic space. When the auditorium was completely dark, and the stage brightly lit, the invisible glass wall functioned as a mirror for the dancer and in turn projected its reflections on to the diagonal mirrors behind, in which the audience perceived the dancer as a disembodied, kaleidoscopic series of images. Alternatively, when the stage was dark and the auditorium lit, the audience could see itself reflected in the invisible glass wall at the front of the stage.[21]

In the earlier dances, Fuller's light projections and magic lantern slides were used to create naturalistic images. Her 'Fire Dance' (1895) used to great effect her device of 'underlighting' (patented in 1893), where the projection of red lights from below, which slowly crept upwards, created the impression that the dancer was being consumed by flames. As time went on, Fuller's lighting effects, and also the dances themselves, became increasingly abstract. In 'The Sea' of 1925, choreographed to the music of Debussy, the performance consisted solely of light, silk, music and movement. The staircase of the Grand Palais was covered with shimmering fabric, and 'the dancers were never seen but served only as a means of controlling the movement of a boundless sea of silk'.[22] Fuller wrote in her autobiography: 'The question of illumination, of reflection, of rays of light falling upon objects, is so essential that I cannot understand why so little import-ance has been attached to it.'[23] She had a laboratory of her own, where, she said, she employed six men, and on which she spent all her savings, science being 'the great scheme of my life'.[24] It was there that she dis-covered the technique of treating fabric with fluorescent salts mixed with paint to make it glow, an effect which she used in her 'Radium Dance', which was first performed on stage in 1904. Her techniques were also based on direct observation, trial and error. 'I began in utter ignorance of the effect of one colour on another, and had to learn as a painter does what colours gained by union, and what colours were ruined by the other. The effect that you saw last evening represents years of patient study, endless experimenting and hard work.'[25]

Contemporary accounts of Fuller's late performances emphasised their dramatic synaesthetic effects and their capacity to evoke differ-ent art forms. Writing on Fuller, Roger Marx referred to 'cette statuaire animée' (this animated statuary), and declared that 'grâce à elle, la danse est redevenue ... l'art digne, selon Lamennais, "de lier la musique à la statuaire et à la peinture"' (thanks to her, dance has once again become ... the art which is worthy, according to Lamennais, 'of linking music to statuary and painting').[26] In 1912, Claude Marx wrote of 'la musique visuelle' (visual music) and 'la musique qui se

déploie dans le silence' (music which unfolds in silence).[27] Louis Vauxcelles, having seen the tremendous light displays Fuller composed in 1914 for Stravinsky's 'Le Feu d'artifice', wondered: 'est-ce là orphisme, simultanisme? Je ne sais. Les arabesques *vivent*, alors que les toiles orphiques sont inertes et glacées' (original emphasis) (is this orphism, simultanism? I don't know. The arabesques *live*, whereas orphic canvases are inert and frozen).[28] Another critic spoke of 'une orchestration des couleurs', where 'les tons et les lumières sont pris comme autant de notes' (an orchestration of colours, where tones and lights are treated like so many notes).[29] Henry Lyonnet described 'une véritable symphonie de couleurs appliquée aux étoffes' (a veritable symphony of colours applied to the fabrics), declaring that Fuller's art consisted in modulating nuances as one does with tones.[30] The sculptor Pierre Roche affirmed that one could not qualify as a 'simple danseuse' (mere dancer) an artist who used colours on stage as she did:

Ces foyers lumineux de nuances précieuses étaient comme autant de couleurs posées sur une palette, l'ordre dans lequel elle les faisait agir séparément ou simultanément n'était ni plus ou moins que le geste du peintre qui pose, en un point déterminé de son tableau, les taches de couleur qui doivent lui donner sa vibration harmonieuse et sa vie.[31]

(These luminous, fiery centres of precious nuances were like colours on a palette: the order in which she made them act separately or simultaneously was neither more nor less than the gesture of a painter who places, in a precise point of his picture, the patches of colour which give it harmonious vibration and life.)

Clearly, Fuller's art overstepped established genre boundaries. Indeed, the programme notes by Léo Claretie of 14 May 1914, for Fuller's performance at the Théâtre Municipal du Châtelet, proclaimed as much: 'Oui, ici s'impose véritablement un spectacle délivré des formes esthétiques connues, les unissant et les détruisant tout ensemble et défiant toute qualification' (Yes, here is truly established a spectacle which has freed itself from known aesthetic forms, both uniting and destroying them and defying all description).[32] Carol-Bérard, an advocate of theatrical synaesthesia of music, movement, light and space, in his *La Couleur en mouvement, décor rationnel de la musique* (1922) (*Colour in Movement, Rational Décor of Music*) recognised in Fuller's art the only realisation of his vision of 'Chromophonie' as an art of the future, which would involve 'l'union des vibrations sonores et des vibrations lumineuses' (the union of sonorous and luminous vibrations).[33] Fuller anticipated effects used later by Gordon Craig and Adolphe Appia, notably Appia's concept

of using light to project colour, his emphasis on the close relation between space and light as important elements in staging, and his active, painterly use of light.[34] Recently, in *Libération*, a critic declared:

Art cinétique, multimédia, abstrait, performance, interactivité, danse contemporaine, à la fin du dix-neuvième siècle, Loïe Fuller avait déjà tout inventé ... Elle inventait l'art cinétique (en animant des matières textiles), l'art électrique (en projetant sur elle-même des lumières), l'art abstrait (en concevant des tâches lumineuses sans figuration): l'art all-over (ses visions sont mouvantes, sans épicentre, sans entrée ni sortie).[35]

(Cinematic art, multimedia, abstract, performance, interactivity, contemporary dance: at the end of the nineteenth century, Loïe Fuller had already invented everything ... She invented cinematic art (by animating fabrics), the art of electricity (by projecting lights on herself), abstract art (by conceiving non-figurative light spots), all-over art (her visions are mobile, without epicentre, without entry or exit.)

These claims, taken in conjunction with contemporary nineteenth-century accounts, convey to us something of the stunning impact of Fuller's innovations.

In these tributes to her late work, which created remarkably abstract effects, Fuller is not seen as a mere 'danseuse', but rather as a synaesthetic artist. Many of her earlier dances, however, where she metamorphosed into myriad organic shapes, fed into the mythification of the female dancer as idealised Nature, epitomised in the curving lines of Art Nouveau flower imagery, or as the seductive and terrifying *femme fatale,* epitomised in the figure of the dancer as 'Salomé'. Jean Lorrain wrote of her 'Fire Dance' (1895):

Loïe Fuller does not burn ... she is flame itself. Standing in a fire of coals, she smiles and her smile is like a grinning mask under the red veil in which she wraps herself, the veil which she waves and causes to ripple like a fire over her lava-like nudity; she is Herculaneum buried beneath the ashes, she is the Styx and the shores of Hades, she is Vesuvius with its gaping jaws spitting the fire of the earth, and she is Lot's wife transfixed in a statue of salt amid the avenging conflagration of the five accursed cities, this motionless and yet smiling nakedness among the coals with the fire of heaven and hell for a veil.[36]

Georges Rodenbach, whom Mallarmé admired, wrote a poem entitled 'La Loïe Fuller', also inspired by the Fire Dance, which contains the lines:

> O tronc de la Tentation! O charmeresse!
> Arbre du Paradis où nos désirs rampants
> S'enlacent en serpents de couleurs qu'elle tresse!

(Oh trunk of Temptation! Oh charmer!
Tree of Paradise where our creeping desires
Intertwine in serpents of colours which she weaves!)

In an article entitled 'Danseuses', published in *Le Figaro* in 1896 and referred to admiringly by Mallarmé (*MOC*, 311),[37] Rodenbach evoked Salomé as the 'type légendaire et définitif de la danseuse' (the legendary and definitive type of the dancer) and argued that, as Mallarmé had affirmed, the dancer is not a woman, but a metaphor, and should therefore not be represented naked, which would cause her to be seen as a mere woman, rather than as 'le Symbole de l'Eternel Féminin que la femme incarne' (the Symbol of the Eternal Feminine which woman incarnates).[38] More than any other woman, the 'danseuse' incarnates this myth of womanhood. According to Rodenbach, 'la Danseuse est celle qui assume, en un éclair, la beauté, le péché, la tentation de toutes les femmes, et l'illusion qu'on les connaîtra toutes en elle!' (the Dancer is she who assumes, in a flash, the beauty, the sin, the temptation of all women, and the illusion that one will know them all in her!). The sight of naked flesh is 'tentante d'être intermittante' (tempting for being intermittent), and 'la Danseuse n'est soi-même que si elle est voilée' (the Dancer is herself only if she is veiled): she is seen as an embodiment of 'l'éternel Désir'.[39]

Even if, as in Mallarmé, the dancer is seen not as a woman but a metaphor,[40] it is precisely the body of the *female* dancer, with its capacity to create and sustain desire by combining concealment and revelation, which enables dance to function as the paradigm of metaphor and symbol. The paradoxical combination of the *presence* of the body of the 'danseuse' with its physical displacement through movement and the imaginary metamorphoses projected by the spectator is central to Mallarmé's fascination with her. Mallarmé, like Paul Valéry, who was strongly influenced by Mallarmé's ideas on dance, was captivated by the self-transformation of the body through movement in the act of dancing and by the 'figurative' dimension of this process. These concepts emerge in Valéry's Socratic dialogue 'L'Ame et la danse', which, although not explicitly about Fuller, was probably inspired by her.[41]

Comme il [ce corps] détruit furieusement, joyeusement, le lieu même où il se trouve, et comme il s'enivre de l'excès de ses changements ... Etant chose, il éclate en événements! – Il s'emporte! ... ce corps ... se donne forme après forme, et il sort incessamment de soi! Le voici enfin dans cet état comparable à la flamme ... Cette femme qui était là est dévorée de figures innombrables.[42]

(How it (this body) destroys furiously, joyously, the very place where it finds itself, and how it intoxicates itself with the excess of its changes ...

Being a thing, it explodes in events! – It is carried away! ... this body ... gives itself form after form, and incessantly goes out of itself! Here it is finally in that state comparable to flame ... This woman who was there is devoured by innumerable figures.)

Here, the body, which is nothing more than itself ('le corps qui est ce qui est'), 'veut jouer à l'universalité de l'âme' (the body which is what is ... wishes to play at the universality of the soul).[43] 'La grande Danse ... n'est-elle point cette délivrance de notre corps tout entier possédé de l'esprit du mensonge ... et ivre de la négation de la nulle réalité?' (Is not the great Dance ... this deliverance of our entire body, possessed by the spirit of the lie ... and intoxicated by the negation of null reality?).[44] Through movement, the body ceases to be mere body. The transforming power of dance is seen as independent of the individual performer, almost as a divine gift, bestowed despite the lowly intellectual status of its (female) recipient.

> O Flamme! ...
> – Cette fille est peut-être une sotte? ...
> O Flamme!
> – Et qui sait quelles superstitions et quelles
> sornettes forment son âme ordinaire?
> – O Flamme, toutefois! ... Chose vive et divine! ...[45]
>
> (Oh Flame! ...
> – This dancer is perhaps a silly girl? ...
> Oh Flame!
> – And who knows what superstitions and
> tall stories fill her ordinary soul?
> – Oh Flame, nonetheless ... Living and divine object!)

The 'danseuse' is thus seen to vacillate between a natural state of mindless corporeality and the status of a quasi-divine being. These extremes, where on the one hand the body is mere matter, devoid of spirituality, and on the other it transcends itself through motion (a material rather than an intellectual means) and through stimulating the spectator's imagination, coincide in dance. This is not only because dance is an art of the body, but also because the agent performing it is typically female and therefore embodies a tension between the extremes of pure corporeality and disembodied ideal. The movement of dance enacts this tension and transformation, which reflect the very process of metaphorical transformation itself.

Although it is expressed in a far less direct manner than in Valéry (suggested rather than stated, as Mallarmé would have it),[46] the self-transformation of the body through motion is also central to Mallarmé's discussion of Loïe Fuller. When writing on ballet, Mallarmé emphasises the hieroglyphical character of the dancer, seen

as an 'incorporation visuelle de l'idée' (a visual incorporation of the idea) (*MOC*, 306): dancing is an 'écriture corporelle' (a corporeal writing) and the dance is a 'poème dégagé de tout appareil du scribe' (a poem completely detached from the scribe's apparatus) (*MOC*, 304). In Fuller, however, what fascinates him is the dancer's expansion, through her drapes, into space, creating a new relationship between body and space, where one seems to be an extension of the other. 'Qu'une femme associe l'envolée de vêtements à la danse puissante ou vaste au point de les soutenir, à l'infini, comme son expansion – La leçon tient en cet effet spirituel' (That a woman associates the flight of clothes with the powerful or vast dance to the point of sustaining them, to infinity, like her expansion. The lesson consists in this spiritual effect) (*MOC*, 308). It seems as if the dancer creates space out of herself: 'L'enchanteresse fait l'ambiance, la tire de soi et l'y rentre, par un silence palpité de crêpes de Chine' (The enchantress creates the ambiance, draws it from herself and returns it there, in a silence fluttered with crêpe de chine) (*MOC*, 309). The movement of the 'crêpes de Chine' enables this process to take place, fragmenting and dispersing the dancer's presence into a light, airy, almost immaterial substance. The critic Jean-Pierre Richard has pointed out Mallarmé's fascination with the processes of 'volatilisation' and 'gazéification' (volatilisation and gasification)[47] and links these processes with the substance 'écume' (foam), which Mallarmé associates with the 'Danseuse', when he refers to her as a 'mouvante écume suprême' (supreme moving foam) (*MOC*, 322), and in his poem 'Billet à Whistler' (Note to Whistler), where he describes the dancer as a 'tourbillon de mousseline ou/Fureur éparse en écumes' (whirlwind of muslim or/Fury scattered in foams).

The whirling lightness of the dancer who creates her own décor is, for Mallarmé, a most welcome change from the heavy scenery of the ballet stage. He laments that in ballet 'le charme aux pages du livret ne passe pas dans la représentation' (the charm of the libretto does not carry through to the performance) and continues, referring to imaginary snow and flowers: 'la Poésie, ou nature animée, sort du texte pour se figer en des manœuvres de carton et l'éblouissante stagnation des mousselines lie et feu' (Poetry, or animated nature, emerges from the text to be fixed in manœuvres of cardboard and the dazzling stagnation of chiffon dregs and fire) (*MOC*, 303). By contrast, he writes of Fuller:

Quand, au lever du rideau dans une salle de gala et tout local, apparaît ainsi qu'un flocon d'où soufflé? furieux, la danseuse: le plancher évité par bonds ou dur aux pointes, acquiert une virginité de site pas songé, qu'isole, bâtira,

fleurira la figure. Le décor gît, latent dans l'orchestre, trésor des imaginations. (*MOC*, 308)

(When, at the rise of the curtain in a gala hall and every premises, there appears like a flake blown from where? furious, the dancer: the floor avoided by jumps or hard on *pointe*, acquires an undreamed-of virginity of site, which the figure isolates, will build, flower. The décor lies, latent in the orchestra, treasure of imaginations.)

Here, the stage is free of unnecessary encumbrances, and can be transformed by the spectator's imagination into a fictive space. 'La scène libre, au gré de fictions, exhalée du jeu d'un voile avec attitudes et gestes, devient le très pur résultat' (The free stage, as fictions dictate, exhaled from the play of a veil with attitudes and gestures, becomes the very pure result) (*MOC*, 309). This transformation of space is also synaesthetic: the movement of Loïe Fuller's veils corresponds to that of the orchestra, bringing about a 'transition des sonorités aux tissus' (transition of tones to fabrics) (*MOC*, 308).

The displacement of physical presence through movement also involves figurative transposition. The dancer metamorphoses before the spectator's eyes, conjuring up kaleidoscopic visions and evoking emotions: 'Sa fusion aux nuances véloces muant leur fantasmagorie oxhydrique de crépuscule et de grotte, telles rapidités de passions, délice, deuil, colère' (Her fusion with swift nuances metamorphosing their oxhydric phantasmagoria of dusk and grotto, such rapidities of passions, delight, mourning, anger) (*MOC*, 308). In this process, her individual being is all but dissolved.

Ainsi ce dégagement multiple autour d'une nudité, grand des contradictoires vols où celle-ci l'ordonne, orageux, planant l'y magnifie jusqu'à la dissoudre: centrale, car tout obéit à une impulsion fugace en tourbillons, elle résume, par le vouloir aux extrémités éperdu de chaque aile et darde sa statuette, stricte, debout – morte de l'effort de condenser d'une libération presque d'elle des sursautements attardés décoratifs de cieux, de mer, de soirs, de parfum et d'écume. (*MOC*, 309)

(Thus this multiple clearing around a nudity, great with the contradictory flights where the nudity orders it, stormy, gliding, magnifies it to the point of dissolving it: central, for everything obeys a fleeting impulse in whirl-winds, she resumes, by willing it at the extremities of each headlong wing and shoots her statuette, strict, upright – dead from the effort of condensing in a liberation almost from her of belated decorative bursts of skies, of sea, of evenings, of perfume and of foam.)

Here there is a perfect match between the physical tensions of opposing movements (the 'contradictoires vols' – contradictory flights), between contrasting dispersal and synthesis, dynamism and stillness,

and between the ontological tensions towards multiplicity ('ce dégagement multiple' – this multiple clearing) and singularity ('une nudité' – a nudity), self and otherness: 'une libération *presque* d'elle' (a liberation *almost* from her: my emphasis). Both sets of tensions are provoked by material, visual means, but have direct parallels with metaphorical transformations in language, which involve semantic dynamism and imaginary transformations. Seen in this way, the 'danseuse', here Loïe Fuller, is indeed a living metaphor: not herself, but a dynamically self-metamorphosing series of images. 'La danseuse *n'est pas une femme qui danse . . . elle n'est pas une femme*, mais une métaphore' (original emphasis) (The dancer *is not a woman who dances . . . she is not a woman,* but a metaphor) (*MOC*, 304).

It is certainly not coincidental that Mallarmé was sensitive to the processes of ontological visual transformation in Fuller's art, which were crucial to his own poetics of the text, which, like the objects to which it alludes, is subjected to a 'presque disparition vibratoire selon le jeu de la parole' (an almost vibratory disappearance according to the play of speech) (*MOC*, 368).[48] One can only speculate as to how Mallarmé would have responded to Fuller's later, more abstract performances,[49] but he would surely have been amazed and delighted, especially by her experimentation with the interplay of light, reflection and movement, creating mobile, prismatic spaces. He might also have been led to reassess his view of the art of dance as unconscious and instinctive, a view which is already coming under pressure in his discussion of Fuller. In relation to the ballet, Mallarmé takes pleasure in the paradox that while dance is an 'écriture corporelle' (corporeal writing) and the spectator 'reads' the ballet, the ballerina herself is 'illettrée' (illiterate) and an 'inconsciente révélatrice' (an unconscious revealer) (*MOC*, 307). Not only was this patently not the case with Fuller, but she was also a consummate technician. Mallarmé acknowledges the coming together of aesthetics and technology in her art ('l'exercice . . . comporte une ivresse d'art et, simultané un accomplissement industriel' – the exercise . . . comprises an intoxication of art, and simultaneous an industrial accomplishment (*MOC*, 307): he is also intrigued to know by what means Fuller produces her effects: 'on rêve de scruter le principe' (one dreams of scrutinising the principle) (*MOC*, 309). He hesitates between describing her as unconscious or self-aware: 'ma très peu consciente ou volontairement ici en cause inspiratrice' (my very little conscious or voluntarily here initiator in question) (*MOC*, 308), but then refers to 'le sortilège qu'opère la Loïe Fuller, *par instinct*' (the spell which Loïe Fuller operates *by instinct*) (*MOC*, 309, my emphasis).

The extent of Mallarmé's respect for dance as an art form can be seen in his reproach to Wagner for neglecting 'la Danse seule capable, par son écriture sommaire, de traduire le fugace et le soudain jusqu'à l'Idée' (the Dance alone capable, by its summary writing, of translating the fleeting and the sudden as far as the Idea), where he even goes so far as to proclaim that 'pareille vision comprend tout, absolument tout, le spectacle futur' (such a vision comprises all, absolutely all, of the future spectacle) (*MOC*, 541). Moreover, the 'impersonnalité de la danseuse' (the impersonality of the dancer) (*MOC*, 296), who is a 'poëme dégagé de tout appareil du scribe' (a poem completely detached from the scribe's apparatus) (*MOC*, 304), is emblematic of his concept of the ideal text ('l'œuvre pure implique la disparition élocutoire du poëte' – the pure work implies the elocutory disappearance of the poet) (*MOC*, 366). However, the female dancer herself, in so far as she operates through instinct, does not reach the same level as the poet. Moreover, although unlike Lorrain or Rodenbach, Mallarmé does not refer to the female dancer in explicitly sexual terms, some of his comments can be interpreted as dovetailing perfectly with the discourse of the mythification of women. This is particularly the case in the article where he expresses his agreement with Rodenbach that the 'danseuse' should not appear naked, arguing that 'le suspens de la Danse, crainte contradictoire ou souhait de voir trop et pas assez, exige un prolongement transparent' (the suspense of the Dance, contradictory fear or desire of seeing too much and not enough, demands a transparent extension). He refers to the necessity for 'une armature, qui n'est d'aucune femme en particulier ... le voile de la généralité' (an armature, which is of no woman in particular ... the veil of generality), and evokes 'l'ondulation des tissus, éparse cette extase' (the undulation of the fabrics, scattered this ecstasy) (*MOC*, 311). There are echoes here of Rodenbach's affirmation that the dancer embodies 'la tentation de toutes les femmes' (the temptation of all women), and even of Lorrain's description of a rippling veil over lava-like nudity. Moreover, a psychoanalytical reading of the 'crainte contradictoire ou souhait de voir trop et pas assez' would suggest that this paradoxical combination of a longing to see with a fear of seeing stems from a fear of recognising the true nature of desire, with its castratory consequences. The necessity to conceal nakedness becomes synonymous with the necessity to conceal knowledge of incest and castration. The 'voile', then, would perform a fetishistic function of signalling difference and lack while at the same time concealing it. The veiled dancer is the epitome of the beautiful woman, who, 'like the mythical hieroglyph, stands for *both*

the possibility and the impossibility of the fulfilment of desire',[50] thereby sustaining it indefinitely.

The image of the 'voile' is also an important motif in Mallarmé's unfinished poem 'Les Noces d'Hérodiade' (The Wedding of Hérodiade), which comprises references to a dance performed by the female protagonist, Hérodiade, based on the biblical figures of Salomé and her mother.[51] This dance is highly abstract: it is described as 'une sorte de danse ... sur place, sans bouger' (a sort of dance on the spot, without moving) (NH, 114).[52] It is also mysteriously self-negating in that Hérodiade dances 'afin d'être à la fois ici là – et que rien de cela ne soit arrivé' (in order to be both here and there – and that none of this should have happened) (NH, 139). While dancing, she lets her veil fall, revealing her nakedness: 'montrant un sein – l'autre – et surprise sans gaze' (showing a breast – the other – and surprised without gauze) (NH, 113); 'de l'un et de l'autre sein/laissant glisser tout voile' (from one and the other breast/letting every veil slide) (NH, 137). It is significant that this nakedness does not occur until Hérodiade is alone, after John the Baptist has been decapitated. Hérodiade is frightened of exposing 'le frisson blanc de ma nudité' (the white shiver of my nudity) and anticipates that 'si le tiède azur d'été,/Vers lui nativement la femme se dévoile,/Me voit dans ma pudeur grelottante d'étoile,/Je meurs!' (if the warm blue of summer,/Towards him natively the woman unveils herself,/Sees me in my shivering starlike modesty,/I die!) (NH, 69). John the Baptist's decapitation is implicitly linked with Hérodiade's loss of virginity through the image of the tearing of the 'voile': 'le glaive qui trancha ta tête a déchiré mon voile' (the sword which cut off your head has ripped my veil) (NH, 136).

Les Noces d'Hérodiade reinforces the importance of the concealing function of the veil and its erotic associations, and it also brings into play a crucial aspect of Mallarmé's attitude towards the naked/veiled female figure, which is not present in the writers discussed above: his own identification with the figure of the 'danseuse', with the object of the gaze, as well as with the process of looking. Evlyn Gould has pointed out the syntactical ambiguity in Mallarmé's piece on Elena Cornalba (MOC, 303–7), where 'La Cornalba me ravit, qui danse comme dévêtue' (La Cornalba ravishes me, who dances as if undressed) (MOC, 303) raises the question: 'Who's dancing? La Cornalba or me, too? ... Mallarmé writes himself into the position of the object, "me": "La Cornalba ravishes me". But in the second half of this phrase, the speaker is also identified with the dancing subject who "dances as if undressed". It is as if, once ravished, "me" dances naked.'[53] (It should be pointed out here that 'ravir' can mean simply

'delight'.) As Gould also notes, such identification with a female figure would not be at all surprising, given the female roles Mallarmé liked to play in his fashion journal, *La Dernière Mode* (*The Latest Fashion*).[54] Interestingly, Mallarmé himself was compared to a dancer: Rodenbach described him as 'un peu de prêtre, un peu de danseuse' (a little like a priest, a little like a dancer),[55] and as Alain Satgé pertinently points out, 'avec celle-ci, l'écrivain partage au moins l'impersonnalité et le silence' (with the dancer, the writer shares at least impersonality and silence).[56]

The role of the poet in arousing the reader's desire by multiplying meanings which conceal as well as expose 'meaning' can be seen as directly analogous to that of the dancer, who arouses desire for the sight of her body through multiple veilings. The 'crainte contradictoire ou souhait de voir trop et pas assez' (contradictory fear or desire of seeing too much and not enough) (*MOC*, 311) attributed to the spectator of dance can also be experienced by the reader of poetry, since it concerns the act of interpretation as well as that of looking. If we see/understand too much, this will be indistinguishable from not seeing/understanding enough, because then undecidability will be removed and we will be forced to confront lack/finitude, whether this be experienced in terms of the sight of the unveiled female body or of unconcealed (and therefore limited) meaning. Mallarmé, who sees it as the task of the poet to avoid direct naming in order to allow the reader to dream ('*nommer* un objet, c'est supprimer les trois quarts de la jouissance du poëme, qui est faite de deviner peu à peu: le *suggérer*, voilà le rêve' (original emphasis) – *to name* an object is to suppress three-quarters of the enjoyment of the poem, which consists in guessing little by little: to *suggest* it, that is the dream) (*MOC*, 869), can therefore identify with what he perceives as the task of the dancer, simultaneously to reveal and conceal the naked truth, thereby perpetuating its enigma and sustaining desire: 'elle te livre à travers le voile dernier qui toujours reste, la nudité de tes concepts, et silencieusement écrira ta vision, à la façon d'un Signe, qu'elle est' (she yields to you through the last veil which always remains, the nudity of your concepts, and silently she will write your vision, like a Sign, which she is) (*MOC*, 307). (Note the association of the dancer's 'nudité' with the spectator's 'concepts', and the dancer's 'écriture' with the spectator's 'vision'.) Mallarmé can also identify with the desire, epitomised in Hérodiade, to remain concealed from the male gaze, inviolate in her virginity, and to dance 'pour elle seule' (for herself alone) (*NH*, 139), an aspiration evoked in his description of the perfect literary work, the 'Livre'. 'Impersonnifié, le volume, autant qu'on s'en sépare comme auteur, ne réclame approche

de lecteur. Tel, sache, entre les accessoires humains, il a lieu tout seul, fait, étant' (Impersonified, the volume, inasmuch as one separates oneself from it as an author, does not call for the approach of a reader. Such, you must know, among human accessories, it takes place all alone, made, being) (*MOC*, 372).

Mallarmé's lifelong fascination with the figure of Hérodiade marks his preoccupation with situating his own subjectivity in terms of female embodiment, and his writings on the 'danseuse' develop this identification in terms of the close relationship between dancing and writing poetry. We may even go so far as to say that the poet 'comes out' as a 'danseuse', in his/her 'pudeur grelottante d'étoile' (shivering starlike modesty) (*NH*, 69). Moreover, we saw that Loïe Fuller's daring innovations unsettle the assurance of Mallarmé's view of the dancer as an '*inconsciente* révélatrice' (my emphasis) (*MOC*, 307). Unfortunately, however, he does not pursue further this possibility of elevating the female dancer to the status of a conscious creator on a par with the poet. Mallarmé's identification with the figure of the dancer is not primarily with the 'danseuse' as woman, but with the 'danseuse' as metaphor, a figure of the (male) imagination.

Notes

1 Anatole France, Introduction to Loïe Fuller's autobiography, *Fifteen Years of a Dancer's Life* (Boston, Small, Maynard & Co., 1913), p. viii. Rodin cited in Clare de Morinni, 'Loïe Fuller, the Fairy of Light', *Dance Index* (March 1942) 47 (pp. 40–51).

2 Margaret Haile Harris, *Loïe Fuller: Magician of Light* (Richmond, the Virginia Museum, 1979), p. 28.

3 Giovanni Lista's *Loïe Fuller, danseuse de la Belle Epoque*, which appeared in 1994 (Paris, Somogy/Stock), is the fullest study to date. The bulk of my research for this chapter was completed before its publication. See also the works cited in notes 17, 21 and 20 below, the chapter by Mary Ann Caws, 'Dancing with Mallarmé and Seurat (and Loïe Fuller, Hérodiade and La Goulue)', in Peter Collier and Robert Lethbridge (eds), *Artistic Relations, Literature and the Visual Arts in Nineteenth-Century France* (Yale, Yale University Press, 1994), pp. 291–302, and also Giovanni Lista, 'Loïe Fuller et les symbolistes', *Revue d'Esthétique*, 22 (1992) 43–52. Along with Isadora Duncan, Ruth St Denis and Adorée Villany, Loïe Fuller was commemorated in an exhibition at the Musée Rodin in 1987 (catalogue by Hélène Pinot, Paris, Musée Rodin, 1987).

4 For instance, Mallarmé's article 'Ballets' is included in the classic collection of texts on dance, edited by Roger Copeland and Marshall Cohen, *What is Dance?* (Oxford, Oxford University Press, 1983). This article appeared in a new translation by Evlyn Gould in the *Performing Arts Journal*, 15 (1993) 106–10. Lucinda Childs' première of 'Rhythm Plus' in 1991 prompted Marcel Michel to ask, in the pages of *Libération*, 'What would Mallarmé have thought?' (cited in programme notes, Playhouse Theatre, Edinburgh, August 1994).

5 Where French writers are quoted using French sources, the translations into English are mine. Readers unfamiliar with Mallarmé's prose should note that his syntax is notoriously convoluted and elliptical. I have endeavoured to render this effect in English by translating as literally as possible.

6 Berthe Bernay, *La Danse au théâtre* (Paris, E. Dentu, 1890), pp. 191 and 8.

7 *Ibid.*, p. 191.

8 Théophile Gautier, *The Romantic Ballet* (London, C. W. Beaumont, 1947), p. 23. This text was written in 1837.

9 Berthe Bernay, *La Danse*, p. 192. The stars of the popular dance halls commanded even less respect, as in fact Loïe Fuller was dismayed to discover when she started to dance at the Folies-Bergère. Arguably, however, there was not much to choose between 'high' and 'low' culture when it came to the image of the 'danseuse' off stage.

10 Jean Lorrain, *Femmes de 1900* (Paris, Editions de la Madeleine, 1932), p. 228, emphasis mine.

11 Michèle Perrot, 'Women, power and history: the case of nineteenth-century France', in Siân Reynolds (ed.), *Women, State and Revolution* (Brighton, Wheatsheaf Press, 1986), p. 55 (pp. 44–59).

12 Alex Potts, 'Dance, politics and sculpture' (review of *Jean-Baptiste Carpeaux, Sculptor of the Second Empire*, by Anne Middleton Wagner (London, Yale University Press, 1986), *Art History*, 10:3 (March 1987) 100 (pp. 91–109).

13 Gautier, Preface to *Mademoiselle Maupin*, cited in Potts, 'Dance', p. 100.

14 Gilles Dusein, 'Loïe Fuller, expression chorégraphique de l'art nouveau', *La Recherche en Danse*, 1 (1982) 86 (pp. 82–6).

15 See Judith Lynne Hanna, 'Patterns of dominance: men, women and homosexuality in dance', *TDR*, 31:1 (1987) 35 (pp. 22–47).

16 Arsène Alexandre, 'Le Théâtre de la Loïe Fuller', *Le Théâtre*, special issue on 'La Danse à l'Exposition', 2:40 (August 1900) 23 (pp. 23–4).

17 See Gabriele Brandstetter and Brygida Maria Ochaïm, *Loïe Fuller: Tanz, Licht-Spiel, Art Nouveau* (Freiburg im Briesgau, Rombach, 1989), p. 30.

18 Loïe Fuller, *Fifteen Years*, p. 8.

19 de Morinni, 'Loïe Fuller', p. 44.

20 Cited in Sally R. Sommer, 'Loïe Fuller', *The Drama Review*, special issue on 'Post-modern dance', 19:1 (March 1975) 62.

21 For these and further details of Fuller's innovations, see the fascinating accounts in Brandstetter and Ochaïm, *Loïe Fuller*, and in Brygida Ochaïm, 'La Loïe Fuller, Licht und Schatten', *Ballett-Journal/Das Tanzarchiv*, 34 (February 1986) 52–9.

22 Harris, *Loïe Fuller*, p. 13.

23 Fuller, *Fifteen Years*, p. 65.

24 Cited in de Morinni, 'Loïe Fuller', p. 47.

25 Cited in Sommer, 'Loïe Fuller', p. 63.

26 Roger Marx, *Estampes modelées de Pierre Roche* (Evreux, Société des Cents Bibliophiles, 1904), pp. 8 and 25.

27 Claude R. Marx in *Le Théâtre*, 20.10.1912, Bibliothèque de l'Arsenal, Fonds Rondel 40 RO 12117.

28 Louis Vauxcelles, 'L'Art de Loïe Fuller', 10.9.1914, Fonds Rondel 40 RO 12117.

29 Anonymous article, 22.3.1914, Fonds Rondel 40 RO 12117.

30 Henry Lyonnet, *Larousse mensuel*, 21 mai 1928, no page numbers, Fonds Rondel 40 RO 12120.

31 Pierre Roche, *L'Art décoratif*, cited in the programme notes of 1 May 1921, Théâtre des Champs-Elysées. Fonds Rondel, RO12.113 (2).

32 Fonds Rondel, RO12.113 (2).

33 Cited in Brandstetter and Ochaïm, *Loïe Fuller*, p. 116.

34 See *ibid*.

35 *Libération*, 22.9.1988, Bibliothèque du Musée d'Orsay, Loïe Fuller file.

36 Cited in Philippe Jullian, *The Triumph of Art Nouveau: Paris Exhibition 1900* (London, Phaidon, 1974), p. 89.

37 *MOC* = Stéphane Mallarmé, *Œuvres complétes*, ed. H. Mondor and G. Jean-Aubry (Bibliothèque de la Pléiade) (Paris, Gallimard, 1945).

38 Georges Rodenbach, 'Danseuses', *Le Figaro* (5 May 1896) 1.

39 *Ibid*.

40 See *MOC*, p. 304.

41 See Frank Kermode, *Puzzles and Epiphanies, Essays and Reviews 1958–1961* (London, Routledge & Kegan Paul, 1962), p. 26.

42 Valéry, 'L'Ame et la danse', *Œuvres*, ed. Jean Hytier (Paris, Gallimard, 1960), II, pp. 171–2.

43 *Ibid*., p. 171.

44 *Ibid*.

45 *Ibid*.

46 '*Nommer* un objet, c'est supprimer les trois quarts de la jouissance du poëme, qui est faite de deviner peu à peu: le *suggérer*, voilà le rêve' (To *name* an object is to suppress three-quarters of the enjoyment of the poem, which consists in guessing little by little: to *suggest* it, that is the dream) (*MOC*, 869).

47 'Figure typique de la volatilisation, la danseuse receuille en elle tout le charme écumeux' (Typical figure of volatilisation, the dancer gathers in herself all the charm of foam), Jean-Pierre Richard, *L'Univers imaginaire de Mallarmé* (Paris, Seuil, 1961), p. 390. See also pp. 382–405.

48 I have discussed this poetics in my *Symbolist Aesthetics and Early Abstract Art: Sites of Imaginary Space* (Cambridge University Press, 1995).

49 Mallarmé's first text on Fuller, 'Autre étude de danse' (*MOC*, 307–9) was written in 1893. The second, undated text (*MOC*, 311–12) was written sometime between 1896 and Mallarmé's death in 1898.

50 Francette Pacteau, *The Symptom of Beauty* (London, Reaktion Books, 1994), p. 119.

51 Mallarmé deliberately chose to use the name 'Hérodiade' in order to distance his character from the connotations of Salomé. See *Les Noces d'Hérodiade, Mystère*, ed. Gardner Davies (Paris, Gallimard, 1959), p. 51.

52 *NH* = *Les Noces d'Hérodiade, Mystère*, ed. Gardner Davies (Paris, Gallimard, 1959).

53 Evlyn Gould, 'Pencilling and erasing Mallarmé's "Ballets"', *Performing Arts Journal*, 15 (January 1993) 99 (pp. 97–105). In French, 'dévêtue' indicates a female subject.

54 Between September and December 1874, Mallarmé edited and wrote single-handed eight editions of this fashion magazine, in which he used the female pseudonyms of Marguerite de Ponty and Miss Satin. See, in particular, Jean-Pierre Lecercle, *Mallarmé et la mode* (Paris, Librairie Séguier, 1989).

55 Cited in Alain Satgé, 'Wagner rêvé par Mallarmé: "Le Chanteur et la Danseuse"', *Romantisme*, 57:17 (1987) 71 (pp. 65–73).

56 *Ibid*.

9

The atelier novel: painters as fictions

IF we consider the depiction of the artist as perceived by Emile Zola, Octave Mirbeau, Camille Mauclair and other writers of the second half of the nineteenth century, we are confronted with a figure in transition who retains certain aspects of the artist as portrayed earlier, but who is committed to a problematic new cause, the cause of modern art. The character's relationship with the demands of his

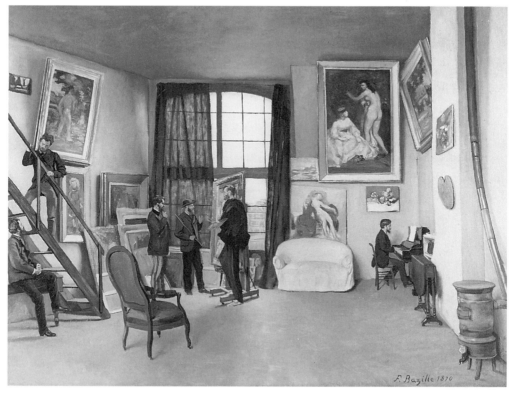

27] Jean-Frédéric Bazille *L'Atelier du peintre*, dated 1870

28] George du Maurier *Taffy à l'échelle*, one of the author's illustrations for *Trilby* (1894), based on his memories of the Paris art world. Whistler is far left

calling is further complicated by changes in the presentation of woman during the same time-span and by the role traditionally attributed to the metropolis. As we chart the perilous itinerary of the artist it becomes clear that while certain stock features are retained, almost all frivolity is pared away until he becomes a tortured individual, usually unhappy in love, destined to struggle bravely against overwhelming odds until his career ends prematurely in despair or suicide.

What are the features which are carried over from the first half of the century to the second? The artist is still seen essentially as a bohemian individual, living on the breadline like Zola's Claude Lantier in *L'Œuvre* (1886).[1] Indeed, poverty is seen for some to be almost a necessity to guarantee the production of authentic art, for Camille Mauclair says of one of his characters in *La Ville lumière* (1904): 'Portraitiste incisif, élégant, Morsanne fût devenu un grand peintre si la pauvreté l'eût contraint de produire' (Morsanne was a penetrating and stylish portrait painter who would have become a great artist if he had been forced to work hard to earn his daily bread).[2] Talent is invariably unrecognised by society at large: in the same writer's *Le Soleil des morts* (1897) we see his Impressionist painter Bussère's

exhibition 'accueillie par des huées' (greeted by jeers)[3] – just as Zola evokes in similar fashion the jeering crowd in front of Claude's *Plein-Air* at the *Salon des Refusés*.[4] Only occasionally is the artist still depicted as the 'idle apprentice' or as a deliberately outrageous figure, like Murger's characters in the early stages of *Scènes de la vie de bohème* (1850)[5] or Frantz Jourdain's Vérin in *L'Atelier Chantorel* (1893).[6]

In the main though, in the latter half of the century the artist is taken seriously and shown to be sincere in his pursuit of art, both within the novel and in real life. In the canvas manifestos of Bazille and Fantin-Latour, *L'Atelier du peintre* [**27**] and *Un atelier aux Batignolles* (both 1870, Musée d'Orsay), the artists are at pains to show the serious nature of the painters, writers and musicians, who are depicted either earnestly practising their art or engaged in sober discussion and contemplation of it. Zola helped jettison the juvenile prankster stereotype popularised by Daumier when he described a friend in his art criticism in 1867: 'Les farceurs contemporains . . . ont fait de Manet une sorte de bohème, de galopin, de croquemitaine ridicule . . . La vérité s'accommode mal de ces pantins de fantaisie créés par les rieurs à gages' (Contemporary journalists . . . have made fun of Manet, turned him into some sort of wild bohemian or ridiculous ogre . . . These fantastic inventions created by the hirelings of the press are very far removed from the reality).[7] His characters in *L'Œuvre* have thoughtful exchanges of ideas when they meet and are never seen indulging in horseplay.

The artist is often presented at the centre of a band of like-minded individuals, and although the figure under consideration here is usually a painter, he is also cast as a representative figure for any creative artist, be he sculptor, architect, poet, novelist, playwright or musician. To add verisimilitude, he and his *cénacle* are often based on real people: such a one is Claude Lantier, who clearly owes much to Monet, Manet, Cézanne and Zola himself; his group includes the novelist Sandoz (another transparent disguise for Zola), the painters Bongrand (Courbet/Flaubert) and Fagerolles (Gervex), and the sculptor Mahoudeau (Rodin/Solari). In *Le Soleil des morts*, as well as the Impressionist painter Germain Bussère, there is the poet Calixte Armel (based on Mallarmé) and his friends Niels Elstiern (Whistler; see [**28**]), the sculptor Urbain Decize (Rodin), Claude-Eric de Harmor (Debussy), the Prince de Lannoy-Talavère (Toulouse Lautrec) and the up-and-coming brilliant young writer Manuel Héricourt, who is, needless to say, Mauclair himself. In Duranty's *Le Peintre Louis Martin* (1881), the eponymous hero is friendly with Maillobert (Cézanne) and meets among others Boudin, Legros, Fantin-Latour, Degas and Guillemet.[8]

The artist figure *can* survive early difficulties and even become a success: in the *Scènes de la vie de Bohème*, at the end of Murger's work, after the death of Mimi, the key figures all achieve distinction and acceptance: Marcel gets into the Salon and obtains a government commission, Schaunard's music becomes popular with the public while Rodolphe produces a book which achieves critical acclaim – though it should be noted that this work, published in 1850, only just slips into the category of works produced in the second half of the nineteenth century. Usually the artist is destined to fail, because the *intellectual* aristocracy (whatever their social origins) tend to be doomed creatures – this is part of the abiding legacy of Romanticism, that Baudelairean *Bénédiction* visited upon the artist figure for whom 'la douleur est la noblesse unique' (pain is the only sign of distinction).[9] Art is a long, painful process – only the rare few are ever allowed to succeed. 'L'artiste a été choisi pour porter une charge plus lourde que celle qui échoit aux autres hommes' (the artist has been chosen to carry a heavier burden than that which falls to the lot of other men), says Mauclair in the preface to *La Ville lumière*. This is a process which can, in the earlier tradition, lead to breakdown or madness, as with Frenhofer in Balzac's *Le Chef d'œuvre inconnu* (1831). This stereotype recurs with disturbing frequency at the end of the century in figures such as Zola's Claude Lantier, Mirbeau's Lucien (*Dans le ciel*, 1892–93) and Mauclair's Brignon in *La Ville lumière*: Brignon's canvas is described as 'un amoncellement de taches qui ne représentaient rien ... il y avait des essais de formes qui prouvaient la démence, des femmes terminées en nuage, des rochers dans le ciel, des rivières verticales, toute une déroute des formes de la vie' (a mass of dots representing nothing ... there were sketchy outlines which proved he was out of his mind, shapes that were half-woman, half-cloud, rocks up in the sky, rivers that ran vertically, a complete jumble of natural forms).[10]

If these are the main features of the *ongoing* tradition of ways of depicting the artist, what are the new elements? Essentially there are two: the first is the key role attributed to woman in the artist's life and the second element is the insistence on his inalienable right to reject tradition, choose his own subject-matter and express his own feelings: 'la peinture ne se fait qu'avec du tempérament', says Maillobert (*Le Peintre Louis Martin*) (painting depends totally on temperament).[11]

Because of the artists' virtual sacerdotal sense of mission commitment to art is seen as a priesthood, while woman is a sin to be avoided. This concept is espoused by Frantz Jourdain, who says Gaston Dorsner's senses are 'canalisés par d'autres passions' (channelled into other passions), that is to say connected only with art

(*L'Atelier Chantorel*).[12] Perhaps he has learned his lesson from litera-ture, for Jourdain shows him reading the Goncourts' *Manette Salomon* (1867), which tells how the painter Coriolis was destroyed by a possessive woman. Camille Mauclair depicts Calixte Armel as the high priest of the religion of art in *Le Soleil des morts* and *La Ville lumière*, while Alphonse Daudet sums up the situation in *Les Femmes d'artistes* (1896), a collection of stories which are a litany of disaster, each one evoking some aspect of the eternal triangle of man, woman and art: 'A cet être nerveux, exigeant, impressionnable, cet homme enfant qu'on appelle un artiste, il faut un type de femme spécial, presque introuvable, et le plus sûr est encore de ne pas le chercher' (For an artist – this nervous, demanding impressionable creature, this half-child, half-man – a special kind of wife is needed that's almost impossible to find – and it's best not to look for one anyway).[13]

So in the second half of the century woman is always inimical to art because she drains the artist of his creative capacities: in *Une grave imprudence* (1880) Philippe Burty's talented artist Brissot, fictional head of the Impressionist movement, wastes his time with his model Pauline – and is subsequently described as 'un homme vidé' (a man mentally exhausted).[14] For the Goncourt brothers 'le célibat était le seul état qui laissât à l'artiste sa liberté, ses forces, son cerveau, sa conscience' (*Manette Salomon*) (celibacy was the only state which left the artist with his freedom, his strength, his mind and his conscience intact).[15] Because of the *total* nature of his commit-ment there is often a complete displacement of feelings with the obsessive artist: when work is going badly Claude Lantier hates his painting like an 'amant trahi' (betrayed lover), and tells Christine 'il ne fallait coucher qu'avec son œuvre (he [an artist] should sleep only with his work).[16] Octave Mirbeau's Lucien says simply 'Je ne couche qu'avec ma peinture' (I sleep only with my painting).[17] There is also clear opposition between producing art and progeny: in *La Ville lumière* when the wife of the artist Aurize wants a child, 'son mari s'y opposait au nom de l'art, du sacerdoce exigeant toutes les forces de l'être' (her husband was in total opposition to the idea in the name of art, that calling which demanded every shred of his being).[18] It goes without saying that an artist should father nothing but his artistic creations: Claude Lantier's sickly child catches his father's attention only in death – and then merely as a subject for a canvas.

Here we should also consider the development of another literary tradition: in the second half of the nineteenth century woman tends to be depicted as the *femme fatale*, a predatory creature who brings death in her wake. As the post-Romantic hero becomes increasingly subject to what might be termed 'the Baudelaire syndrome', that is

to say prone to lethargy, ennui, despair and ultimately inaction, so woman becomes more energetic, decisive, irresponsibly destructive and all-consuming. This concept is essentially a theme culled from the Romantics. It has been shown elsewhere that the stereotype was reinforced and popularised by the way in which the academic painter Gustave Moreau depicted Salomé in his canvases at the Salon in 1876.[19] Suffice it to say that the influence exercised by this disturbing incarnation of woman was a major conditioning factor of her image as projected by artists and writers in the late nineteenth century. In *Le Soleil des morts* Lucienne Lestrange is presented as a latter-day Salomé figure, a dancer who performs with veils like Loie Fuller;[20] she is a dominant female, who destroys the inspiration of her lover, André de Neuze, whom she then dismisses, saying: 'Suis-je faite pour consoler des vaincus? . . . Vos sources d'art . . . comme cela sent la maladie, la vieillesse, la phtisie traînant dans les feuilles mortes' (Do I exist to console failures? . . . Your sources of inspiration are rank with sickness, old age, consumption lingering among dead leaves).[21] The author draws a direct parallel between Lucienne and the doom which overtakes the whole of his group: 'ses cheveux d'or brillaient, vaporeux comme un dernier rayon de soleil, et c'était peut-être en effet, cette tête impérieuse et ardente qui serait l'image du soleil des morts, la suprême clarté de volupté et de gloire charnelle dans l'élite avant l'enlisement, la nuit, la chute, la déchéance' (her golden hair shone like gossamer, like a last ray of sunlight; it might indeed be the case that this imperious, fiery head was the symbol of the sunlight of the dead, that supreme and final incandescence, that peak of sensuality expressed by artists before they decline and fall into endless night).[22] Christine, the wife of Lantier, is also shown with the cascading hair and determined jaw of the wilful woman; she triumphs temporarily over her own likeness on the unfinished canvas, from which she lures Claude to her bed, though in remorse at this infidelity to his art he kills himself immediately afterwards.

The second new element in the depiction of the artist was his position *vis-à-vis* society: his poverty and lack of recognition are given a new twist in that they are no longer just passively accepted features of the artist's lot but accusations against a hostile society, part of a campaign against the traditionalist powers-that-be of the art world that refuse to recognise and reward original talent. 'Society' in this context means on the one hand the philistine *bourgeoisie* which makes fun of what it cannot comprehend – this is of course a constant in the *roman d'atelier* – and the phoney intellectual élite, which has a vested interest in preserving the *status quo*. This 'élite' is the Art Establishment, those running the Académie des Beaux-Arts, the

Institut and the Salon system: in order to preserve their stranglehold the new artists and the type of subjects they represent must be suppressed – because they threaten the fashionable cult of the antique subject, the 'old-fashioned' pictures produced by the Academicians. As Mauclair says in *La Ville lumière*: 'On vient y porter son travail, le soumettre au jugement ironique et hâtif d'une petite société qui s'arroge le droit de faire et défaire les gloires . . . un troupe d'audacieux, épars dans le monde, les jurys, les salonnets . . . s'arroge avec tapage la prétention de représenter l'art' (You bring your work in to submit it to the hasty, mocking judgement of a little Arts society who takes it upon itself to make or break reputations . . . a band of impudent individuals variously scattered among juries and art critics who assume with great fuss and pretension the right to represent Art).[23]

Professionally, an original artist is in an impossible position, because he cannot gain acceptance within the system propagated by the Ecole des Beaux-Arts which decreed strict adherence to tradition and blind acceptance of the rigid formulae of aesthetics which they prescribed. Success was only to be gained by being trained at the Ecole des Beaux-Arts, and – for the lucky future academic painters – by winning the Prix de Rome which enabled the holder to study classical subjects for three years in Italy. Success in the Salon was virtually automatic for those who thrived on being 'processed' in this manner, and commissions – both public and private – followed hard upon this success. There is no place in this 'closed shop' system for an innovator. Yet many painters, both real and fictional, continued to see admission into this inner sanctum as the ultimate rite of passage for the successful artist: even Cézanne hoped for most of his life to be accepted into 'le salon de Monsieur Bouguereau'.[24] All who opposed it were 'poursuivis par la rancune des nullités officielles' (jealously persecuted by those who had power but no talent).[25] The adventurous young architect Gaston Dorsner in *L'Atelier Chantorel* believes firmly that 'on peut admirer et aimer les cendres mais on doit se garder de les remuer. Un tel régime conduit à la sterilité et à la mort' (you can love and admire the embers [of past civilisations) but you must take care not to disturb them. Such a practice leads to sterility and death).[26] He is, however, told by his teachers to redo his projects in a classical Italian style during his training, and when at last like his creator Frantz Jourdain, the architect of La Samaritaine, he can design a building for the modern age in glass and ironwork, the shock of the new gets him laughed at and refused at the Salon.[27]

Accordingly, when he opted for Baudelaire's 'héroisme de la vie moderne' the artist was automatically opting out of the system, consigning himself to little chance of recognition although faced with the

tyranny of earning a living: some acquire their daily bread by prostitu-
tion of their talents – producing for their arch enemy, the well-heeled
bourgeois, sugary confections which bordered on the titillating, on
the lines of the famous canvases which were both called *La Naissance
de Vénus*, painted by the artists who ran the Salon, Cabanel and
Bouguereau;[28] indeed, Louis Martin is specifically advised: 'Pensez
comme les élèves de Bouguereau et de Cabanel ... Faites-vous un
sort assuré' (Do what the pupils of Bouguereau and Cabanel do ...
Get yourself a secure future).[29] Similarly, though at the other end of
the scale, Zola's Claude has to compromise his artistic integrity by
painting cheap decorative pictures for the mass market and trade.[30]

What were the new subjects unconsecrated by tradition and seen as
a threat by the Establishment? Apart from Impressionist treatment
of landscape, the main bone of contention was paintings inspired by
aspects of the French metropolis and its anonymous hordes of inhab-
itants. Again, all goes back to Baudelaire who set the example with
his own *Tableaux parisiens*, and who said of Paris: 'Tu m'as donné
ta boue et j'en ai fait de l'or' (You gave me your mud and I turned
it into gold).[31] He challenged the academic tradition as early as 1846
when he praised 'l'habit, la pelure du héros moderne – bien que le
temps soit passé où les rapins s'habillaient en mamamouchis et fumaient
dans des canardières – les ateliers et le monde sont encore pleins de
gens qui voudraient poétiser Antony avec un manteau grec ou un
vêtement mi-parti' (the frock-coat, the outer covering of the modern
hero – although the time is long since past when every little painter
got himself up as the Grand Panjandrum and smoked a pipe as long
as a duck-gun – both society and the studios are still full of people who
would like to drape Antony in a Greek robe or dress him in motley).[32]

This idea is echoed throughout later nineteenth-century novels,
notably in Zola's *L'Œuvre*, Mirbeau's *Dans le ciel* and Mauclair's *La
Ville lumière*. Once the painters rejected 'la vieille cuisine au bitume'
and 'ce métier de costumier' (the old pitch-like tones and putting
people into fancy-dress),[33] that is to say the *beau idéal* of the biblical,
historical and classical motifs, Paris was *the* obvious subject. Here
after the extensive redevelopment programme of Baron Haussmann
in the 1850s and 1860s is a dynamic new range of subjects – the
motifs Baudelaire lauds in his art criticism from 1846 onwards:[34] the
capital with its teeming population at work and at play, the boule-
vards, the traffic, street scenes, shops, the industrialised suburbs. It is
within this redeveloped thoroughly modern city that the battle of the
fictional modern artist must be fought, because at its core there still
remains the bastion of traditional art, the non-restructured Louvre
and the principles for which it stands.

Significantly, the fictional artists who work *outside* Paris do not bring their works to fruition. Lucien, another Impressionist, paints themes from the countryside, but returns to the capital for his major painting in Mirbeau's *Dans le ciel*. As Mauclair says: 'Souffrir à Paris leur semblait plus enviable que le bonheur en province. Paris était une religion' (It seemed to them preferable to suffer in Paris rather than be happy in the provinces. Paris was like a religion for them.)[35] Claude Lantier works at Bennecourt for two years, producing beautiful *ébauches*, but soon hears the siren song of the big city and is lured back because it is the spiritual home of the authentic artist. He needs the city itself, not only to make his mark there but also because essentially the artist's subject in the second half of the nineteenth century *is* contemporary Paris – as Baudelaire maintains: 'La vie parisienne est féconde en sujets poétiques et merveilleux' (Parisian life is rich in marvellous poetic subjects).[36]

But here obtrudes the third major complication inherited from the literary tradition: Paris in the nineteenth-century novel is always perceived as the testing ground: only the totally strong, ambitious or ruthless individuals survive there for any length of time – people like Balzac's Vautrin or Rastignac, Zola's Aristide Saccard or Eugène Rougon. 'Tout ce qu'il y a de fort, tout ce qu'il y a de bon, Paris l'appelle et le dévore', says Mirbeau (Paris lures everything that is strong and everything that is good only to devour it).[37] In the main the artist is not equipped to survive: on the most basic level he is physically challenged because of the deprivations of diet and dwelling and above all mentally challenged because of his obsessive commitment to art (and in Claude Lantier's case he was threatened by his heredity as well). Jourdain's Dorsner ends up a broken man and his painter friend Pierre Durand dies of the struggle while Mauclair's group all suffer mental agony, for 'L'Art, c'est une maladie triste' (Art is a tragic illness).[38] Mauclair stresses that the artist is an eternal perfectionist who can never be content with what he produces, and his dedication of *Le Soleil des morts* is: 'Aux insatisfaits de l'époque et d'eux-mêmes' (To those who are dissatisfied with the period and with themselves).

Historically characters in the later novels of the nineteenth century are also threatened by the *Zeitgeist*, the *fin-de-siècle* Romantic Agony which paralyses the artist in front of his blank canvas and the writer before his virgin page. Four excellent examples of such characters are: Manuel Héricourt, the 'observateur aigu et souffrant de l'agonie d'une race dont il était le trop clairvoyant héritier' (the keen-eyed and suffering observer of the death-throes of a race that he knows all too well as a descendant of it);[39] Zola's Claude, from the start a prey

to 'la gangrène romantique' (the Romantic gangrene); the painter
Bongrand who complains bitterly that 'l'air de l'époque est mauvais'
(the very air of the period is unhealthy); and their friend Sandoz,
who sums up their plight, saying each of them was 'victime de son
époque ... notre génération a trempé jusqu'au ventre dans le
romantisme' (victim of the epoch ... the people of our generation
have been steeped right through to their guts in Romanticism).[40]

Nevertheless, although beset by personal problems in his relation-
ship with woman, frustrated by lack of acceptance in the official art
world and impeded by the spirit of the age, when the fictional artist
does manage to get something on to canvas, the chosen themes are
usually images of contemporary Paris and the technique used is in-
spired by Impressionism – Baudelaire's Impressionism!, for the poet
said: 'Je voudrais ... les prairies teintes en rouge, les rivières jaune
d'or et les arbres peints en bleu. La Nature n'a pas d'imagination' (I
would like to see meadows dipped in red, rivers golden-yellow and
trees painted blue. Nature has no imagination).[41] In *Le Peintre Louis
Martin*, Duranty says of the protagonist:

Ses yeux s'imbibaient des aspects parisiens, du mouvement de la foule, des
couleurs des magasins. Les gens des pavés, la perspective des rues, l'allure
des passants, le jeu des voitures bariolées l'intéressaient profondément. Il
était un des rares artistes que la vie moderne, sa fièvre, son flux, son caractère
particulier impressionnaient.[42]

(His vision became imbued with the different aspects of Paris, the rippling
movement of the crowd and the colourful shops; he was absolutely fascin-
ated by the people on the street, the proportions of the streets themselves,
the way passers-by walked and the interplay of the variegated colours of
passing traffic. He was one of those rare artists who responded strongly to
the special flavour of modern life, in all its feverish flurry.)

His other subjects echo Manet, Monet and Pissarro, with his canvas
of workmen in the street and his *Par ma fenêtre*, 'un square ... où
fourmillaient les personnages parmi les arbres et les gazons pleins
d'air, de lumière, de verdeur' (a square ... with figures milling about
amongst trees and on lawns suffused with air, light and greenery).[43]
Mauclair's painter Julien Rochès also has 'l'instinct impressionniste'
and becomes obsessed with the spectacle of the anonymous hordes,
'ce reflux d'humanité en travail éclaboussée de couleurs violentes'
(the ebb and flow of a surging mass of people splashed with vivid
colours) and the bustle of the Parisian street scene: 'tout le fracas, le
disparate de ce monde s'agitant sous les panaches des arbres, d'un
vert criard ... dans de grands coups de soleil jaune badigeonnant
crûment les façades et les trottoirs, allumant des éclairs aux panneaux

des fiacres ou aux jets des lances d'arrosage' (all the confusion and
clashing colours of this crowd milling about under the awning of
garish green foliage . . . in big splashes of yellow sunlight which gave
a rough colourwash to the facades and pavements and picked out
burnished panels on passing carriages and the play of light on the
water-jets from hose-pipes).[44] Claude Lantier and Mirbeau's Lucien
are Impressionists who experiment with Chevreul's theory of com-
plementary colours and use a brilliant palette in their scenes from the
countryside: Claude paints 'un terrain lilas ou un arbre bleu . . . un
peuplier lavé d'azur' (a patch of ground daubed in lilac . . . or a tree
in blue, a sky-blue poplar),[45] while Lucien depicts 'peupliers en rouge,
en jaune, en bleu' (poplars painted red, yellow or blue),[46] but it is in
the metropolis that they find a new, hitherto unexplored realm of
beauty.

 Both achieve a certain level of success according to their own scale
of values when they follow the dictates of their own programme.
Claude begins a defiantly modern painting of the Seine viewed from
the Pont des Saints-Pères, its cranes against the skyline and men
unloading barges in the foreground:

Au milieu, la Seine vide montait, verdâtre avec des petits flots dansants,
fouettés de bleu, de blanc et de rose, et le pont des Arts établissait un second
plan, très haut sur ses charpentes de fer, d'une légèreté de dentelle noire . . .
on voyait les vieilles arches du Pont-Neuf, bruni de la rouille des pierres:
une trouée s'ouvrait à gauche . . . une fuite de miroir d'un raccourci
aveuglant.[47]

(The Seine stretched away in the centre, free of traffic, greenish in colour
and flecked with little dancing waves and swirls of blue, white and pink; the
middle section was defined by the Pont des Arts, riding high on its iron
framework which was as delicate as black lace . . . you could see the old
arches of the Pont-Neuf, darkened by the rust-coloured stonework; there
was an opening to the left . . . like a dazzling looking-glass stretching away
to vanishing point.)

 In a proposed composition which recalls Monet's *Les Déchargeurs
de charbon*,[48] Lucien envisages a similar view with men unloading
barges on the Seine but like his Whistlerian nocturne it never reaches
the canvas:

Le fleuve noir roulait ses eaux toutes pailletées de lueurs courtes, toutes
moirées de reflets changeants comme une robe de bal; les maisons profilaient
leurs masses parallèles dans des perspectives de ténèbres, frottées de clartés
tremblotantes; au loin, les arcs constellées des ponts réfléchissaient dans
l'onde leur lumière qui serpentaient en zigzags tronqués et mouvants, ou
bien s'enfonçaient en colonnades incandescentes, dans des profondeurs
infinies, dans des ciels renversés, couleur de cuivre.[49]

(The black river rolled on, the whole surface of its waters spangled with little glimmers of light, shimmering with changing reflections like a ball-gown; the bulky outlines of the houses followed one after another, disappearing into the shadows and touched by the interplay of flickering patches of light. In the distance the arches of the bridges that were studded with lights were reflected in the water and seemed to meander, moving and foreshortened, into the distance; or else they seemed to cast incandescent colonnades of pillars into the bottomless depths, into the reflections of copper-coloured skies.)

Ultimately, however, they both abandon these promising subjects. Claude superimposes on his an 'idole ... de métaux, de marbres et de gemmes' (an idol made from metals, marble and gemstones)[50] – an image of woman which recalls strongly the *femme fatale* of the arch-traditionally trained Gustave Moreau, member of the Institut and teacher at the Ecole des Beaux-Arts; Lucien turns to a subject treated by Whistler, but an early Whistler touched by a favourite Pre-raphaelite motif – the one he used as his dominant theme in his Peacock Room in 1876: 'Les paons tenaient toute la largeur de la toile dans des mouvements superbes et étranges ... Devant et derrière les paons se déroulait, tapis merveilleux, un champ de pensées' (The peacocks took up the whole width of the canvas with their strange, exquisite movements ... In front of the peacocks and behind them there stretched a field of pansies, like a magic carpet) – to this he wants to add a figure dear to the *fin de siècle*, 'une figure nue, une femme ... traitée dans le sens du décor ... avec une chevelure rousse, une chevelure d'or qui s'éparpillerait dans la toile, ainsi qu'une queue de paon' (a female nude ... presented like the décor ... with a head of reddish-gold hair which would spread throughout the canvas, like a peacock's tail),[51] like the woman of Moreau, Mucha or Klimt.

Neither painter can see that the choice of subject is totally alien to his belief in modernity of subject-matter, although fellow artists point this out. Only at the end do they realise they have damaged their artistic integrity by a sad compromise: this explains why each of them commits suicide, for both ignore in their last works their professed aim: modern subjects treated in the Impressionist manner. It is a supreme irony that the writers who created them – all first-rate art critics, sometime painters and friends of the Impressionist group – became deeply imbued with the latter's vision. Perhaps this is why they can achieve in their descriptive sequences of modern Paris that ideal synthesis which melds a brilliant palette, simplified detail, the liquid quality of light and shimmering reflections into a dazzling Impressionist vision which their painters are so tragically unable to achieve.[52] Ultimately it is the novelists – and not the artists they depict – who succeed where their artists fail, for only they present an

Impressionist version of Baudelaire's 'héroisme de la vie moderne'. In *L'Œuvre*, for example, Zola describes Paris (filtered through the sensibility of Claude, admittedly, though he is simply registering the scene, not specifically sizing it up as a possible motif):

[L]a belle journée s'achevait dans un poudroiement glorieux de soleil ... [L]'avenue des Champs-Élysées montait tout là-haut, terminée par la porte colossale de l'arc de Triomphe, béante sur l'infini. Un double courant de foule, un double fleuve y roulait, avec les remous vivants des attelages, les vagues fuyantes des voitures, que le reflet d'un panneau, l'étincelle d'une vitre de lanterne semblaient blanchir d'une écume. En bas, la place ... s'emplissait de ce flot continuel, traversée en tous sens du rayonnement de ses roues, peuplée de points noirs qui étaient des hommes.[53]

([T]he beautiful day was just beginning to wane in a golden haze of glorious sunshine ... The Champs-Elysées climbed up and up, as far as the eye could see, up to the gigantic gateway of the Arc de Triomphe, wide open on infinity. The avenue itself was filled with a double stream of traffic, rolling on like twin rivers, with eddies and waves of moving carriages tipped like foam with the sparkle of a lamp-glass or the glint of a polished panel down to the Place de la Concorde, which was filling up with this continuous stream, crossed in every direction by the flash of wheels, peopled by black specks which were really human beings.)

Mirbeau evokes a similar view witnessed by his painter Lucien:

Cette fin de jour resplendissait. Le soleil déclinant donnait, aux massifs d'arbres, un aspect léger, poudroyant, et le rectangle de l'Arc de Triomphe s'enlevait, tout bleu, de l'illumination du ciel occidental, tout bleu et cerné d'un rai de lumière orangée. Sur le tapis des avenues, mille choses brillaient, chatoyaient, des voitures comme des pierreries, des toilettes, comme des fleurs.[54]

(This day was ending in a blaze of glory. The setting sun reduced the clumps of trees to an insubstantial shimmer of gold, and the rectangular shape of the Arc de Triomphe came out blue against the sky lit up by the setting sun, an intense blue outlined by a ray of light tinged with orange. Along the avenue countless things sparkled and shimmered, carriages glistened like precious stones, women's dresses caught the light like flowers.)

Both examples typify what happens to the artist in the atelier novel: he sees clearly what he *should* paint, but other factors conspire to prevent him accomplishing his aim, whether they stem from conflict with the Establishment, from emotional problems with the woman in his life or from a combination of psychological, physical and financial handicaps. His only choice is between living with despair or opting for death. Let us leave the last word to Claude Lantier: 'Il faut le soleil, il faut le plein air, une peinture claire et jeune ... les choses

et les êtres dans de la vraie lumière ... la peinture que nos yeux d'aujourd'hui doivent faire et regarder' (You need the sunlight, the fresh air, a light-toned youthful painting ... things and people seen in real light ... the painting of and for today by contemporary artists).[55] That is a clear definition of his ultimate aim, but like other artists of the *roman d'atelier*, he had to leave it to the author to paint in words what he failed to capture on canvas.

Notes

I should like to record my gratitude to the British Academy for the grant which made this research possible.

1 Dates given in the main text indicate when the work was first published. Zola, *L'Œuvre*, in *Œuvres complètes*, ed. H. Mitterand (Paris, Cercle du livre précieux, 1966–69), V. I am indebted to T. R. Bowie's *The Painter in French Fiction: A Critical Essay* (University of North Carolina, Chapel Hill, 1950), which first interested me in this subject, and to chapter 5 of P. Brady's *L'Œuvre de Emile Zola. Roman sur les arts: manifeste, autobiographie, roman à clef* (Geneva, Droz, 1967), pp. 133–47.

2 Mauclair, *La Ville lumière* (Paris, Ollendorff, 1904), p. 22. This features some of the same group of *fin-de-siècle* characters in *Le Soleil des morts* (1897).

3 Mauclair, *Le Soleil des morts* (Geneva, Slatkine, 1979), p. 124.

4 Zola, *L'Œuvre*, p. 538.

5 Henri Murger, *Scènes de la vie de bohème* (Paris, Calmann Lévy, 1880): see especially Schaunard, the musician, who wears as a dressing gown 'un jupon de satin rose semé d'étoiles en pailleté' (a skirt in pink satin covered with stars picked out in sequins) (p. 16), left behind by a girlfriend after a masked ball.

6 Frantz Jourdain, *L'Atelier Chantorel* (Paris, Charpentier, 1893):

Vérin se levait à onze heures, touchait barre rue Mazarine afin de raccrocher un ami avec lequel il déjeûnait, et ne rentrait à l'atelier que fort tard dans l'après-midi ... Armé d'un long T en guise de bâton de commandement, il s'improvisait chef d'orchestre et distribuait autour de lui des instruments imaginaires (pp. 106–7)

(Vérin would get up at 11 a.m., stop by the rue Mazarine to get hold of a friend to have lunch with and return to the studio only in late afternoon ... Armed with a long set square for a baton, he acted the orchestra-conductor and pretended everybody around him was playing imaginary instruments.)

7 Zola, *Salons*, in *Œuvres complètes*, vol. XII, p. 827. The joker stereotype resurfaces briefly in Zola's 'Bohêmes en villégiature': the artists Charlot, Bernicard, Chamborel with fellow-conspirators Laquerrière, poet-cum playwright, and Morand, journalist, play tricks on the painter Planchet: 'on a attaché un hareng saur à sa ligne; on a emporté ses vêtements pendant qu'il se baignait, on a introduit dans ses draps des orties fraîches' (they attached a herring to his fishing-line, carted his clothes away while he was having a swim and slipped freshly picked nettles between his sheets) (*ibid.*, vol. IX, pp. 1082–7); finally they pretend that Louise, the mistress of Morand, is in love with him, but the joke turns sour when she and Planchet run away together. This story appeared in November 1877 in *Le Messager de l'Europe*, then in A. de Nocée (ed.), *Poètes et prosateurs: anthologie*

contemporaine des écrivains français et belges (Brussels and Paris, Librairie nouvelle, 1887–88).

8 Louis Edmond Duranty, *Le Peintre Louis Martin*, in his *Le Pays des Arts* (Paris, Charpentier, 1881). Similar support groups appear in Paul Alexis's *Madame Meuriot* (Paris, Charpentier, 1890), which features Edouard Thékel, 'maître de l'Ecole des Batignolles, pionnier de la peinture claire' (Master of the Batignolles school, pioneer of light-toned painting) (p. 300), with Kabaner, the musician, and Aigueperse, the poet; in Mauclair's *La Ville lumière* there is the misanthropic Hubert Feuillery, painter of dancers (Degas), the Symbolist Weuille, who paints unicorns and subjects from the classical and biblical traditions (Moreau), Manuel Sériey (painter of nudes), Brignon, Dalauze (the landscape painter) and Julien Rochès (the Impressionist).

9 In 'Bénédiction' the artist proclaims: 'Je sais que la douleur est la noblesse unique' (I know that pain is the only sign of distinction), Baudelaire, *Les Fleurs du mal*, in his *Œuvres complètes*, ed. C. Pichois (Paris, Pléiade, NRF, 1975), I, p. 9.

10 Mauclair, *La Ville lumière*, p. 181.

11 Duranty, *Le Peintre Louis Martin*, p. 381.

12 Jourdain, *L'Atelier Chantorel*, p. 78.

13 A. Daudet, *Les Femmes d'artistes* (Paris, Lemerre, 1896), p. 6.

14 P. Burty, *Une grave imprudence* (Paris, Charpentier, 1880), p. 207.

15 Edmond and Jules de Goncourt, *Manette Salomon* (Paris, 10/18 Union générale d'éditions, 1979), p. 145. Similarly the artist Pierre Durand in *L'Atelier Chantorel* 'considérait la femme comme une créature dangereuse, une sorte de bestiole inférieure capable d'une piqûre infectieuse' (considered woman as a dangerous being, a sort of inferior creature capable of giving a dangerous infection through its sting) (p. 165).

16 Zola, *L'Œuvre*, pp. 476 and 722.

17 Mirbeau, *Dans le ciel*, ed. P. Michel and J.-F. Nivet (Caen, L'Echoppe, 1989), p. 94. This work originally appeared in *L'Echo de Paris* from 11 October 1892 to 2 May 1893.

18 Mauclair, *La Ville lumière*, p. 187. Cf. 'La Bohême en famille' (Daudet, *Les Femmes d'artistes*), Simaise is a promising young sculptor whose 'famille exigeante à nourrir . . . l'a maintenu dans la médiocrité' (the great demands of keeping his family fed . . . ensured that he remained a mediocre painter) (p. 113).

19 See J. Newton, 'More about Eve: aspects of the *femme fatale* in literature and art in 19th century France,' in *Essays in French Literature*, 28 (1991) 23–35. Moreau exhibited two Salomés at the 1876 Salon: *Salomé dansant devant Hérode* (Hammer Collection, County Museum of Art, L.A.) and *L'Apparition* (Musée d'Orsay); these canvases were to exercise a significant influence in shaping the aesthetic of Zola, Flaubert, Huysmans and Montesquiou, all of whom visited the exhibition.

20 The dancer and choreographer Loie Fuller (1869–1928) inspired a number of artists including Rodin, Whistler and Toulouse Lautrec.

21 Mauclair, *Le Soleil des morts*, p. 150.

22 *Ibid.*, p. 125.

23 *Ibid.*, p. 68.

24 Sophie Monneret, *L'Impressionnisme et son époque* (Paris, Denoel, 1978), I, p. 88.

25 Mauclair, *Le Soleil des morts*, p. 120.

26 Jourdain, *L'Atelier Chantorel*, p. 76. Both Gaston and his painter friend Pierre Durand are resolutely modern: 'Oh la joie d'assister à l'effondrement du colosse . . . de jeter à l'égoût la friperie antique, de chasser les divinités de mardi gras de

leur Olympe' (How wonderful it was to witness the collapse of the academic tradition in art . . . to throw out the tired old trappings of antiquity and topple the divinities in their fancy dress from their hitherto sacrosanct Mount Olympus) (p. 281).

27 Frantz Jourdain (1847–1935) designed La Samaritaine in 1905 and numerous theatres such as the Sarah Bernhardt, the Variétés and the Nouveautés.

28 *La Naissance de Vénus* by Alexandre Cabanel (1823–1889) and *La Naissance de Vénus* by William Bouguereau (1825–1905) were very successful works shown at the Salon in 1863 and 1879 respectively; Cabanel's painting received the ultimate accolade when it was purchased by the Emperor for his private collection.

29 Duranty, *Le Peintre Louis Martin*, p. 325.

30 'Claude avait dû se résigner à des travaux de commerce . . . Il connut les chemins de croix bâclés au rabais, les saints et les saintes à la grosse, les stores dessinés d'après des poncifs, toutes les besognes basses' (Claude had had to resign himself to producing work for trade . . . he had to toss off stations of the cross at reduced rates, male and female saints by the gross, blinds with designs from stencils, all the demeaning jobs) (p. 640).

31 Baudelaire, *Œuvres complètes*, vol. I, quotation from 'Projets d'un Épilogue pour l'édition de 1861', p. 192.

32 *Ibid.*, vol. II (1976), 'Salon 1846', p. 494 ('De l'héroïsme de la vie moderne').

33 Zola, *Salons*, in *Œuvres complètes*, vol. XII, p. 1037, and cf. *L'Œuvre*, p. 540 and Duranty, *Le Peintre Louis Martin*, p. 322.

34 *Œuvres complètes*, vol. II: see 'Salon 1846' ('De l'héroïsme de la vie moderne'), pp. 493–6, and 1863, 'Le peintre de la vie moderne', esp. pp. 685–97.

35 Mauclair, *La Ville lumière*, p. 276.

36 *Œuvres complètes*, vol. II, 'Salon 1846', p. 496.

37 Mirbeau, *Dans le ciel*, p. 97.

38 Mauclair, *Le Soleil des morts*, p. 58. The artists in this novel are 'neurasthéniques, marqués par des tares modernes . . . tous malades, tous faibles, touchés de l'agonie séculaire, désorientés' (depressive, scarred by modern flaws . . . all ill and weak, marked by the agony of the century in its final death throes, disorientated) (pp. 117–22).

39 *Ibid.*, p. 137.

40 Zola, *L'Œuvre*, Claude Lantier, p. 482, Bongrand and Sandoz, p. 731.

41 Baudelaire, cited by Jules Levallois, 'Au Pays de Bohême', *La Revue Bleue*, 4th series, 3 (5 January 1895) p. 4.

42 Duranty, *Le Peintre Louis Martin*, p. 322.

43 *Ibid.*, pp. 325 and 349.

44 Mauclair, *La Ville lumière*:

Par delà, vers cinq heures, se cendraient de lilas les ciels de Paris, incomparables . . . enveloppant toute chose de leur fluidité pastellisée, créant, au bout des avenues, de soudaines gloires . . . Peindre les êtres, après n'avoir peint que les choses, et de mêler aux tâches d'ombre et de clarté dont se bariole l'illusion de vivre le fourmillement des taches pensantes, des atomes volontaires que sont les hommes des villes. (pp. 26–8)

(Beyond, towards five in the afternoon, the skies of Paris turned a dusky lilac; they were incomparable . . . covering everything with their fluid pastel tones, offering sudden exquisite vistas of the sky at the end of the avenues . . . How wonderful it was to paint living beings, after only painting things, and to mix with the patches of shade and light which make up our gaudy-coloured images of life the teeming mass of thinking atoms, the wilful specks who are our city-dwellers.)

45 Zola, *L'Œuvre*, p. 561.
46 Mirbeau, *Dans le ciel*, p. 109.
47 Zola, *L'Œuvre*, p. 609. Cf. also Philippe Burty, *Une grave imprudence*:

> La Seine y glisse entre de vastes berges grises ... tachetée à quai par les chalands réchampis de rouge, enrubanés par la fumée des Mouches, reflétant à petits flots l'azur rompu, les flottantes vapeurs, les nuages aux découpures fines ... Des ponts enjambant d'une rive à l'autre fourmillent de vie. Les omnibus roulent des taches jaunes par-dessus les parapets ... Notre-Dame, avec son abside aux flancs dévidés, sa flèche, les tours, son ton robuste sur un ensemble élégant, établit la masse de fond. (p. 55)

> (There the Seine glides along between immense grey banks ... the embankments are dotted with barges set off in red, with ribbons of smoke curling round them from the glass-topped river boats, reflecting in little stretches the broken blue patches of sky, the hovering haze, the clouds with their delicate jagged edges ... Bridges bestriding the river from one bank to another teem with life. The yellow blocks of colour of the omnibuses show above the parapets as they move along ... Notre Dame with its apse and hollow flanks, its spire, towers and strong colour-note set against an elegant overall picture, fills in the background.)

48 *Les Déchargeurs de charbon* (1875, Private Collection) was sold at the *Vente Morisot, Monet, Renoir et Sisley*, Hôtel Drouot, 24 March 1875. It was exhibited again in 1879. See *L'Echo Universel*, 23 March 1875, and D. Wildenstein, *Claude Monet: biographie et catalogue raisonné* (Lausanne, Bibliothèque des Arts, 1974), I, p. 270.
49 Mirbeau, *Dans le ciel*, p. 95.
50 Zola, *L'Œuvre*, p. 722.
51 Mirbeau, *Dans le ciel*, p. 139. Whistler decorated The Peacock Room for F. R. Leyland in Princes Gate, London, in 1876 (now in the Freer Art Gallery, Washington, D.C.). A cartoon for the peacocks is in the Hunterian Art Gallery, Glasgow University.
52 Cf. also F. Jourdain, *L'Atelier Chantorel*, pp. 74 and 210:

> Le soleil qui se couchait derrière le casque d'or des Invalides irisait tout d'une flamme pâle, argentée, ... divinement adoucie par la buée montante de la Seine. Semblable à un écran de soie mate et transparente, le ciel, frangé de jaune, de vert et de rose, tamisait délicatement la lumière. Les arbres des Tuileries, à peine tachetés de feuilles naissantes, s'emmaillotaient de gaze mauve.

> (The sun which was setting behind the golden helmet of Les Invalides made everything iridiscent with a pale silvery flame of light, exquisitely muted by the rising mists of the Seine. The sky, fringed with yellow, green and pink, filtered the light delicately like a screen of transparent, natural silk. The trees in the Tuileries, as yet barely dotted with budding leaves, looked as if they were swathed in mauve gauze.)

53 *L'Œuvre*, p. 491.
54 Mirbeau, *Dans le ciel*, p. 128.
55 Zola, *L'Œuvre*, p. 466.

10 To move the eyes: Impressionism, Symbolism
 and well-being, *c.* 1891

DURING the early 1890s three writers discussed Impressionist
practice – particularly that of Claude Monet, Camille Pissarro
and Paul Cézanne – in an unusually complex and challenging manner.
They distanced Impressionism from prevailing notions of naturalism
and objective observation, yet reaffirmed the painters' engagement
with external nature. Octave Mirbeau (1848–1917), Gustave Geffroy
(1855–1926) and Georges Lecomte (1867–1958) are the writers in
question. Mirbeau is featured in this chapter, especially his thoughts
about Monet and Vincent Van Gogh, two painters linked by their
sensitivity to 'l'âme exquise des fleurs' (the exquisite soul of flowers).[1]
A feeling for flowers is something Mirbeau would notice, since he
was himself an avid horticulturist. To imply, as he did, that the art
of Monet and Van Gogh shared a common motivation entailed a
certain risk, for the one was being celebrated as leader of the Impres-
sionists and the other as an inspiration for the Symbolists. Far more
than most critics, Mirbeau was in a position to argue that the careers
and projects of these two painters were shaped by a single cultural
paradigm.

Mirbeau remains celebrated today as a novelist; Geffroy and
Lecomte were novelists also, but are now better recognised as art
critics and biographers.[2] The three had much in common: apprecia-
tion for the naturalist tradition in literature coupled with a commit-
ment to its necessary evolution and change; anarchist and socialist
activism; resistance to organised religion; connections to Félix Fénéon;
intimacy with Monet (Geffroy), or Pissarro (Lecomte), or both
(Mirbeau). Encouraged by Monet and Pissarro, the three critics wrote
repeatedly in support of Cézanne even as his eccentricities assumed
an increasingly reactionary cast. Indeed, the 'classicism' and religios-
ity that others perceived in Cézanne's life and art attracted compet-
ing support for his painting from Catholic revivalists, chauvinists and
royalists (the likes of Emile Bernard, Maurice Denis and Joachim

Gasquet). The documents of Cézanne's early reception show him accumulating praise within a matrix of conflicting intellectual and political perspectives, from factions both 'left' and 'right'.

With a comparable crossing of discursive boundaries, the writings of Mirbeau, Geffroy and Lecomte conflate Impressionist and Symbolist aims and principles, primarily by accommodating the Symbolist emphasis on an internal source for artistic expression. The term 'Impressionist' itself, with its connotations of subjectivity, drifted towards the extreme end of what is usually called naturalism, and even beyond.[3] Lecomte, for instance, argued that the Impressionists had liberated themselves from any empirical attempt to record precise appearances; they had become painters of *le rêve* (fantasy, imaginative vision) and of 'le grand mystère de la nature' (the great mystery of nature). It followed that the Symbolists 'innovent moins qu'ils ne le pensent' (innovate less than they think).[4] Lecomte's position recognised major aspects of contemporary psychological and aesthetic theory, including belief in the merging of subject and object in experience and emphasis on the determining role of an artist's mental predisposition. The views of an aesthetician of the period, Gabriel Séailles, are typical: art, he states, 'n'est que l'image d'un rêve réfléchi dans une apparence qu'il a créée et qui le reproduit ... Il confond ... la matière et la pensée' (is nothing but the image of a fantasy reflected in an appearance it has created and which reproduces it ... It unites ... material substance and immaterial thought).[5] In effect, representation was conceived to operate reciprocally. By setting external appearances into a form consistent with the artist's habitual fantasies, representation reconfirmed and strengthened the very same mentality that brought it to life.

Under such conditions, art becomes self-fulfilling, the material and gestural realisation of one's being – the manifestation of *sensation* and *émotion* (to use a terminology of perception favoured by the Impressionists, acknowledging both external and internal sources of artistic motivation), as well as *désir*, *idée* and *rêve* (to use a terminology of psychic experience favoured by the Symbolists, masking out external, material causes). Art that succeeds in combining self-assertion and self-fulfilment, art that satisfies the desire to project one's view so that the self is both discovered and imposed through the process – such art knows no natural bounds. As the manifestation of desire and not the mere execution of a limited task of representation, artistic creation becomes an obsessional activity, to be repeated without end or resolution and very much identified with life itself.[6] In quite a straightforward way, any particular exercise of art, conducted by an individual, is life-affirming and self-affirming. More than that, the

self-affirming character of artistic practice acquires a double sense: it reinforces itself through its repetition, while it also expresses the artist as a manifestation of particularity. No matter how conventional an artist's technique, its repetition in the hands of the individual renders that person's idiosyncrasy all the more evident with every instance of graphic representation.[7]

Repetition (affirming the integrity and consistency of the self) and lack of resolution (affirming the continuing development of the self) were late Impressionist themes among both artists and critics. Without forcing the issue, critics could convincingly link these two potentially damaging qualities – repetition and lack of resolution – to both Cézanne and Monet. Cézanne's pursuit of an ever evasive realisation was widely reported; he appeared to leave the majority of his works unfinished and was said to abandon many of them while working outdoors at the site.[8] Monet habitually attempted what could not be satisfactorily completed, sometimes becoming despondent.[9] Both painters repeated favoured motifs and returned to work on surfaces painted years before. In Geffroy's opinion, Monet had no need to shift to new motifs since he was capable of expressing a different artistic experience at every moment; similarly, Cézanne's paintings exhibited 'un certain inachèvement' (a certain incompletion) because his motif, as well as his emotional response to it, was 'en perpétuelle transformation' (in perpetual transformation).[10] In such practice, the passage of time, as registered by human consciousness or states of mind, is exchanged for movement in space, the register of a material environment or states of nature.[11]

As it had developed by around 1891, the Impressionist project might be characterised in the following manner. For the most part, the individual artist was creating a succession of easel paintings that closely resembled each other with respect to subject, composition and technical qualities. The similarities insured that no single work could be regarded as definitive; nor would artistic success or perfection appear to be attained at any precise moment. This manner of working responded to a combination of at least four goals or conditions. First, a social ideal – to develop a free mode of productivity, following the changeable rhythms of the individual creator. Second, an investigative project – to study man and nature in their infinite variety and interaction. Third, a professional project – to establish individual identity through a personalised artistic manner. Fourth, a market demand and its economic opportunity – to produce works suitable for decorating private bourgeois interiors. Yet this cannot be all. The Impressionists' characteristic serial production of paintings indicates the existence of still another condition, a perceived psychological and

social need. Serial production suggests that the artist creates cease-lessly and indeterminately because the act of painting itself affirms life, even when the individual enterprise fails in the marketplace or in the painter's own estimation. Certainly, painting both exemplified (as an activity) and represented (as a depiction) an ideal of intense immersion in personal sensation. And sensation formed a bond of affect between man and nature.[12] On this point, Impressionist and Symbolist perspectives converge; and this is why the tone of Mirbeau's critical reviews might sometimes seem to derive from a Symbolist origin he clearly rejected.

Mirbeau, Geffroy and Lecomte each had a personalised sense of why Impressionist painting was valuable, but their views were de-veloped within a literary environment dominated by the discourse of Symbolism. Whether or not their positions adequately represented those of the artists they championed (whose interests and social orientations varied), each writer effectively appropriated prevailing critical values by claiming for his favourites a decidedly active sub-jectivity. In 1892, for example, the paintings of Pissarro and Monet appeared to Lecomte just as poetically evocative as they were attent-ive to nature's facts, 'aussi suggestives que représentatives' (just as suggestive as descriptive).[13] Accordingly, Lecomte alluded to wilful decorative construction: Pissarro 'fit voguer dans ses ciels limpides des nuages gracieusement arabesqués' (makes his clouds drift through limpid skies with graceful arabesques); and Monet 'semble de plus en plus abstraire des complexes apparences le caractère durable des choses' (seems more and more to abstract from complex appearances the lasting character of things).[14]

In 1891 Mirbeau wrote of Monet in precisely the same spirit: 'réaliste evidemment, il ne se borne pas à traduire la nature' (clearly a realist, he does not limit himself to translating nature).[15] Mirbeau's specific phrasing indicates that he may have been engaging the young Sym-bolist critic Albert Aurier in tacit dialogue. At that same moment Aurier was attempting to separate Realists and Impressionists from idealists and Symbolists according to their level of subjectification; he faulted Pissarro and Monet for translating only 'la chose matérielle, la chose réelle' (the material thing, the real thing).[16] In his own state-ments – counterstatements, as it were – Mirbeau collapsed much of the difference Aurier sought to establish.[17]

By emphasising the subjective, Mirbeau could reassert an Impres-sionist claim to modernity at a time when French social theorists were particularly concerned with the life of the mind. Such life was directed not only by sensations and attendant emotions but by obsessions and neuroses. It became commonplace to attribute the psychological

formation of neurotics to an increasingly urbanised society, with its unhealthy crowding, anonymity and artificiality. This was the dark side of modernity during the 1890s: emotional stress, a loss of natural physicality, neurasthenia, nervous exhaustion. Modernity also connoted the malady traditionally suffered by sensitive and contemplative artists: melancholic depression (*mélancholie* or *tristesse*).[18] An obvious remedy was to escape, either physically or psychically, to a land of traditional beauty, to 'oublier la laideur des rues devant le paysage idéalisé' (forget the ugliness of city streets when facing an idealised landscape).[19] Social conservatives in particular advocated this solution because it re-established a hierarchical order in cultural production analogous to a societal order of authority. 'Classic' beauty – a timeless beauty associated with an idealised landscape, often Mediterranean in character – was to be privileged over any deviant aesthetic quality that might emerge unpredictably when an individual artist responded to his or her chance, immediate environment at a particular moment (as seemed to be the case with Monet and Cézanne, given Geffroy's interpretation of them).

Among painters, Van Gogh may have best exemplified the problematic of the modern condition. He could readily be categorised (most famously, by Aurier) as neurotic and hypersensitive, and his technique itself seemed obsessively frenetic. Fénéon expressed that quality in a remarkable sentence: 'Les *Iris* de celui-ci [Van Gogh] déchiquètent violemment leurs pans violets sur leurs feuilles en lattes' ([Van Gogh's] *Irises* shred wild tatters of violet on the thin laths of their leaves) [**29**].[20] Van Gogh escaped 'la laideur des rues' (the ugliness of city streets) in Paris by going to Arles (just as Monet escaped to Vétheuil and then Giverny), but his manner of painting led neither him nor his work to any satisfying resolution. Yet this artist could be a hero: life was not to be suffered passively, as it might be in cases of extreme melancholy or depression; it was to be experienced in its animated exercise, as creative performance.[21] As gifted neurotic and hyperactive painter, Van Gogh might create beautiful images; yet his works also emblematised his society's failure to satisfy its own consuming desires.[22] Van Gogh's beauty, the product of an act of will, was without any possible perfection or completion. Mirbeau seems to have invested in this cultural construction of Van Gogh, which the critic shared with Symbolists. He wrote in 1891 that the deceased painter had worked 'sans trève ... Un besoin de produire, de créer, lui faisait une vie sans halte, sans repos ... Sa personnalité ... débordait de lui ... Il avait forcée [la nature] à se mouler aux formes de sa pensée' (without any respite ... A need to produce, to create, gave him a life without rest or relief ... He was carried away by his

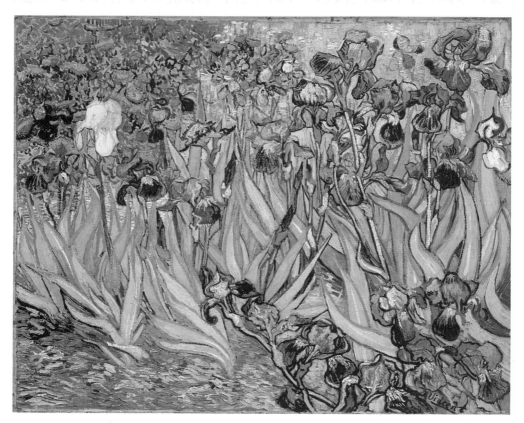

29] Vincent van Gogh *Irises,* 1889

personality ... He had forced [nature] to be moulded to the forms of his thought).[23]

If Van Gogh's obsessive pursuit of painting signified his distinct and tragic modernity, then Mirbeau, in his capacity as creative writer, was following the same model of artistic determination, applying an intensified will to whatever he produced. Like Van Gogh, he marked his works thoroughly by the peculiarities of his thought, a personal response to a modern condition. To perceive this, one might turn to Mirbeau's novels (which reflect his knowledge of the painters) or to the details of his biography.[24] His criticism alone, however, renders his intellectual patterns evident enough; and they are hardly unexpected given the cultural context. Mirbeau imposed but one creative syndrome – a constellation of insistent will, hypersensitivity, unrealisable aims, and obsessive productivity – on both Van Gogh and Monet, despite their differences. In doing so, he caused the latter to appear as the moderated, self-controlled version of the former, with Monet being characterised by a 'superbe santé morale que rien n'amollit' (superb mental health which nothing weakens).[25] In its entirety, Mirbeau's

formulation of the two painters – one tragically failed, the other brilliantly successful, both working with extraordinary sensory and emotional concentration, both extending their creative efforts beyond what could possibly be attained – might well be taken to represent aspects of the writer's own character, at least as he conceived of it.

In the case of Monet, as with Van Gogh, Mirbeau referred to the painter's desire to impose his will on nature, 'de tout soumettre à la domination de son génie' (to submit everything to the control of his genius).[26] This description of Monet's attitude could hardly have surprised the artist, not only because he collaborated intimately with Mirbeau, his favourite critic, but because he too adopted this image of obsessive struggle. Monet spoke of his repeated attempts at 'des choses impossibles à faire' (things impossible to do) and of the incompatibility of art and perfection under his life's conditions: 'Celui qui dit avoir fini une toile est un terrible orgueilleux. Finir voulant dire complet, parfait, et je travaille à force sans avancer, cherchant, tâtonnant' (Whoever would claim to have finished a painting is dreadfully arrogant. Finished means complete, perfect, and I work extremely hard with no advance, searching, groping).[27] At such moments of Monet's distress, Mirbeau, in keeping with his view of this painter's healthy psychological constitution, advised him, 'Ne vous martyrisez pas à vouloir l'impossible' (Don't martyr yourself in desiring the impossible).[28] Yet Mirbeau, true to the generic artistic type he imagined, experienced his own variant of creative frustration and imperfection, complaining to Monet of an incessant need to correct, adjust and revise the writing of a novel.[29] Such sentiments may well be commonplace throughout the entire modern period; and they can be expected to accompany forms of labour with which workers easily identify, those that are neither mechanised nor thoroughly ritualised. But these thoughts also seem particularly specific to the years c. 1891. Critics and artists were representing themselves as experiencing the very same kinds of obsessions, drives and frustrations they attributed to those they idealised, as if their own lives would never be marked by 'genius' without being marked by such problems. Their writings and paintings confirmed the existence of a specifically artistic mode of life (the free, but socially embattled individual) and its corresponding psychological types (either strongly resistant yet sensitive, or hypersensitive and neurotic).

If exemplary modern artists were to be strong and wilful, yet incapable of fully satisfying their desires for expression, productivity and knowledge, what were critics to see in their works? Mirbeau, Geffroy and Lecomte did not regard Impressionist paintings as pointed observations of the material conditions of modernity, the kind of

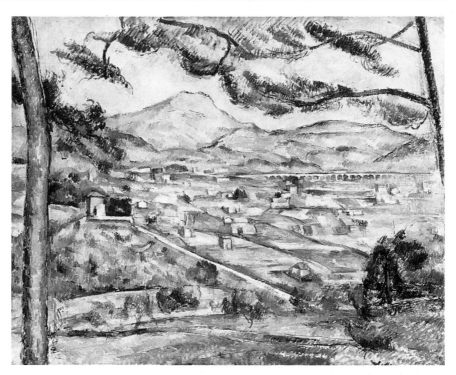

30] Paul Cézanne *Mont Sainte-Victoire with large pine*, 1886–87

descriptive project that standardised technical procedures could master and complete, as if a study in physiognomy. Instead these writers stressed emotionally evocative aspects of the facture and colour used by the painters to render natural effects – the very same qualities taken to excess by Van Gogh. Such pictorial qualities were subject to infinite variation even within the context of an obsessively repeated motif. By concentrating on these technical qualities of painting, critics gained access to Cézanne, whose inscrutable images rarely looked particularly 'contemporary', nor did they express any obvious political allegory or any traditional patterns of idealisation. A painting of male bathers, Geffroy wrote in 1894, 'prend l'aspect brillant et blanc bleuté d'une faïence grassement décorée' (assumes the brilliant, bluish-white quality of richly decorated faience); while Cézanne's landscapes produce the 'sourde beauté de tapisserie' (muted beauty of tapestry) [30]. Geffroy thus located referents for Cézanne's visual effects outside of natural conditions, in artefacts crafted in other mediums.[30]

Consistent with this attention to pictorial or artefactual qualities, Mirbeau, Geffroy and Lecomte accepted unusual degrees of variation in facture, describing paintings as if they not only recorded the look of a living nature but also bore life within themselves.[31] Paintings by

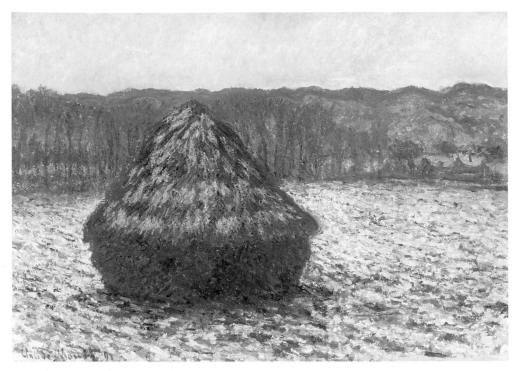

31] Claude Monet *Stack of wheat*, 1891

Cézanne and Monet manifested such organicism because their techniques sustained great amounts of reworking without any appreciable loss of an animated quality of surface. For nineteenth-century viewers, such handling connoted 'spontaneity' and 'originality' even while it incorporated the visible record of successive changes.[32] To capture a momentary effect was never Cézanne's stated purpose (as it was Monet's).[33] Yet the techniques of both painters involve repetitive and generally nondescriptive marking, which facilitates quick response to momentary impulses as well as a process of construction. Such Impressionist method suits the aim of seizing transient impressions – whether atmospheric or emotional. Because such technique is infinitely additive and requires no material erasure (scraping down), it also accommodates painters who have difficulty attaining decisive finality. No individual mark is a 'mistake', yet every mark is subject to the alteration that results from being overlaid by another [31].

For Mirbeau, Geffroy and many others, the degree of energetic physical involvement in making a painting – reworkings, hesitations, failures, corrections, excesses – indicated the level or intensity of true experience, the convergence of subject and object in the very life of the work. Such life was often signified pictorially as the agitated course

of a line or flow of paint. Of special fascination were objects and substances that seemed, by their very nature, to translate immediately into effects natural to brushed pigment and to organic, manual gestures – hence the exaggerated sensuality and eroticism of such motifs, which allow nature and its image to converge seamlessly in both paintings and their ecphrastic commentaries. Such motifs seem to exist in a natural state of *rêve*, available to either pictorial or verbal description and therefore already in a form to which human desire would convert them.

Life moves. In a study of movement, the aesthetician Paul Souriau had cause to explain what movement in water is like and how it might feel to the painter engaged in what amounts to gestural mimesis: 'Faites couler largement vos couleurs, poussez-les à grands coups de brosse; que le mouvement de votre main suive et indique les ondulations de ces vagues' (Spread your colours broadly and push them with generous brushstrokes so that the movement of your hand follows along and indicates the undulations of the waves).[34] The concept of following usually implies an origin – for instance, the start of a trail – but not in this case; wavelike action has no particular beginning or end. Monet tried his hand at representing watery undulation and found it quite impossible to do, that is, impossible to complete, because the action had no clear resolution. True to his role, Mirbeau provided a well-wrought description: in Monet's paintings of canoeing, there is

toute une vie florale interlacustre, d'extraordinaires végétations submergées ... qui, sous la pousée du courant, s'agitent, se tordent, s'échevèlent, se dispersent, se reassemblent ... et puis ondulent, serpentent, se replient, s'allongent.

(a whole life-world of extraordinary underwater plants ... which tumble, twist, whip, spread and gather in the current's thrust ... they undulate, weave, wind back around, and stretch.)[35]

Mirbeau's statement applied to Monet's *En canot sur l'Epte* [32], one of the paintings in which the artist (in his own description) attempted 'des choses impossibles à faire' (things impossible to do), specifically 'de l'eau avec de l'herbe qui ondule dans le fond' (water with vegetation that weaves in the depths).[36] Monet rendered the underwater plants as a mass of interwoven linear strokes, as if he were engaging nature with the strongest sense of mimesis – acting out the life of the object imitated, much the way Souriau described it. It was this visualised organicism that Mirbeau translated into his moving series of verbs, of necessity an incomplete movement, like any other linguistic or pictorial attempt to fix such a theme. For the

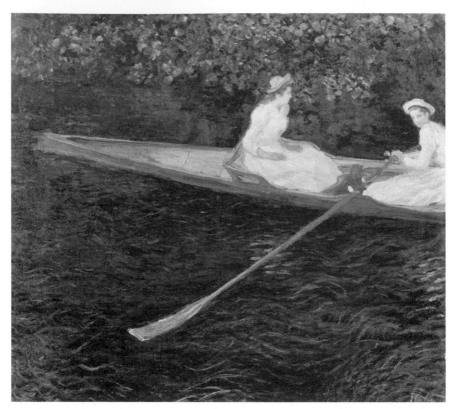

32] Claude Monet *En canot sur l'Epte*, c. 1888

viewer who followed the undulation of either the painter's strokes or
the writer's words, traces of hand-work moved the eye emotionally
as well as physically. Mirbeau stated the matter in a letter to Monet:
'Nous sommes tout à fait d'accord: en peinture, c'est par les yeux que
la pensée doit être excitée. Il faut d'abord que les yeux soient charmés,
émus' (On this we agree completely: in painting, it's through the eyes
that the mind gets stimulated. First, the eyes have to be charmed,
moved).[37] Implicitly, Mirbeau was criticising Symbolists for advanc-
ing an art in which ideas so dominated vision and skills of the hand
that viewers lost contact with the moving physicality of life. Some-
what later, he would compose a caustically humorous account of a
fictive Symbolist, Kariste. This hypercerebral painter recognises only
too late in life that Monet's Impressionist art maintains 'une belle
santé' (its well-being) by integrating mind and matter, reaching the
highest imaginative state of *le rêve*.[38]
 Despite such expressions of division within the art world, the face
value of statements by Symbolist-oriented artists and critics estab-
lishes little difference between their sense of emotional content and

Mirbeau's Impressionist 'movement'. It is easy enough to merge any number of Maurice Denis's statements into Mirbeau's programme: 'C'est par la surface colorée, par la valeur des tons, par l'harmonie des lignes que je prétends atteindre l'esprit, éveiller l'émotion' (It's through the coloured surface, the value of tones and the harmony of lines that I expect to reach the mind and awaken emotion), Denis said to an interviewer in 1891.[39] A difference can nevertheless be found: Denis's position (like that of the fictional Kariste) assumes that a picture performs its function when completed as it had been conceived; in contrast, Mirbeau believed that the very process of painting held significant meaning.

Shortly before Mirbeau composed his statement on corporal and emotional movement, he published an essay on Pissarro, contrasting his 'ciels mouvants, profonds, respirables' (deep, moving, breathing skies) to the unanimated 'ciels en ciment' (cemented skies) of his recent predecessor Théodore Rousseau.[40] The critic extended his metaphor so that his reader imagines much more than a moving sky; every feature of the picture subjected to verbal description, every differentiated area of paint, 'moves' before the reader's ear and eye as it might before the picture's viewer. The effect depends largely on poetic assonance: 'cette terre rose dans la verdure, cette terre qui vit aussi, qui respire' (this reddish earth amongst the greenery, this earth which also lives and breathes). Mirbeau suggested that Pissarro converted his image of nature into a living, breathing organism possessing vital fluids – in this instance the critic's word was 'sèves' (saps), by which he referred to an energy and a flow in both man and nature.[41] And, as elsewhere, the critic's own flowing language manifests repetitious phrasing, reinforcing the evocation of organic rhythm.

Mirbeau began his essay on Pissarro by introducing the artist as an anarchist (without using that word) concerned with social equality and 'harmony', a key term for anarchist theory; he then proceeded to discuss generalised pictorial qualities rather than specifics of subject-matter. The reader surmises that the living harmony of Pissarro's forms corresponds to the ideal social harmony anarchists imagine – their *rêve*, their *pensée* (thought, idea), as it were. Formal harmonies represent the anarchist's ideal as much or more than any other aspect of painting. Accordingly, Mirbeau could oppose Jean-François Millet to Pissarro and conclude with a metaphor of human and pictorial organicism that might appeal to naturalists, Impressionists and Symbolists alike:

La terre n'est pour lui [Millet] qu'une toile de fond où il met en relief ses personnages . . . [Au contraire,] Pissarro procède par grandes généralisations

... Dans ses œuvres, l'homme est ... fondu avec la terre, où il n'apparaît que dans sa fonction de plante humaine.

(The earth is for [Millet] merely a backdrop against which he sets his figures in relief ... [In contrast,] Pissarro proceeds by broad generalisations ... In his works, man is ... fused with the earth, where he appears only in his function as human plant.)[42]

The analogies here are quite complex. Millet, it seems, sets his figures against their pictorial ground in the most conventional, mechanistic way; whereas Pissarro 'plants' his figures within the ground, realising a utopian, agrarian ideal as well as a moving pictorial harmony. Pissarro's figures, his motives, are formally integrated with their (pictorial) ground, not removed from it.

Mirbeau's suggestion of a correspondence between an individual artist's formal inclinations (Pissarro's 'broad generalisations') and a healthily integrated being (a 'human plant') has an echo in the painter's subsequent remark to his critic: 'Soyons d'abord artiste et nous aurons la faculté de tout sentir, même un paysage sans être paysan' (Let's be artists first of all, and we'll have the capacity to feel all things, even a country landscape without being a peasant).[43] Pissarro is recommending that one attend to the harmonious structures painting can reveal and generate – an attitude perhaps exemplified by his having once created a composition on a palette so that the process of painting takes thematic precedence over the agrarian scene represented [33].[44] Since formal relationships belong to paintings (and not to painters' models in nature), they best correspond to, and even express, the subjectivity of the individual creator. For participants in the politics of art as a social force, however, spontaneously achieved formal harmonies also express the development of a society of individuals who are sufficiently liberated to enact such productive expression.[45] Artistic creation becomes an affirming political and spiritual act, and art seems to supplant religion. Thus one reviewer wrote of Geffroy: 'Il va dans les musées comme d'autres vont aux églises' (He goes into museums the way others go into churches).[46]

All this points to the conclusion (as Mirbeau's fictional Kariste realised) that artists remain among the select few responsible for the healthy development of their society. Then how could the unhealthy Van Gogh, a neurotic and a suicide, function as one of modernity's best representatives? Would the mere fact that he devoted himself to an emotionally intensified mode of painting be sufficient to establish his beneficence? It seems Mirbeau believed so, but Monet hesitated.

Since he had so loved flowers and been so masterful at rendering them, why – Monet asked Mirbeau – had Van Gogh himself been

33] Camille Pissarro *The artist's palette with a landscape, c. 1878.*

'si malheureux' (so miserable)? The question arose when Mirbeau proudly showed Monet Van Gogh's *Allée d'iris* [**29**] (which he acquired in 1891), apparently initiating a series of taunts of the kind that the best of friends exchange.[47] On his part, Mirbeau was pitting one painter of flowers against another. In his view (as expressed in 1901), Van Gogh had been consumed by unrealisable creative desire: 'Il n'était jamais satisfait de son œuvre ... Il rêvait l'impossible' (He was never satisfied with his work ... He dreamed of the impossible).[48] Yet the critic disputed those who associated Van Gogh with perversions and Symbolist excesses, and suggested that this painter was not very different from either Monet or Cézanne.[49] On being shown *Allée d'iris*, a reminder of Mirbeau's taste for deviant genius, Monet may have wanted to pique his friend in return by presenting an irreverent challenge: if Van Gogh's art is so remarkably good, and if this painting so dramatically moves eye and mind – here, imagine Monet slyly smiling – why did its creator never manage to feel good or be happy? No doubt, the question had more than one level of irony since Mirbeau was accustomed to see Monet himself endure fits of despair.[50] Despite the unfailing mental fortitude Mirbeau attributed to him, Monet, too, was often far from happy.

There is a wider implication to Monet's clever banter, for it reveals the status that artistic creation had acquired by the early 1890s as a kind of therapeutic activity. Being an artist allowed the individual to become an exemplary figure within society, entrusted with demonstrating how both individual and social body might work creatively to maintain themselves in health. Just as paintings (as representations) were said to introduce a sense of political and psychological harmony to their collective viewing audience, so painting (as an activity) induced a sense of well-being through its creative production, relieving the artist's personal anxiety or neurosis. Mirbeau recalled Pissarro's words to this effect: 'Le travail est un merveilleux régulateur de santé morale et physique' (Work is a marvellous regulator of mental and physical well-being).[51] A cliché, yes, but a particularly meaningful one c. 1891.

Mirbeau actually complained in 1892 that there were too many painters and collectors of painting (he himself was both); the whole matter had become a fashion: 'Etre peintre ou n'être peintre! Telle est la grande angoisse moderne ... Nous serons dans l'âge de l'huile' (To be a painter or not to be a painter! Such is the great modern anguish ... We will be in the age of oil).[52] In his view, artistic excellence did not follow from the mere appropriation of pigments and brushes, for the individual's creative harmony and well-being was not so easily attained; it was perhaps as unstable and evolving as the movements of Monet's underwater vegetation. This harmony constituted the ultimate resistance to rigid hierarchical order and to related social and political structures of domination; to realise it artistically required the concentrated energy that only a Monet or a Van Gogh could provide. Since harmony of the senses and emotions was to be experienced through the act of creation itself, the painter needed to keep painting and to avoid any false sense of completion. As Mirbeau stated, Van Gogh had 'un besoin de produire, de créer' (a need to produce, to create); but in this case the compulsion overwhelmed the unfortunate painter's means, 'le devastait peu à peu ... Il est mort de cela, un jour!' (wasting him away little by little ... One day he died of it!).[53]

Despite his fatal obsessiveness, Van Gogh clearly understood the organicist metaphors that both Impressionists and Symbolists found acceptable; and he endorsed the ideological function of art as society's salvation. He wrote in 1888 of the pantheistic religiosity of the Japanese 'qui vivent dans la nature comme si eux-mêmes étaient des fleurs' (who live within nature as if they themselves were flowers). And he added: 'On ne saurait étudier l'art japonais, il me semble, sans devenir beaucoup plus gai et plus heureux' (One cannot study Japanese art, it seems to me, without becoming much more joyous

and happy).[54] This is why Van Gogh imitated the movement of a Japanese line.

Notes

1 See Octave Mirbeau, 'Rengaines' (1891), 'Vincent van Gogh' (1891), in his *Des artistes*, 2 vols (Paris, Flammarion, 1922–24), I, pp. 140, 137. Translations are mine unless otherwise noted.

2 On Mirbeau's career, see Martin Schwarz, *Octave Mirbeau: vie et œuvre* (The Hague, Mouton, 1966); Reg Carr, *Anarchism in France: The Case of Octave Mirbeau* (Manchester, Manchester University Press, 1977); Pierre Michel and Jean-François Nivet, *Octave Mirbeau, l'imprécateur au cœur fidèle* (Paris, Séguier, 1990). On Geffroy as critic, see JoAnne Paradise, *Gustave Geffroy and the Criticism of Painting* (New York, Garland, 1985); John Rewald, *Cézanne, Geffroy et Gasquet* (Paris, Quatre Chemins-Editart, 1959), pp. 9–21. Of the three writers, Lecomte is the least known; he was Pissarro's biographer (*Camille Pissarro* (Paris, Bernheim-Jeune, 1922)) and, in 1924, was elected *membre de l'Académie Française*. Of particular relevance to this chapter is Robert L. Herbert, 'The decorative and the natural in Monet's cathedrals', in John Rewald and Frances Weitzenhoffer (eds), *Aspects of Monet* (New York, Abrams, 1984), pp. 160–79; Herbert identifies a number of attitudes shared by Mirbeau, Geffroy, Lecomte and several other critics in Monet's circle, probing them in relation to the concept of *décoration* (decoration). See also four comprehensive studies of Monet: John House, *Monet: Nature into Art* (New Haven, Yale University Press, 1986); Steven Z. Levine, *Monet, Narcissus, and Self-Reflection* (Chicago, University of Chicago Press, 1994); Virginia Spate, *Claude Monet, Life and Work* (New York, Rizzoli, 1992); Paul Hayes Tucker, *Monet in the 90s: The Series Paintings* (New Haven, Yale University Press, 1989).

3 Concerning the points at which Impressionism and Symbolism might become more convergent than divergent, see Richard Shiff, *Cézanne and the End of Impressionism* (Chicago, University of Chicago Press, 1984), pp. 1–52, 187–9. For an indication as to how divergent the connotations of 'naturalism' and 'Impressionism' had become within literary discourse by 1891, see Ferdinand Brunetière, 'La Critique impressionniste', *Revue des Deux Mondes*, 103 (1 January 1891) 210–24; and Anatole France, 'Préface' (1891), in his *La Vie littéraire*, 4 vols (Paris, Calmann Lévy, 1895), III, pp. i–xix. On internalisation, cf. Charles Morice, *La Littérature de tout à l'heure* (Paris, Perrin, 1889), pp. 166, 276:

> [Les choses] n'ont de vérité qu'en lui [l'artiste], elles n'ont qu'une vérité interne . . . Notre expression est le symbole de notre rêve, notre rêve est le symbole de notre pensée; tout vient, tout rayonne d'elle

> ([External objects] acquire their truth only within [the artist], they have only an internal truth . . . Our expression is the symbol of our fantasy, our fantasy is the symbol of our thought; everything derives, everything radiates from it).

Morice was Paul Gauguin's supporter and literary collaborator.

4 Georges Lecomte, *L'Art impressionniste d'après la collection privée de M. Durand-Ruel* (Paris, Chamerot et Renouard, 1892), pp. 260–1.

5 Gabriel Séailles, 'L'Origine et les destinées de l'art', *Revue Philosophique*, 22 (1886) 347. Compare these allied formulations from studies of perception: 'Les noms . . . de moi et de matière ne désignent que des entités métaphysiques' (The

words ... for self and substance register only a metaphysical distinction) (Hippolyte Taine, *De l'intelligence*, 2 vols (Paris, Hachette, 1888 (1870)), II, p. 5); 'Nous ne trouvons plus ... de distinction véritable entre la perception et la chose perçue, entre la qualité [le moi] et le mouvement [la matière]' (We can no longer make a true distinction between perception and the thing perceived, between quality [self] and movement [substance]) (Henri Bergson, *Matière et mémoire* (Paris, Presses Universitaires de France, 1968 (1896)), p. 245). And from theories of art: 'Le peintre porte son tableau en lui-même (The painter bears the picture within himself) (Théophile Gautier, 'Du beau dans l'art', *Revue des Deux Mondes*, 19 (1847) 891); 'La nature est pour lui [le peintre] ce qu'il veut qu'elle soit' (Nature is for [the painter] what he wants it to be) (Charles Blanc, *Grammaire des arts du dessin* (Paris, Laurens, 1880 (1867)), p. 532).

6 Such associations inform G.-Albert Aurier's assessment of Van Gogh's theme of the sower, 'qu'il peignait et repeignait si souvent' (which he painted and repainted so often) ('Les Isolés: Vincent van Gogh', *Mercure de France*, 1 (January 1890) 27).

7 Hence, the late nineteenth-century interest in graphology (studies of handwriting) as a means of analysing personality. See, e.g., Paul Gauguin's use of graphology to interpret Cézanne: Gauguin, letter to Emile Schuffenecker, 14 January 1885, in Victor Merlhès (ed.), *Correspondance de Paul Gauguin, 1873–1888* (Paris, Fondation Singer-Polignac, 1984), p. 88.

8 See, e.g., Gustave Geffroy, 'Paul Cézanne' (1894), *La Vie artistique*, 8 vols (Paris, Dentu (vols 1–4), Floury (vols 5–8), 1892–1903), III, pp. 256–7.

9 See letter of Monet to Geffroy, 22 June 1890, in Gustave Geffroy, *Claude Monet, sa vie, son œuvre*, 2 vols (Paris, Crès, 1924), II, p. 47; letter of Mirbeau to Monet, 10 September 1887, in Pierre Michel and Jean-François Nivet (eds), *Octave Mirbeau, correspondance avec Claude Monet* (Tusson, Du Lérot, 1990), p. 50.

10 Geffroy, 'Histoire de l'impressionnisme' (1893), *La Vie artistique*, III, pp. 82–3; 'Salon de 1901', *ibid.*, VIII, p. 376.

11 Thus Impressionist painters, like nineteenth-century naturalists, remained bound to a certain historical contemporaneity, which was their own 'time', experienced quite personally and perhaps even in the solitude of nature. Symbolists, however, sought through internalisation to free themselves from all external contingencies: 'Il faut être libéré de son temps' (One must be liberated from one's time) (Camille Mauclair, *Eleusis, causeries sur la cité intérieure* (Paris, Perrin, 1894), p. 30).

12 Cf. Shiff, *Cézanne*, p. 43. See also below, note 37.

13 Lecomte, *L'Art impressionniste*, p. 260. Apparently, the critic thought his formulation so clever that he applied it to the neo-Impressionists as well; Georges Lecomte, 'L'Art contemporain', *La Revue Indépendante*, 23 (April 1892) 13.

14 Lecomte, *ibid.*, pp. 9–10. Cf. Georges Lecomte, 'Camille Pissarro', *La Plume*, 3 (1 September 1891) 302.

15 Octave Mirbeau, 'Claude Monet', *L'Art dans les Deux Mondes* (7 March 1891) 184. *L'Art dans les Deux Mondes* was sponsored by the dealer in Impressionist painting, Paul Durand-Ruel.

16 G.-Albert Aurier, 'Le Symbolisme en peinture: Paul Gauguin', *Mercure de France*, 3 (March 1891) 157. Aurier's position did not prevent him from praising Monet's 'divines éblouissances' (divine radiances) ('Claude Monet', *Mercure de France*, 5 (April 1892) 304). On Mirbeau in relation to Aurier, cf. James Kearns, *Symbolist Landscapes* (London, Modern Humanities Research Association, 1989), p. 46.

17 According to Mirbeau, it was Aurier who could not keep to distinctions, at least when he encountered Mirbeau in person: 'Il convient de tout, en souriant

bêtement' (He agrees with everything, smiling stupidly) (letter of Mirbeau to Pissarro, 16 December 1891, in Pierre Michel and Jean-François Nivet (eds), *Octave Mirbeau, Correspondance avec Camille Pissarro* (Tusson, Du Lérot, 1990), p. 78).

18 In accord with intellectual preoccupations of the time, Mirbeau in 1890 was reading (with disapproval) 'un livre de pathologie cérébrale' (a book on mental illness), Cesare Lombroso's notorious *L'Homme de génie* (Mirbeau, letter to Monet, mid-May 1890, in Michel and Nivet, *Correspondance avec Claude Monet*, p. 95); while Aurier complained of 'la décrépitude de notre art et ... de notre imbécile et industrialiste société' (the decrepitude of our art and ... of our imbecilic industrialised society) ('Les Isolés', pp, 27–8). On melancholy, cf. Anatole France, 'Pourquoi sommes-nous tristes?' (1889), *La Vie littéraire*, III, pp. 1–9. In an analysis offered by Fernand Caussy, Impressionism appeared to result from neurasthenia and responded to a society alienated from its inner life ('Psychologie de l'impressionnisme', *Mercure de France*, 52 (December 1904) 631, 647). Concerning the links between psychological and artistic theories, see Filiz Eda Burhan, 'Vision and Visionaries: Nineteenth Century Psychological Theory, the Occult Sciences and the Formation of the Symbolist Aesthetic in France', Ph.D. diss., Princeton University, 1979. On the cultural 'obsession' with nervous stimulation, nervous exhaustion and neurosis, see Debora L. Silverman, *Art Nouveau in Fin-de-Siècle France* (Berkeley, University of California Press, 1989), pp. 75–91; Anson Rabinbach, *The Human Motor: Energy, Fatigue, and the Origins of Modernity* (Berkeley, University of California Press, 1990), pp. 146–78.

The critical themes I explore in this chapter are linked to two broad sociopolitical issues: first, the republican promotion of a medical or psychological authority to replace traditional clerical authority (cf. Jan Goldstein, *Console and Classify: The French Psychiatric Profession in the Nineteenth Century* (Cambridge, Cambridge University Press, 1987), pp. 369–77); second, the attribution to (or appropriation by) male artists of a neurasthenic or hysterical sensitivity traditionally associated with women. Lucien Arréat wrote that 'les artistes, on l'a répété cent fois, sont les plus féminins des hommes' (artists, it has been repeated a hundred times, are the most feminine of men) (*Psychologie du peintre* (Paris, Alcan, 1892), p. 252); while Aurier referred to Van Gogh as having the 'nervosités de femme hystérique' (nervous irritability of a hysterical woman) ('Les Isolés', p. 29). Developments in medicine, psychology and art criticism depended on a philosophical and scientific demystification of the mind/body dualism, with mental functions being explained by analogy to material phenomena and mechanisms; cf. Jean Marie Guyau, 'La Mémoire et le phonographe', *Revue Philosophique*, 9 (1880) 319–22.

19 Alphonse Germain, 'Le Paysage décoratif', *L'Ermitage*, 2 (November 1891) 645.

20 Félix Fénéon, 'Exposition de M. Claude Monet; 5e Exposition de la Société des artistes indépendants' (1889), in Joan U. Halperin (ed.), *Œuvres plus que complètes*, 2 vols (Geneva, Droz, 1970), I, p. 168 (the translation is by Halperin, *Félix Fénéon: Aesthete & Anarchist in Fin-de-Siècle Paris* (New Haven, Yale University Press, 1988), p. 208). Emile Bernard, recalling days at the atelier Cormon (in notes composed in 1889 for Aurier's use), referred to Van Gogh's incessant activity, as would so many critics subsequently: 'Il faisait par séance trois études, s'embourbant dans des pâtes, recommencant incessamment sur de nouvelles toiles' (He was making three studies each session, getting mired in muddied paint, forever beginning anew on fresh canvases); see Roland Dorn, 'Bernard on Van Gogh', in MaryAnne Stevens, *Emile Bernard 1868–1941* (Zwolle, Waanders, 1990),

p. 383. Such information encouraged Aurier to interpret Van Gogh's art in terms of neurotic excesses: 'Ce qui particularise son œuvre entière, c'est ... l'excès en la nervosité ... [Il] est un hyperesthésique ... [un] névrôsé' (What sets his entire œuvre apart is ... excessive nervous sensitivity ... [He] suffers from hyperaesthesia ... from neurasthenia) ('Les Isolés', pp. 26–7).

21 Cf. Gustave Kahn, 'Difficulté de vivre', *Le Symboliste*, 2 (October 1886) 1.

22 If Van Gogh suffered from temporal lobe epilepsy, his hyperactivity as painter (as well as letter writer) might be considered a manifestation of the associated abnormality known as hypergraphia, 'a tendency to write excessively and compulsively' (David Myland Kaufmann, *Clinical Neurology for Psychiatrists* (Philadelphia, Saunders, 1990), p. 206). I thank Anne Collins and Dr Shahram Khoshbin for information on hypergraphia.

23 Mirbeau, 'Vincent van Gogh', *Des artistes*, I, pp. 136, 134.

24 On the thematics of Mirbeau's art criticism common to his novels – his eroticisation of flowers and conversion of the wondrous into the sinister – see Emily Apter, 'The Garden of Scopic Perversion from Monet to Mirbeau', *October*, 47 (Winter 1988) 91–115. For an instance of Mirbeau's characteristic mix of aestheticism and prurience (appropriate to the physical distancing afforded by vision), see his letter to Monet, c. 10 February 1891, in Michel and Nivet, *Correspondance avec Claude Monet*, p. 118: 'J'ai vu une sorte de vase de lui [Gauguin], une fleur sexuelle étrangement vulvique, dont l'arrangement est vraiment très beau et qui est d'une obscénité poignante et haute' (I saw a type of vase by [Gauguin], a sexual flower curiously vulval, of which the composition is truly beautiful and which is of a strikingly arch obscenity).

25 Mirbeau, 'Claude Monet', *L'Art dans les Deux Mondes*, p. 185. Similarly, Pissarro's supporters stressed his health and vigour despite his relatively advanced age, referring to his 'inaltérable jeunesse d'âme [et] visage d'ancêtre resté jeune homme' (unchanging spiritual youth [and] the look of an ancestor who remained a young man) (Lecomte, 'Camille Pissarro', p. 302).

26 Mirbeau, 'L'Exposition Monet-Rodin' (1889), in Michal and Nivet, *Correspondance avec Claude Monet*, p. 250.

27 Letters to Geffroy, 22 June 1890, 28 March 1893, in Geffroy, *Claude Monet*, II, pp. 47, 63.

28 Letter to Monet, 25 July 1890, in Michel and Nivet, *Correspondance avec Claude Monet*, p. 103.

29 Letter to Monet, beginning of February 1889, *ibid.*, p. 72.

30 Geffroy, 'Paul Cézanne' (1894), *La Vie artistique*, III, p. 259; cf. Georges Lecomte, 'Paul Cézanne', *Revue d'Art*, 1 (9 December 1899) 86. To the extent that critics evaluated technical effects independent of naturalistic referents, they followed the precedent of the 'Symbolist' Stéphane Mallarmé more than the 'naturalist' Emile Zola, although, as Mirbeau insisted, both were to be admired; cf. Mirbeau's statement (1891) in Jules Huret, *Enquête sur l'évolution littéraire* (Paris, Charpentier, 1913), p. 214. On the critical divergence of Mallarmé and Zola, see Jean-Paul Bouillon, 'Manet 1884: un bilan critique', in Jean-Paul Bouillon (ed.), *La Critique d'art en France 1850–1900* (Sainte-Etienne, Université de Saint-Etienne, 1989), p. 171.

31 This put them in conflict with Fénéon, who preferred Georges Seurat's technique 'puisque toute difficulté matérielle de facture est écartée' (because every material difficulty in the making is circumvented); 'L'Impressionnisme' (1887), in Halperin, *Œuvres plus que complètes*, I, p. 67.

32 For detailed discussion of the technique, see Shiff, *Cézanne*, pp. 99–123, 199–219; and Richard Shiff, 'Cézanne's Physicality: The Politics of Touch', in Salim Kemal and Ivan Gaskell (eds), *The Language of Art History* (Cambridge, Cambridge University Press, 1991), pp. 129–80.

33 See, e.g., W. G. C. Byvanck, *Un Hollandais à Paris en 1891* (Paris, Perrin, 1892), p. 177.

34 Paul Souriau, *L'Esthétique du mouvement* (Paris, Alcan, 1889), p. 246.

35 Mirbeau, 'Claude Monet', *L'Art dans les Deux Mondes*, p. 185. For extended discussion of Monet's paintings of canoeing and Mirbeau's commentary, see Levine, *Monet*, pp. 123–36.

36 Letter to Geffroy, 22 June 1890, in Geffroy, *Claude Monet*, II, p. 47; cf. also Daniel Wildenstein, *Claude Monet: biographie et catalogue raisonné*, 5 vols (Lausanne, La Bibliothèque des arts, 1975–91), III, p. 132.

37 Letter to Monet, 10 February 1891, in Michel and Nivet, *Correspondance avec Claude Monet*, p. 118 (original emphasis). Mirbeau was reassuring Monet that although he had prepared a laudatory essay on Gauguin (with language suited to Gauguin's Symbolist interests), he found Gauguin's painting somewhat limited visually. With the verb *émouvoir*, which has the archaic meaning of setting something in motion, he referred to an emotional or affective movement that conjoins bodily movement with intangible psychic experience. The double meaning of this 'movement' corresponds to the double meaning of 'sensation'; and this is evident in Western thought as far back as the ancients. See Plato, *Philebus*, 34a, where Socrates suggests that the term 'sensation' should be applied to the 'movement [that] occurs when soul and body come together in a single affection and are moved both together' (trans. R. Hackforth, in Edith Hamilton and Huntington Cairns (eds), *The Collected Dialogues of Plato*, (Princeton, Princeton University Press, 1961), p. 1112).

38 Mirbeau, 'Des lys! Des lys!' (1885), *Des artistes*, I, p. 218.

39 Denis, quoted in Jacques Daurelle, 'Chez les jeunes peintres', *L'Echo de Paris* (28 December 1891) 2.

40 Octave Mirbeau, 'Camille Pissarro', *L'Art dans les Deux Mondes* (10 January 1891) 84. Mirbeau repeated his remarks on Rousseau as part of a memorial to Pissarro ('Camille Pissarro' (1904), *Des artistes*, II, p. 231). See his similar statements in 'Camille Pissarro' (1892), *Des artistes*, I, p. 150; and 'L'Exposition Monet-Rodin', in Michel and Nivet, *Correspondance avec Claude Monet*, pp. 246–7. Perhaps comparisons with Rousseau carried particular rhetorical force since it was said that this artist, too, sometimes reworked his most ambitious paintings excessively; cf. Alfred Sensier, *Souvenirs sur Théodore Rousseau* (Paris, Techener, 1872), pp. 281–3.

41 Mirbeau, 'Camille Pissarro' (1891), *L'Art dans les Deux Mondes*, p. 84; concerning *sève*, cf. Mirbeau, 'Vincent van Gogh', *Des artistes*, I, p. 136.

42 Mirbeau, 'Camille Pissarro' (1891), *L'Art dans les Deux Mondes*, p. 84. Mirbeau's language evokes theories of genetic evolution as well as the argot, *une belle plante*, referring to an exemplary specimen of human life; the critic called Van Gogh 'cette belle fleur humaine' (this beautiful flower of humanity) ('Vincent van Gogh', *Des artistes*, I, p. 134). On Pissarro's distance from Millet, see his letters to Lucien Pissarro, 2 May 1887, and Georges Pissarro, 17 December 1889, in Janine Bailly-Herzberg (ed.), *Correspondance de Camille Pissarro*, 5 vols (Paris, Presses Universitaires de France (vol. 1), Valhermeil (vols 2–5), 1980–91), II, pp. 157, 313. Critical debates over the social and aesthetic values of Impressionism

and Symbolism could only be confusing to a painter like Pissarro who was already idealising his naturalist themes (cf. Belinda Thomson, 'Camille Pissarro and Symbolism: some thoughts prompted by the recent discovery of an annotated article', *Burlington Magazine*, 124 (January 1982) 14–23). In support of Pissarro's position in 1891, Lecomte applied a quasi-Baudelairean theory of modernism that could appeal to both Impressionists and Symbolists; he stated that Pissarro observed 'les effets transitoires' (transient effects) and fixed them by 'intervention personnelle' (personal intervention) and 'synthèse philosophique' (philosophical synthesis), so as to attain 'le caractère de Permanente Beauté' (the quality of Permanent Beauty) (Lecomte, 'Camille Pissarro', *La Plume*, p. 302). For a similar formulation, see Mirbeau, 'Camille Pissarro' (1892), *Des artistes*, I, p. 148. On the complexity of Pissarro's artistic programme, see Paul Smith, ' "Parbleu": Pissarro and the political colour of an original vision', *Art History*, 15 (June 1992) 223–47.

43 Letter of 21 April 1892, in Bailly-Herzberg, *Correspondance*, III, p. 217.

44 For the dating of this painting to either 1878 or 1879, see *ibid.*, V, pp. 399–400.

45 Mirbeau's concept of *mystère* (mystery) was related to such principles and opposed (as it was for Lecomte) to the *mysticisme* (mysticism) of the Symbolists; see Herbert, 'The decorative and the natural', pp. 165–7. Pissarro referred to his own position as 'anti-autoritaire et antimystique' (anti-authoritarian and anti-mystical); letter to Lucien Pissarro, 20 April 1891, in Bailly-Herzberg, *Correspondance*, III, p. 66. On mysticism, religiosity and Symbolist art, see also Burhan, 'Vision and Visionaries', pp. 130–1.

46 Gaston Deschamps, 'L'Historien de l'impressionnisme' (1895), in his *La Vie et les livres*, 6 vols (Paris, Colin, 1895–1903), III, p. 73.

47 The exchange between Monet and Mirbeau, along with a characterisation of their mode of interaction, appeared in the obituary Léon Daudet wrote for Monet: 'Un Prince de la lumière: Claude Monet', *L'Action Française* (8 December 1926) 1. The exchange appears to date close to the time of Mirbeau's purchase of *Allée d'iris* from the dealer Julien Tanguy (April 1891); cf. Pierre Michel et Jean-François Nivet (eds), *Octave Mirbeau, Correspondance avec Auguste Rodin* (Tusson, Du Lérot, 1988), p. 100, note 3.

48 Mirbeau, 'Vincent van Gogh' (1901), *Des artistes*, II, p. 148.

49 Mirbeau, 'Vincent van Gogh' (1901), *Des artistes*, II, pp. 146–7. In point of fact, like both Van Gogh and Monet, Cézanne was known as someone 'toujours insatisfait, toujours se meurtrissant à la poursuite d'un but jamais atteint' (always unsatisfied, always killing himself by pursuing a goal never attained); Emile Bernard, 'Paul Cézanne', *Le Cœur*, 2 (December 1894) 4.

50 See Mirbeau's recollections in Maurice Denis, *Journal*, 3 vols (Paris, La Colombe, 1957–59), II, p. 46.

51 Mirbeau, 'Camille Pissarro' (1904), *Des artistes*, II, p. 226.

52 Mirbeau, 'Etre peintre!' (1892), *Des artistes*, I, pp. 158–9.

53 Mirbeau, 'Vincent van Gogh' (1891), *Des artistes*, I, p. 134; 'Vincent van Gogh' (1901), *Des artistes*, II, p. 148.

54 Letter to Theo van Gogh (25 or 26 September 1888), in *Correspondance complète de Vincent Van Gogh*, ed. Georges Charensol, 3 vols (Paris, Grasset, 1960), III, p. 213.

Index

Note: page numbers in *italics* indicate illustrations.